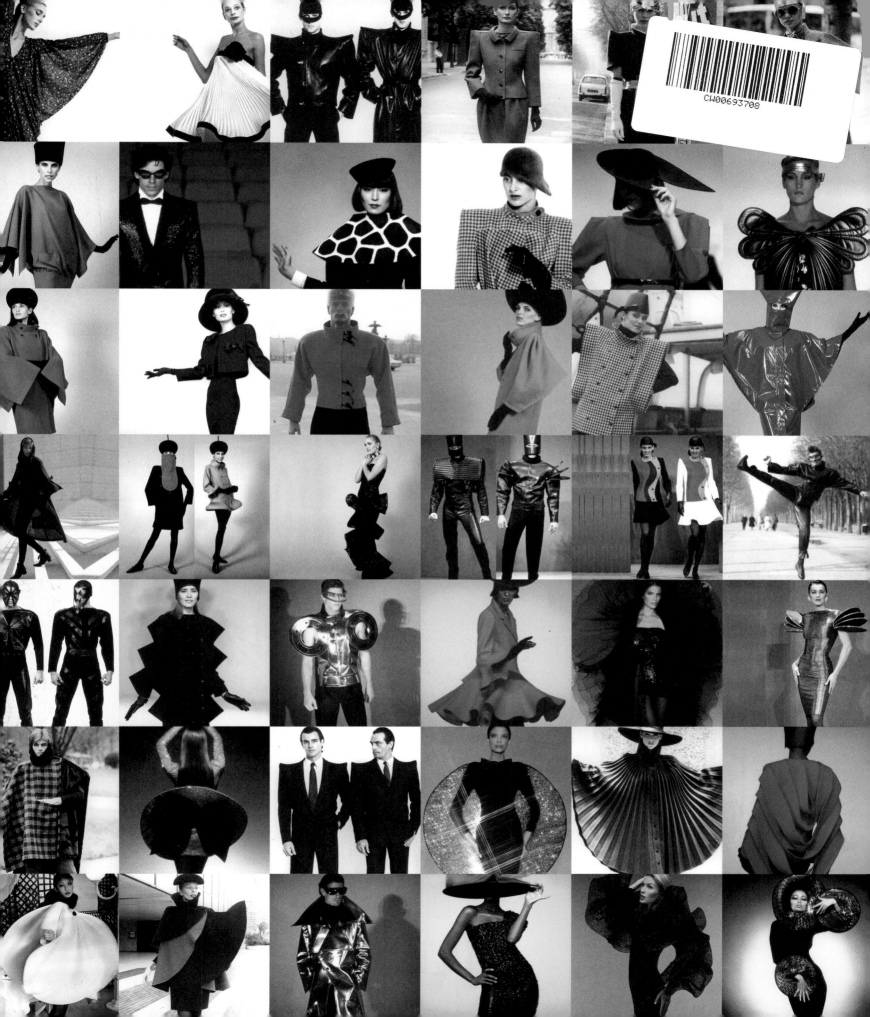

pierre cardin

pierre cardin
fifty years of fashion and design

Elisabeth Längle

The Vendome Press

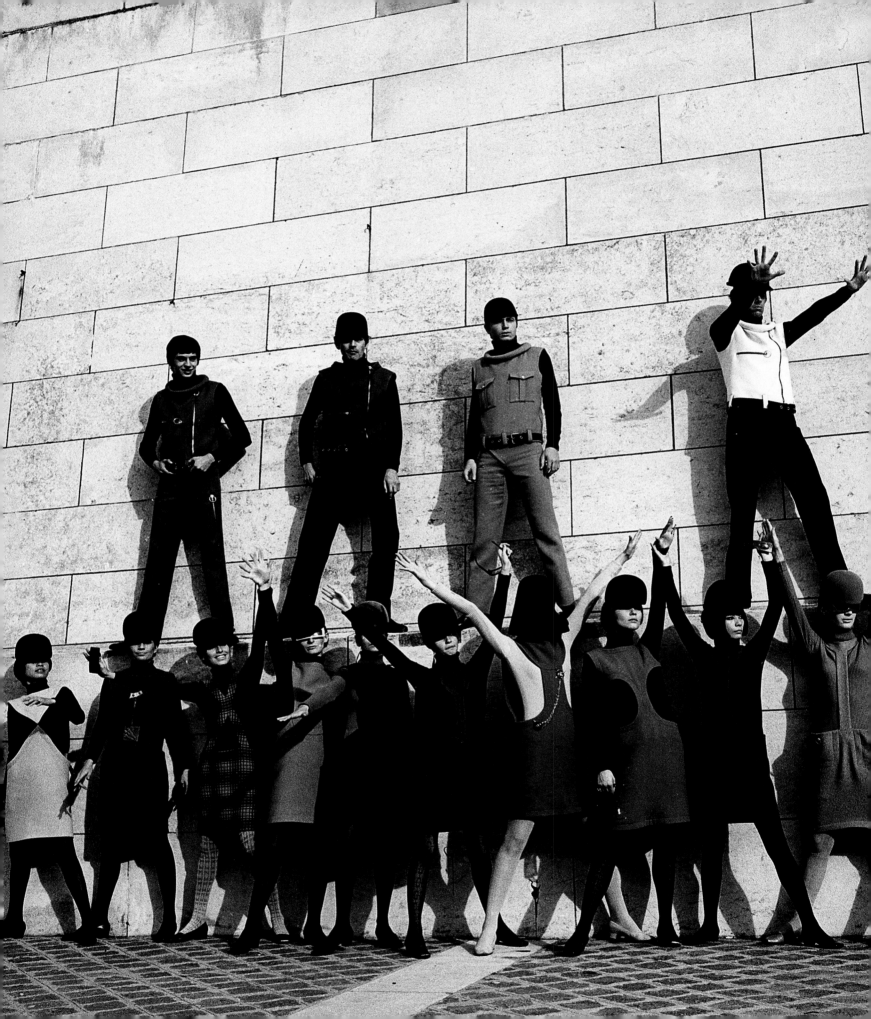

CONTENTS

'I love to design in the absolute without restrictions. Whether I am designing the sleeve of a dress or the leg of a table, it is the same.'

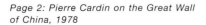

*Page 2: Pierre Cardin on the Great Wall
of China, 1978*

Opposite: Ready-to-wear Cosmocorps collection, 1967
Right, from top to bottom:
Pierre Cardin at a fitting with Jeanne Moreau, 1968
Accessory, 1971
Utilitarian sculpture, 1977
Espace Cardin, 1975
Le Palais Bulles, 1989
Kiri Te Kanawa with Pierre Cardin at Maxim's, 1981

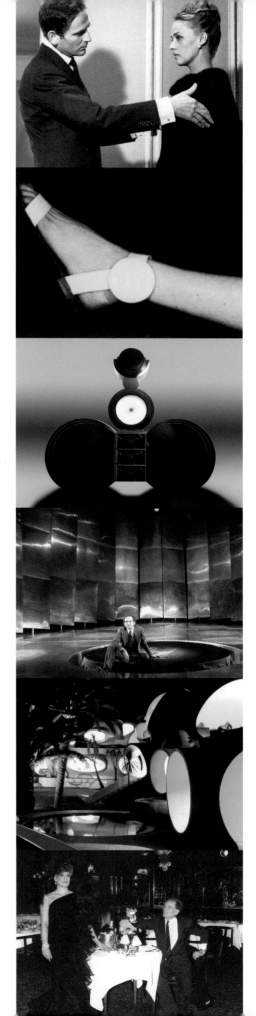

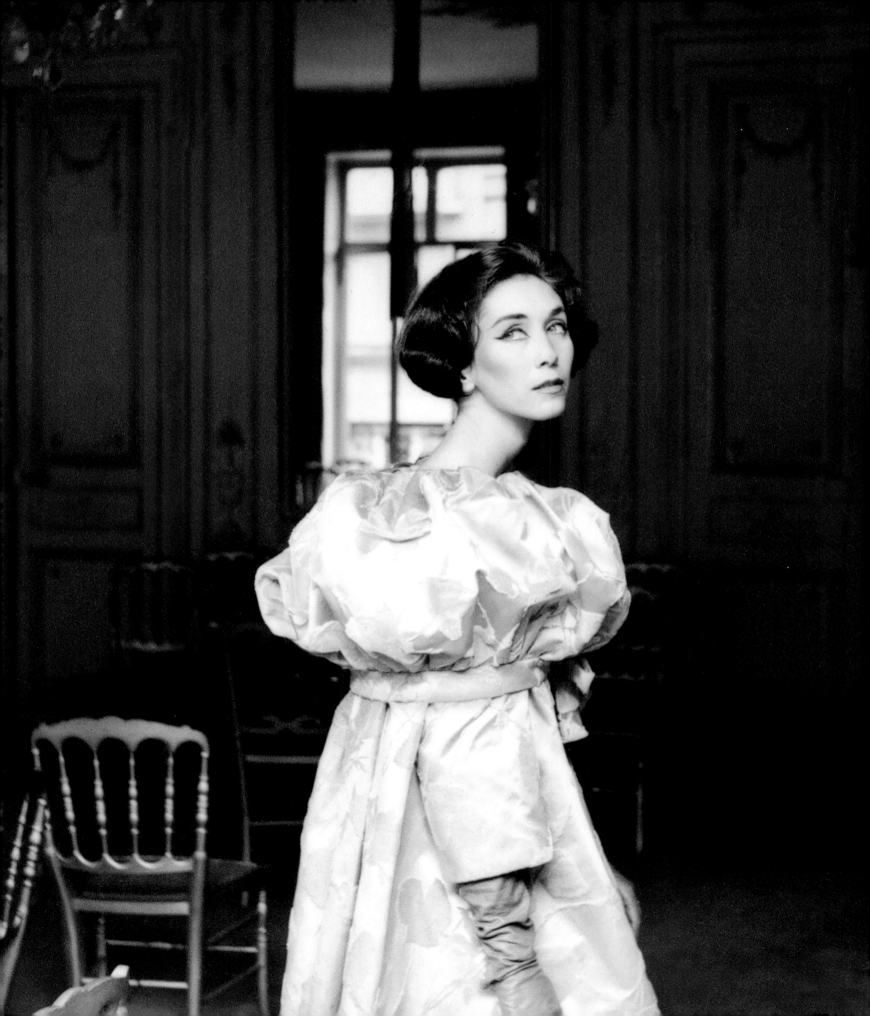

INTRODUCTION

'I wanted my name to become a brand and not just a label.'

Pierre Cardin. Avant-gardist and worker. Couturier and hotelier. Agitator and master of chic. Minimalist and patron. Midas and model. Sculptor and theatre-maker. Stylist and costume designer. Revolutionary and traveller. Ambassador of design. Venetian-born venturer and world-renowned Frenchman.

The controversial culminates in the being of this visionary. For Pierre Cardin two working days equal 35 hours, and he toils tirelessly on his business, the monument of his own immortality. Work is his religion: boundless, interdisciplinary, inimitable, passionate and cosmopolitan. At the epicentre of a network of art and culture, people and fashion, experiments, inventions, businesses and licences spanning all five continents stands Pierre Cardin himself – a man of the world and a global brand.

Haute couture is the nucleus of Cardin's universal creativity. During his apprenticeships with Jeanne Paquin, Elsa Schiaparelli and Christian Dior, he recognized that his orbit as a couturier would have to course beyond known galaxies. Cardin founded his business in 1950 and presented his first haute couture collection in 1953. In 1954 his 'bubble dress' sparked a revolution in fashion that was not confined to haute couture salons but struck a chord with the everyday woman on the street. It was Cardin who first equated fashion design with the masses, and he made the notion of luxury for everyone into an international currency. In 1959 he showed the first ready-to-wear (*prêt-à-porter*) collection in fashion history in the Parisian department store Au Printemps, where anyone could buy it. Having been banned from the Olympus of haute couture for breaking its elitist rules, in 1960 he returned to the lofty seat of the French fashion gods as the Zeus of men's fashion with the very first ready-to-wear collection for men in the world, underlining his conviction that luxury should be affordable for everyone. Haute couture remained his laboratory for new ideas.

Before becoming a couturier, Cardin was a costume designer, and theatre has continued to hold a great fascination for him. The 1946 film *The Beauty and the Beast*, for which Cardin designed the costumes, achieved cult status. In 1970 he manifested his passion for film and theatre in an art and cultural centre in the heart of Paris, the Espace Cardin, which incorporates a theatre, cinema, gallery, exhibition hall and restaurant. Towards the end of their careers, both Ella Fitzgerald and Marlene Dietrich trod the boards there.

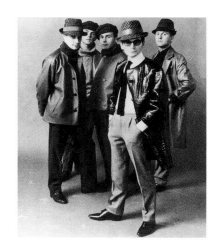

Opposite: Bubble dress, 1954
Left: Pierre Cardin with students from the Sorbonne, 1960

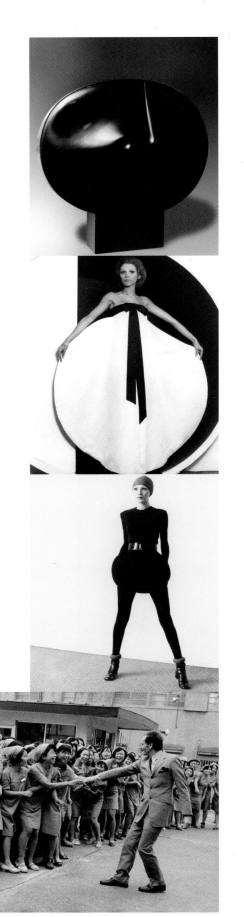

The basic formal language of geometry is the hallmark of Pierre Cardin's fashion, furniture, objects, designs and accessories. His style is that of a sculptor: plastic and monumental. The only difference lies in the fact that his sculptures are animated. He created a collection of haute couture furniture in 1977, which he called Sculptures Utilitaires (Utilitarian Sculptures), and designed wardrobes, chests of drawers, cupboards, shelves and sideboards as free-standing objects in space. Their functions remain hidden beneath their glossy lacquered surfaces.

In 1981 the couturier purchased the legendary establishment Maxim's de Paris – a restaurant without which Paris simply would not be Paris – and gave it back its lustre. He exported Maxim's as an Art Nouveau *gesamtkunstwerk* all over the world. A range of licensed products under the Maxim's brand in duty-free shops and boutiques attested that luxury *à la* Maxim's was affordable. Cardin took fashion to Japan, China and Russia before the fashion world outgrew France. He paid tribute to Russia's political opening with a fashion show for 200,000 people in Red Square, and he planted 200,000 trees in Israel as a symbol of peace.

No other figure from the art or business worlds has been presented with as many awards and honours as Pierre Cardin. Retrospectives in museums the world over have celebrated the work of a couturier and designer who is a legend in his own lifetime. His status as an icon of the avant-garde is sacrosanct. His signature is unmistakable in the sea of fashion labels. Like a sculptor, he forms couturier fashion, accessories and furniture into three-dimensional objects, which he creates for the world of tomorrow. They remain as timeless as a circle. Pierre Cardin, the entrepreneur, gives his countless and diverse businesses and projects the structure of a cosmos. In its circular symbol of unending space, he faces the immense challenge of constantly realizing new projects and concentrically extending existing circles, whose shared centre is Pierre Cardin. He is sole owner and ruler in a worldwide brand and licensing empire, which he has recently extended to include arguably the most important business sector of the century – water. For him, exacting labour is as much the prerequisite for the artist–businessman as any visionary quest. This constellation determines Pierre Cardin's radius of activity and success. He has made it his task to invent the future, which is reflected in his driving desire to work to his last breath.

Left, from top to bottom:
Utilitarian sculpture, 1977
Haute couture gown, 1969
Ready-to-wear gown, 1971
Pierre Cardin in Japan, 1957
Opposite: Ready-to-wear men's wear, 1983

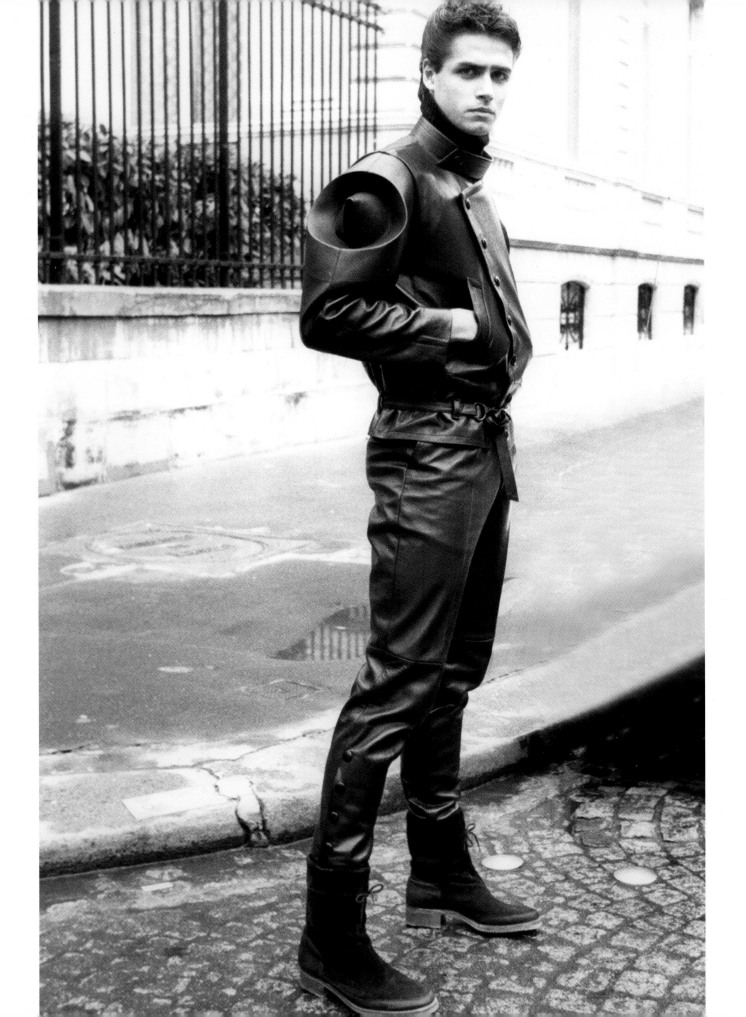

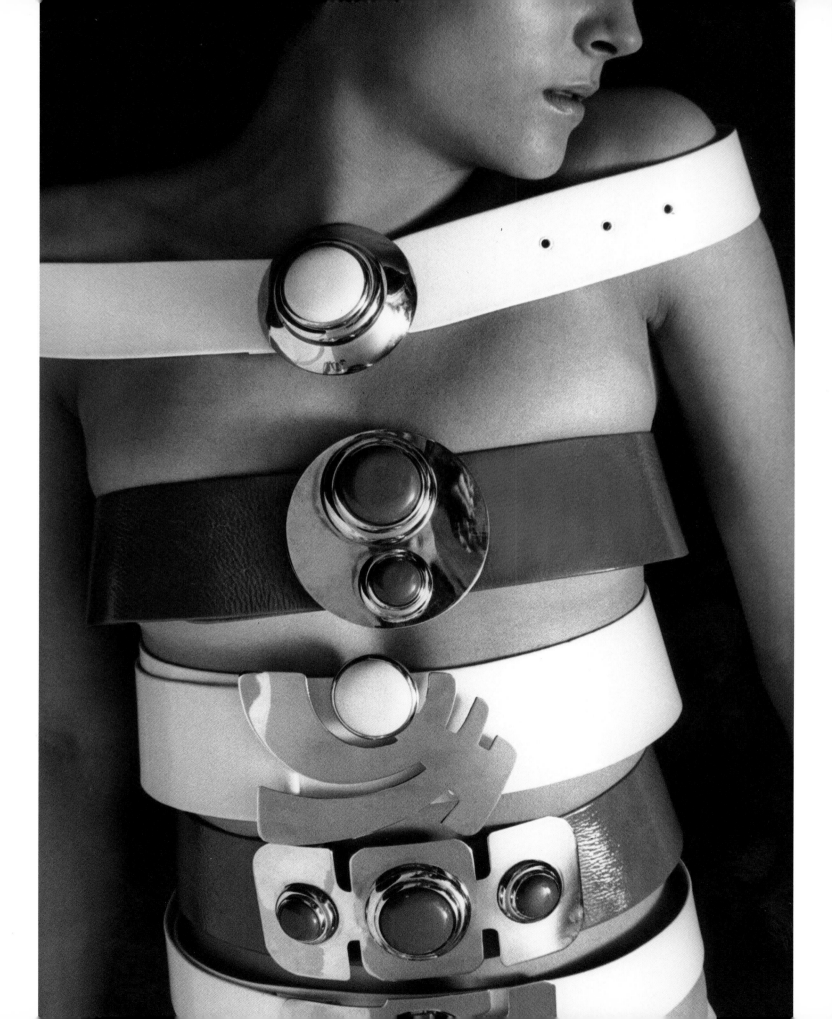

FASHION AND ACCESSORIES

'As a little boy I dreamed of being big. Big in two senses: both grown up and someone who counts in the world.'

In the world of fashion the working relationship between master and assistant is not ideal. The assistant remains undiscovered and unknown for as long as he is working for his master. The assistant's best work automatically becomes his master's latest creations. The very nature of this relationship means that the best assistants leave their master after a relatively short period of apprenticeship. However, their physical separation does not necessarily result in a spiritual one. Consciously or unconsciously, the experiences gained during apprenticeship flow into independent work, eventually taking on their own form after a process of development and maturation. Extraordinary talents always outstrip their masters.

Pierre Cardin was able to learn tailoring of the highest standard and acquaint himself with the world of luxury at the houses of Jeanne Paquin, Elsa Schiaparelli and Christian Dior. Madame Paquin (1869–1936) was the first Parisian couturier to expand from her salon base to take her fashions to the places society spent its weekends – the racecourses of Longchamps and Chantilly. She created the first mobile couture salon in the USA, which toured principal American cities once a year equipped with twelve models. She engaged George Barbier, Paul Iribe and Leon Bakst, all prominent artists, for the design of her accessories, which she presented to the world in a catalogue. Paquin celebrated the transfer of ideas and images from one art form to another on the highest of levels. The hallmarks of her fashion were graphic forms and brilliant colours, which she contrasted with black. Her coats and suits with oversized collars became must-haves for women playing an active role in their profession and society. In 1913 she became the first woman of fashion to be received into the French Legion of Honour. Between 1936 and 1944, the Spanish couturier Antonio Castillo ran the Paquin fashion house. In November 1944, Pierre Cardin started his career at Paquin's salon, where he worked for one year.

In 1927 Roman-born fashion designer Elsa Schiaparelli (1890–1973) opened her couture salon, Pour le Sport, at Place Vendôme 21, in the heart of Paris. 'Shocking' was the name of her perfume, the shade of pink she promoted and the title of her memoirs, but it is also an apt description of the style of this highly unconventional couturière, with its mixture of Surrealist fantasies and modern austerity. Every collection of 'Schiap' was a fashion revolution. Artists such as Jean Cocteau and Salvador Dalí designed pictorial motifs and

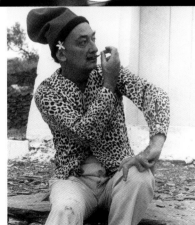

Opposite: Ready-to-wear belts, 1972
Left, from top to bottom:
Elsa Schiaparelli, 1937
Salvador Dalí, 1960

accessories for her. Her miniature animal buttons, including lobsters, cicadas and ants, her black velvet telephone handbag with gold dial and her aspirin tablet necklace were sold around the world. Among the big names in high fashion who shone like fixed stars at that time, Elsa Schiaparelli's star was undoubtedly the most dazzling of all. She gave the female body its sharpest forms with diagonal cuts and the fashion world the boldest of prototypes for a modern lifestyle. Her ideas told a fantastic story of a creative poetess who transformed fashion into artworks with humour and frivolity. Her conviction that clothes should not be tailored for the body but that the body should be trained to suit the clothes ignored the status of haute couture as the highest art of individual bespoke creations. Schiaparelli was the protagonist of a modern body consciousness and emphatic body language that was better understood in North America than in Paris, and during the Second World War she emigrated to America. Pierre Cardin served with her for two months.

Christian Dior (1905–57) felt drawn to the architectural profession but, complying with his industrialist background, studied political science instead for a career in diplomacy. After his studies at the École des Sciences Politiques in Paris, he opened a small gallery and became one of Salvador Dalí's patrons. When his father's business collapsed, Dior had to earn his living as a fashion illustrator for *Le Figaro Illustré*. In 1938 he secured a position as designer at the fashion house of Robert Piquet, followed in 1941 by a period with Lucien Lelong. He baulked at opening his own salon because of the financial risks involved. In 1946 he accepted an offer from the textile industrialist Marcel Boussac to become artistic director of a new haute couture house. He brought his name and talent as a fashion designer to the collaboration, while Marcel Boussac provided the capital and experience in distribution and the promotion of a brand.

'My priority is financial independence. It guarantees my artistic freedom.'

On 18 November 1946, immediately after Christian Dior's couture salon had opened on the Avenue Montaigne, Pierre Cardin was invited by Dior himself – one of the many admirers of his theatre and film costumes – to work at the couture house, which employed six people at the time. Under Christian Dior's name he designed the suits and coats of the first collection, La Ligne Carolle, which was presented on 12 February 1947 and was a worldwide success. American journalists called it the 'New Look' – round shoulders, narrow waists, wide-cut full skirts and skin-tight bustiers over masses of expensive fabrics. It set off a fashion-quake that could not be measured on any Richter scale. Against all the laws governing a post-war economy, Dior celebrated an extravagantly wasteful use of fabric that was capable of fulfilling women's secret desires for luxury and not totally at odds with the interests of his partner, Marcel Boussac. Christian Dior acceded to the throne of haute couture, buoyed by the wave of enthusiasm created by the 'New Look', and from that throne he was able to dictate over fashion, making Paris the undisputed centre of the fashion world. In 1948 the full circular skirt fell out of favour and was replaced by the pencil skirt. In 1949 Christian Dior New York Inc. was established as a bridgehead to market the Christian Dior name, and the first licensed product was launched – women's stockings. Colleagues in haute couture put down this strategy as vulgar and unworthy of a couturier. Perfume was the only luxury product under the Dior umbrella to be used as a commercial brand carrier by other couturiers such as Paul Poiret, Coco Chanel and Jean Patou. Christian Dior died of a heart attack in 1957.

Left, from top to bottom:
Christian Dior, 1950
Pierre Cardin in Café de la Paix, 1949

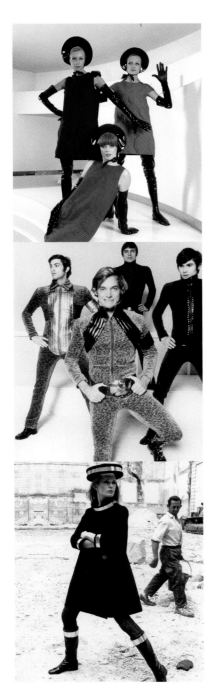

Pierre Cardin set up his own business in 1950. He had started working as a costume designer in 1945 in the Rue Richepanse, and his work with Jean Cocteau, Christian Bérard and Marcel Escoffier on the cult film *The Beauty and the Beast* had made him a great talent in the eyes of theatre and film makers, Luchino Visconti among them. In 1950 he designed the costumes for another Jean Cocteau film, *Orphée*.

It is part of a costume designer's job to subordinate himself to the director and the main stars. Costumes transform the appearance of the actors in order to communicate a certain role to the audience. It was his desire for independence that inspired Cardin to establish his couture house and design his own creations, which were first presented to the public in 1953, and a year later he shot to fame in the fashion world with his bubble dress. Cardin became the young star couturier virtually overnight. The upturn in the market for his creations made them blue chips. Creative and strategic, both untiring and independent, he worked on the potential of his luxury brand for industrial marketing.

Pierre Cardin's formal language, derived from elementary geometric shapes, became his unmistakable signature. Circle, triangle, square, cylinder, sphere and cone determined the plastic volume, cut and composition of a couturier who works like a sculptor. Rather than designing fashion for the figure of a certain person, Cardin draped his formal language over body language. In this way, he transferred his independence as a formalistic couturier to his creations, which were developed irrespective of trends. The common practice of categorizing fashion forms according to decade has structured countless retrospectives of a fashion designer whose programme was always determined by perspective: 'The dresses I prefer are those I invent for a life that does not exist yet – the world of tomorrow.'

In the fifties, sixties and seventies, he gave anticipatory forms to the influences of politics, economy, art, science and technology, which are all reflected in fashion as a social phenomenon. He did not change his geometric vocabulary in the eighties and nineties but modified it. On the ever-changing world stage of fashion Cardin remained a master of geometry, using his intuition and talent for marketing fashion to reinvent himself as a global brand. In his case, artistic creativity and business acumen are on a par.

Left, from top to bottom:
Haute couture gowns, 1968
Ready-to-wear men's wear, 1971
Haute couture gown, 1970

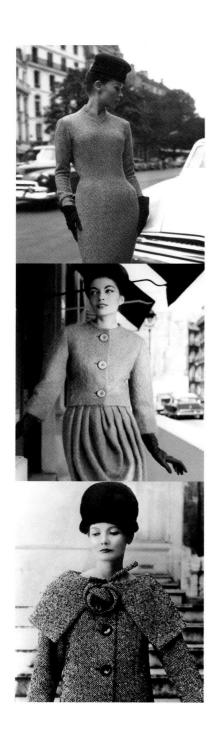

In Paris, the fifties began with liberation – on 25 August 1944. Paris presented itself as the never-ending city with endless liberties. Intellectual fashions changed as quickly as the fashions dictated by haute couture. The sepia-coloured war between the *homme nu* of Jean Paul Sartre and the *homme révolté* of Albert Camus only affected the existentialist minority in a society recently delivered from war. The majority had to satisfy themselves with headlines from the haute couture in a world shaped by radio and newspapers. Television was too expensive. The paradoxical variety in art between the past and future corresponded to the social dilemma between a newly aroused *joie de vivre* and fear of the bomb during the Cold War.

Pierre Cardin fashioned his couture creations on the basic forms of geometry. After the linearity of the pencil in 1951 came voluminous trapezoidal cuts in 1952. Circular-shaped collars on coats and suit jackets enriched everyday fashion with a colossal effect and functional aspect. Enormous collars in evening fashions became his dramatic accent *par excellence*. In 1953 Dmitri Shostakovich's *Seventh Symphony* had its premiere in Paris. This work, formed by austerity and modernity, tore music from its historical tradition. Cardin developed the style of his haute couture with the classical use of materials and cuts but also gave it a new element in sculptural form. The unwonted tones of chaos within the musical order of Shostakovich are comparable with the unaccustomed plasticity of clothes inside the elegance of haute couture. In 1954 Cardin's bubble dress made the plastic dimension of high fashion into a worldwide success. He opened the women's fashion boutique Eve in the same year at Rue du Faubourg Saint-Honoré 118 in Paris. His drive, powered by his creativity, energy, vision and optimism, did not correspond with Françoise Sagan's novel, *Bonjour Tristesse*. The bubble dress was followed by three-dimensionally cut and ruffled bubble skirts in 1955.

In 1956, the year of the Suez Crisis, the couturier cut segments out of the circle of fabric and draped them over the back of jackets and coats and concentrically over the front of the skirts. Asymmetrical diagonals gave garments the sharpness of chiselled stone. The helmet-like head gear heralded the beginning of space exploration. Cardin created the three-dimensional stringency of his fashions and accessories in harmony with the flowing lines of the future – those of André Oliver. This marked decisive changes not only in Paris but also in the rest of the world. The art, music and film worlds were already larger than France. Hollywood had created new heroes of the younger generation in figures such as James Dean and Marlon Brando, who wore jeans, T-shirts and leather jackets and represented a revolutionary counterdraft to the establishment in English suits. The time was right for a different kind of men's fashion.

Pierre Cardin opened the Adam boutique in 1957, where printed shirts and ties were the augurs of his future men's line. He travelled to Japan as the war was starting in Vietnam. As a visiting professor at the Bunka Fukosa College for Design, where he taught for one month, he let the Japanese students into the secrets of the three-dimensional cut. In 1958 he was awarded the Young Designers' Award in Boston. Young Americans had already

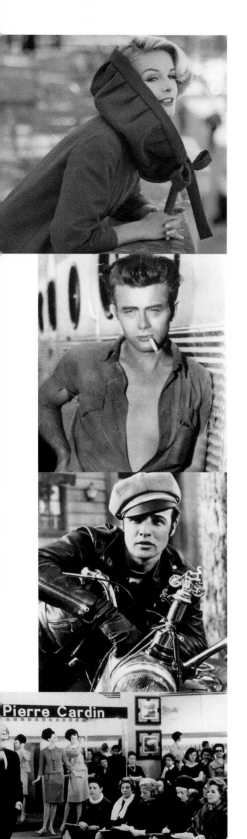

developed their own music, culture, language and clothes by the time Charles de Gaulle became President of France. Lordship over the world market now belonged to a new target group – the youth. They met in cafés, dancehalls and department stores at the beginning of the Space Age.

In 1959 Pierre Cardin presented his first ready-to-wear collection in the Parisian department store Au Printemps. This revolutionary form of distribution and diversification for a couturier was the logical step, given his conviction that the right to luxury should not be limited only to an elite few but should also be enjoyed by millions of women. He broke the elitist rules of haute couture and, as a result, the Chambre Syndicale de la Couture excluded him. Nevertheless, he had opened the doors to the design-conscious consumer world of the future. *Crowds and Power*, Elias Canetti's masterpiece, described the political effect of a social phenomenon that also fascinated Pierre Cardin – the masses. They became the exponential factor in Cardin's business success.

Opposite, from top to bottom:
Haute couture gown, 1953
Haute couture gown, 1957
Haute couture gown, 1958
Left, from top to bottom:
Haute couture gown, 1954
James Dean, 1956
Marlon Brando, 1955
Pierre Cardin in the Au Printemps department store, 1959

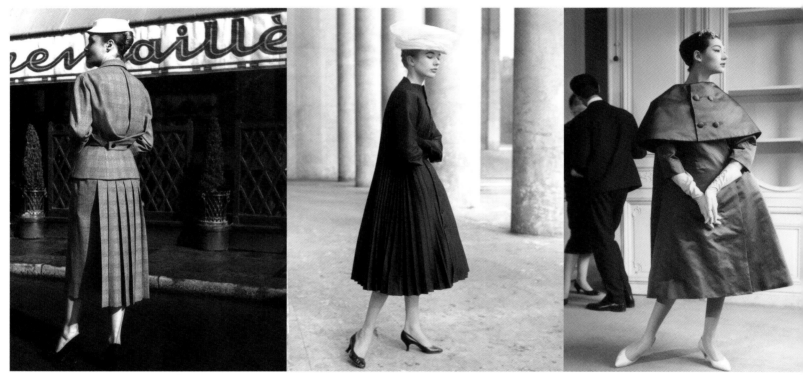

1951 1952 1955

'The circle is the symbol 'One can't learn the
of eternity. I am a Pierrot symbiosis of creativity
Lunaire who is fascinated and commerce. It's like a
by the cosmos. I love the circle. plant which produces
The moon, the sun, the earth both flowers and leaves.
are pure creations, boundless, In my case, something
without beginning and end.' quite natural.'

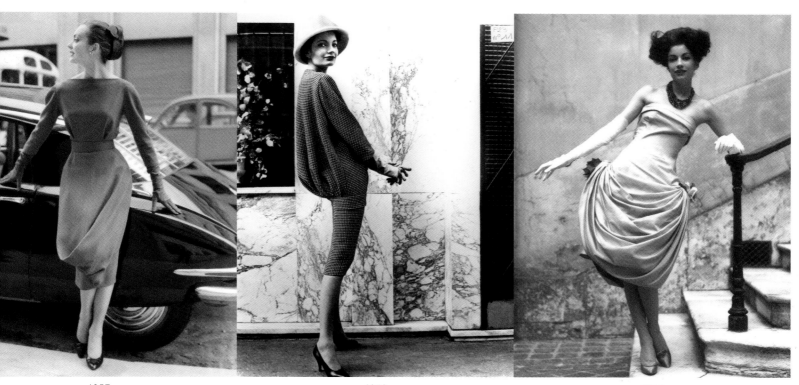

1957

1958

1959

'Every creation is an
architectonic or plastic
construction. The only
difference is that its
forms are animated.'

'In 1959 I asked myself why should
only the rich be able to afford
exclusive fashion, why not the
man and woman on the street as
well? I can change that!
And I did. Luxury should be
affordable for millions of people.'

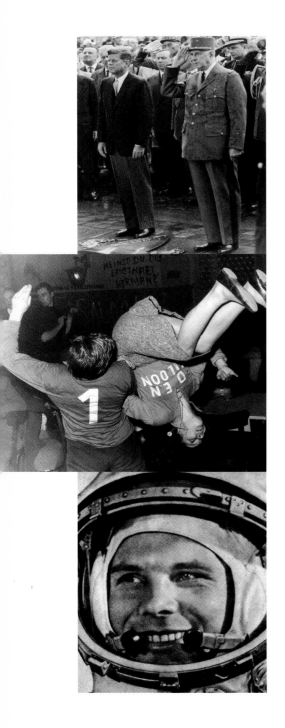

In 1960 Pierre Cardin presented the first men's line in fashion history to those for whom it had been created: 250 students from the Sorbonne were employed as dressmen in the cylinder look, which spoke the new language of the new age with its slender style. It gave politics its first youthful face in the American President John F. Kennedy in 1961. Jazz, rock, beat and pop determined the musical rhythms of a new generation which tolerated dictates in fashion as little as any other directive. Pierre Cardin established a ready-to-wear department for men's fashion and accessories in 1961. Its opening coincided with the first men in space and the first James Bond films. A ready-to-wear department for women followed in 1963. Cardin maintained haute couture as an experimental laboratory. He created the style image of the Beatles: slim-cut, collarless jackets with narrow black piping on light grey fabric. Underneath they wore white shirts with black ties. Tight, dark trousers completed the style of the band whose message 'all you need is love' made them millionaires. He was the designer for the British television series *The Avengers*, which ran successfully from 1961 to 1967. Patrick Macnee (aka John Steed) and Diana Rigg (aka Emma Peel) promoted his fashionably forward-looking collections on the Continent too. He gave them the dynamism of the beat in space: young, short, colourful, hip, plastic and techno. He combined materials such as plastic, vinyl and artificial leather with comfortable jerseys in ensembles fit for the street and space. For the conspicuously growing number of female fans of short skirts he invented opaque hosiery. Monochrome and patterned tights, thigh-length boots and skin-tight rollnecks all had the force of great music and freedom.

Film, television and the media multiplied the demand for the power look of a generation that was fuelling the consumer and fashion market. It was the time when mass fashion found its ideas in London's Carnaby Street, where England's youth celebrated life in one enormous party. Cardin created a dress for young people around the world that could be sold in every street of the luxury market. His pop, beat and space fashions had more to offer than simply the minidress, miniskirt, rollneck pullovers, blousons of artificial fibres and sparkling boots. The body-hugging silhouettes of his suits for men and women set trends, as did his tubes and smocks from the three-dimensional moulded 'Cardine' fabric. Graphically constructed pinafore dresses of densely woven fabric, plastic overalls with zips – all were paying tribute to man setting foot in space. He revoked the simplicity of the shift dresses with two- and three-dimensionally moulded applications, providing them with plastic sex appeal. The life style of the young appeared to be a boundless playground

Left, from top to bottom:
John F. Kennedy on a state visit with Charles de Gaulle, 1962
A couple dancing rock and roll, 1960
Astronaut Yuri Gagarin, 1961
Opposite, from top to bottom:
The Beatles sporting the Pierre Cardin look, 1964
Andy Warhol, 1969
Joseph Beuys, 1965
Pierre Cardin with Cecil Beaton, 1963
Large photo: Cylinder style, 1960

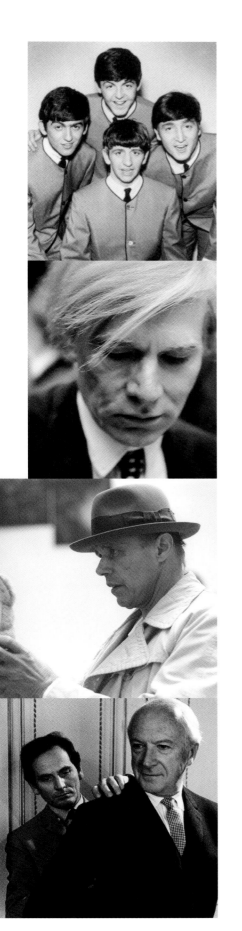
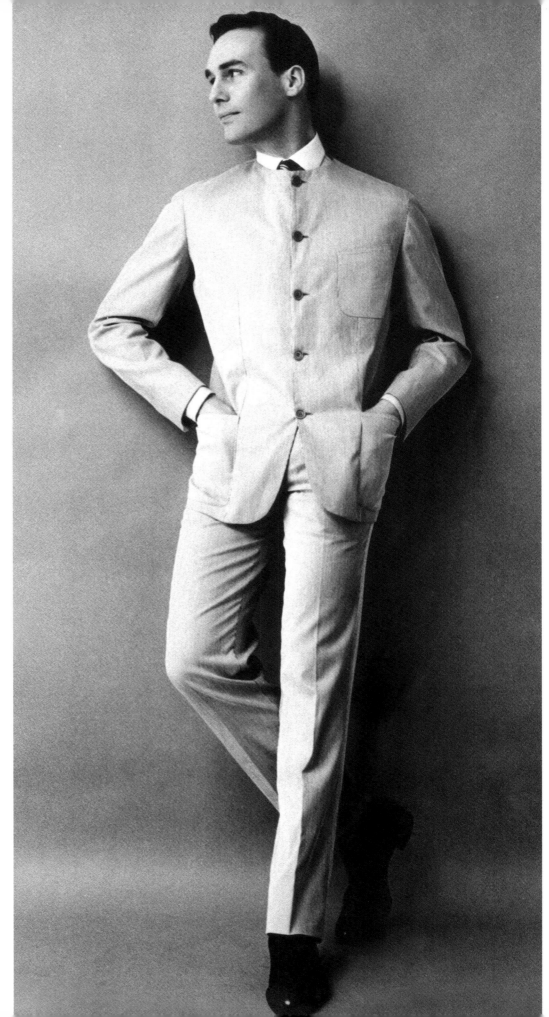

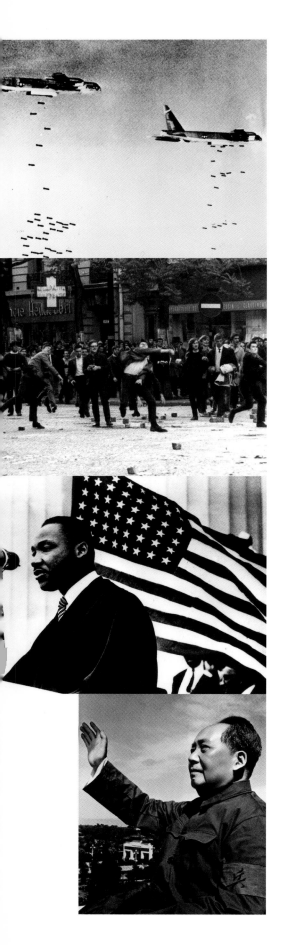

where Cardin's fashion took on colours, shapes and volumes as the building bricks of success. He signed them with his initials. Changes in youth culture did not just make skirts shorter and hair longer – they also transformed girls into boys and vice versa. Pierre Cardin's solution for the switch in gender roles was unisex, skin-tight body suits. They established androgynous chic, including leggings and zipped vinyl jackets. He was the first fashion designer to globalize the catwalk with the Japanese model Hiroko Matsumoto in 1962.

A successful consequence of society's search for boundless freedom was the discovery of endless possibilities to combine fame with wealth. Greats from the world of sport became pop stars, and pop stars heroes. To the young, the roles they played were more important than those of statesmen. Pop culture developed from bright comics, and industrial soup tins became Pop Art with the help of a silkscreen. Art did not just borrow its subjects from commerce, it turned into commerce itself. Pop Art icon Andy Warhol created new pop stars with the power of millionaires. Cardin was the fashion designer who sold himself like a pop star. The epithet 'McFashion' does not alter the fact that in the sixties Cardin already did what everybody else only started to do decades later – building up a global licensing business.

Before the children of the swinging sixties became raucous students, Pierre Cardin invited every triplet in Paris to the presentation of the first children's collection in 1966. He prevailed upon the Chambre Syndicale de la Couture to let him have male as well as female models in his couture show by threatening to leave. When students brought public life in Germany, France and the USA to a standstill with demonstrations in 1968, he opened his first boutique for children's fashion.

Cardin launched flower shirts for men, before the flower children of California became the hippies of the world in 1969, fought for freedom with free love and used drugs to escape from a reality that caused unbearable suffering. Russian tanks destroyed the Prague Spring. Mao Tse Tung initiated the cultural revolution in China. The war of independence in Nigeria heralded the bloody end of colonialism. The Six Day War in the Middle East left the third millennium with a time bomb. The misery and horrors of the war in Vietnam surpassed the agonies of all the other wars at this time. The race riots in the USA and South Africa lost their heroes and gained more victims. Nelson Mandela was imprisoned, and Martin Luther King was killed. Peace and freedom hung on a silk thread. The economy reached the limits of growth.

In 1968 the hemlines of skirts dropped to the floor. Pierre Cardin slit skirts open, developed asymmetrical pointed hems as a stylistic reference to dissolution and invented constructed transparency with mobile tabs attached to the hemline. He never left the terrain of geometry. In the year of uprisings he agreed a licensing deal for the production of porcelain and crockery with the German company Hutschenreuther. This was followed by the licensed production of WMF cutlery. Like Marco Polo, he was fascinated by adventure and new territory. In 1969 Neil Armstrong became the first man to set foot on the moon. Pierre Cardin was to be the only person on this planet to appear in the original space suit worn by Armstrong. In 1970 he designed space suits for NASA.

Left, from top to bottom:
Vietnam War, 1965
Student protests in the Latin Quarter, 1968
Martin Luther King, 1968
Mao Tse Tung, 1969
Opposite, from top to bottom:
Neil Armstrong on the moon, 1969
Pierre Cardin in the space suit worn by Neil Armstrong, 1969
NASA style, 1969–70
Large photo: Ready-to-wear, 1969

Overleaf: Ready-to-wear Cosmocorps collection, 1967

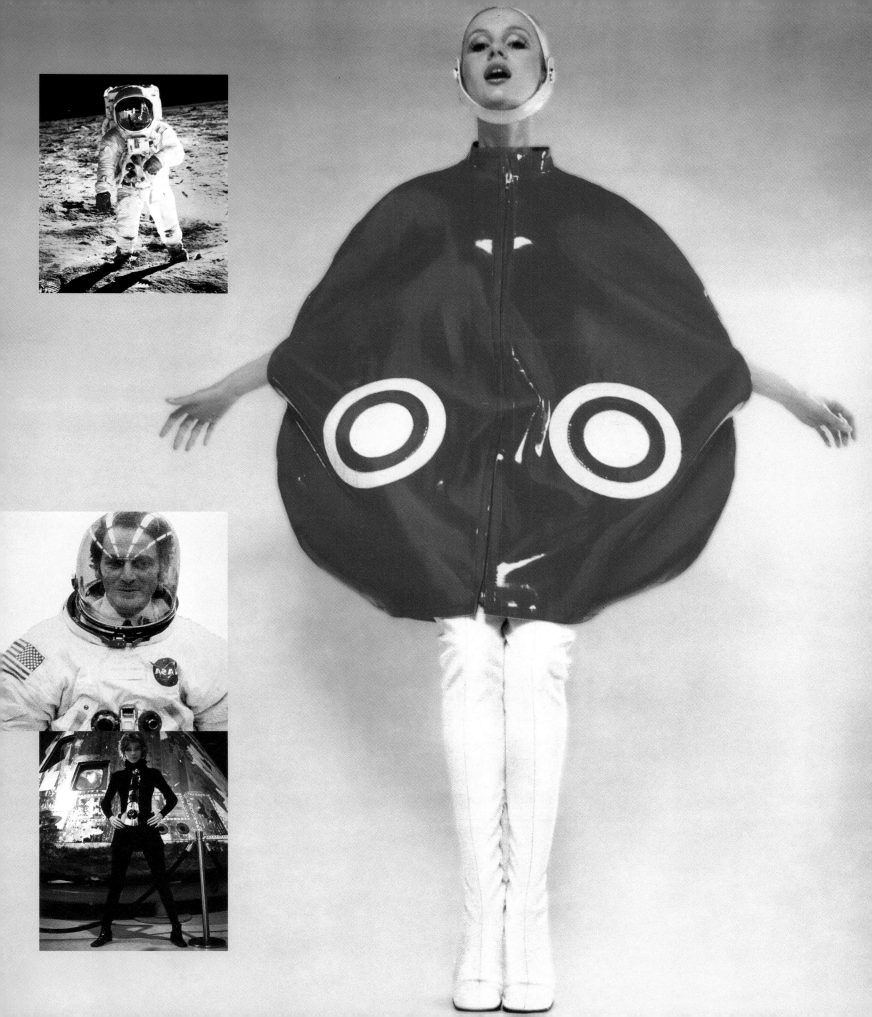

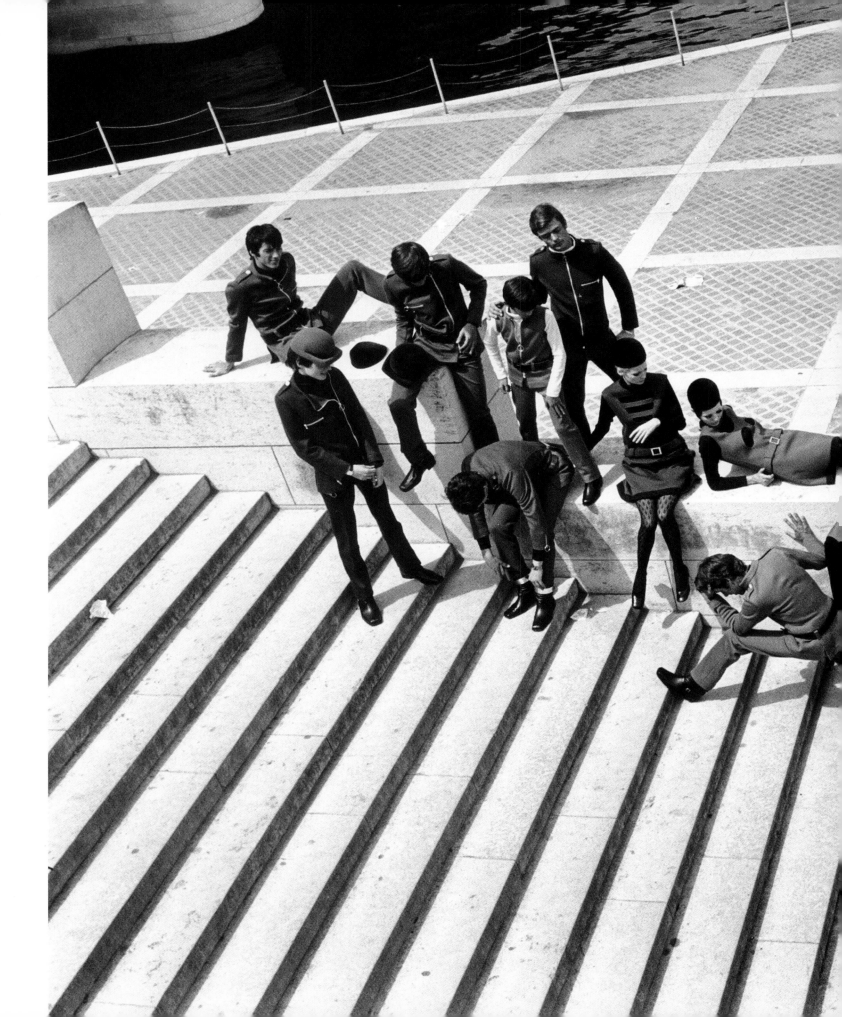

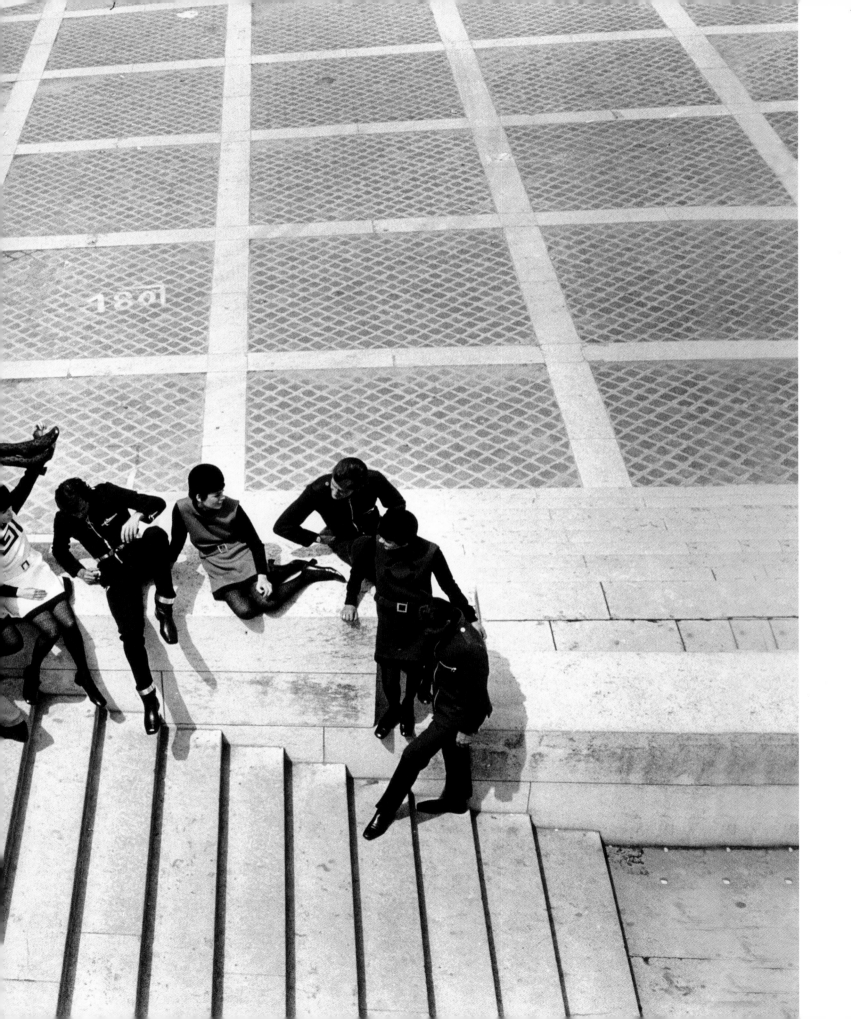

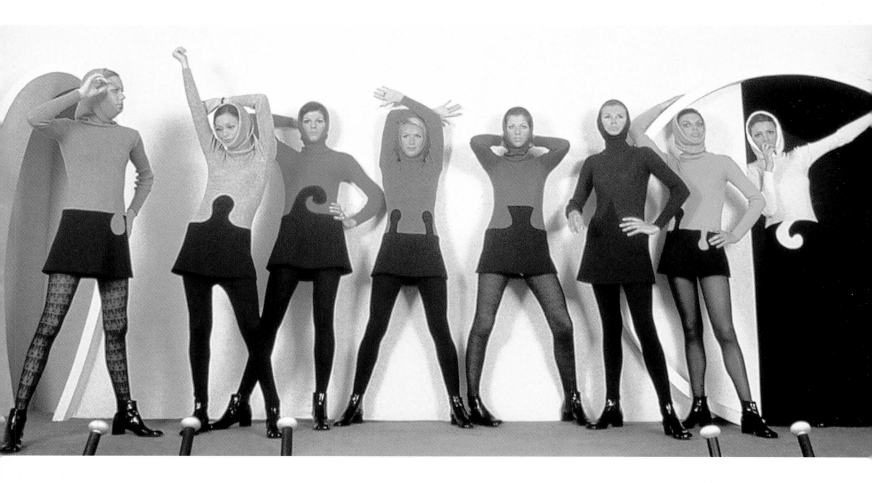

'One should not be influenced but should influence.
One can only survive with originality, and not with
copies. When copying something, one is at best the
second. I wanted to be the first.'

'The cosmos, science, satellites and the universe inspire me. My point of reference lies in these spheres: who can this other person be who differs from all other people?'

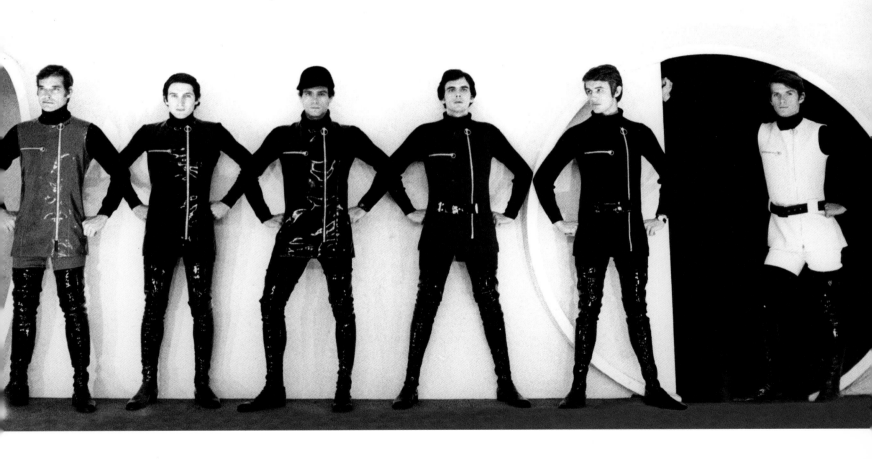

Opposite: Ready-to-wear women's collection, 1969
Above: Ready-to-wear men's collection, 1969

Coco Chanel, *grande dame* of French fashion, confessed in 1970 that the youth was a phenomenon she did not understand. Pierre Cardin was the couturier of the youth. Young people brought about the boom in music, theatre, film, dance and literature festivals that is so characteristic of the seventies. In 1970 Pierre Cardin founded the Espace Cardin. The costume designer became theatre-maker and art patron. As couturier and designer he remained a sculptor. The first furniture series, Meubles Sculptures, followed the idea of combining the colour and form of pop fashion with quality objects for the interior. Its futuristic appearance of being like strikingly coloured plastic furniture had its intentional contradiction in the Far Eastern lacquering of the wooden surfaces. This costly and laborious finish made the *prêt-à-meubler* collection too expensive. In contrast, his top fashion collections were the success model of the early seventies. Colourful and easy-to-combine pieces for men and women constructed from comfortable and artificial materials possessed the dynamism and energy of an exciting era. Skirts were belted with rings of fabric. Tops had peep holes in ribbed pullovers. Plastic caps had the form of satellites. Fake furs were conspicuous in bright colours and audacious patterns. They were also worn by young men. An arsenal of accessories such as glasses, belts, bags, watches, jewelry, shoes, head gear, gloves and stockings all formally and physically epitomized the endless possibilities of the new materials industry had made available. Artists also developed a comparably limitless repertoire of new art forms: Land Art, light art, video art, concept art, laser art. The punks had their own street art in graffiti. Joseph Beuys, the inventor of social sculpture, made everyone an artist.

During the mid-seventies the streets of cities became the stage for demonstrations in support of environmental protection and women rights and in protest of atomic energy and vivisection. Science produced the first test-tube babies. François Truffaut, Francis Ford Coppola, Martin Scorsese and Stanley Kubrick created a new film genre – realism. Actors such as Jeanne Moreau, Lauren Bacall, Simone Signoret, Charlotte Rampling, Barbra Streisand, Shirley McLaine, Meryl Streep and Liza Minelli were the same in their films as in life, as God intended them to be. The perfect Hollywood goddesses no longer existed. Only the Rolling Stones kept rolling. For everything that was here and now in art, the Piano & Rogers studio constructed the Georges Pompidou Centre as a museum machine in Paris. Rome was responsible for what was not yet here. For the first time in 450 years, a non-Italian ruled in the Vatican, Pope John Paul II.

Left, from top to bottom:
Espace Cardin, 1970
Espace chest of drawers, 1970
Pierre Cardin visiting Pope John Paul II, 1979
Opposite: Ready-to-wear men's wear, 1971

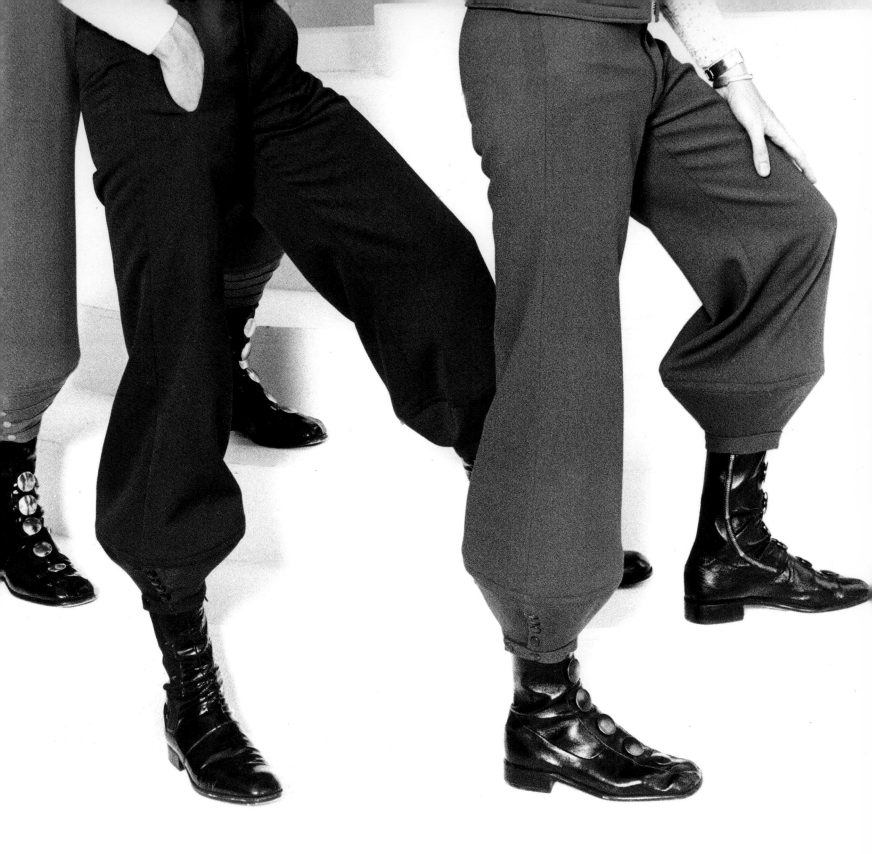

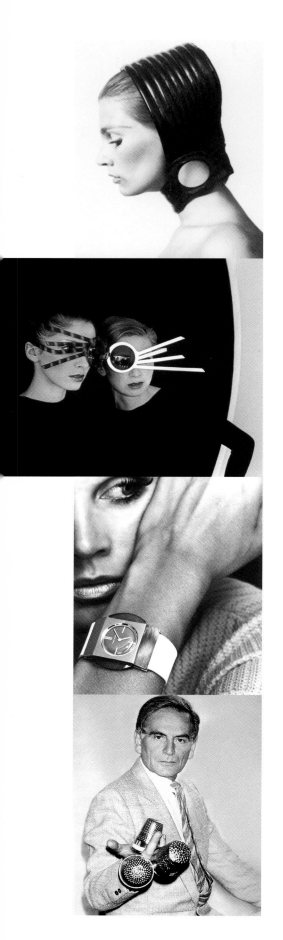

The code word of fashion became deformation. Hot pants, miniskirts, mididresses and maxicoats, platform shoes and ethnic sandals, Op Art patterns and flower prints, colourful fake fur and handknits all concurred with the motto *vivre libre*. Pierre Cardin set another new trend: 'mod chic' gave the zeitgeist of this creative period a new garb. Only the designer who fully masters the principle of originality earns the attribute of being 'new' in fashion. This holds true for form which did not exist before or for a combination of forms into an unwonted whole. Pierre Cardin was the first to combine extremely short and ankle-length pieces, animating sheath dresses with slits, making batwing sleeves with aeronautical dimensions into eyecatchers, coordinating circular flounce and gypsy skirts with austerely constructed tops, which contrasted frilled and flounced volumes with straight lines and gave straight lines circular volume.

Plurality in art inspired a plurality in fashion. Pierre Cardin remained the sculptor of fashion. He extended his geometric play of shapes like the circle, triangle, trapezoid, square and cylinder with animated accents such as pompoms, fringes and slits. He used appliqué work, holes and shoulder pads as means of dynamic distortion. After his first trip to China in 1978, the shoulder lines in men's and women's suits took on the form of pagodas. In 1977 and 1979 he was awarded the Golden Thimble by the French haute couture, each time for the most creative collection of the season. This award was produced by Cartier. He cut men's trousers under the knee. He tucked the over-long and over-wide trousers into calf-length boots. He created square-cut capes in enormous check and turned right-angled coat and jacket collars into neck supports and wind breakers. Sharply cut lumber and bomber jackets in leather, body suits in jersey and tight, tapered trousers shaped a superman whose face was protected from extraterrestrial rays by a visor. Pierre Cardin's accessories were objects from science fiction. They conquered the front pages of fashion magazines and added the image of being a futurist to that of sculptor.

In 1977 he carried this over into his first series of haute couture furniture, Utilitarian Sculptures. He entered the luxury market of haute cuisine with the development of a licensable range under the Maxim's brand, using the name and the image of the legendary Art Nouveau restaurant in Paris, which he purchased in 1981, as well as a new brand market for evening wear, accessories and perfumes. At the same time he prepared new markets for the Pierre Cardin and Maxim's brands with fashion shows in Peking and Shanghai. Pierre Cardin transplanted his business success into his fashion. Powered by success. Anatomically constructed lines with emphasized shoulders, narrow waists and hips, like a streamline, were shaped for the career and contrasted with voluminous capes.

Left, from top to bottom:
Accessory, 1971–72
Glasses, 1971–72
Watch, 1971–72
Pierre Cardin with the Golden Thimble.
He was awarded the Golden Thimble by the Parisian
haute couture in 1977, 1979 and 1982 for the most
creative collection of the season.
Opposite: Haute couture gown, 1970

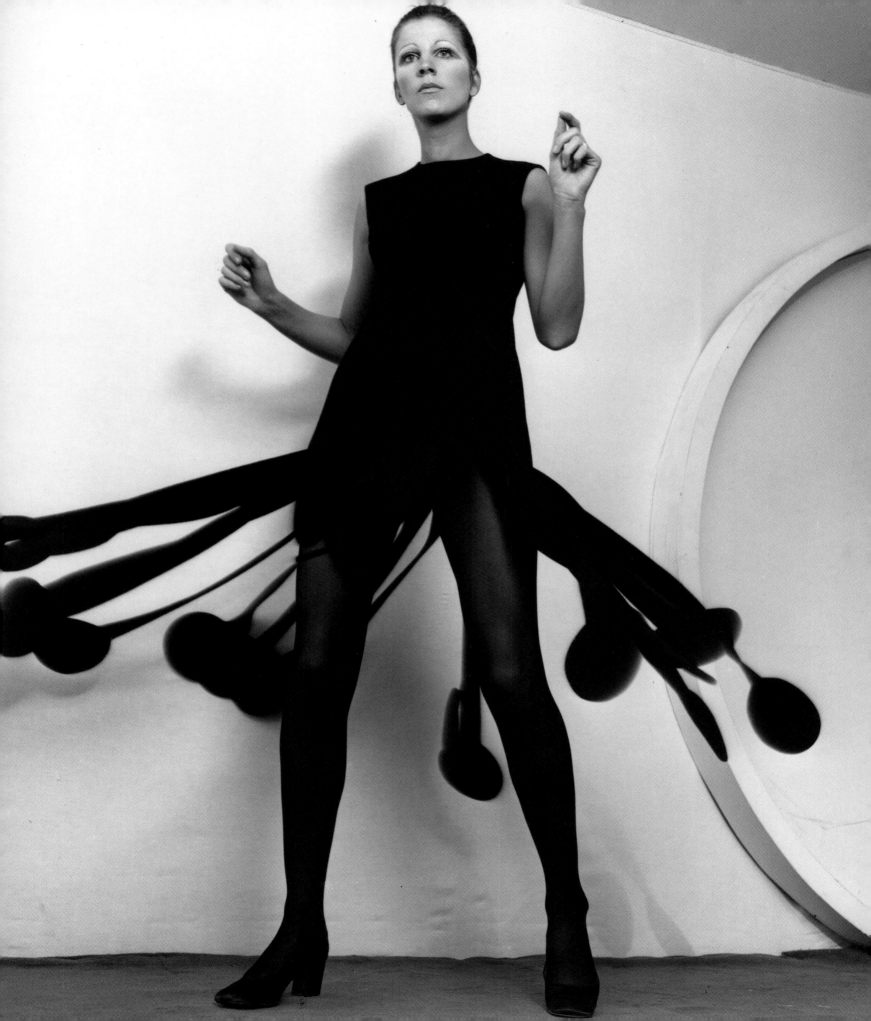

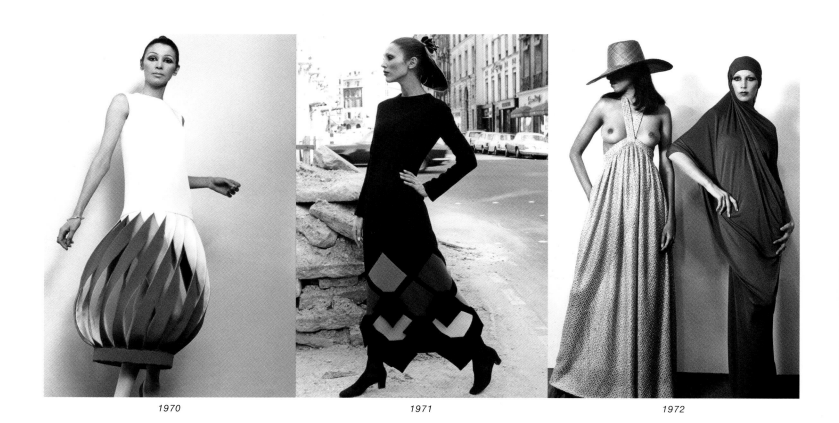

1970 1971 1972

'Real success is not expressed
in privileges but in popularity.'

'I have always liked existing
through my work and I
have never enjoyed looking
for enjoyment.'

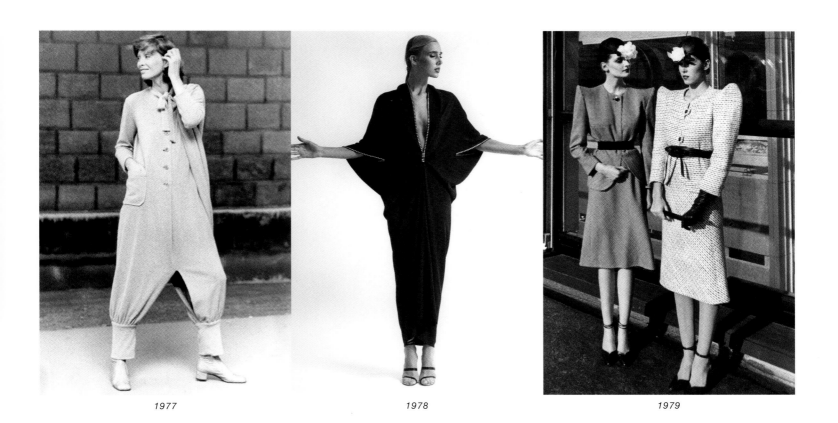

1977

1978

1979

'Luxury is connected with the freedom of the body. Women work, travel, play sport and pursue a career. Therefore luxury is a question of the spirit animating the body.'

'I prefer the type of woman who is made up of a subtle melange of a good body and intellect. Whether the woman is brunette or blonde, tall or short, is unimportant. Her character is important.'

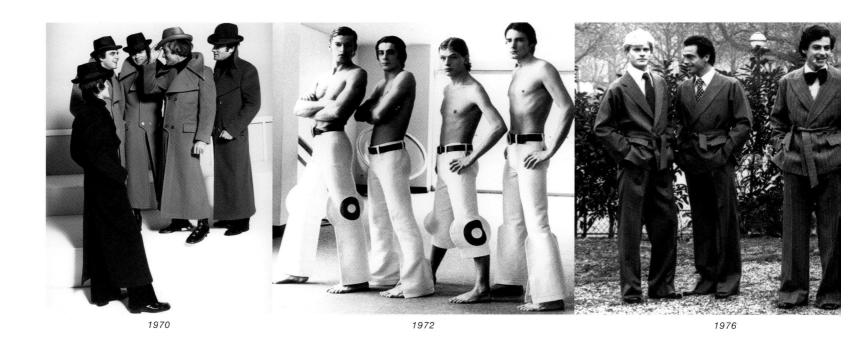

1970 1972 1976

'I have always worked in the name of exclusivity. Exclusivity means creativity. I am at the service of people, and whatever I have made, I have made for the masses. The exponential factor is very important to me. I am the greatest socialist among the capitalists.'

'I am someone who works for someone they call Pierre Cardin.'

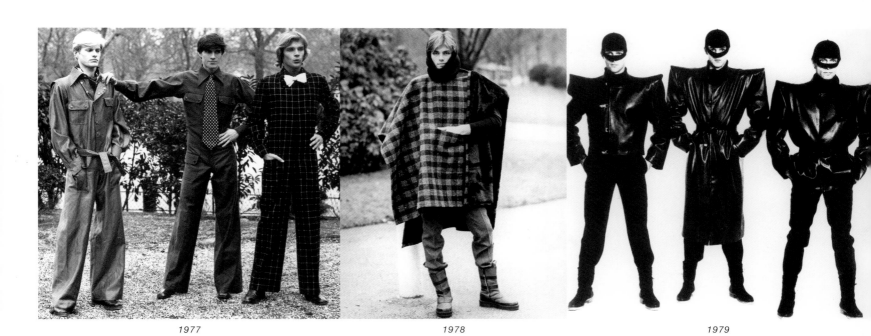

1977

1978

1979

'The value of my empire
is larger than it is said but
smaller than it is thought.'

'I have always worked on my
style. It differs from all other
styles. That was at any rate
my intention, to be different.
One only exists in the long term
when one distinguishes oneself
from the others.'

The era of the 'New Wave' arrived silently in 1980. Pierre Cardin was quick off the mark. He designed a jet aeroplane for the American Westwind Corporation, complete with its interior, as a homage to the female top managers of the United States. He provided 300 exclusive Cadillacs with the esprit of street jets in their form and interior. For his very own métier as fashion designer he chose to follow an evolutionary strategy. He varied and modified his vocabulary of geometric lines and plastic volumes. This concept was in accord with the basic philosophy of eclecticism – to avail oneself of insights and styles that could be developed further. Society had entered the Postmodern age. Old novelties were being readopted in all areas of art. The avant-garde became the trans-avant-garde, Land Art developed into Neo Geo, photo art combined with computer and video art to produce multimedia art. Tokyo became the metropole of architecture. Japanese fashion designers set up camp on the Seine. The Chinese architect Io Ming Pei constructed a pyramidal mirror in the court of the Louvre. Past and future met each other under the open sky on its glass skin. The motto of the present became fun. Endless fun in XL format was sought by society in cells of opulence, fast money, status symbols, music and discos, images and brands.

The time Pierre Cardin had foreseen had arrived. A life with and through designer brands. The so-called zeitgeist offered only one choice: design or resign. The blend of leisure-time pursuits and cultural consumption, high life and big money not only created new museum buildings, pleasure grounds and temples of entertainment, it also brought a new scourge – Aids. Trends came out of Disco 54 in New York City. Supermodels gave the fashion consciousness of the masses its ideal form. They were dressed in trend-setting fashion by them and not the couturiers. The shows of young fashion makers functioned according to the rules of a circus: one sensation after another. The fashion circus toured London, Paris, Milan, New York and Tokyo. New names moved into the venerable salons of haute couture as artistic directors. They moved out just as quickly. Pierre Cardin remained the head of his own house. The Metropolitan Museum in New York, the Grand Palais in Paris and the Sogetsu Kaikan museum in Tokyo honoured his 30 years of work as a couturier with retrospectives. Cardin continued working in the accustomed way: 400 creations per season. In 1982 the Chambre Syndicale de la Couture awarded him the Golden Thimble for the third time for the best collection of the season. He had adapted the appearance of his fashion to social changes.

Day wear was presented online with computers and technology; the extravagancies for the evening remained the centre of a social event. Wearable and producible collections didn't make the headlines. The media communicated the fashion of the moment and promoted young fashion makers into shooting stars, their fame often only lasting no longer than one season. Neither the quick success nor the short sensation fitted into Pierre Cardin's concept. He worked for lasting success and social sensation. In 1983 Pierre Cardin travelled to Moscow. In 1985 he gave energy, esprit and dynamism to the flight attendants' uniforms of the Hungarian airline Malév. In the eighties he remained the master of geometry and the sculptor of fashion he had been for three decades.

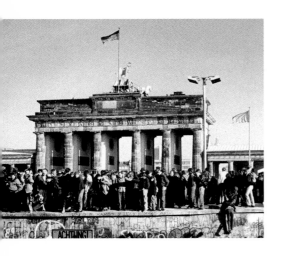

'My fashion does not express the times in the air but the ideas and attitudes of a period. I don't look back but forward.'

Animated pleated segments on the backs of garments became characteristic, as did distinctive shoulders streamlining the silhouette, hoops worked into tube dresses, plastically enlarged spikes and teeth on sleeve and side seams, circular collars taking over half or the whole front, pleated and draped semi- and full-circular capes and tops, overskirts and evening dresses in sun pleats, and asymmetrical overlays of narrow bustier dresses. For men he invented box-shaped jackets with deep side slits, sent racing trousers on to the catwalk, decorated knitted pullovers with leather strips and leather jackets with knitted patches, and structured casual wear as generally accepted clothing.

As couturier and designer he gave cars, aeroplanes, jewelry, belts, glasses, bags, scarves, fountain pens and countless other objects of everyday use his distinctive mark and always kept to the pulse of the times. Auction houses, museums, art galleries, shops and industrial re-editions testified to the stimulated interest in design. The eighties were an intensive period for Cardin, the creative universalist and global businessman. He established Maxim's restaurants as a multiple of the Art Nouveau in Brussels, Peking and Rio de Janeiro and invented the floating Maxim's des Mers, which he sent on its maiden voyage to mark the centenary of the Statue of Liberty. He gave hotels in Paris, Palm Springs and New York the brand name Résidence Maxim's. He launched perfumes and champagnes under the Maxim's brand and campaigned in China with fashion shows for the luxury brand that carried his name around the world. Between 1980 and 1990, Pierre Cardin boutiques were opened in Sofia, Paris, Budapest, Peking and London. He received decorations and awards like no other couturier before him. Tirelessly he circled the world in search of new opportunities for his brand, fashion and licensing empire. His journeys took him to Brazil, Argentina, Mexico, repeatedly to China, Japan and the USA, but also to the Vatican, Thailand, Indonesia, Pakistan, Malaysia and the Philippines.

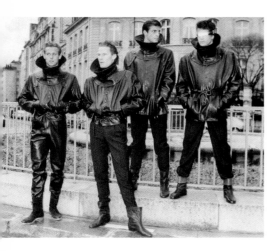

Preceding pages, left, from top to bottom:
Michel Legrand, Barbra Streisand and Charles Aznavour in Maxim's, 1985
Pierre Cardin's first trip to Moscow, 1983
Pierre Cardin at Le Palais Bulles, 1995
Preceding pages, right:
Ready-to-wear women's wear, 1981

Left, from top to bottom:
Fall of the Berlin Wall, 1989
Ready-to-wear men's wear, 1982
Opposite: Haute couture women's wear, 1980–85

Overleaf: Ready-to-wear men's collections, 1982 and 1986

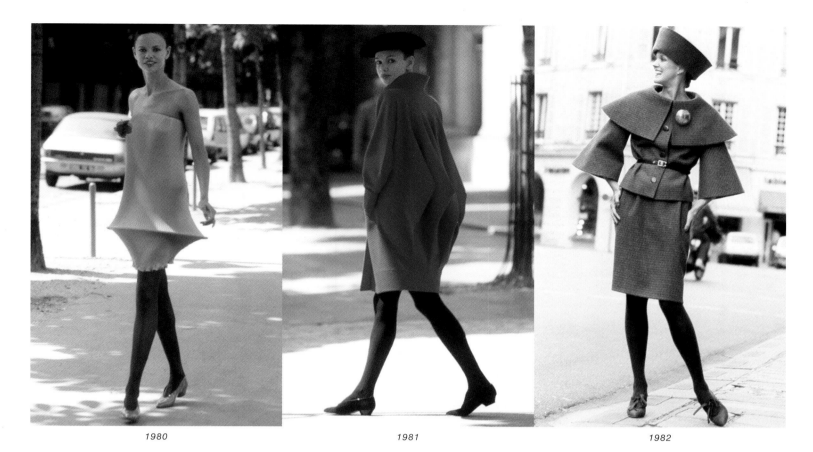

1980 1981 1982

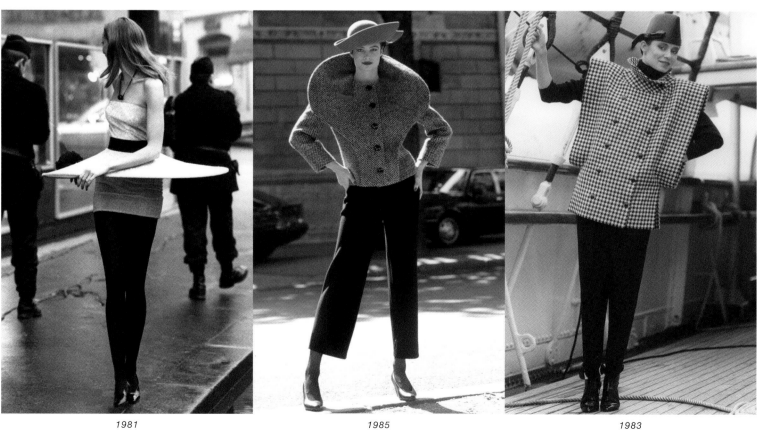

1981 1985 1983

1982

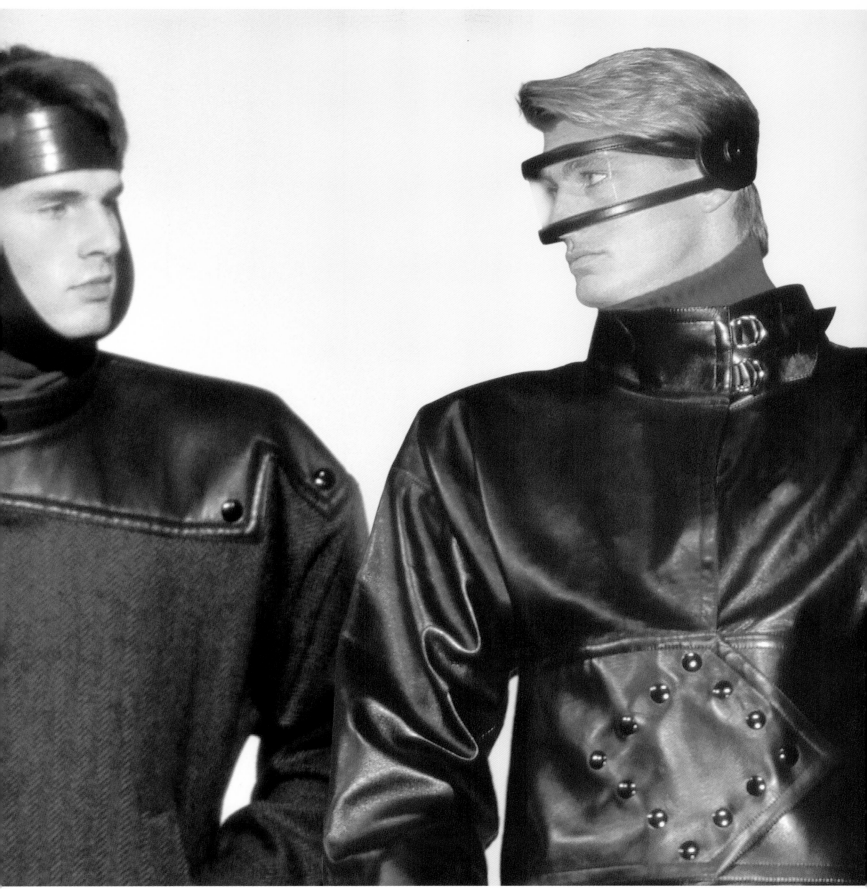

1986

*'I have created
everything one can
create, even my own
water. I have created
perfumes and sardine
tins. Why not? During
the war the smell of
sardines was more
familiar to me than that
of perfumes.'*

Political events wore light garments of hope at the turn of the decade. The return of Nelson Mandela marked the end of apartheid in South Africa. On an altogether different political stage, Mikhail Gorbachev had prepared the way for fundamental changes in Russia and the member states of Comecon with *glasnost* (transparency) and *perestroika* (reconstruction). The fall of the Berlin Wall and the Iron Curtain in 1989 put people in an optimistic mood. In fashion the nineties started where the eighties had left off in the conspicuous consumption of a fun-loving society. Grunge and trash continued as an expression of 'neo-miserablism' among the youth. The face of young fashion showed itself to be tattered and threadbare, crushed and artificially aged. It had adapted to the economic, moral and social crisis that soberly followed abundance. Cool became the new in-word. It was cool to refuse to consume. It was uncool to buy new clothes. A paradoxical mixture of false and true, natural and artificial, vintage and neo-retro was given the accolade 'mega cool'. It was mega cool to dress in ashes and sackcloth on the boulevard for the funeral procession of broken dreams and cry for paradises lost. Under the impressions of the Gulf War, the wars in the Balkans and terrorist attacks, the slogan 'more ethics, less aesthetics' took on surprising forms. Piercings, tattoos and folklore became fashionable aspects of a cultural colonialism. This found its expression in fine art as trans-cultural process art. Style, genre, form, material and technique were deplaced from the north to the south and from the west to the east. The Internet opened up an escape route from reality into the virtual world of cyberpunks, chatrooms, cyberart and cyber shops.

Then the nineties grew up. Clothes and fashion had to be 'intelligent'. This appeared first in a minimalist and androgynous guise. This style of new modesty had its fashion heroes and fashion victims. The 'now wear' came from America. Smooth, colourless, simple and comfortable. Anti-fashion became the fashion of reality, Friday wear the fashion of leisure time. It was easy to copy. Digital technology made it possible to duplicate at low prices. Vertically organized chains flourished. Other than quality and price there was neither a temporal nor stylistic difference between the original and the plagiarized version. The change in fashion was pre-programmed: after 1995 there was a return to glamour and opulence as a middle-class virtue, something that had itself long since become historic. Elaborately staged and medially transmitted images artificially increased the market value of designers. They became trade goods and their purchasers were large industrial concerns. These in turn competed with one another to acquire brands and designers and did battle for the favour of consumers in glossy advertising campaigns. In the zoom of the rich, famous, eternally young and beautiful, the fashion world became an illusory one that generated too little return for the future.

Left: Pierre Cardin taking his place in the French Academy of Fine Arts, 1992
Opposite: Haute couture gown, 1990

Overleaf, left: Haute couture gowns, 1990–96
Overleaf, right: Ready-to-wear men's wear, 1990

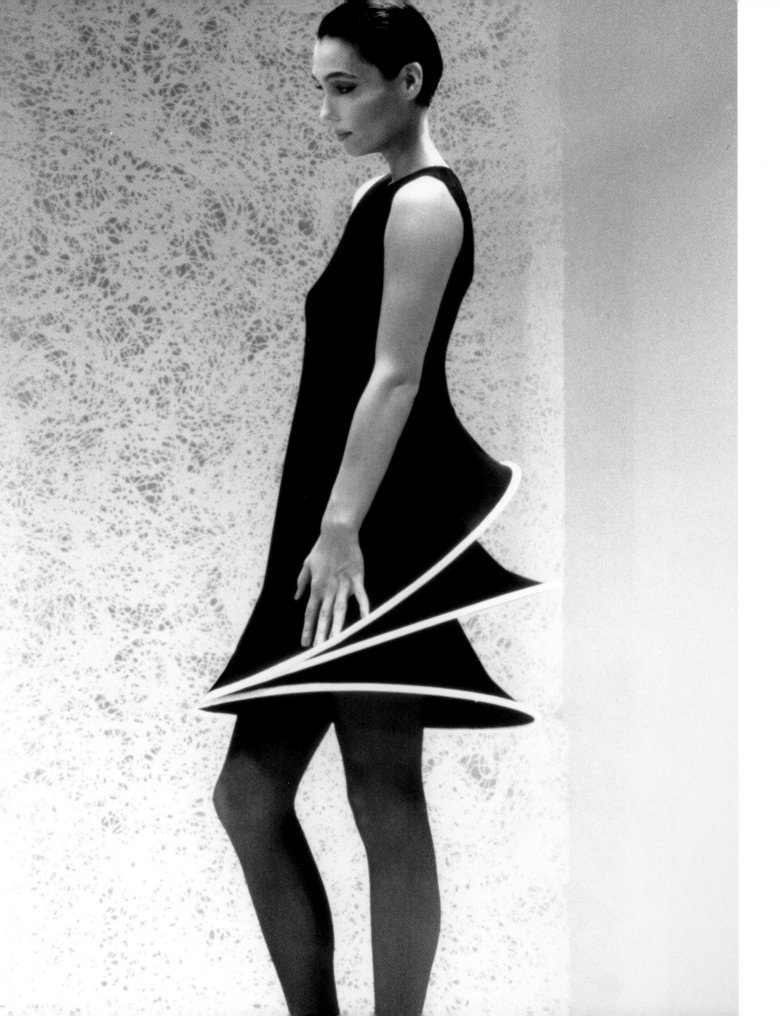

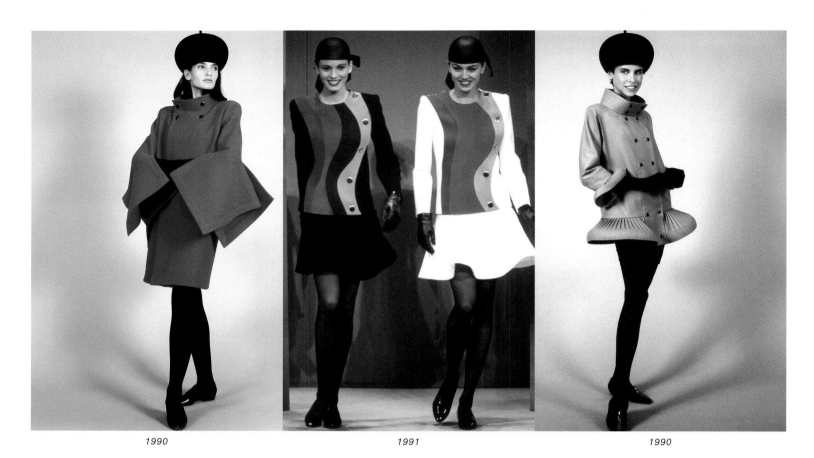

1990 1991 1990

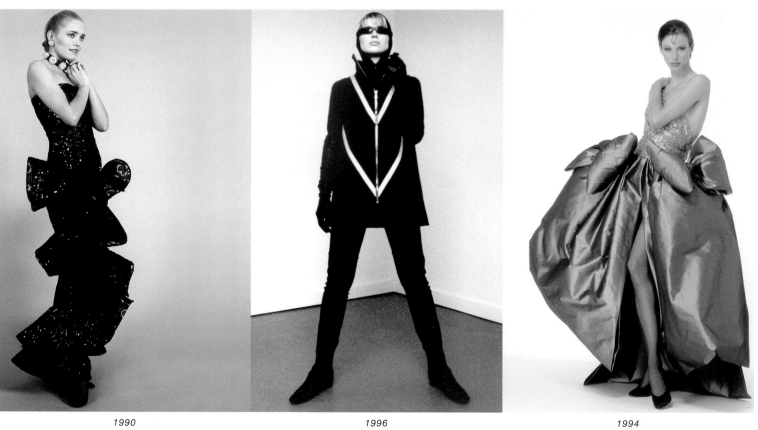

1990 1996 1994

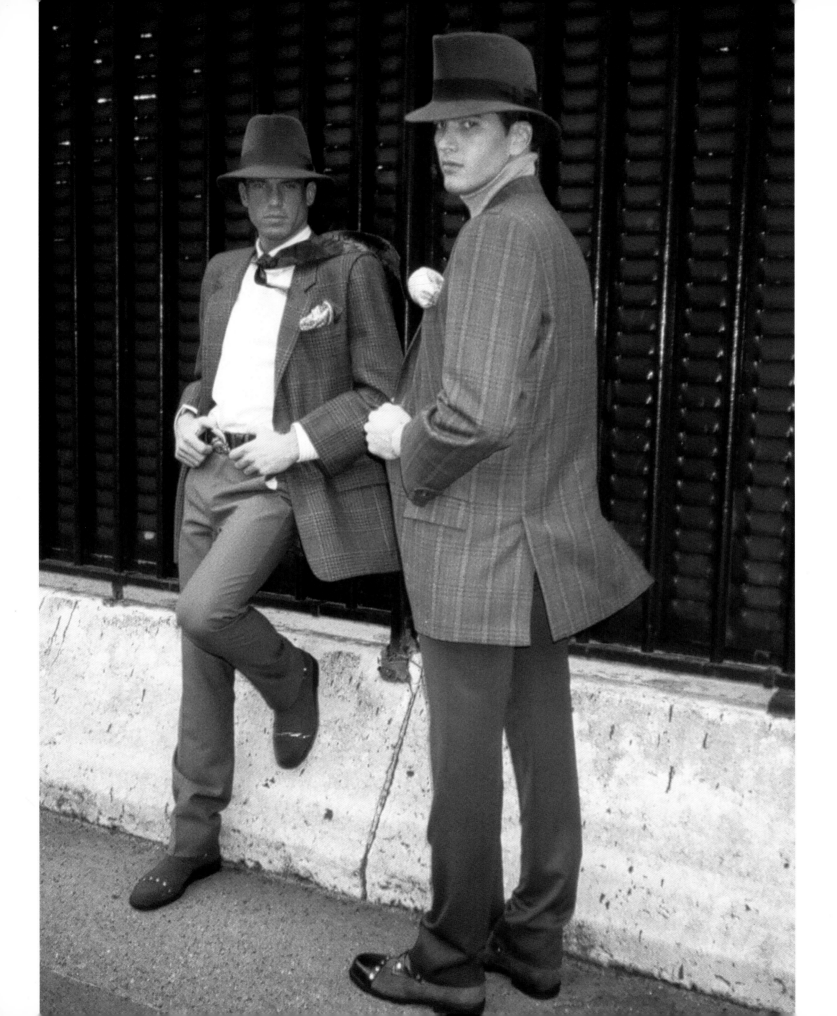

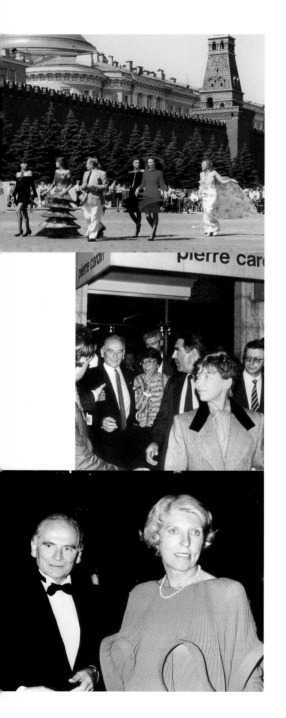

The changeover of owners, financiers, strategists, designers and styles accelerated in the haute couture houses. In Pierre Cardin's house nothing changed, however. Work on the development of the brand and design empire continued. Pierre Cardin was his own, untiring foreman: 'I am someone who works for someone they call Pierre Cardin,' he said. In 1990 the Victoria & Albert Museum in London paid tribute to Cardin in a retrospective celebrating the designer's work over forty years in the business. Another retrospective followed in May 1991 at the Museum of Fine Arts in Montréal. In June 1991, Pierre Cardin put on a fashion show for 200,000 people in Moscow's Red Square. In the same year he was made Chancellor for UNESCO and designed a decorative sculpture and medals for the UNESCO aid programme for the victims of Chernobyl. With verve and courage he opened more boutiques and restaurants, launched new fragrances and collections, developed new markets and made new contacts by travelling around the world. He was the first couturier ever to be admitted into the French Academy of Fine Arts and designed the regalia of immortality himself. He was made Officer of the Legion of Honour and honorary citizen of the city of Xian. Pierre Cardin travelled to China in September 1994 for the twenty-first time to set up a Pierre Cardin Fashion and Design Center at the Institute for Textile Research and Textile Technology. The retrospective of Cardin's 40 years of design was opened in Tokyo in November. He showed his gratitude by putting on a dazzling fashion show in the royal Sennyuji Temple in Kyoto. Inbetween his numerous activities as fashion designer, theatre-maker, artist, patron and businessman he found time to plant 200,000 trees as a sign of peace in Israel and present the flags of tolerance he had selected to an international audience in Eilat and Petra.

In 1996 he gave his farewell haute couture show, privately but prominently. He did not retire into private life though. His life remained work. In the turbulent environment of fashion clashes and stylistic collages characteristic of the nineties, he created two new collections, two new men's fragrances as well as perfumes and cosmetics lines for women. He went to Burma, Vietnam, Cuba, again to South Africa, Lebanon, Japan, China, Russia and the United States to open shops and exhibitions, and promote and foster brand marketing for his licensing deals with fashion shows. The media became the newest addition to his cosmos. He took part in the Parisian ready-to-wear fashion shows on the usual scale. Pierre Cardin kept the balance between inspiration and expression.

During the decades of his activity as a couturier and designer, he had implemented, revolutionized and innovated everything possible and realized the impossible. The focus of his work in fashion therefore lay in the further development of the unmistakable style he had developed from the formal canons of geometry and had never abandoned. Voluminous coats and jacket forms accompanied body-hugging dresses, knee-length skirts were tipped with circles and bubbles, colours contrasted with non-colours, woolly materials with technical, plastic was joined to leather, chunky woollens with fake fur, pattern with pattern, circles with diagonals, triangles with squares, cylinders with cones, trapezoids with lines – the list goes on. Large coats and blouson collars for men were as up to date as pleated capes for women, batwing sleeves issuing from the waist as modern

'I am a dreamer and a realist. A realistic dreamer who dreams for the realization. Nothing is impossible and I still want to do more. My greatest desire is to work to my last breath.'

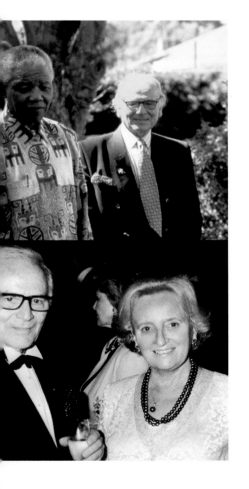

and aesthetic as knotted tunics over slender sheath dresses. The luxury of Pierre Cardin is self-evident rather than loud. The clients for his men's fashions are active both in their professions and in their social life – men who wear designer jeans, comfortable pullovers and well-cut leather garments in their leisure time and prefer to be subtly elegant in their busy working lives. The female clientele has always been able to select timeless clothes from Pierre Cardin collections for work, travel, sport and holidays, for modest and grand appearances. Not every colour became fashionable, but every palette and every design were in harmony with the style, cut, form and material of the garment.

For half a century the Pierre Cardin brand has animated the expectations of consumers, licensing partners and vendors. The production of approximately 900 licensed products on all five continents is controlled from the creative headquarters in Paris. Cardin's licensing empire provides work for 200,000 people in 180 countries, including China with 40,000 workers producing around 30 licensed products for the Pierre Cardin brand. The global brand marketing of a couturier and designer has a completely different dimension to the fashion talk of the season.

Pierre Cardin opened the nineteenth Maxim's restaurant in Monaco in 2000. There was a retrospective celebrating Cardin's fifty years in the business in Peking and Shanghai. Exhibitions followed in 2002 in Los Angeles and Tokyo, featuring selected creations from his career. Franca Sozzani's gallery in Milan presented Pierre Cardin as the trendsetter of pop fashion in 2004. In 2005 the sculptor of fashion showed some 200 masterpieces in the exhibition 'Pierre Cardin: Design & Fashion 1950–2005' at Vienna's Academy of Fine Arts.

Since purchasing the Marquis de Sade's (1740–1814) castle in the South of France in 2001, the passionate theatre-maker and art patron has shared this magical place with artists and art fans from all over the world through festivals of music, dance and literature. He dedicated his most recent fragrance, Tristan & Yseult, to his ardent involvement in the performing arts. Just as passionate a worker and as farsighted as ever, he extended the Pierre Cardin cosmos to include the most topical business area of the third millennium: water, the elixir of life. The mineral water bubbles from copious Tuscan springs belonging to and marketed by Pierre Cardin. Mineral water is the largest growth market worldwide. With his mineral water, the visionary reaches those fashion nomads who swap fashion brands on a daily basis in their search for the latest thing or those who simply do not figure Pierre Cardin among their spontaneous purchases. He has made his cosmos their oasis. His perspective remains the future. After all, Pierre Cardin is the couturier who invented it.

Opposite, from top to bottom:
Fashion show in Moscow's Red Square, 1991
Raissa Gorbachev in Paris, 1990
Pierre Cardin with Mrs Claude Pompidou, 1986
Left, from top to bottom:
Pierre Cardin with Nelson Mandela, 1995
Pierre Cardin with Mrs Bernadette Chirac, 1996

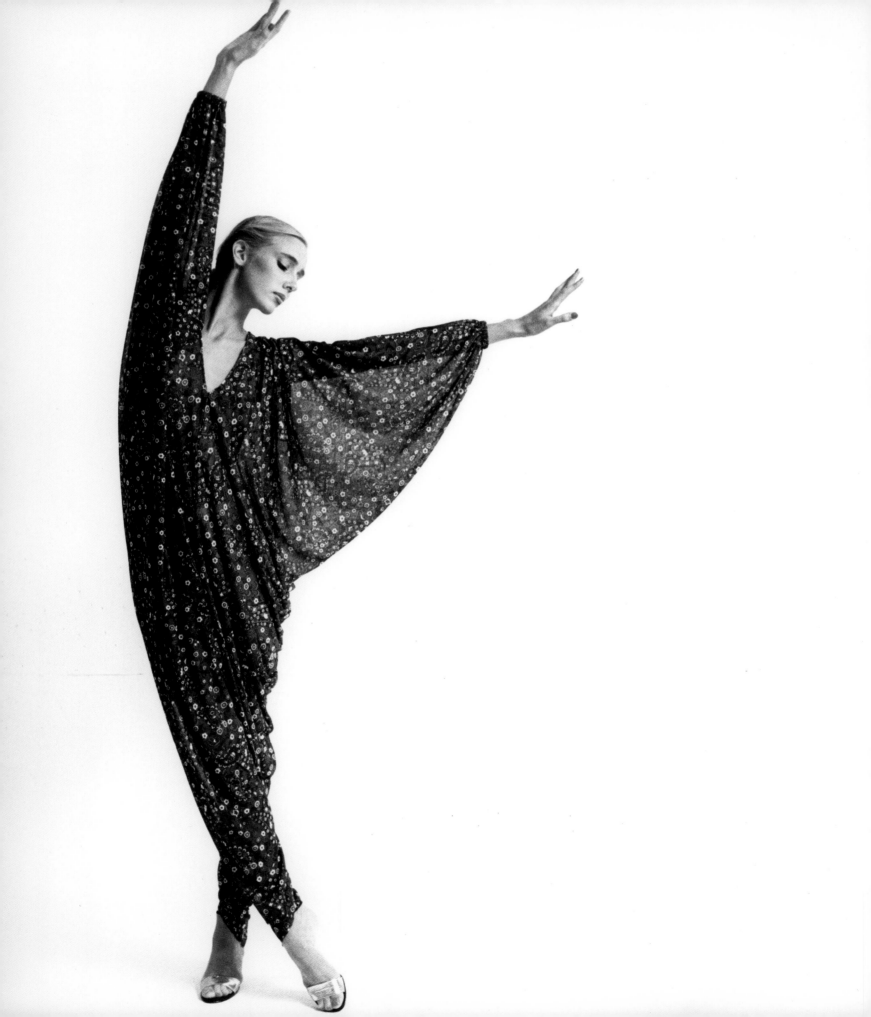

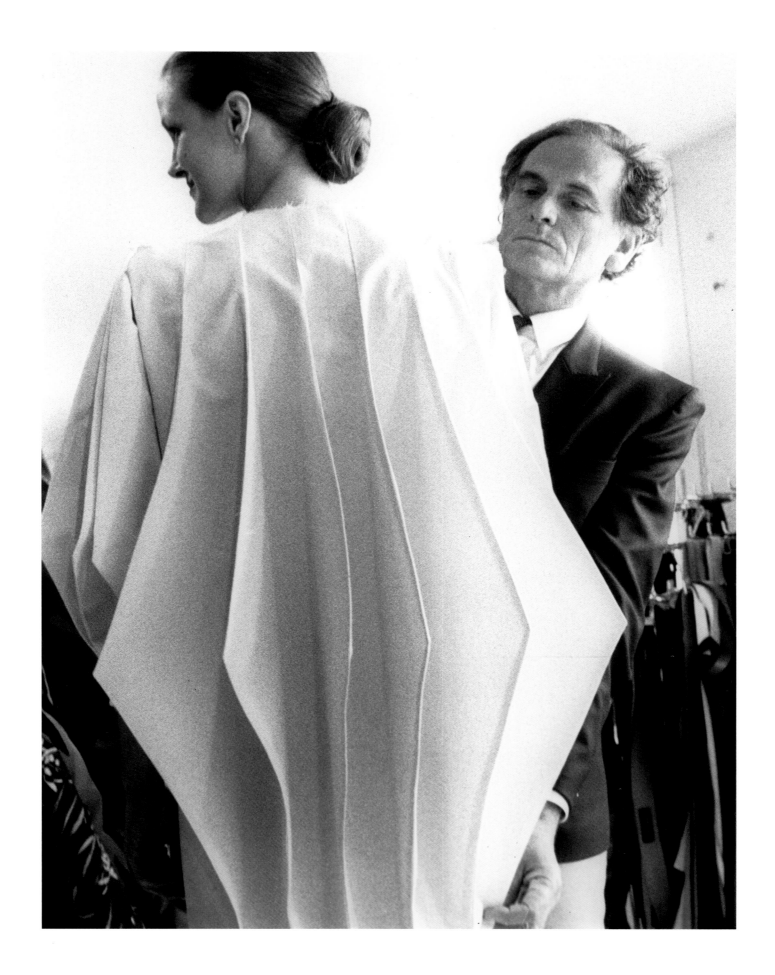

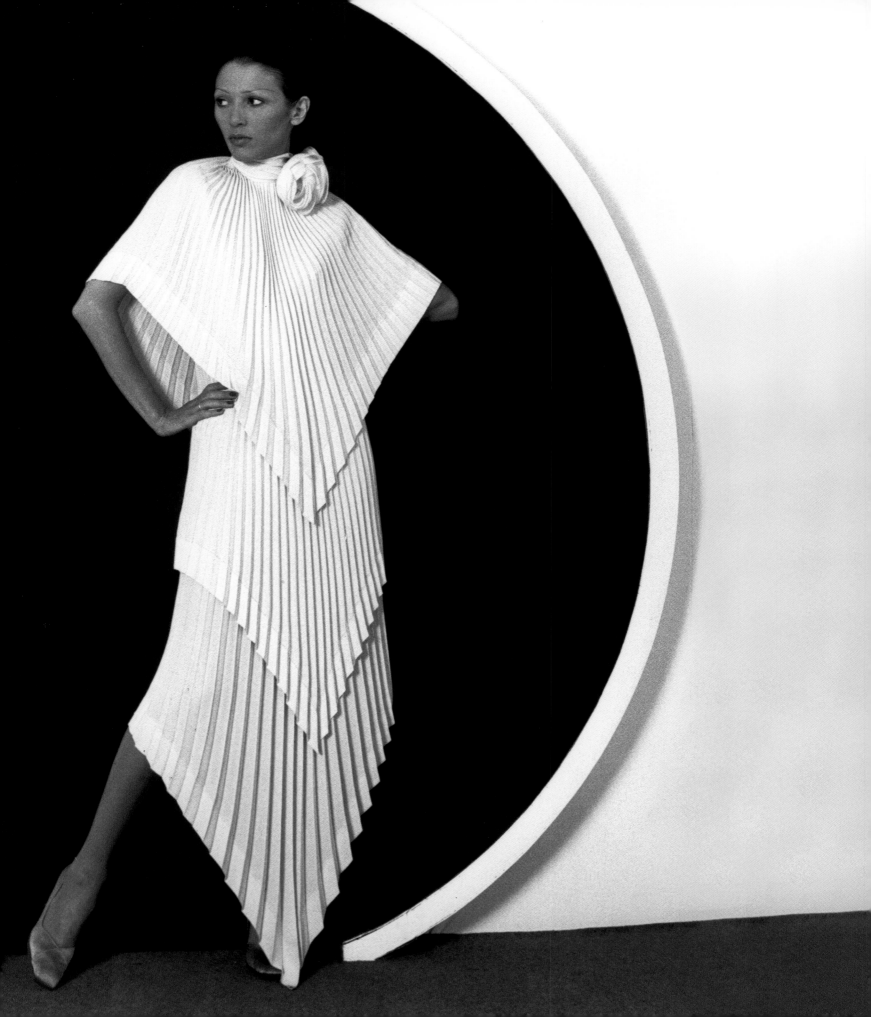

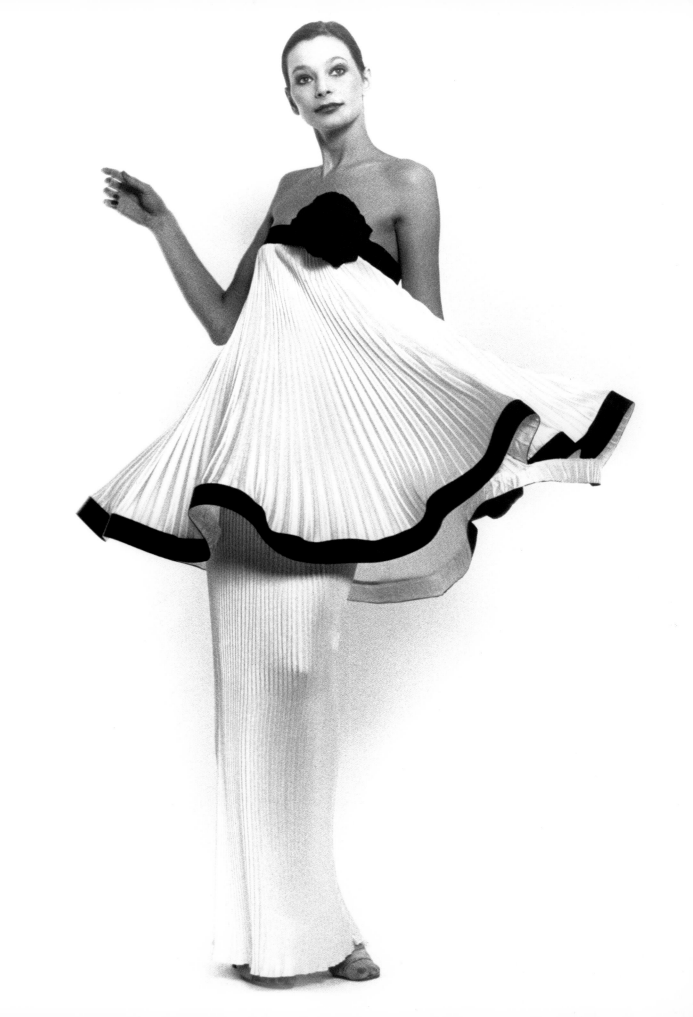

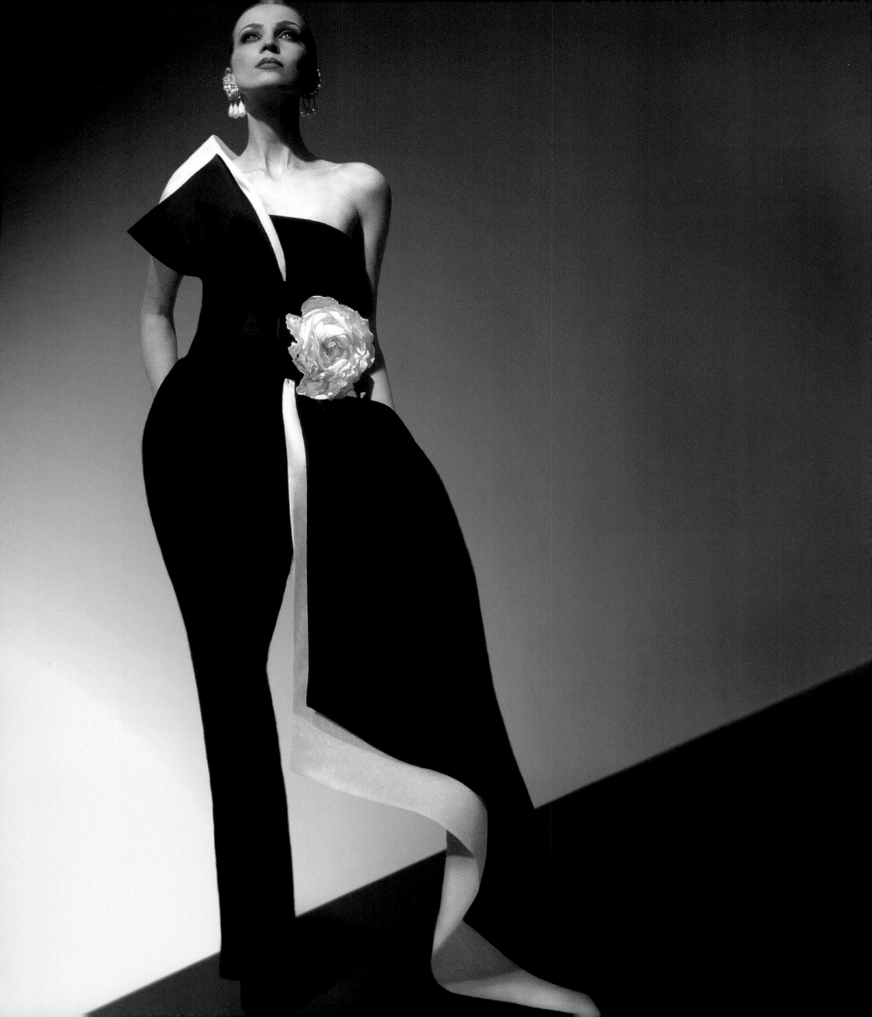

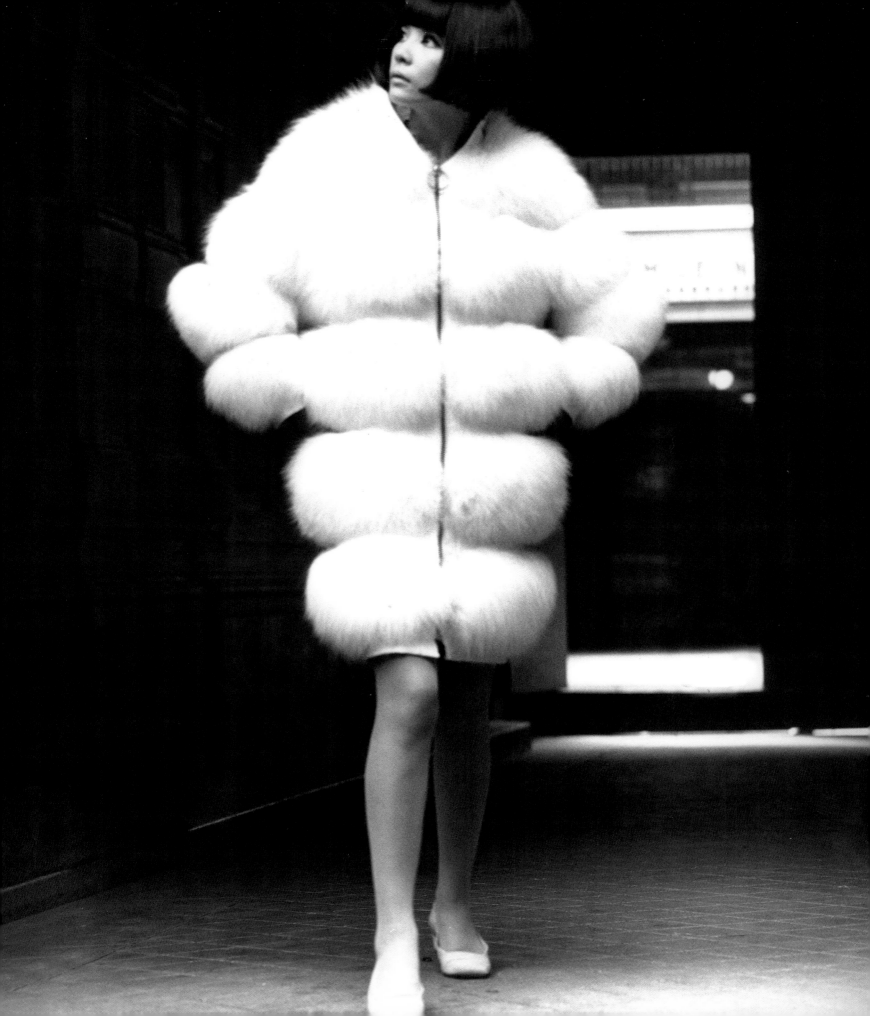

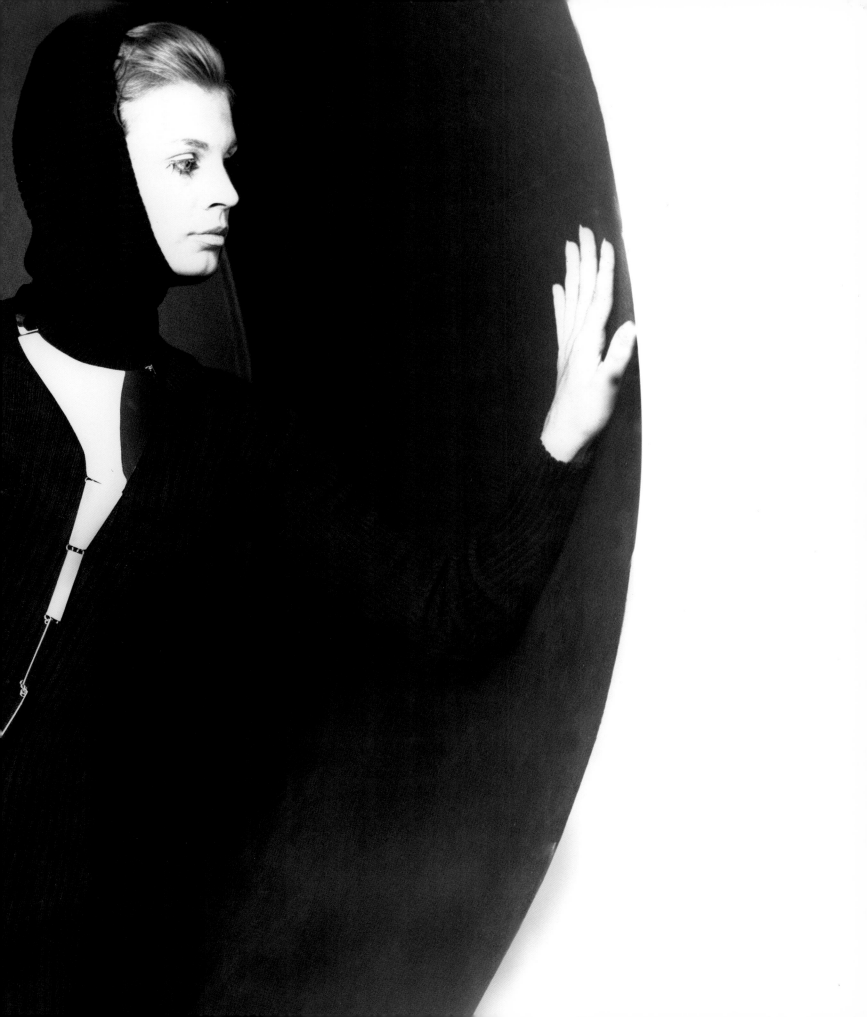

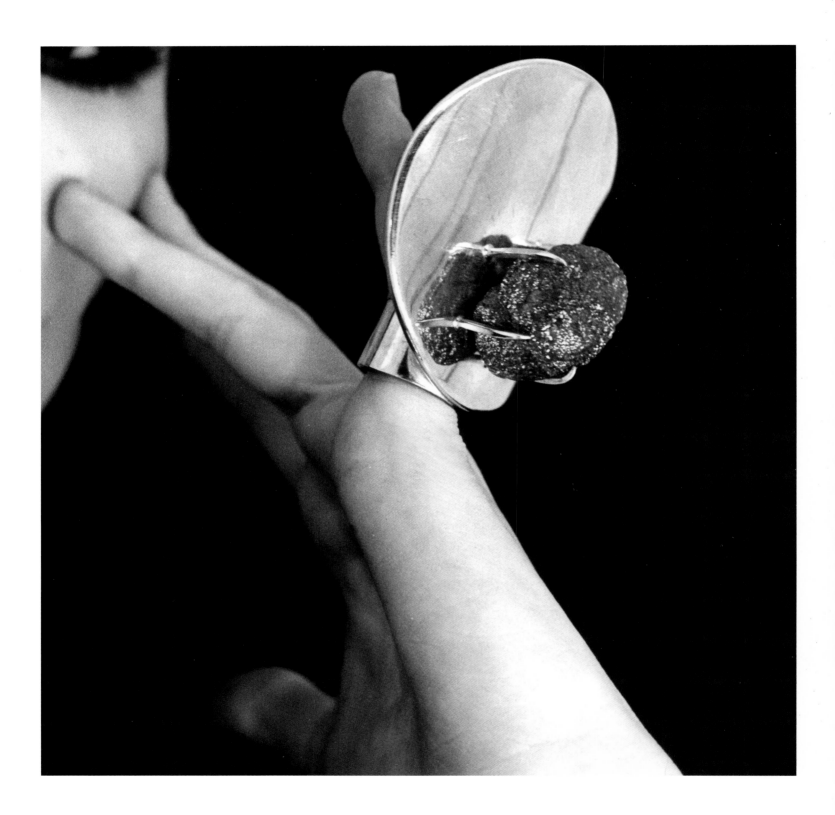

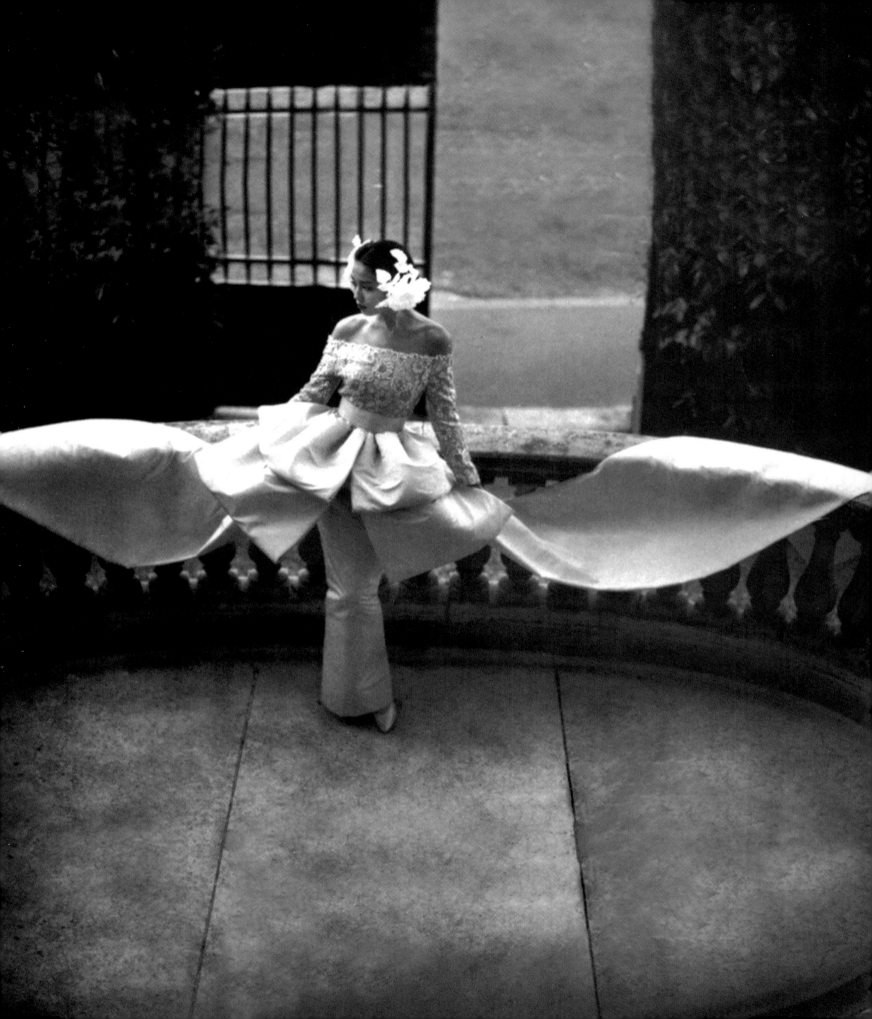

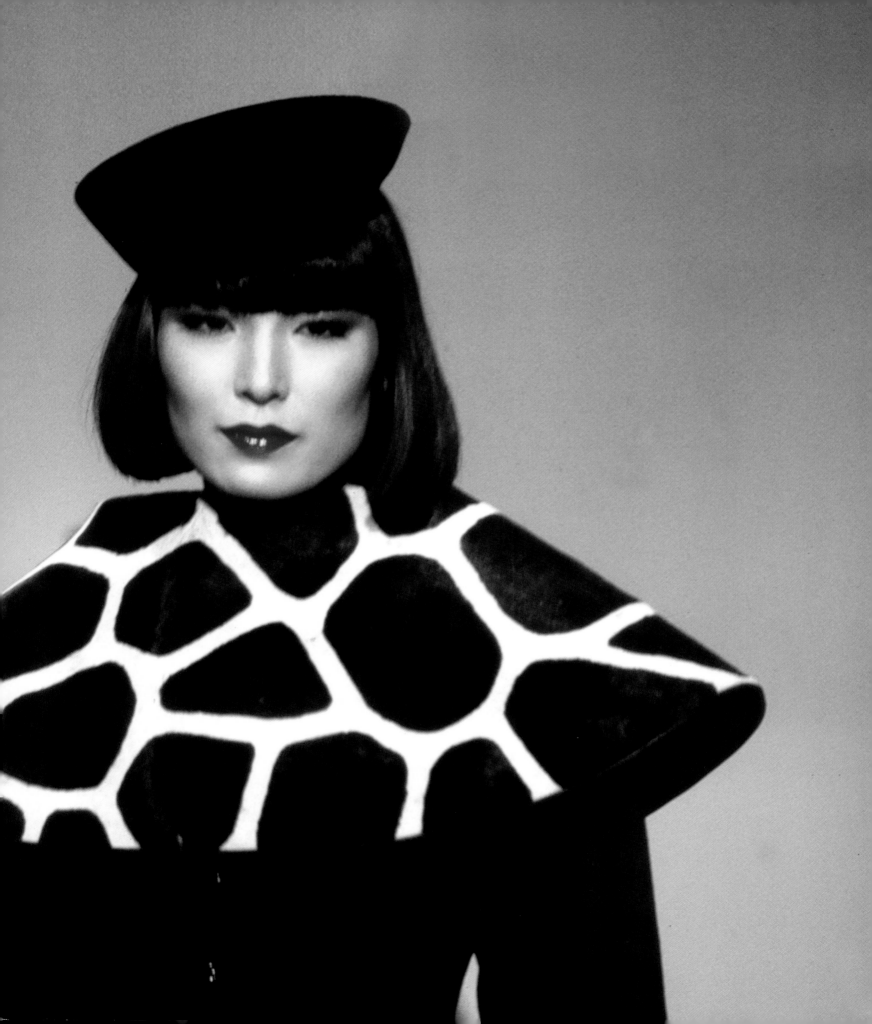

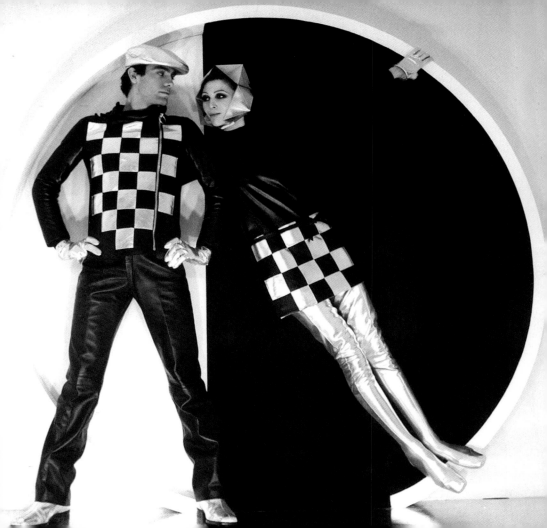

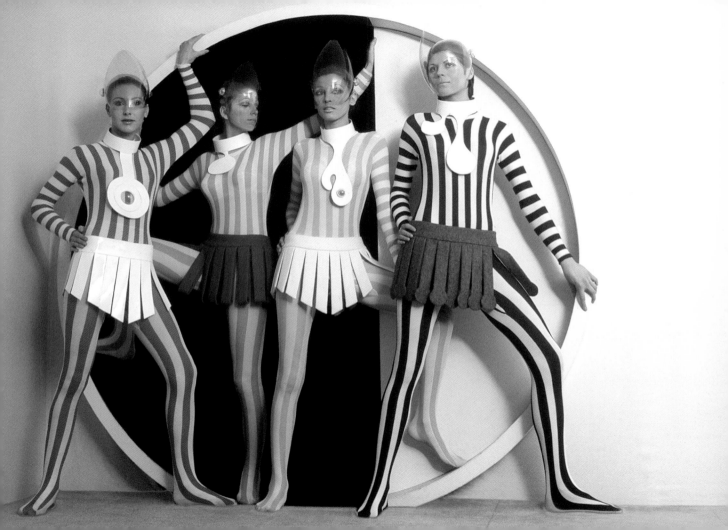

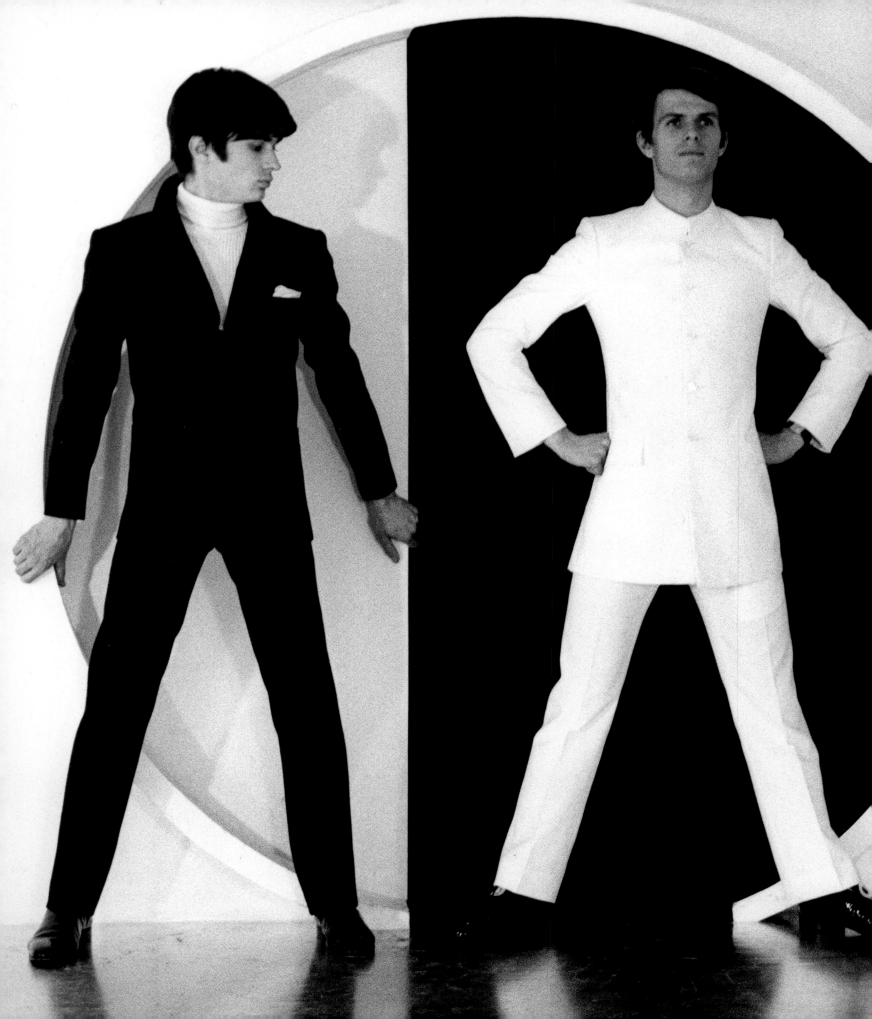

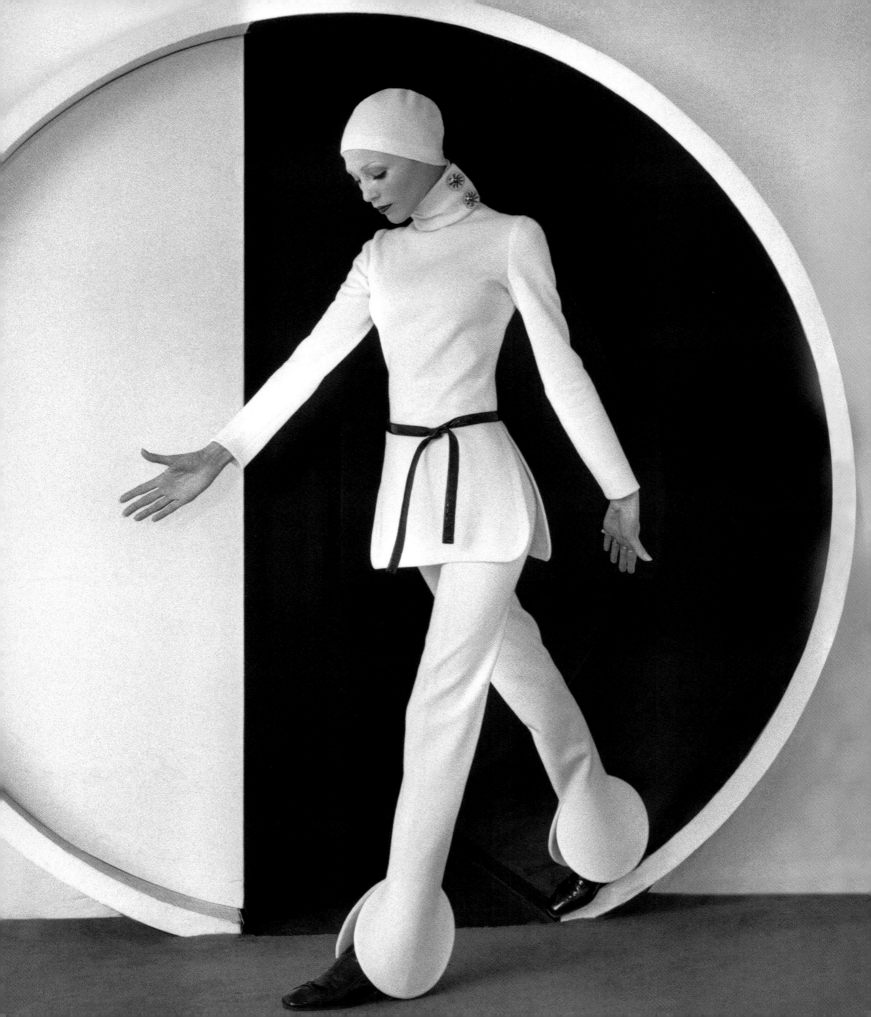

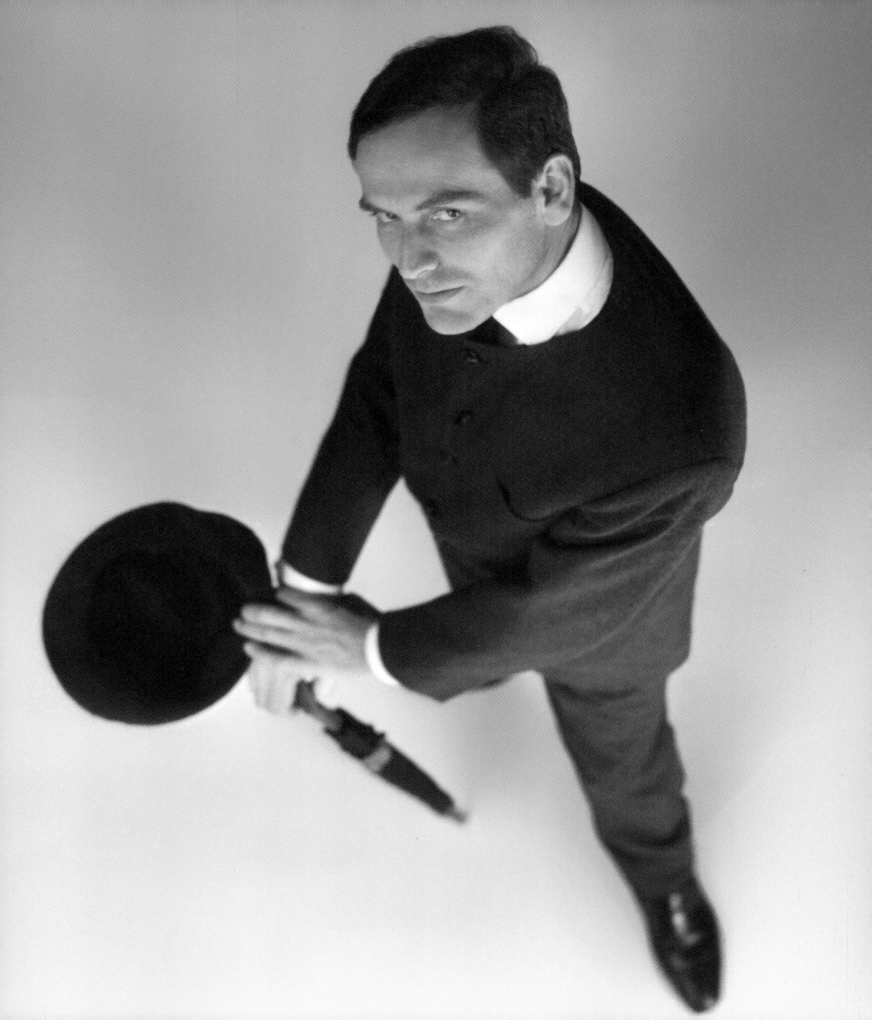

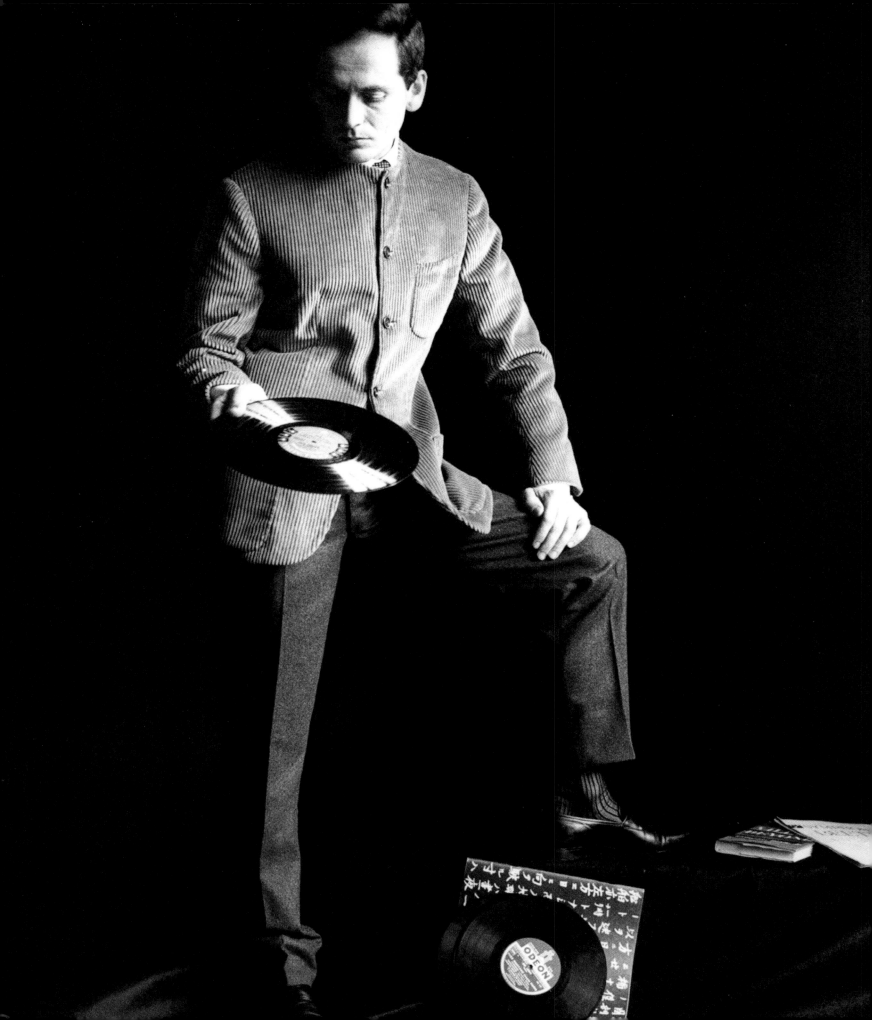

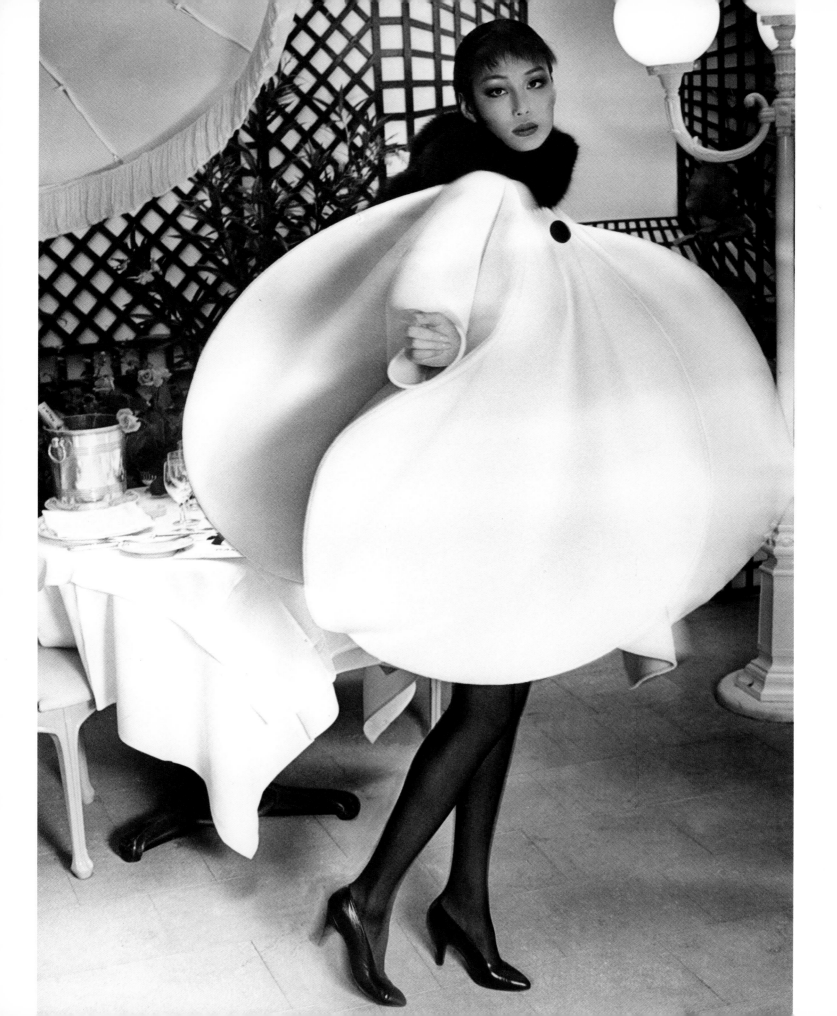

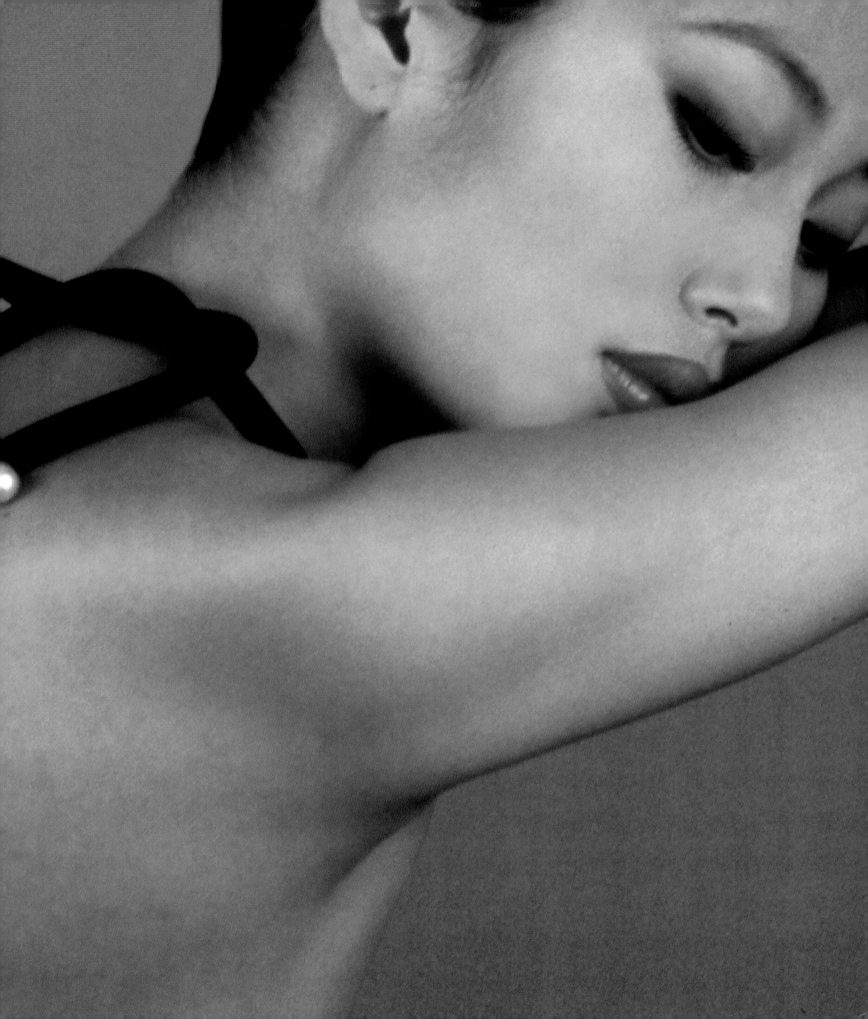

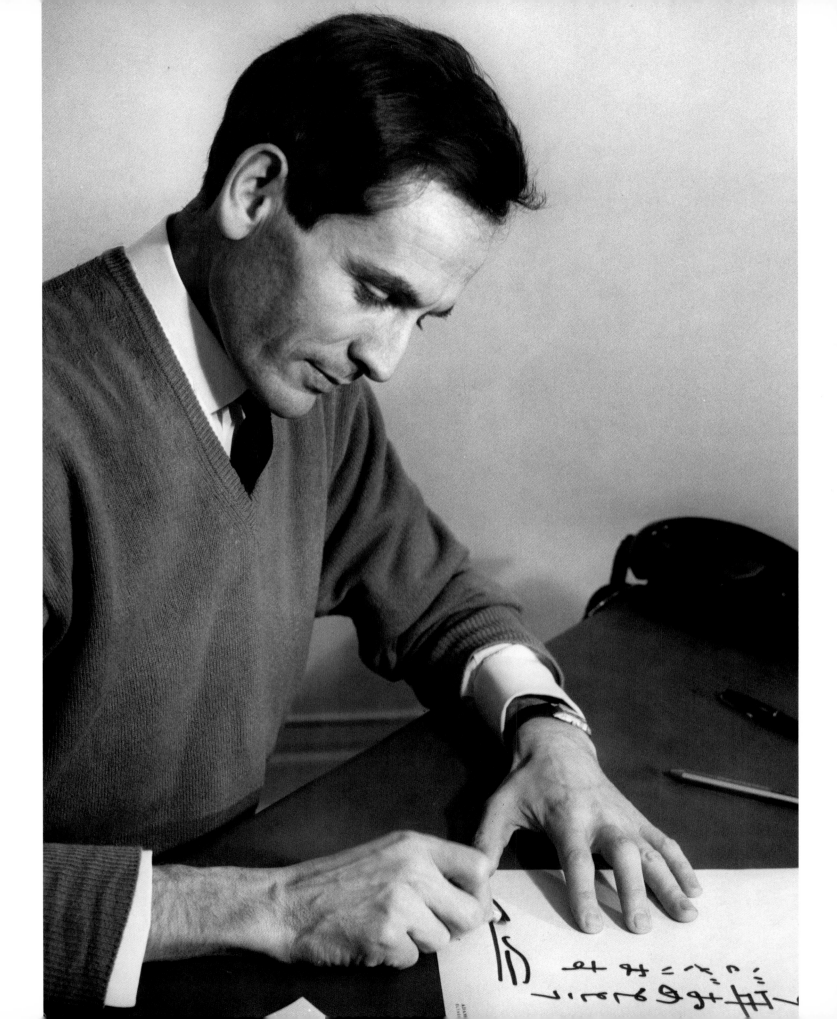

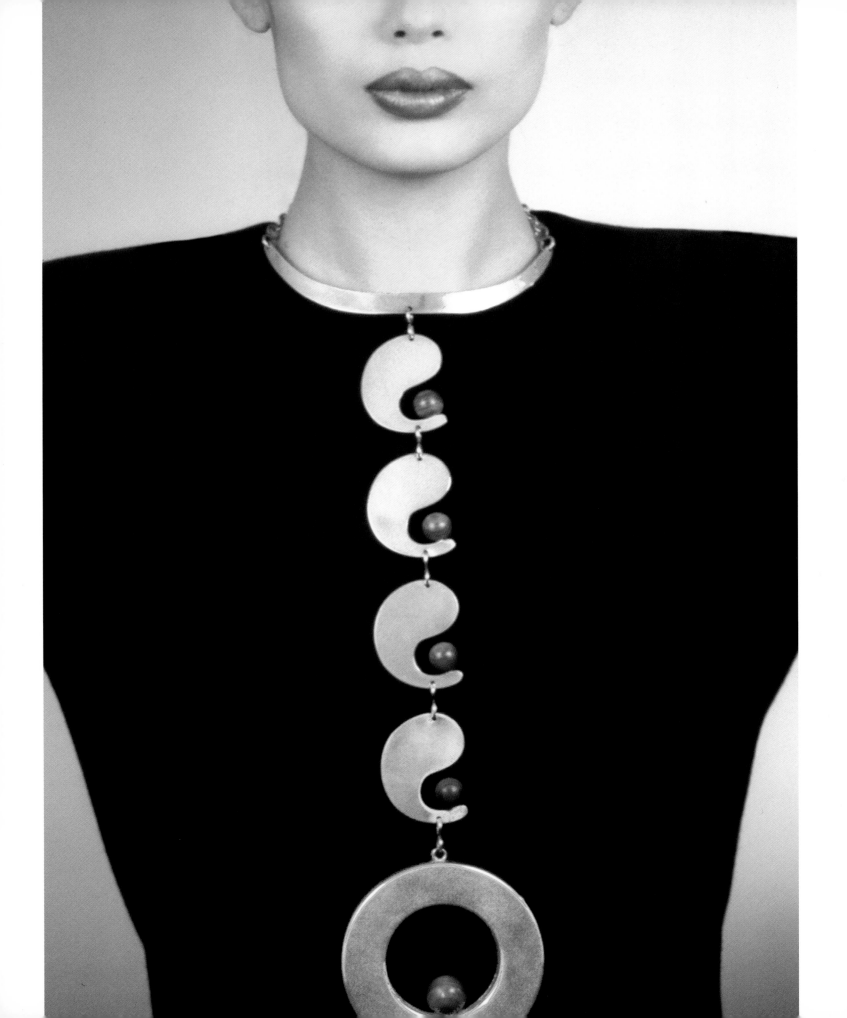

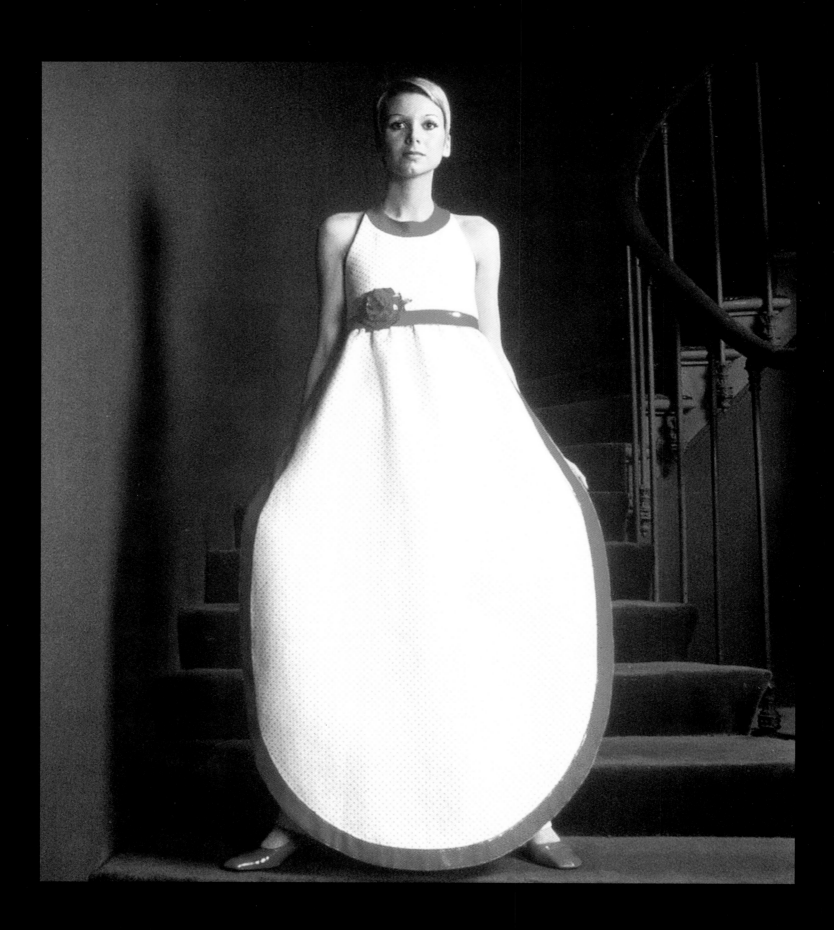

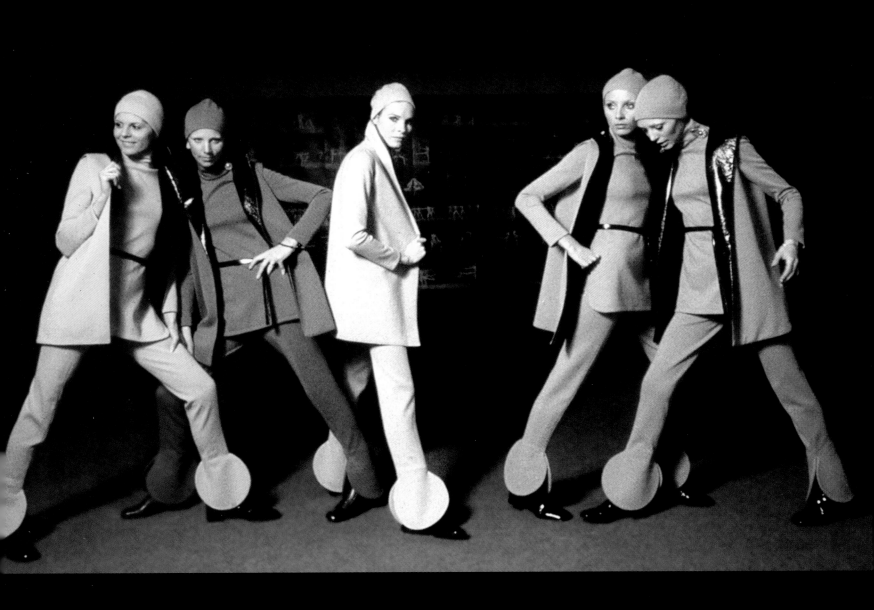

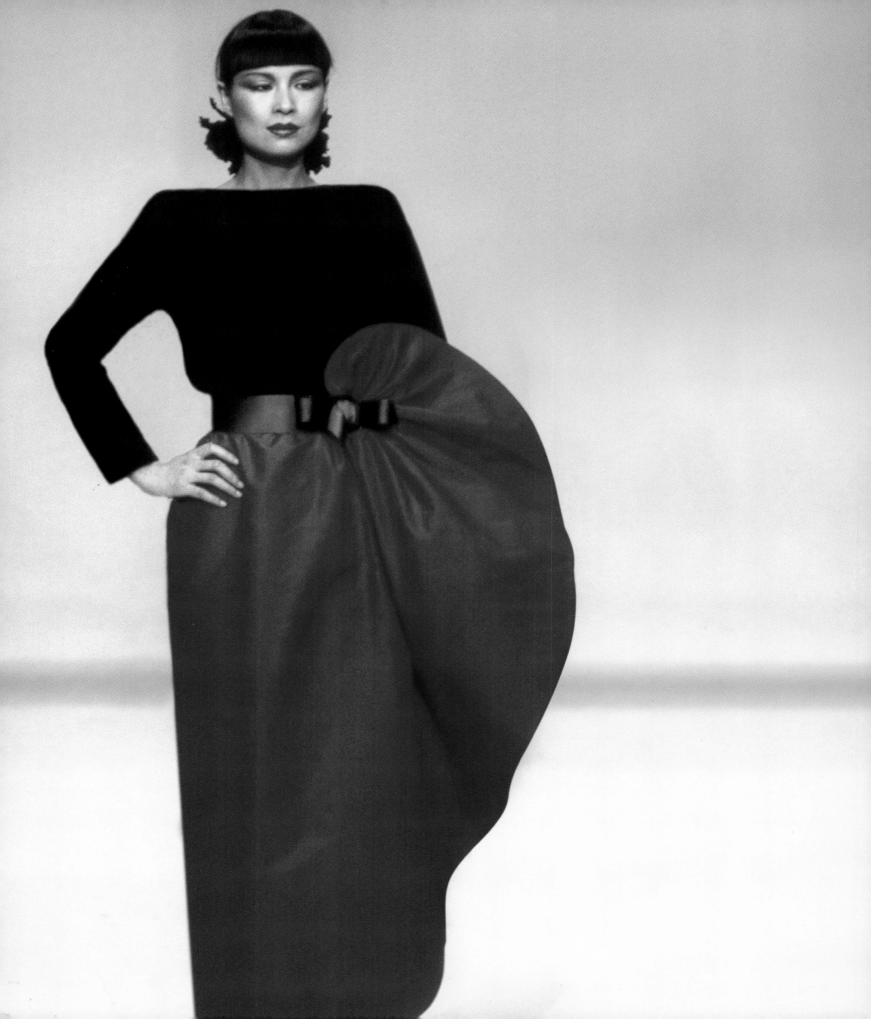

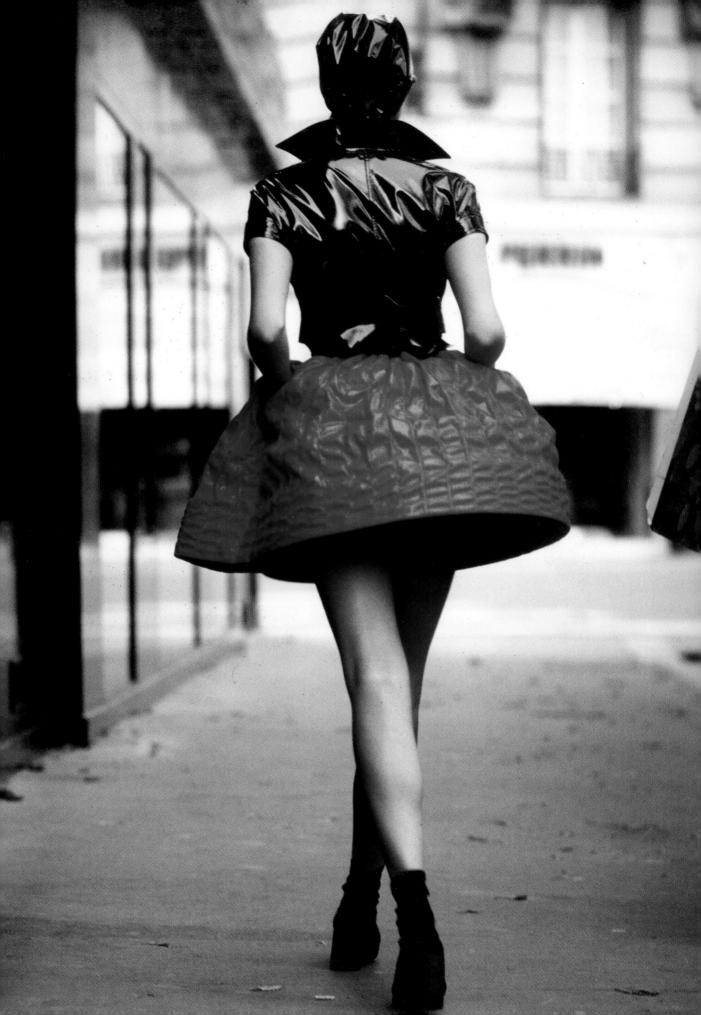

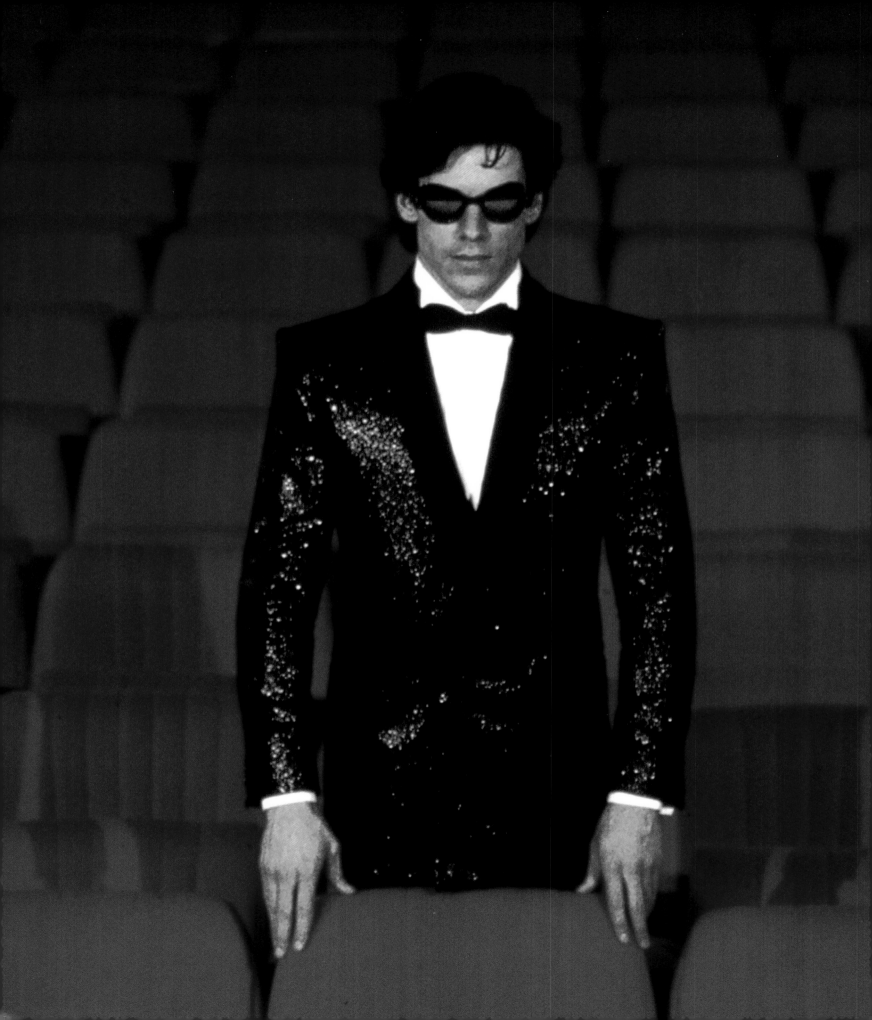

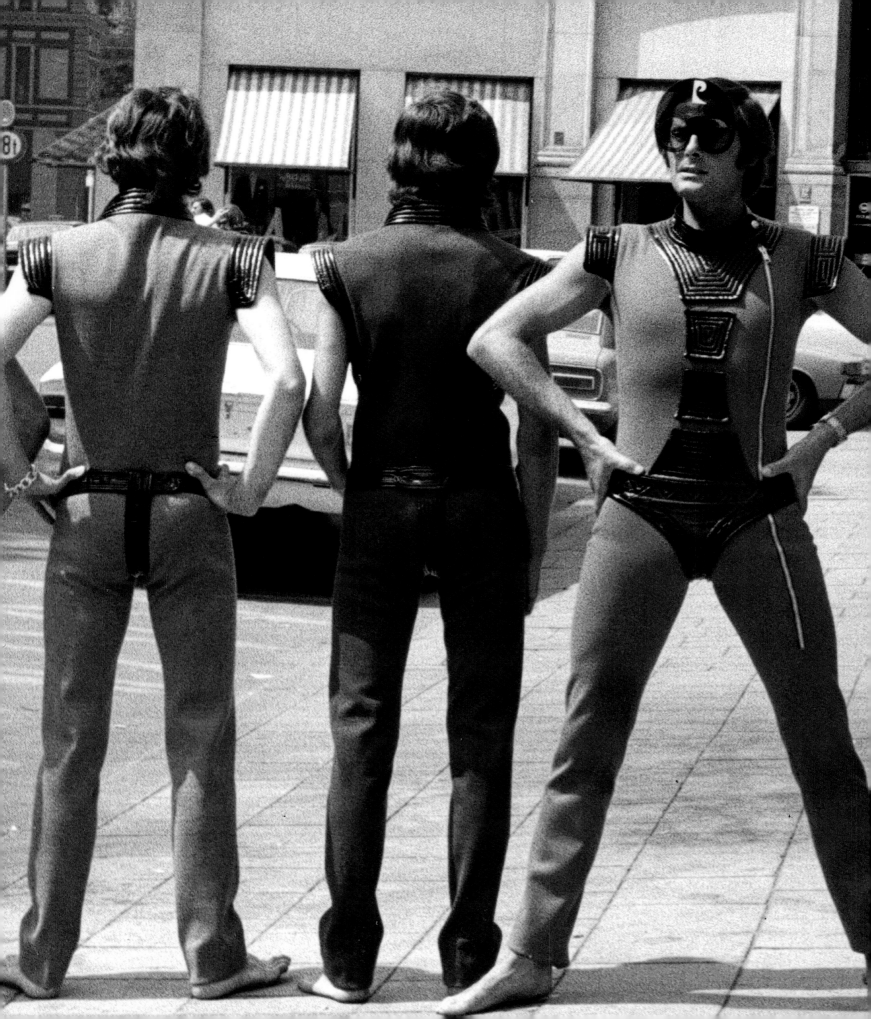

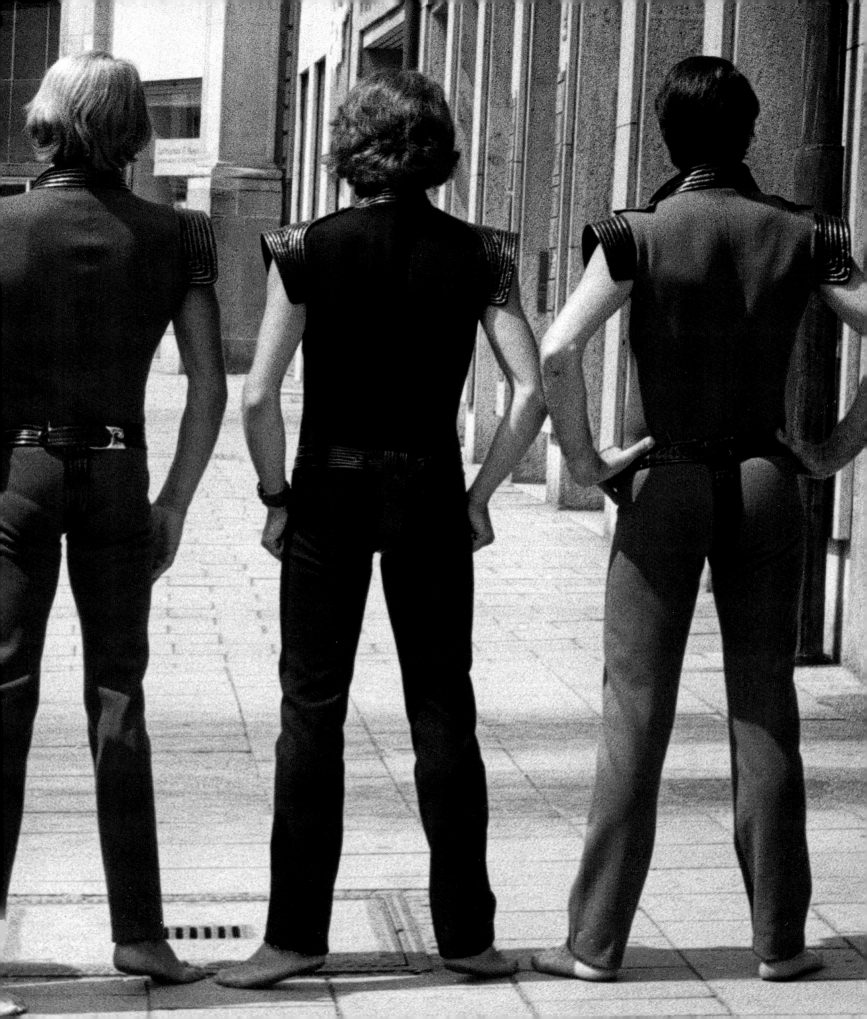

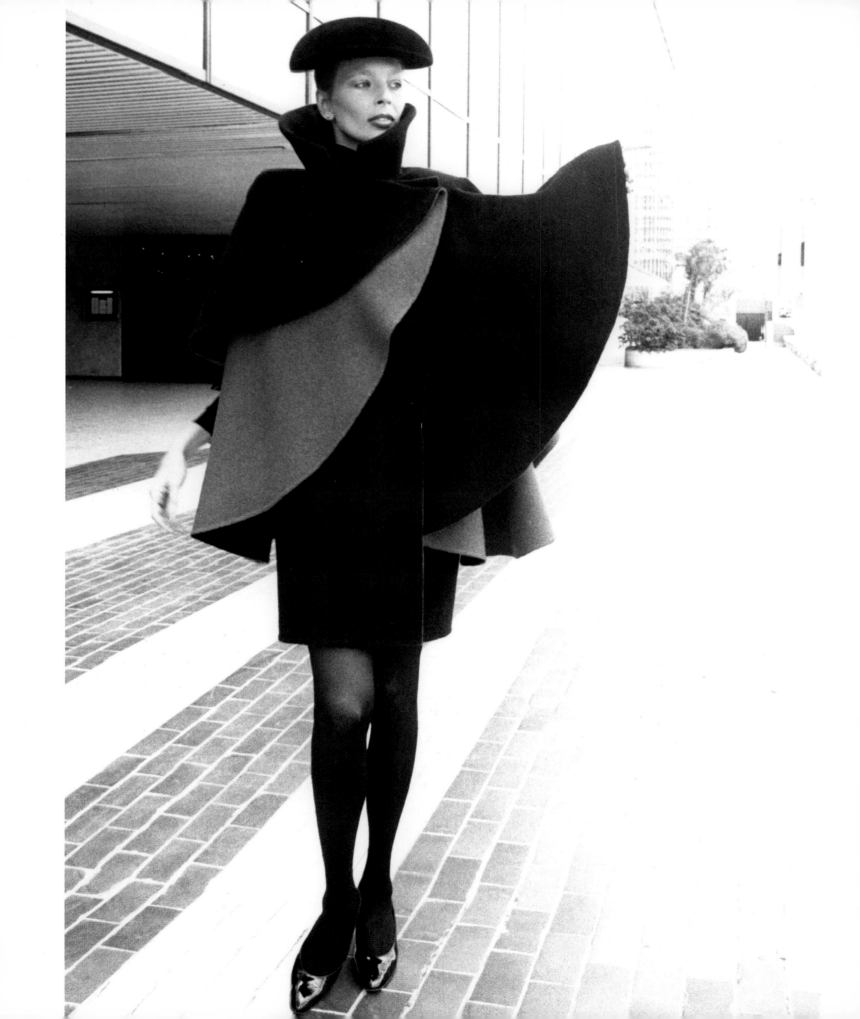

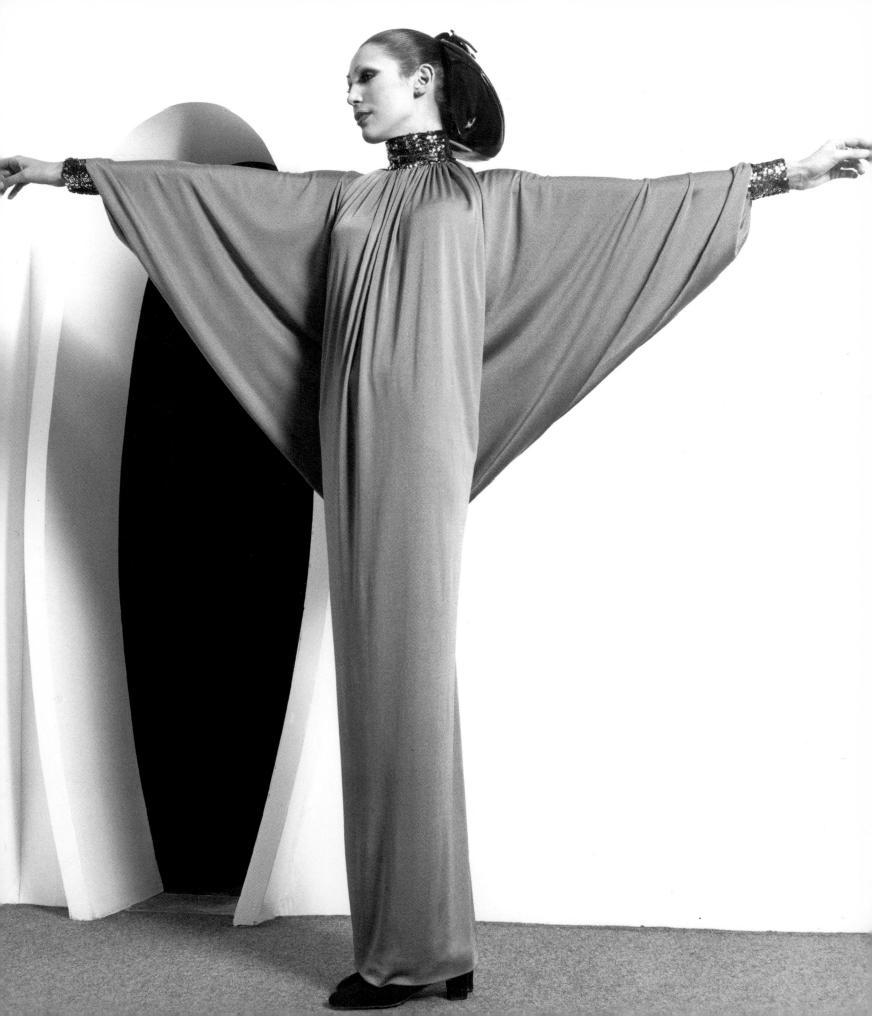

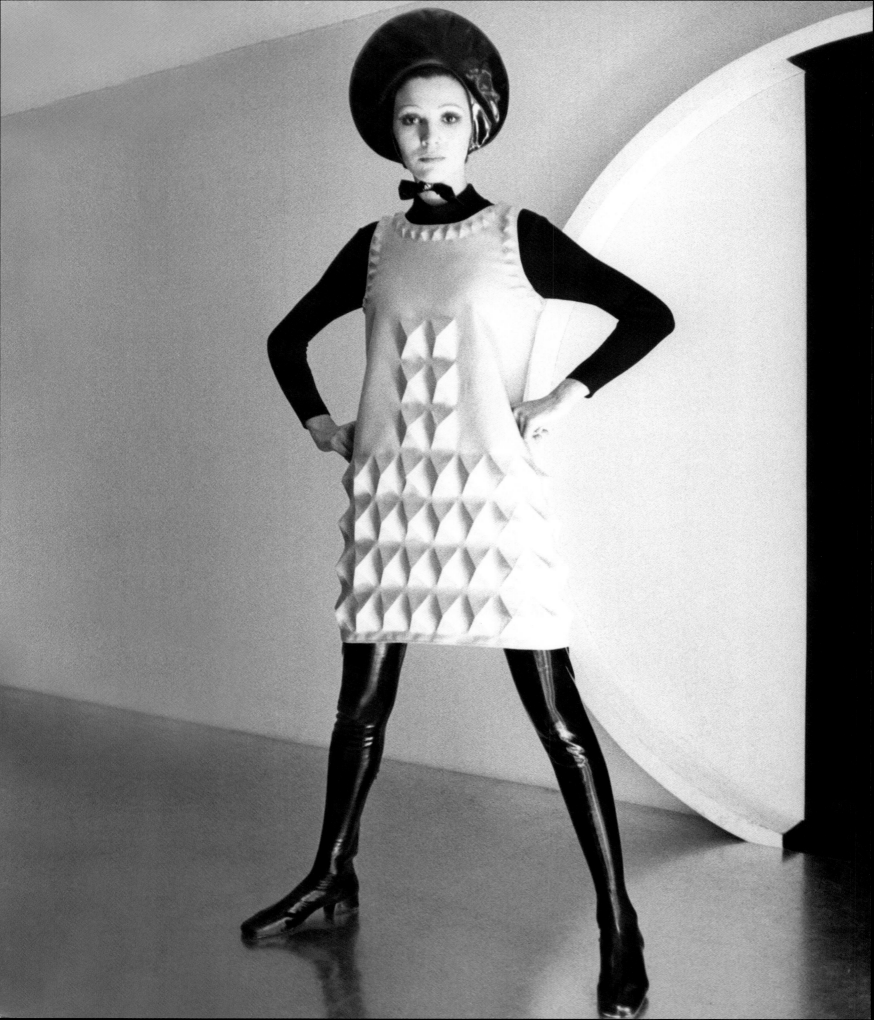

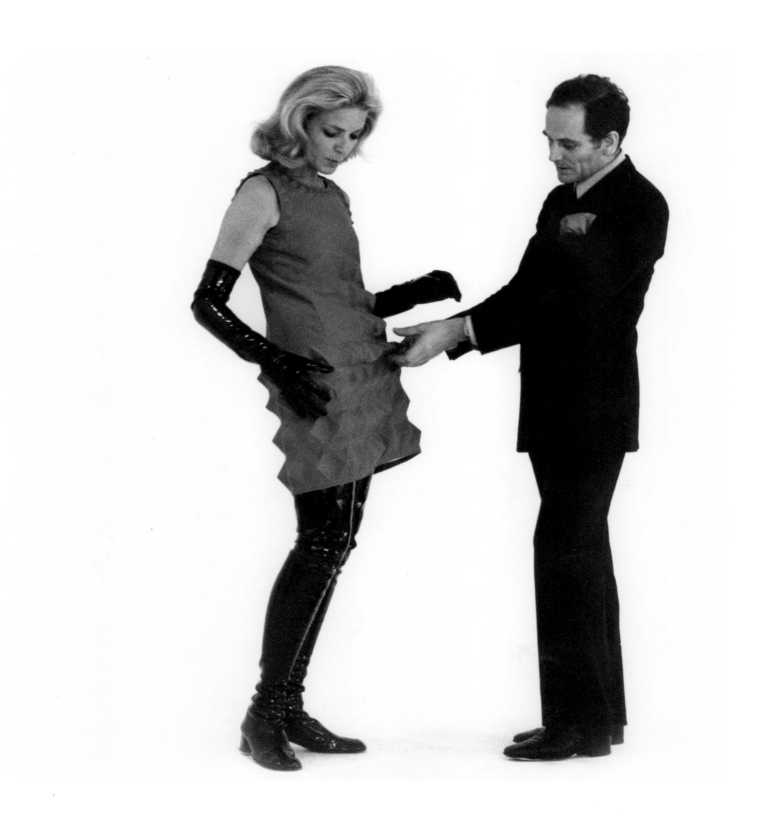

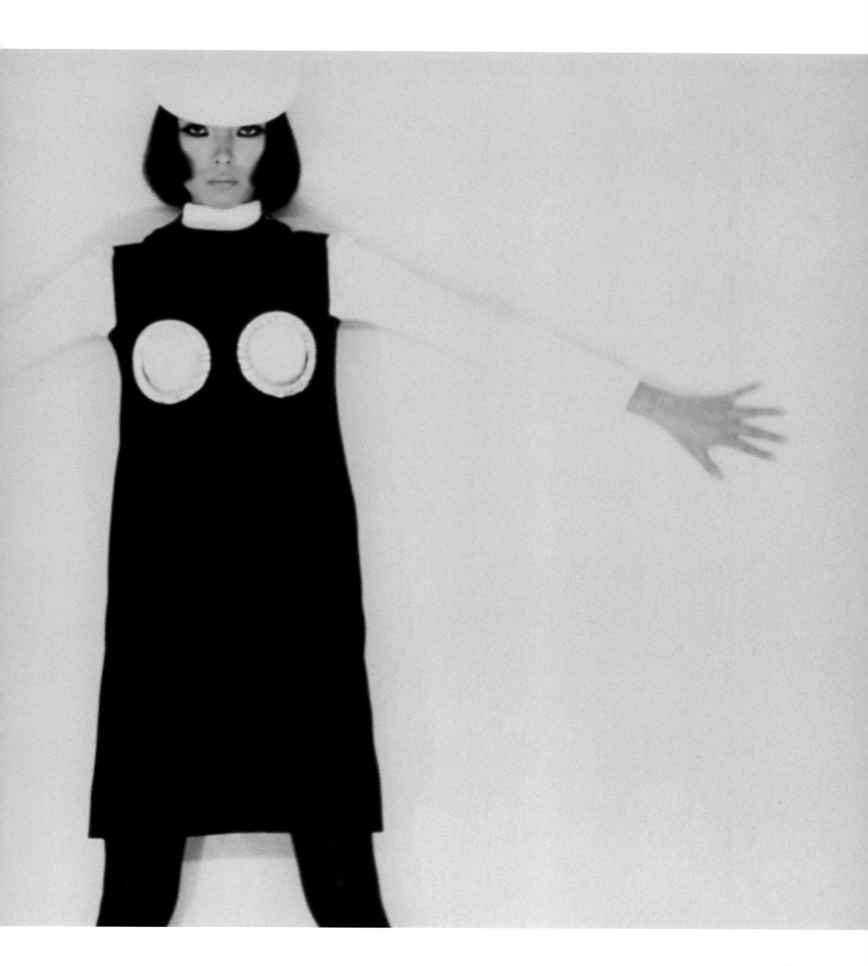

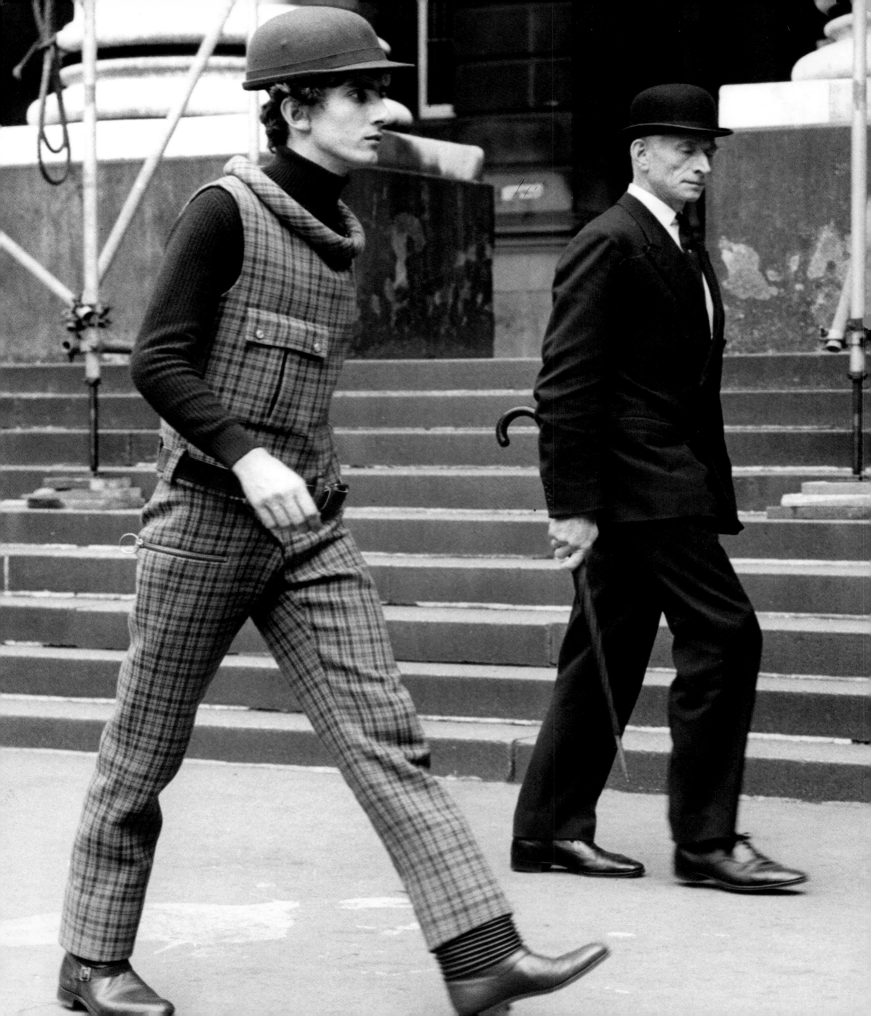

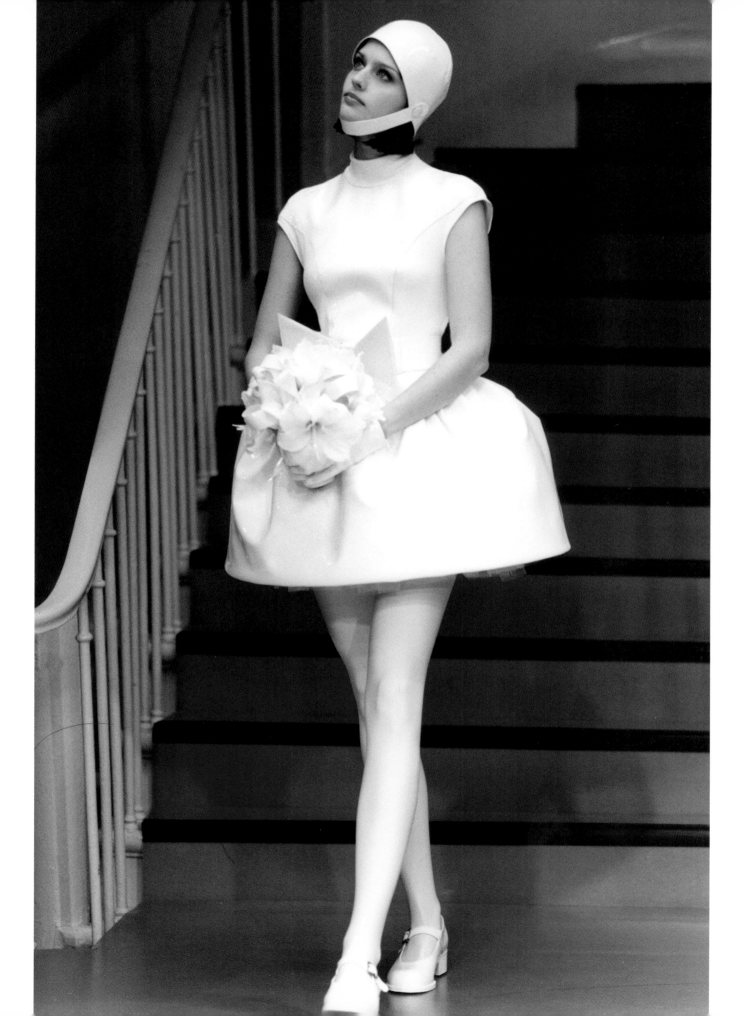

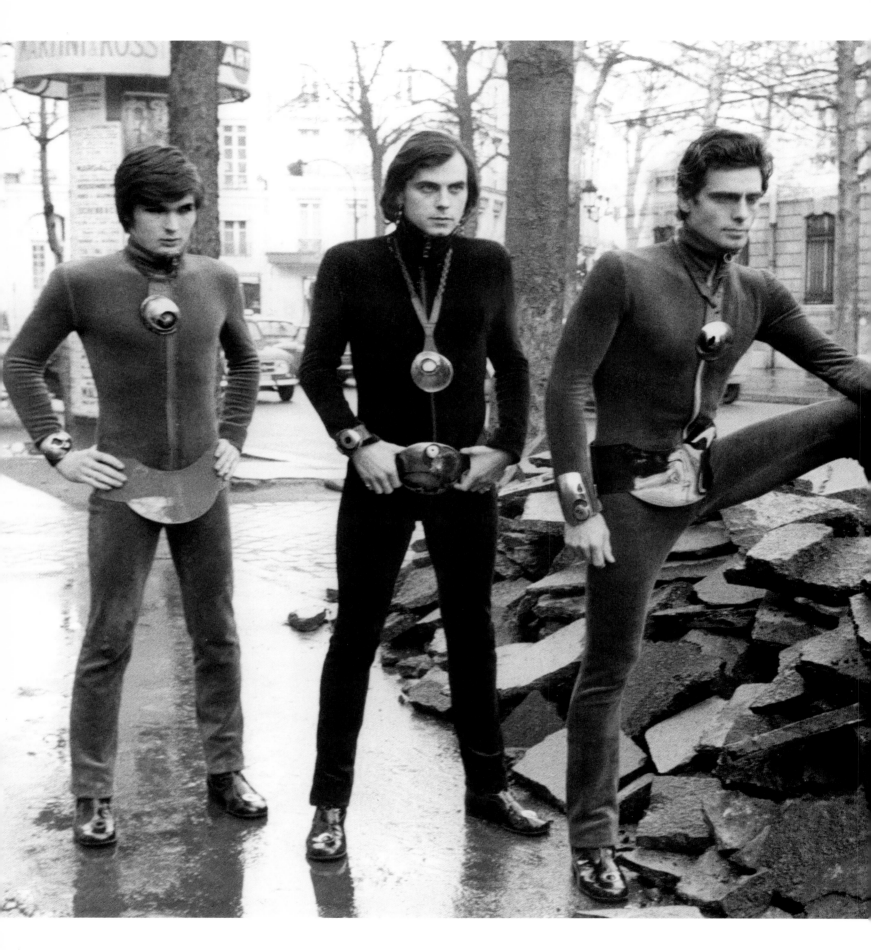

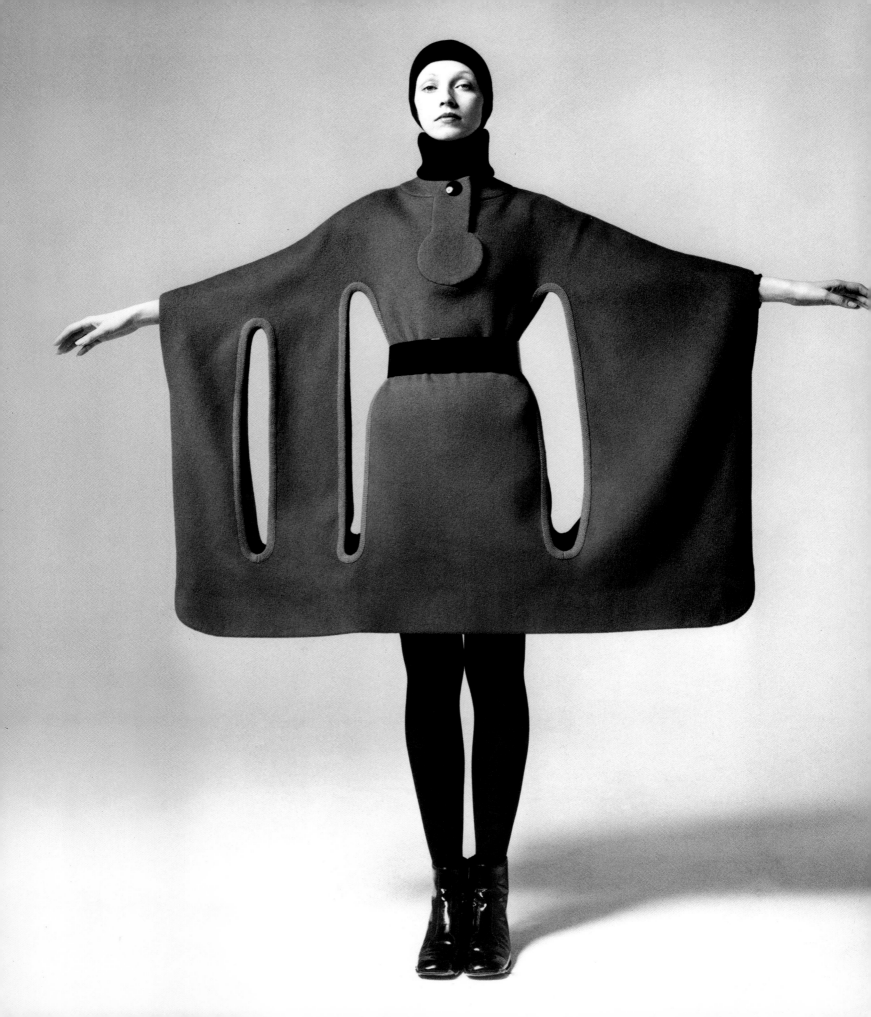

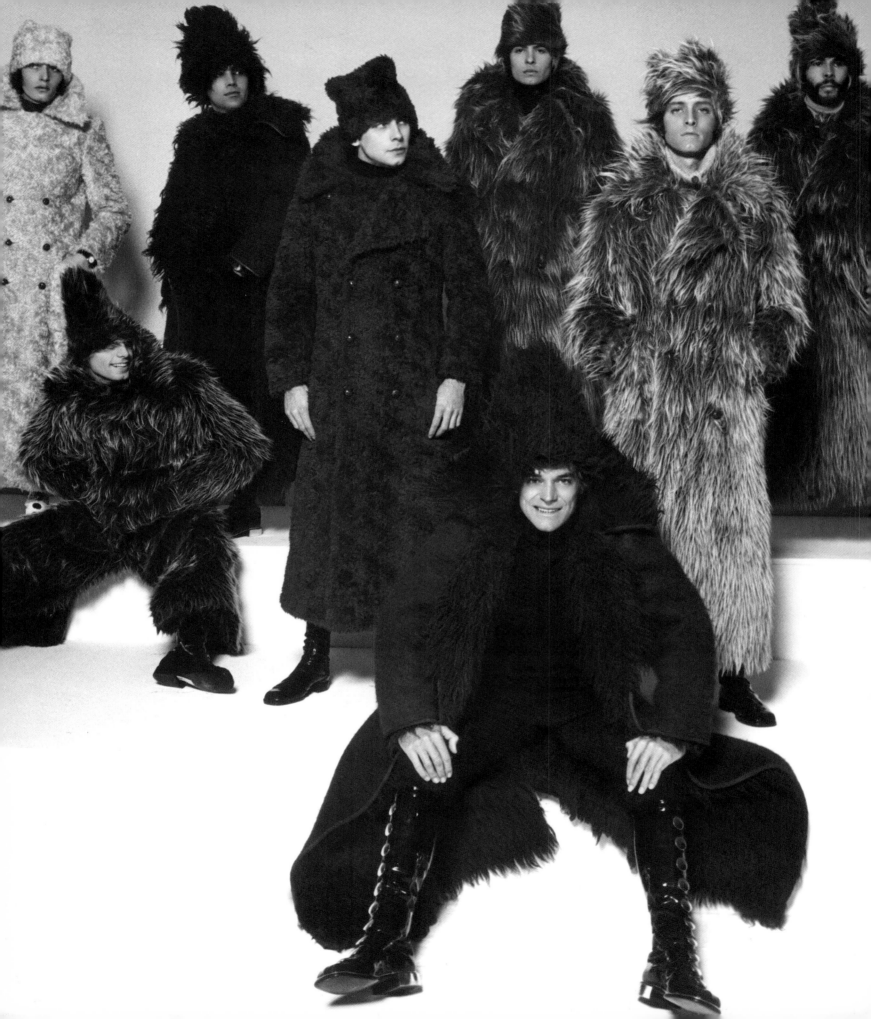

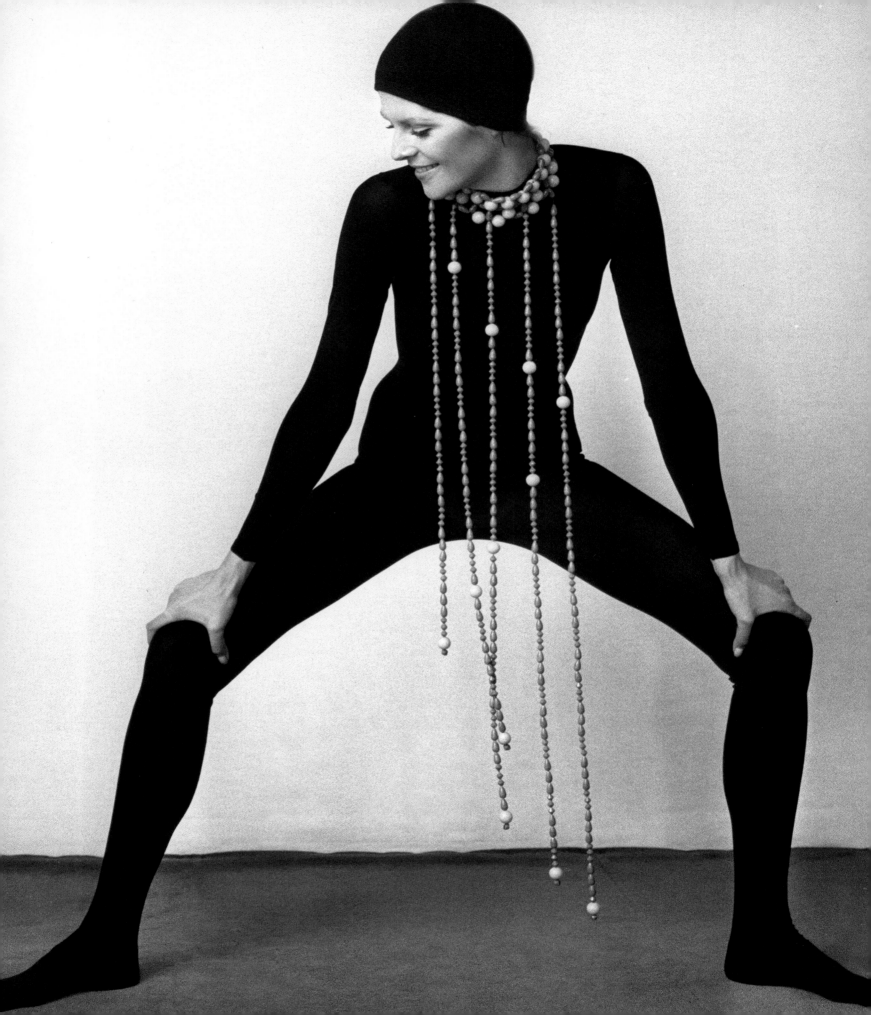

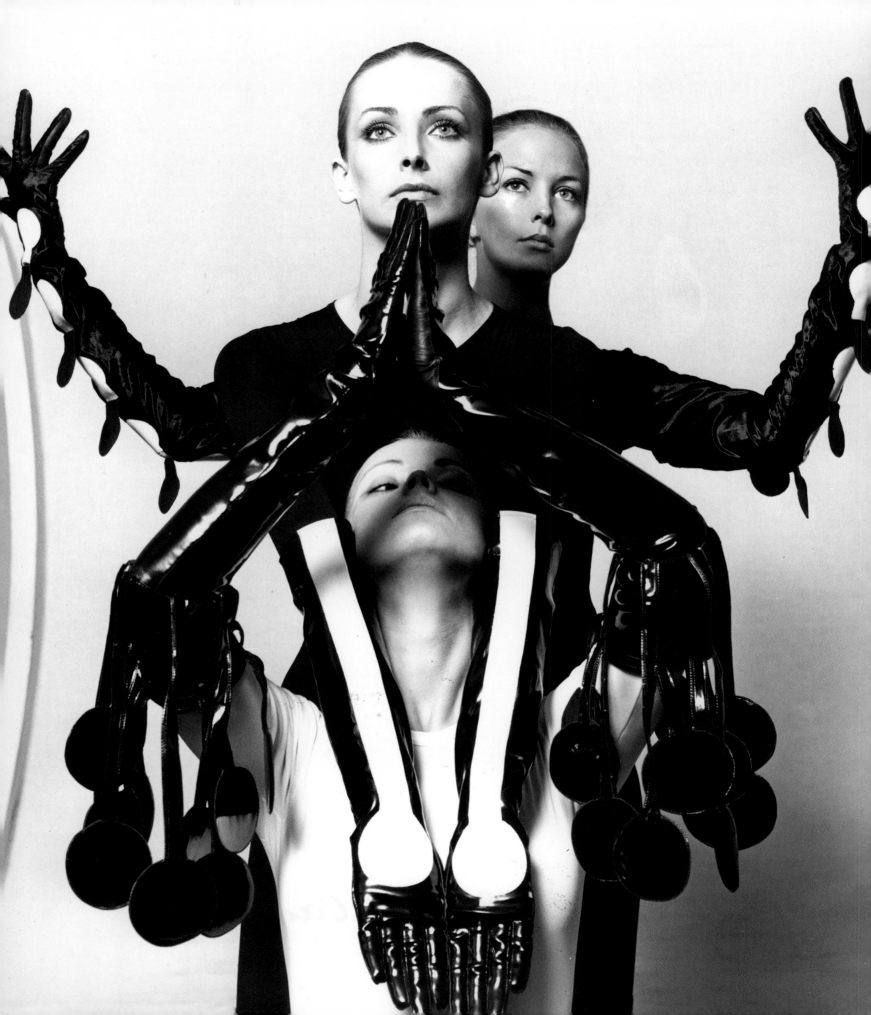

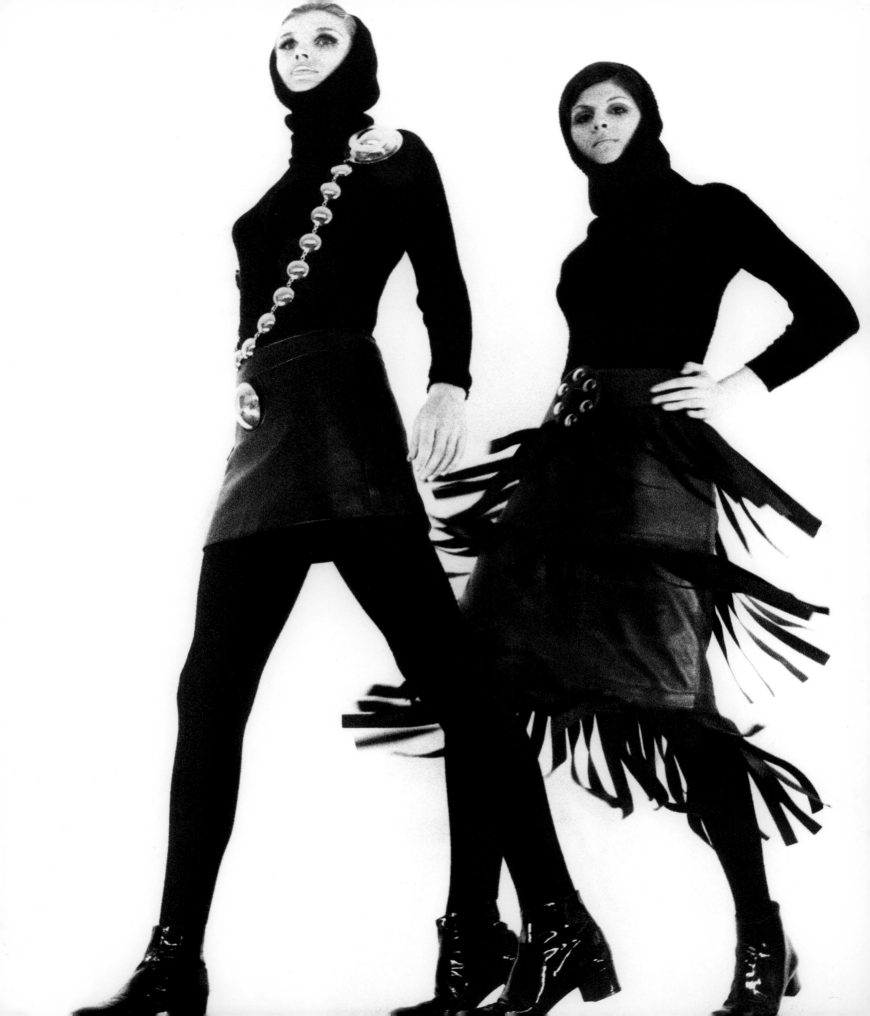

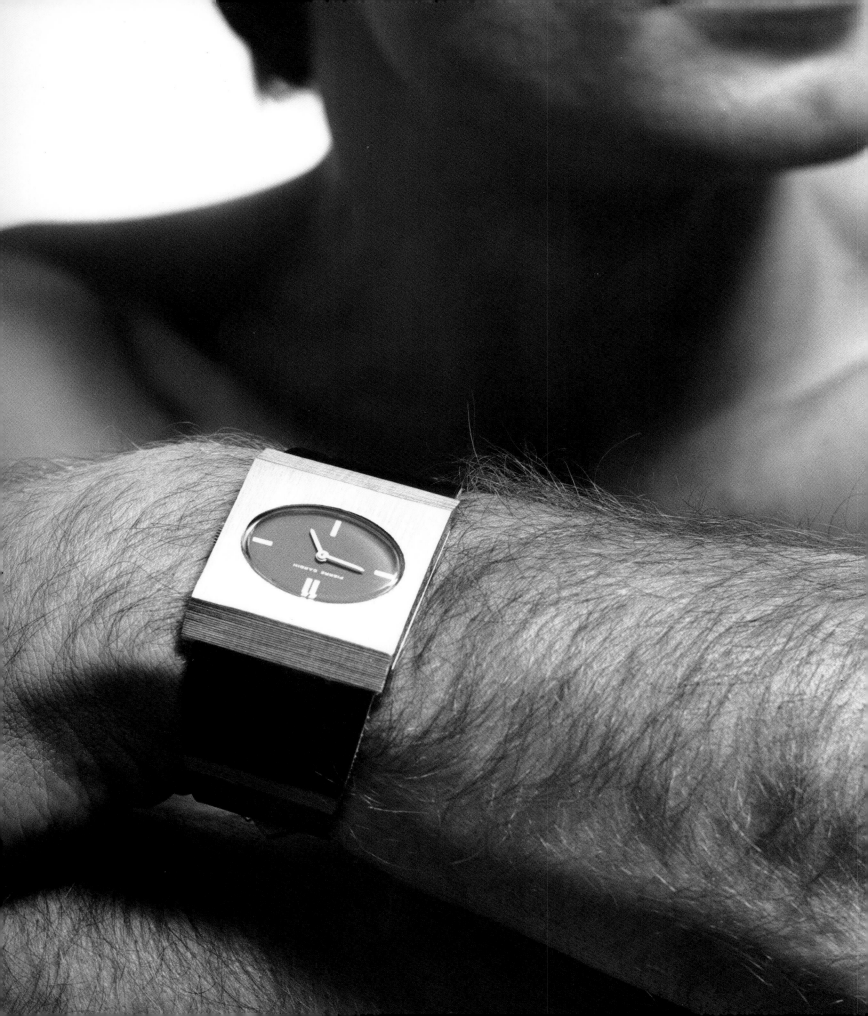

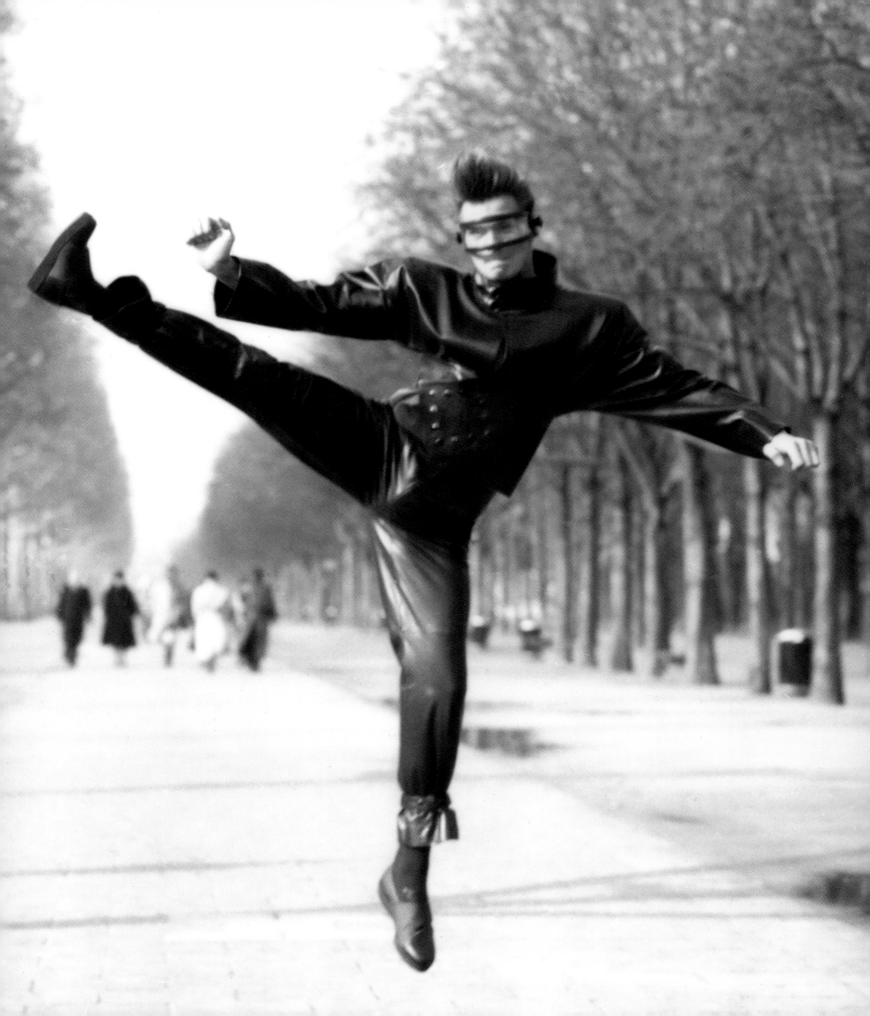

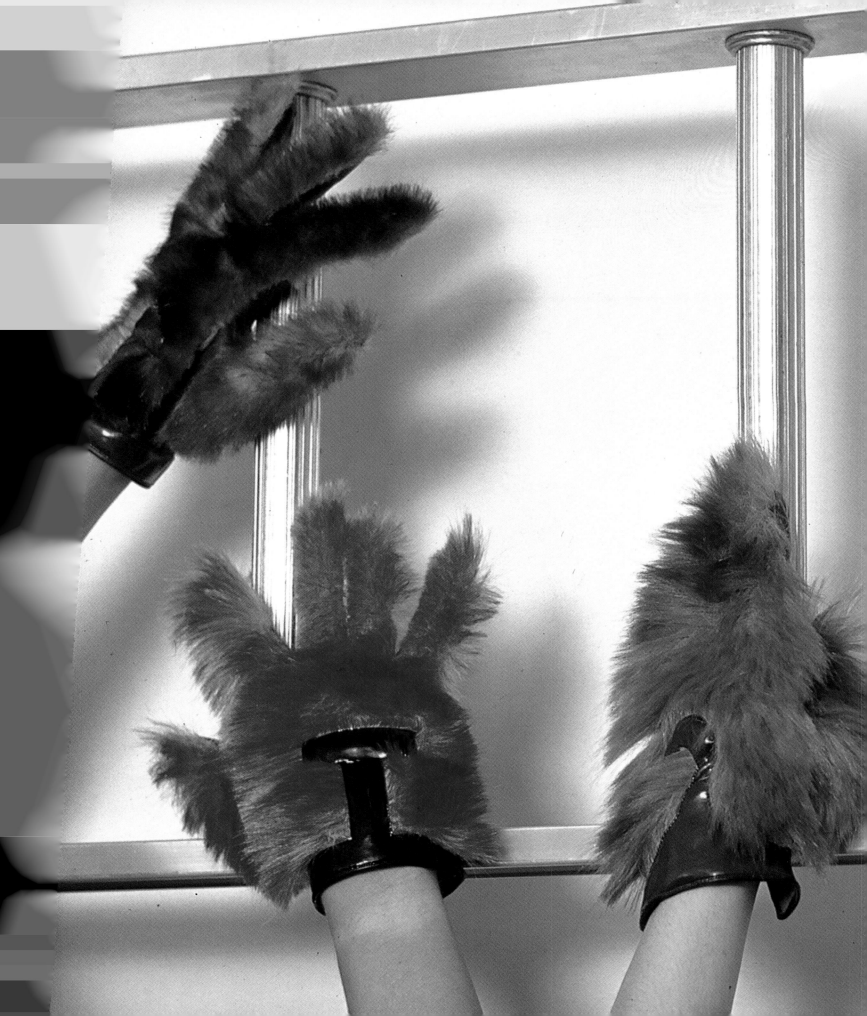

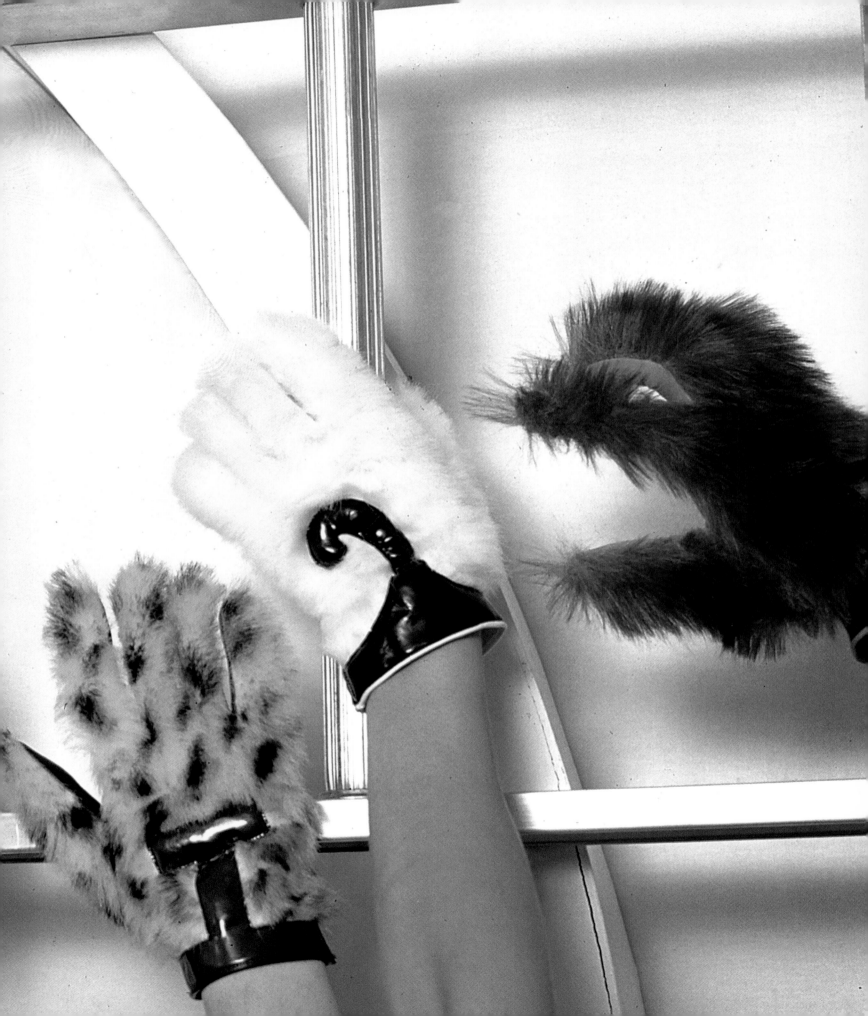

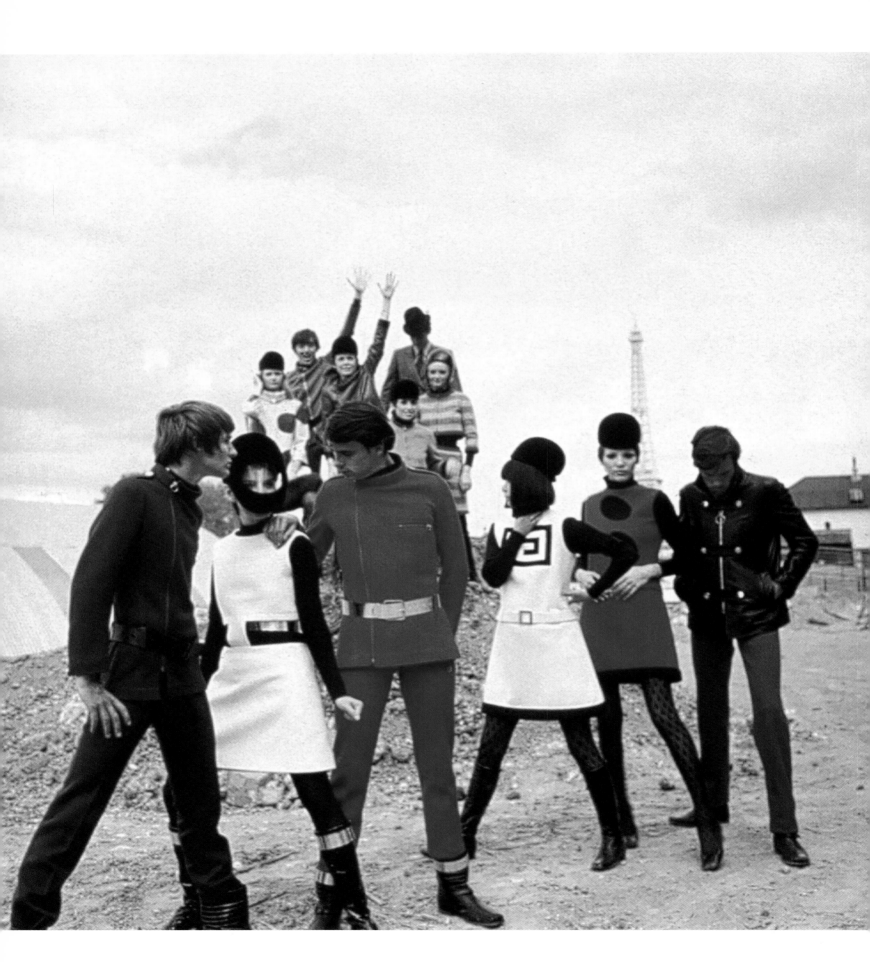

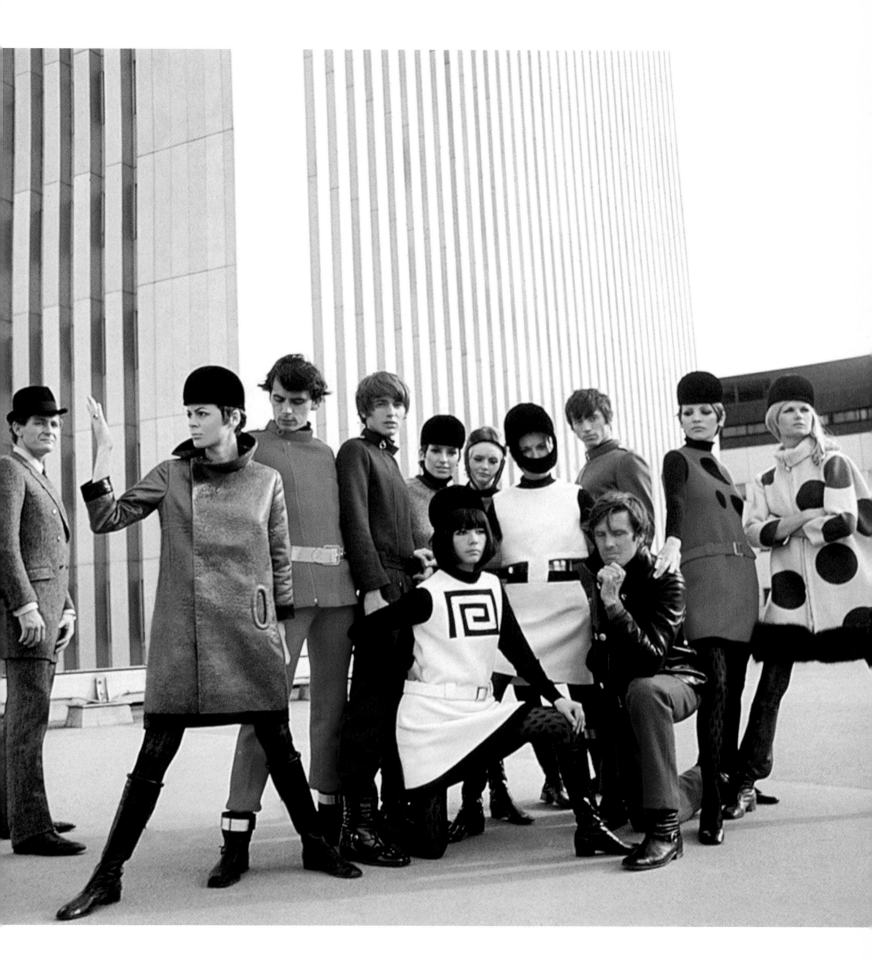

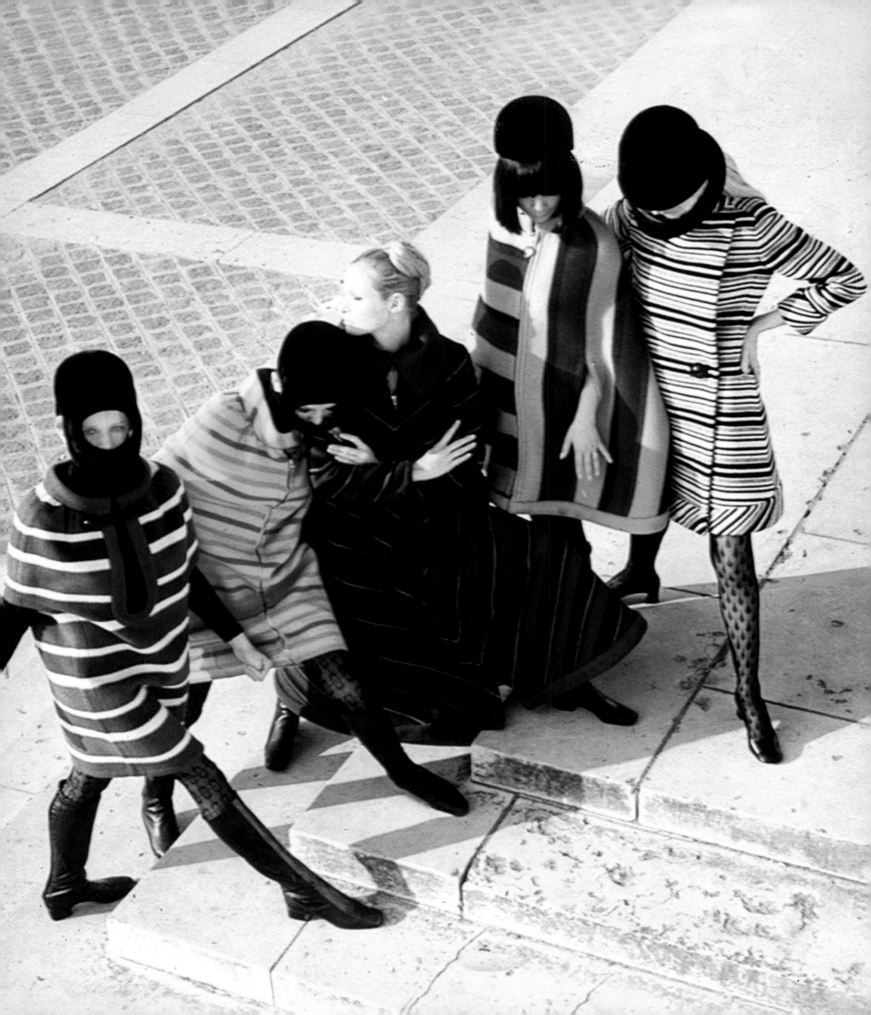

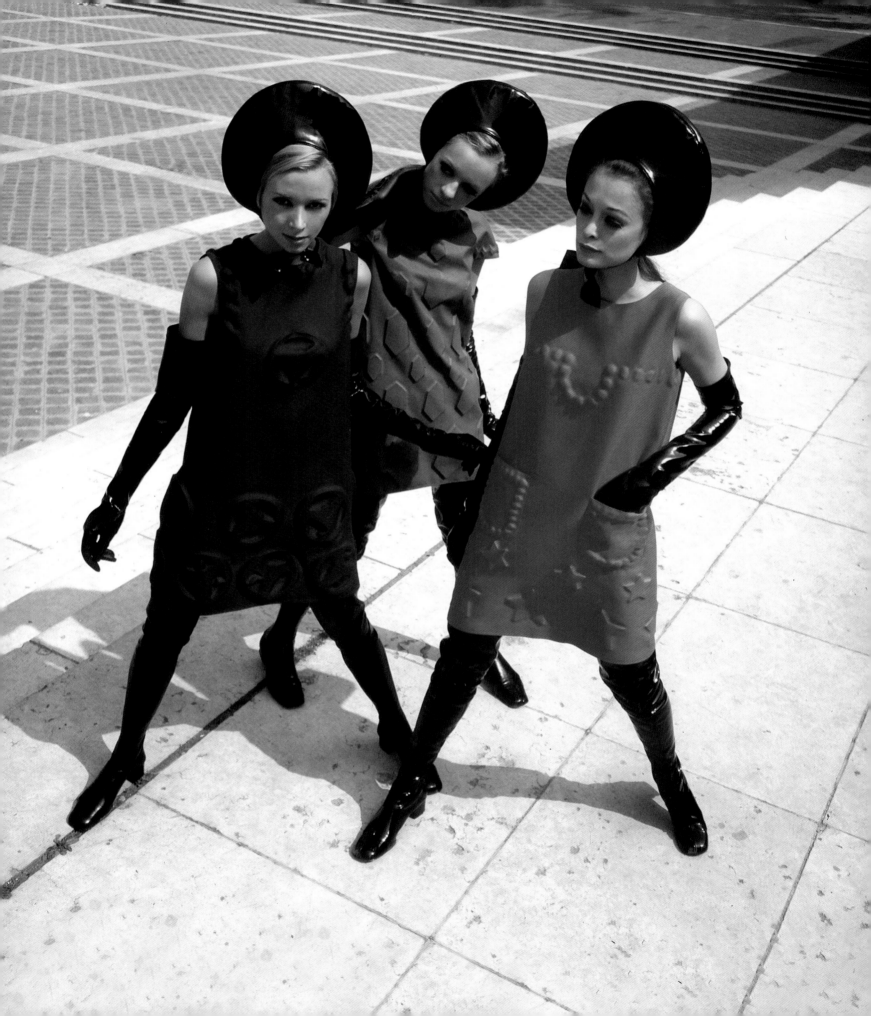

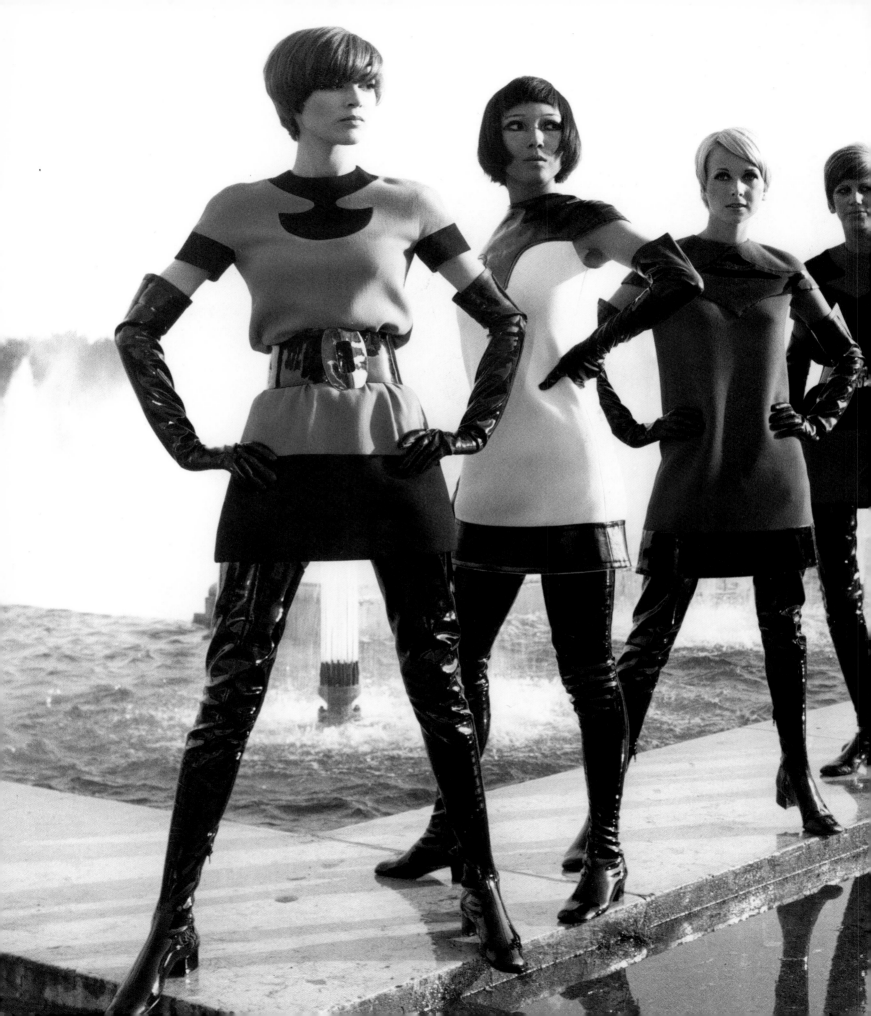

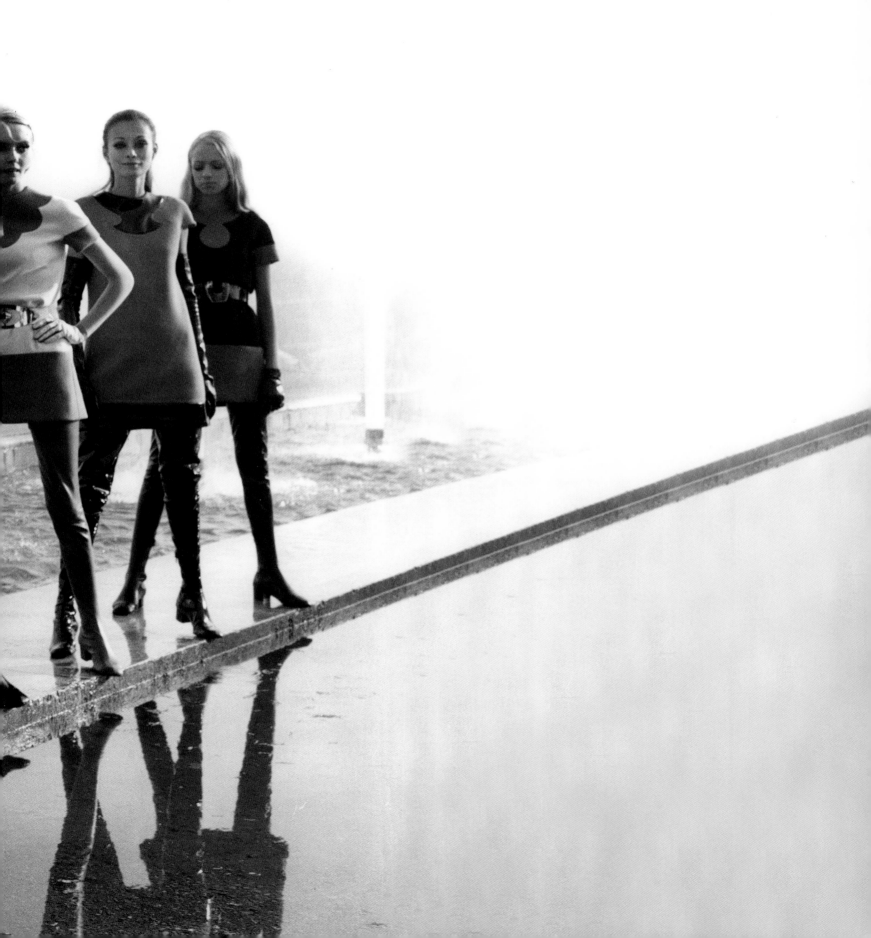

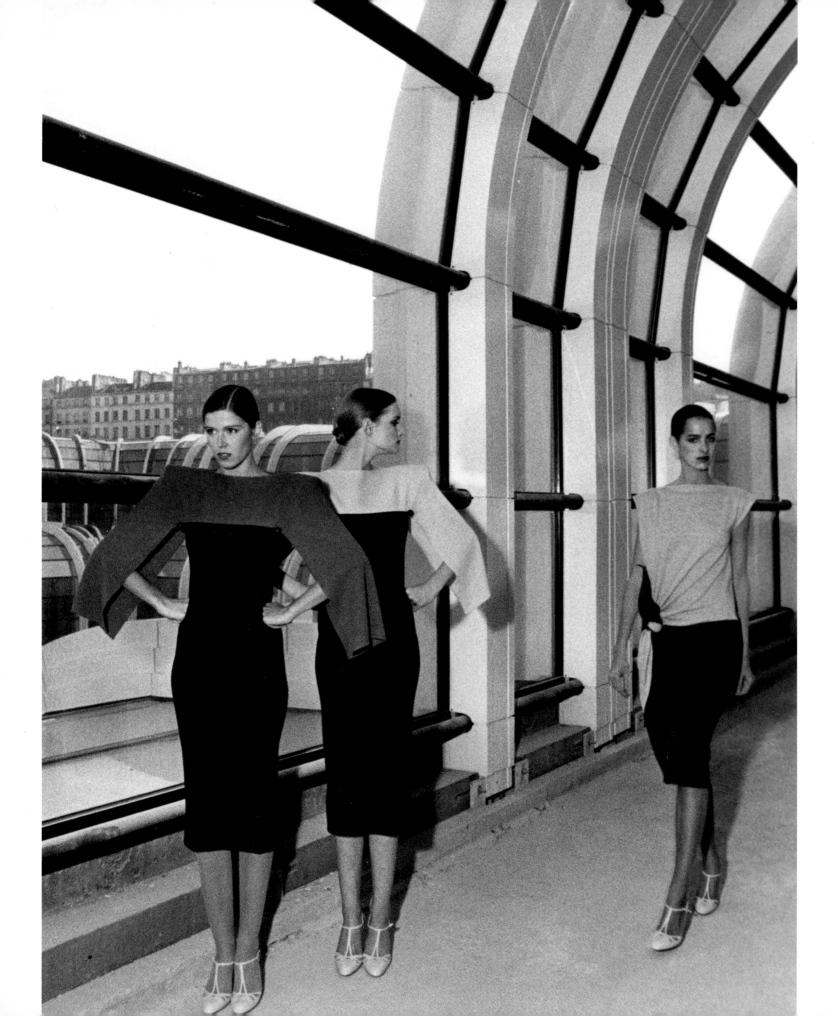

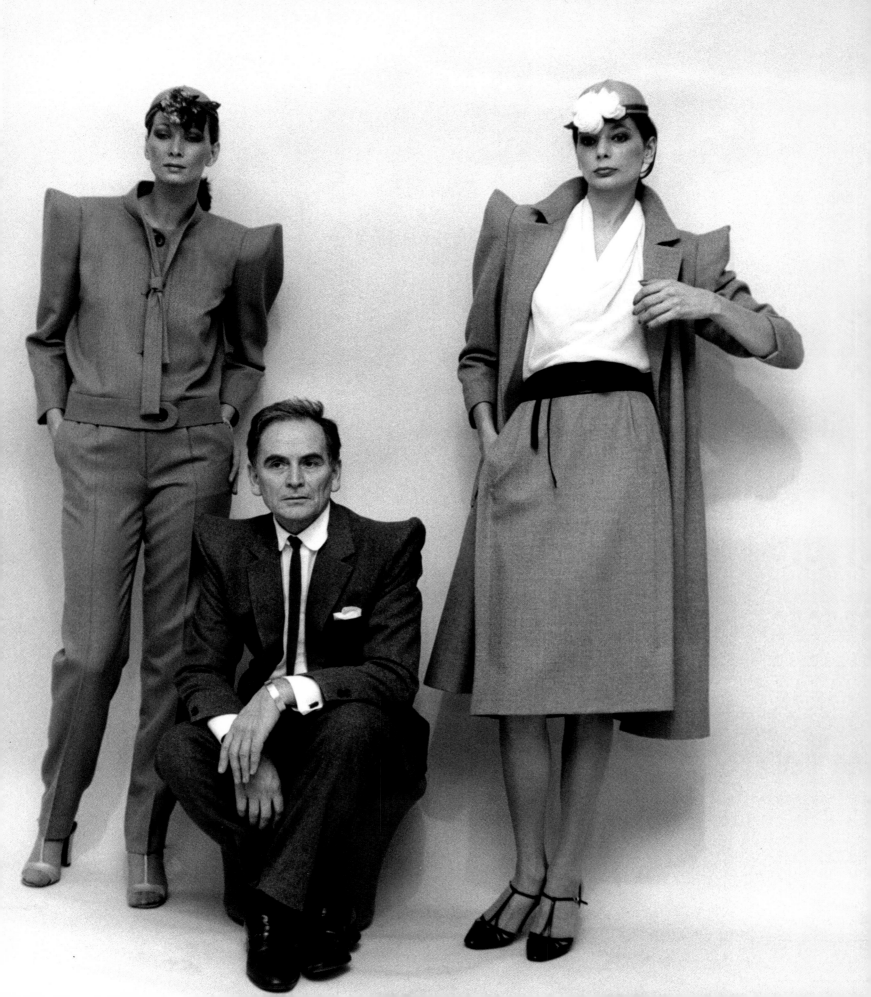

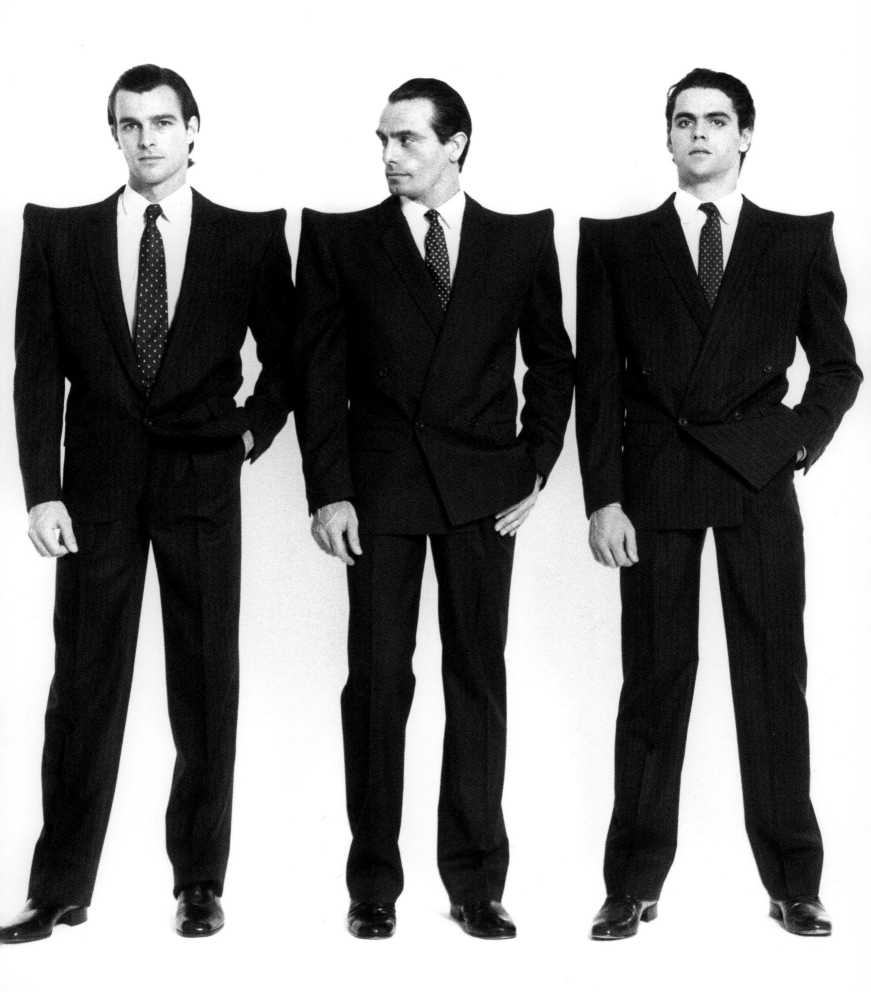

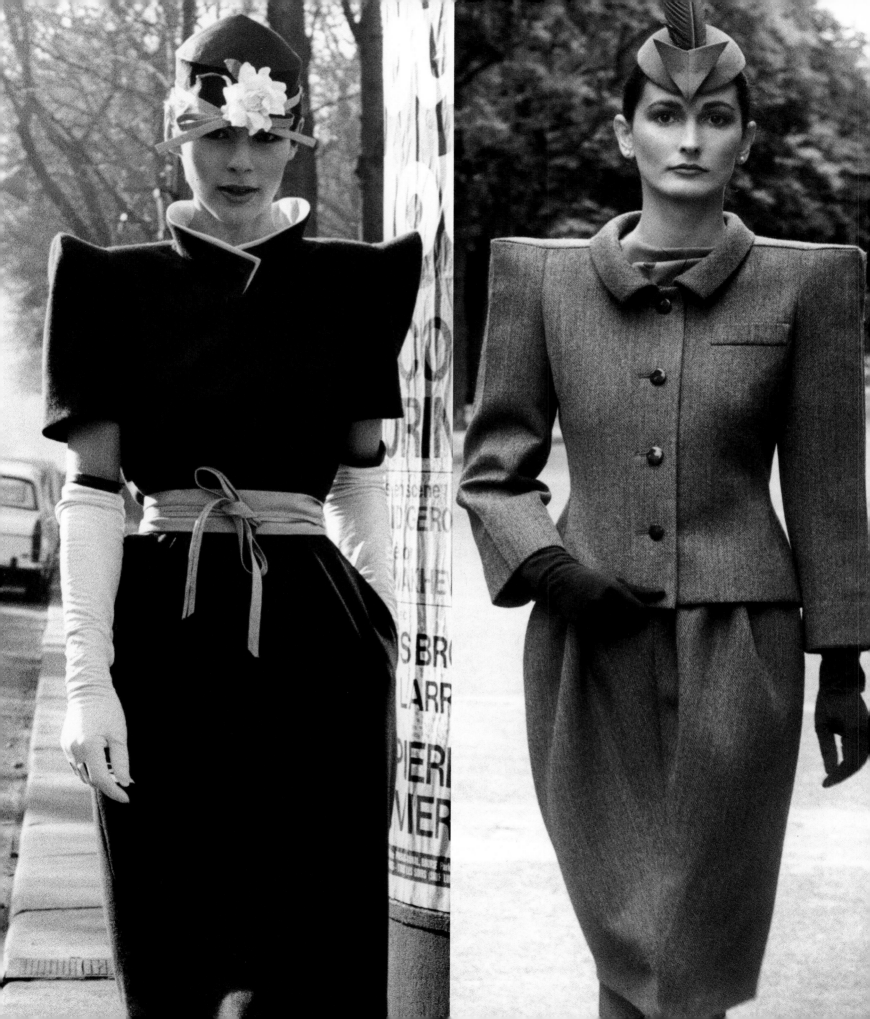

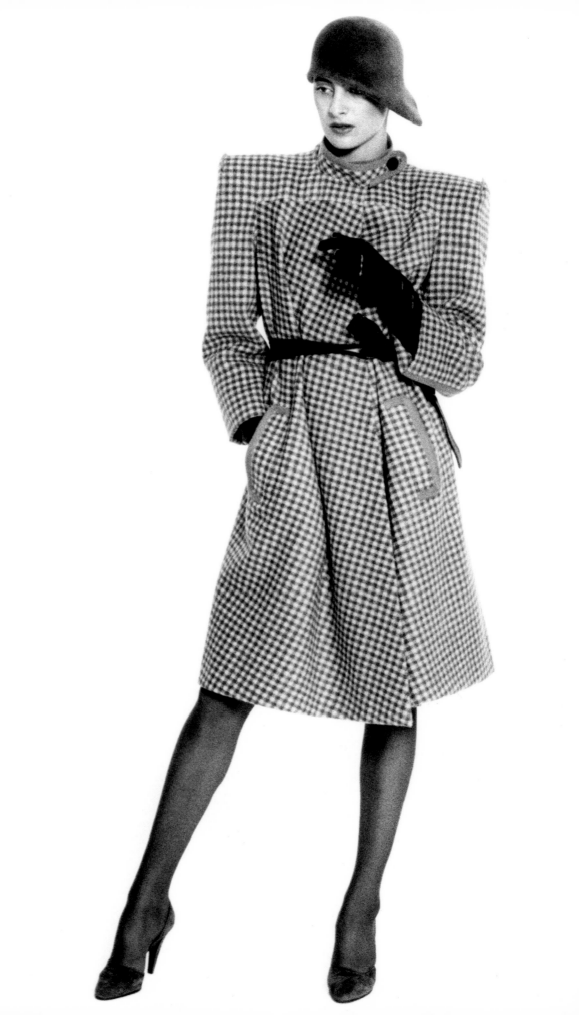

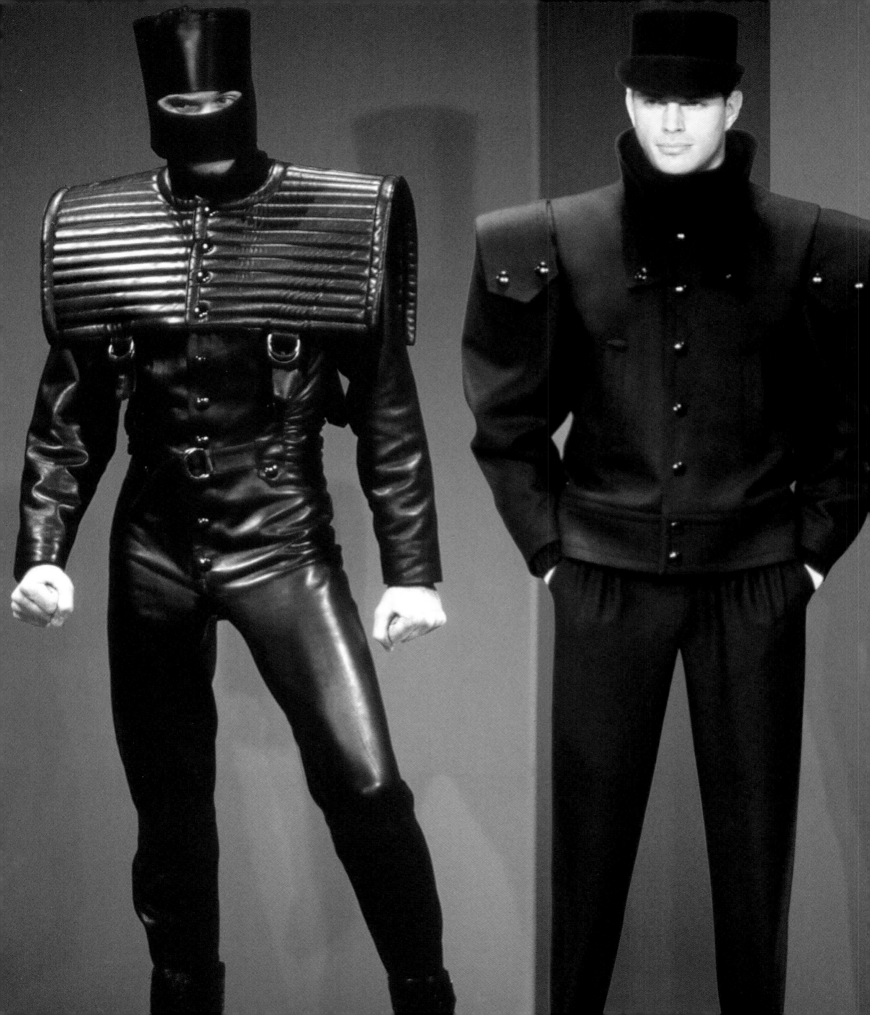

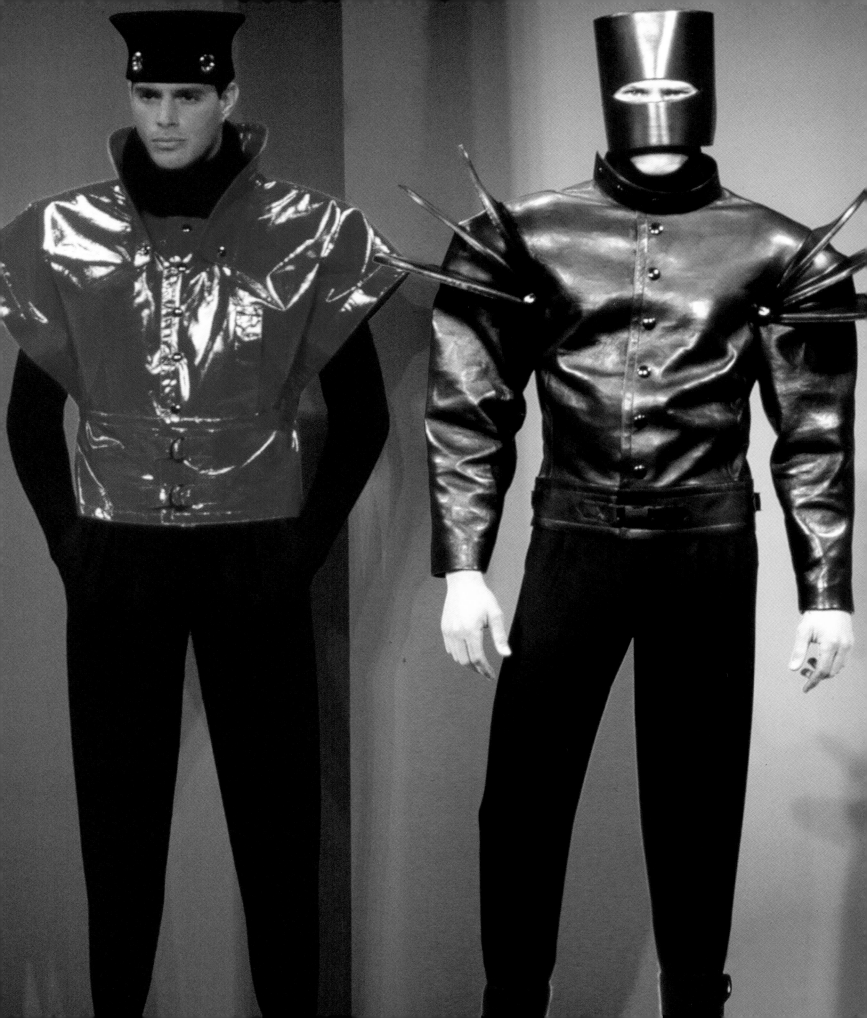

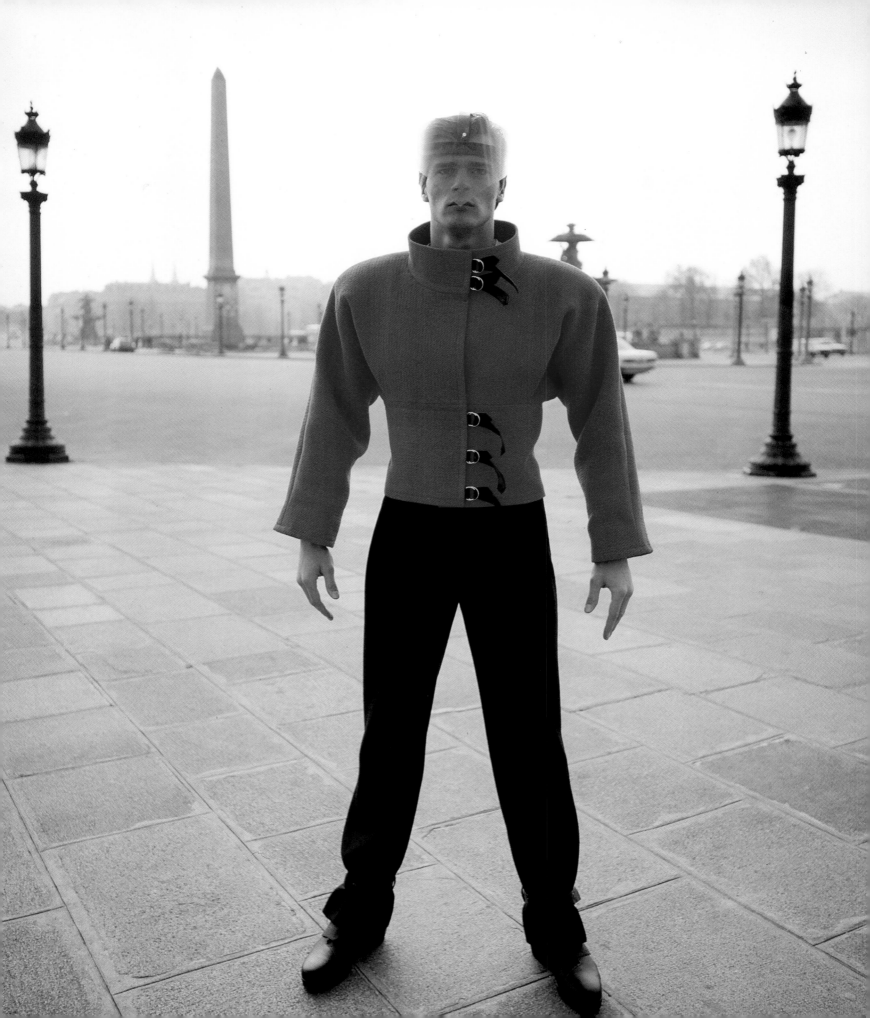

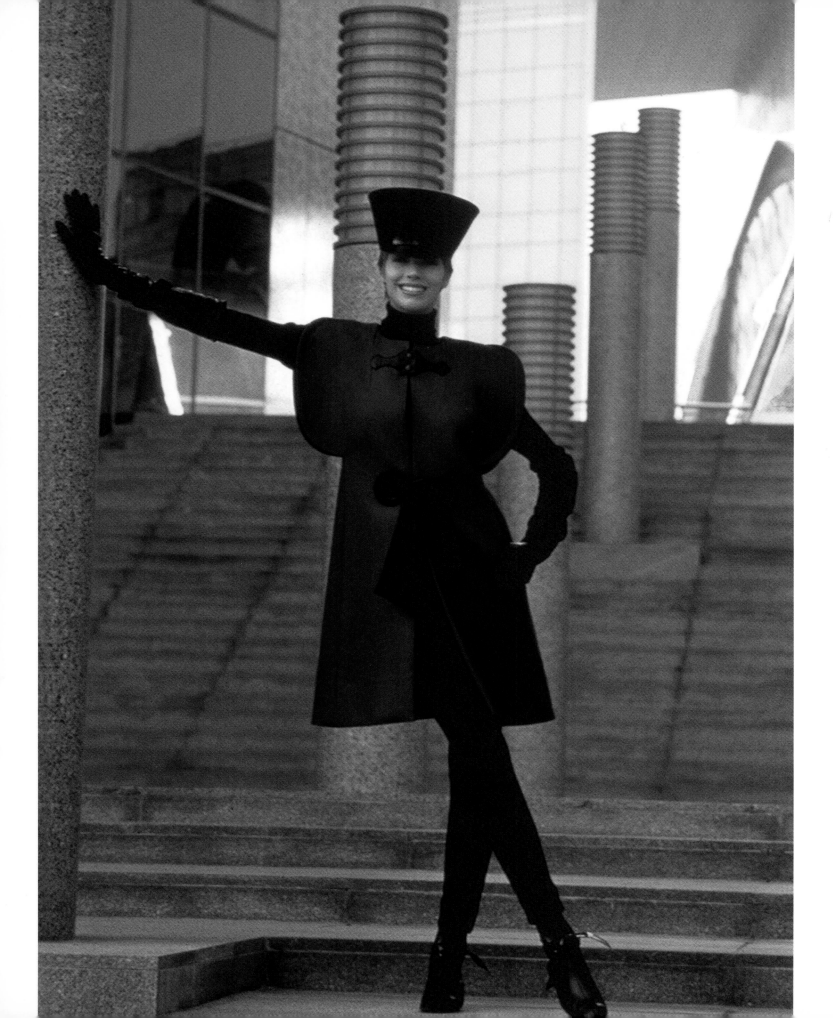

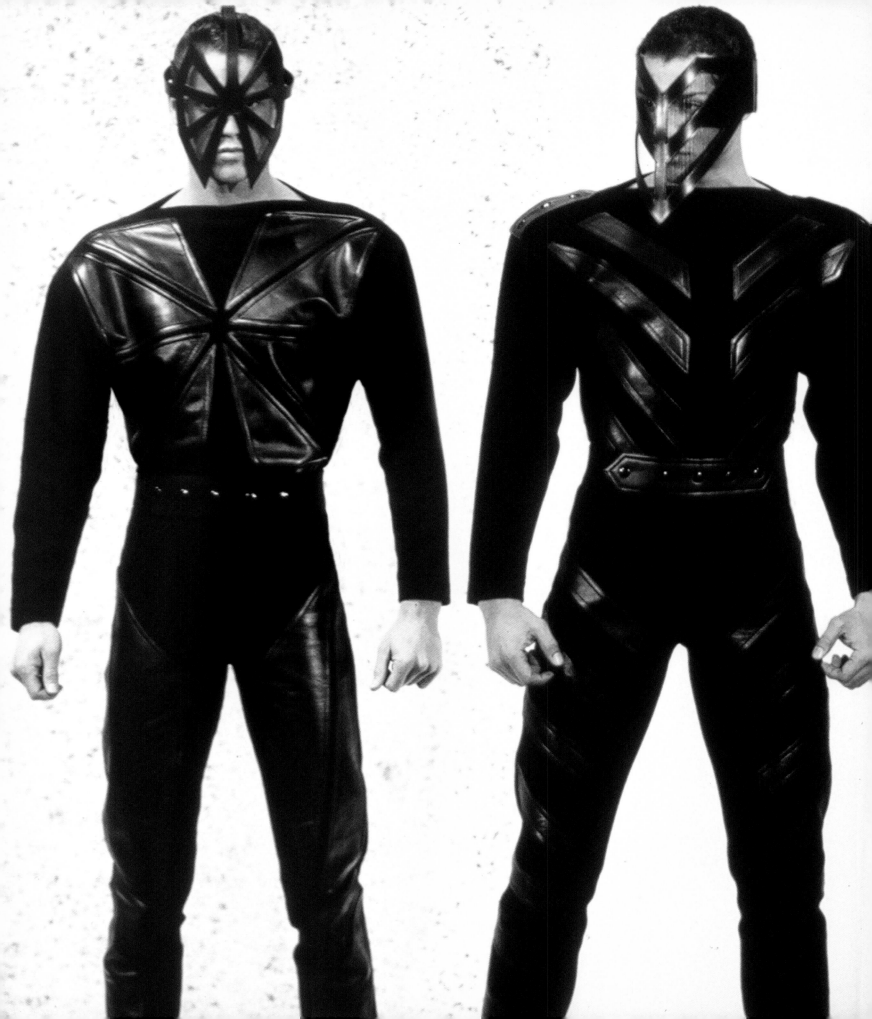

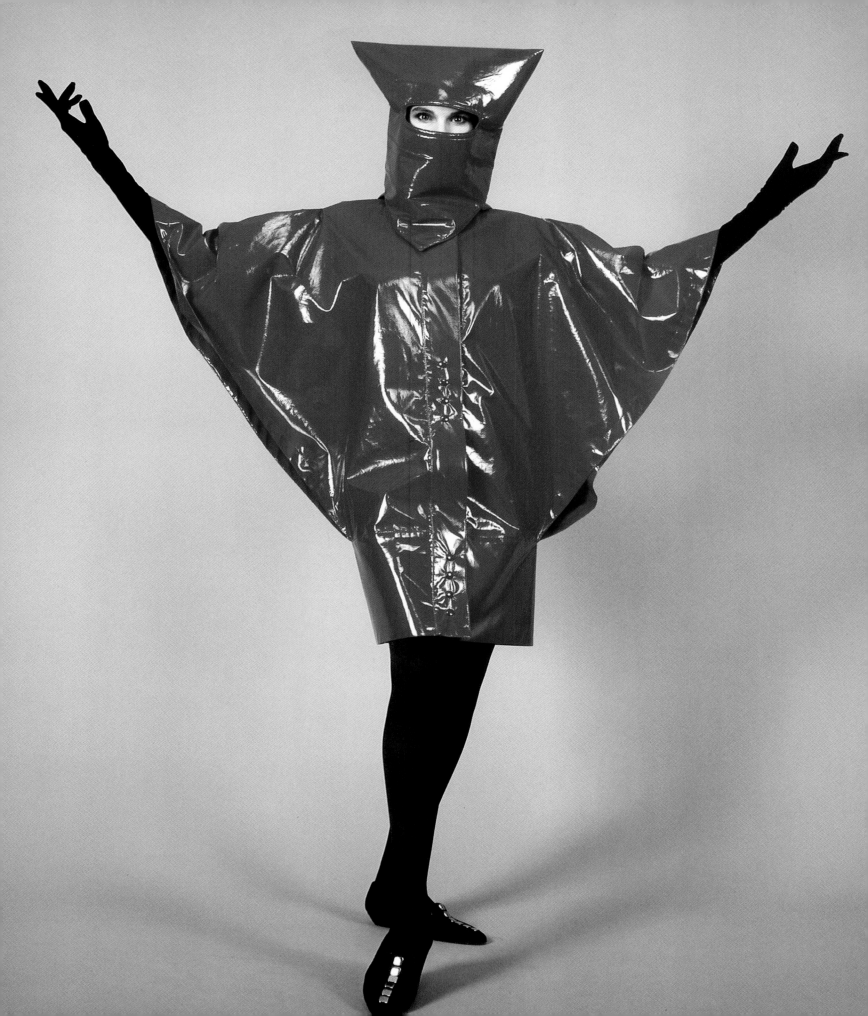

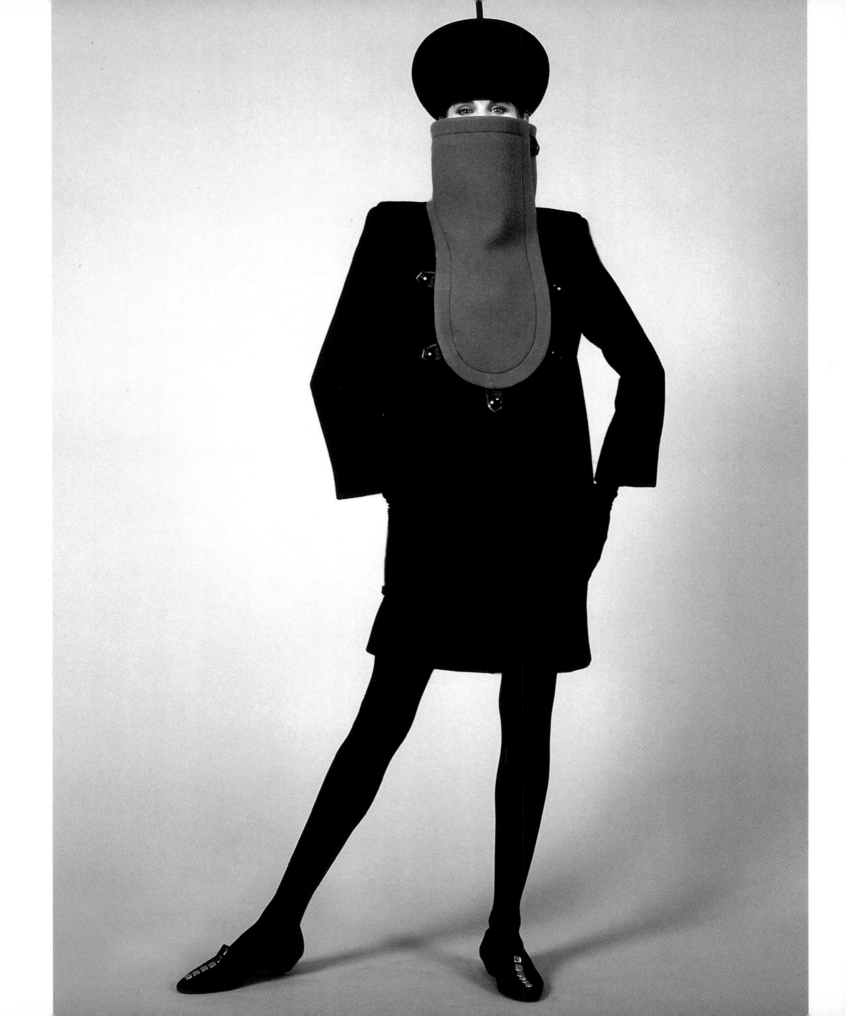

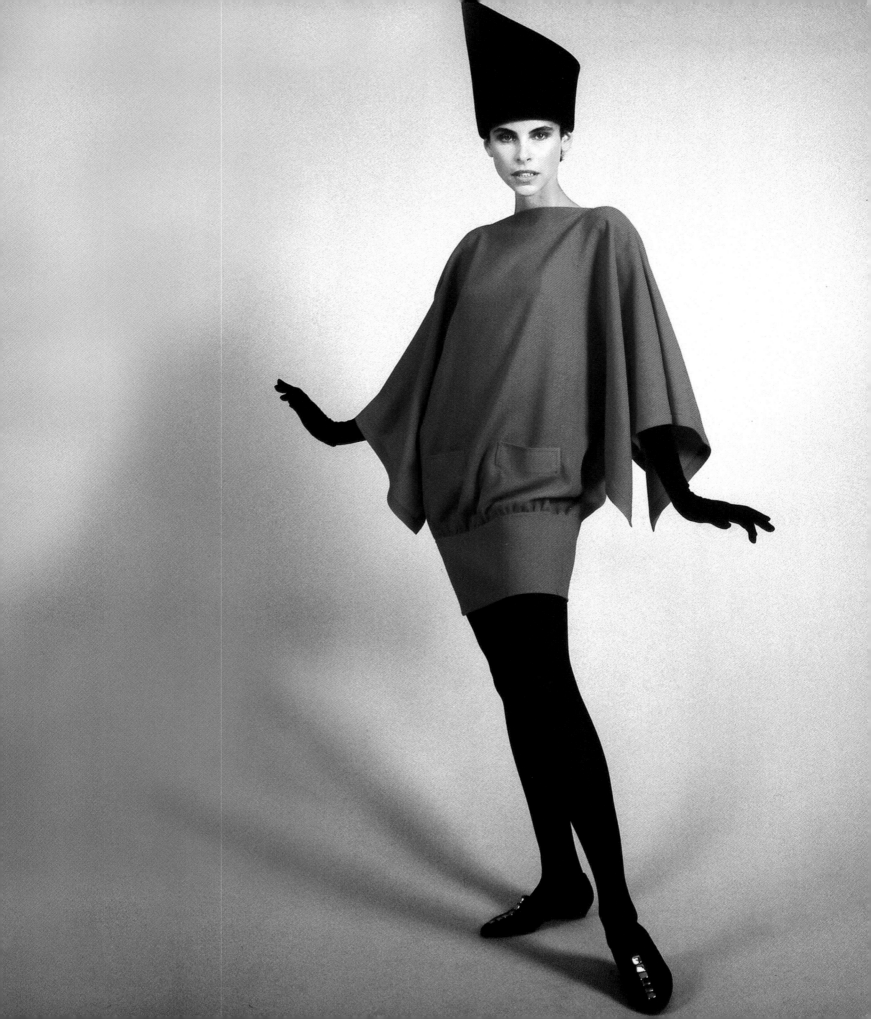

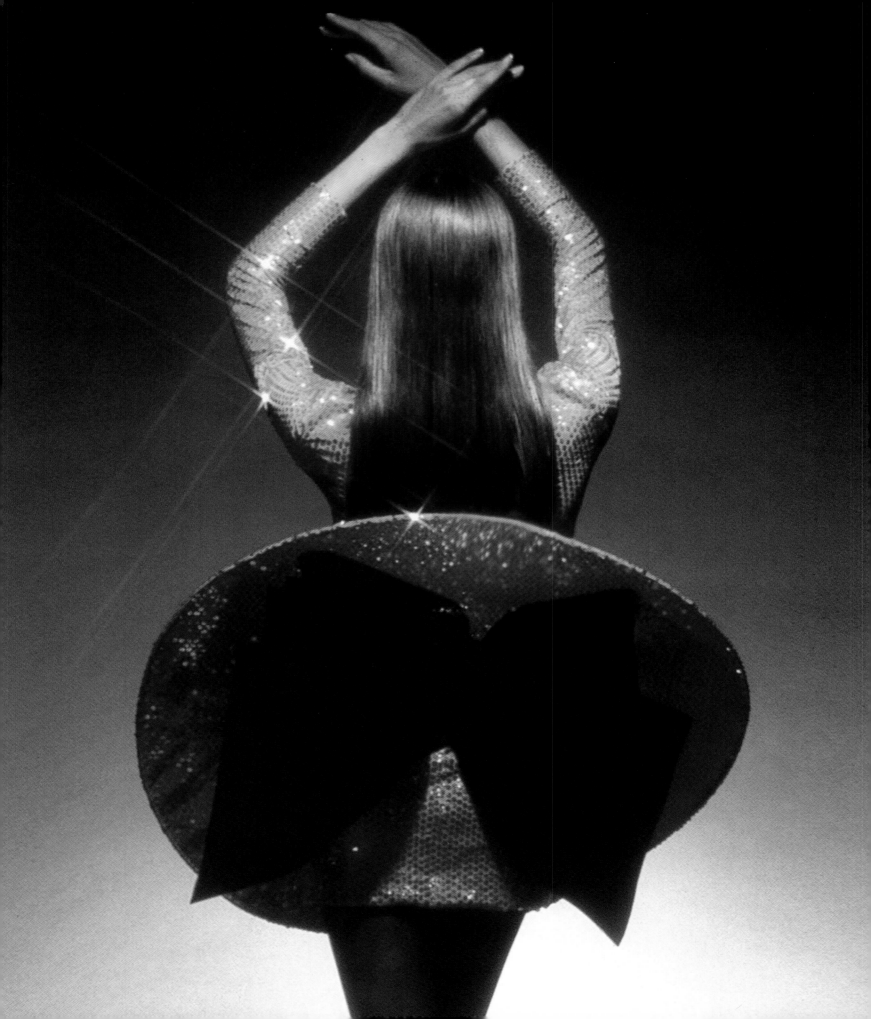

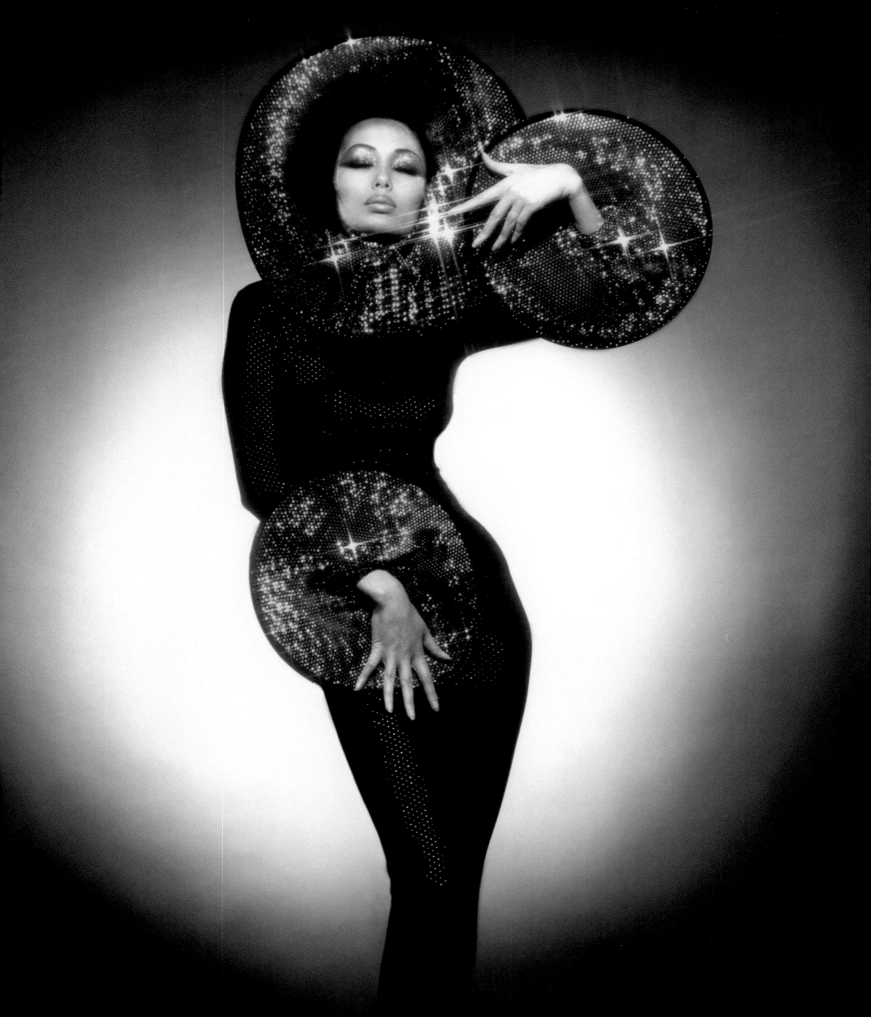

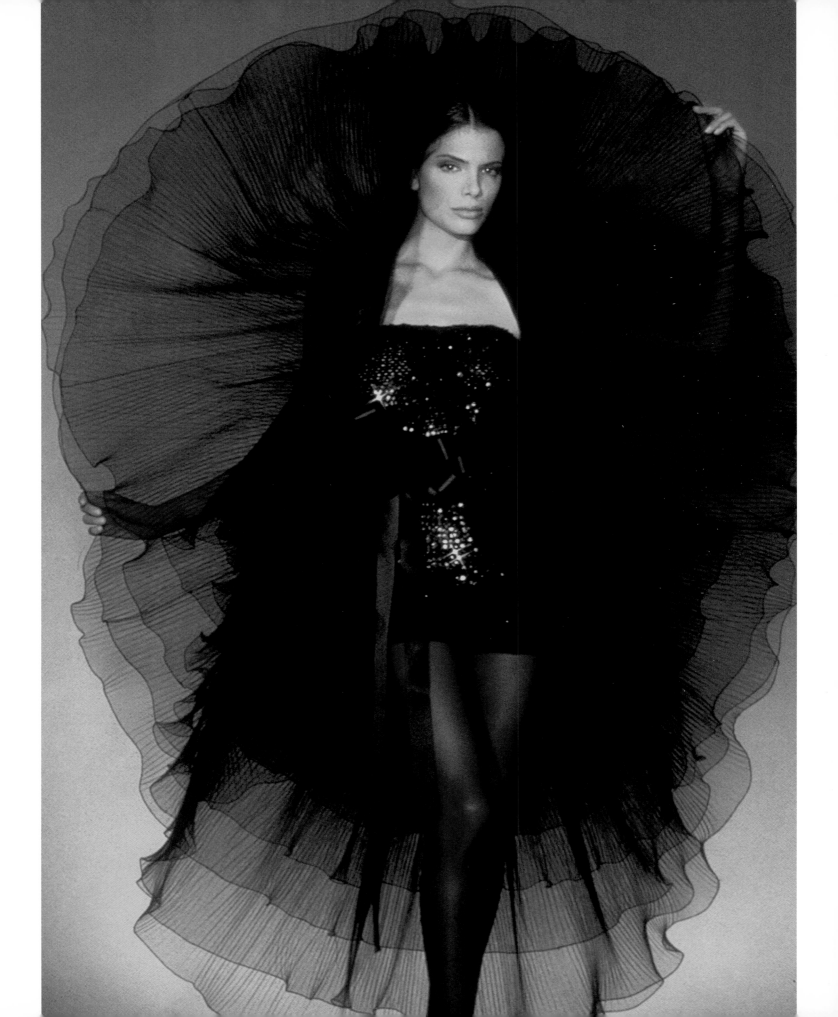

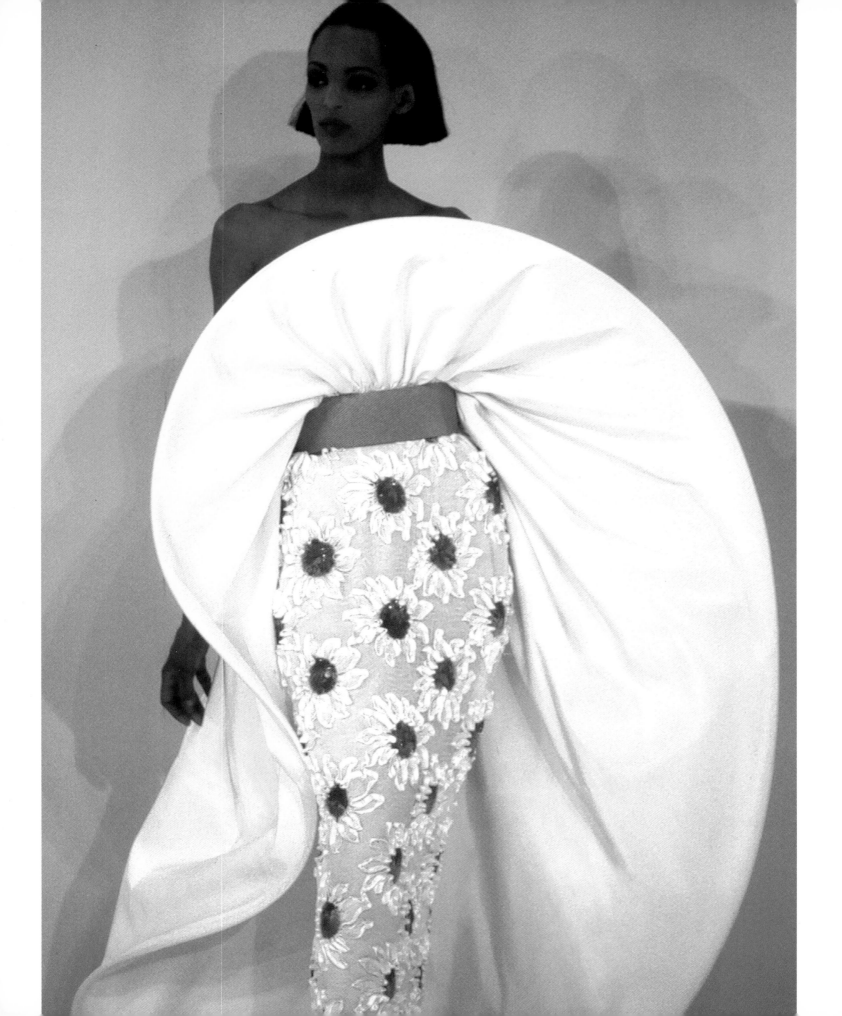

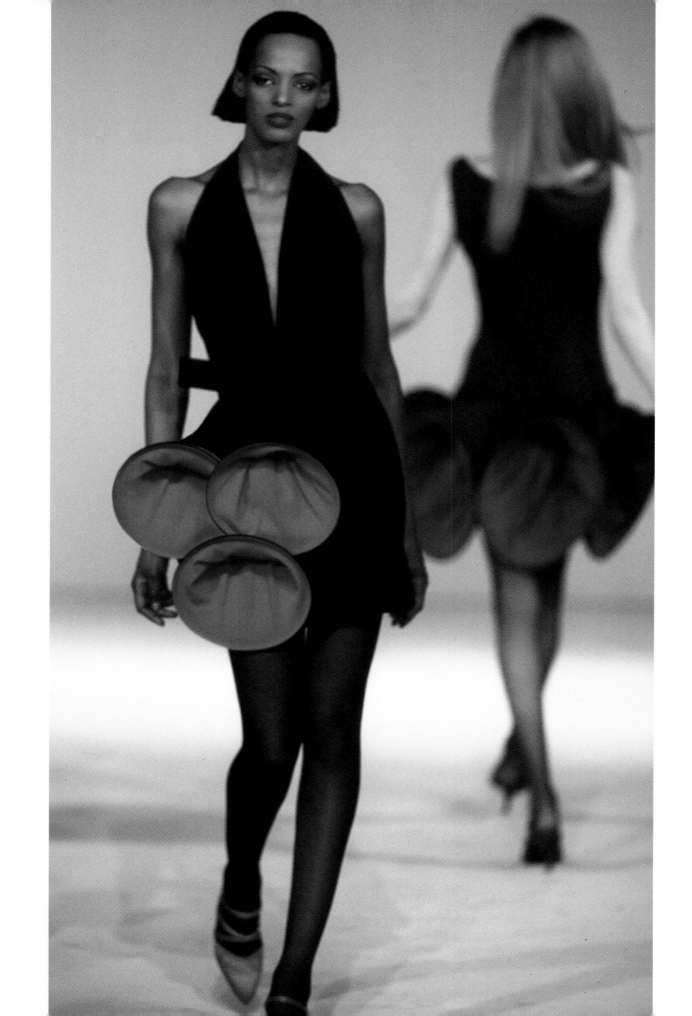

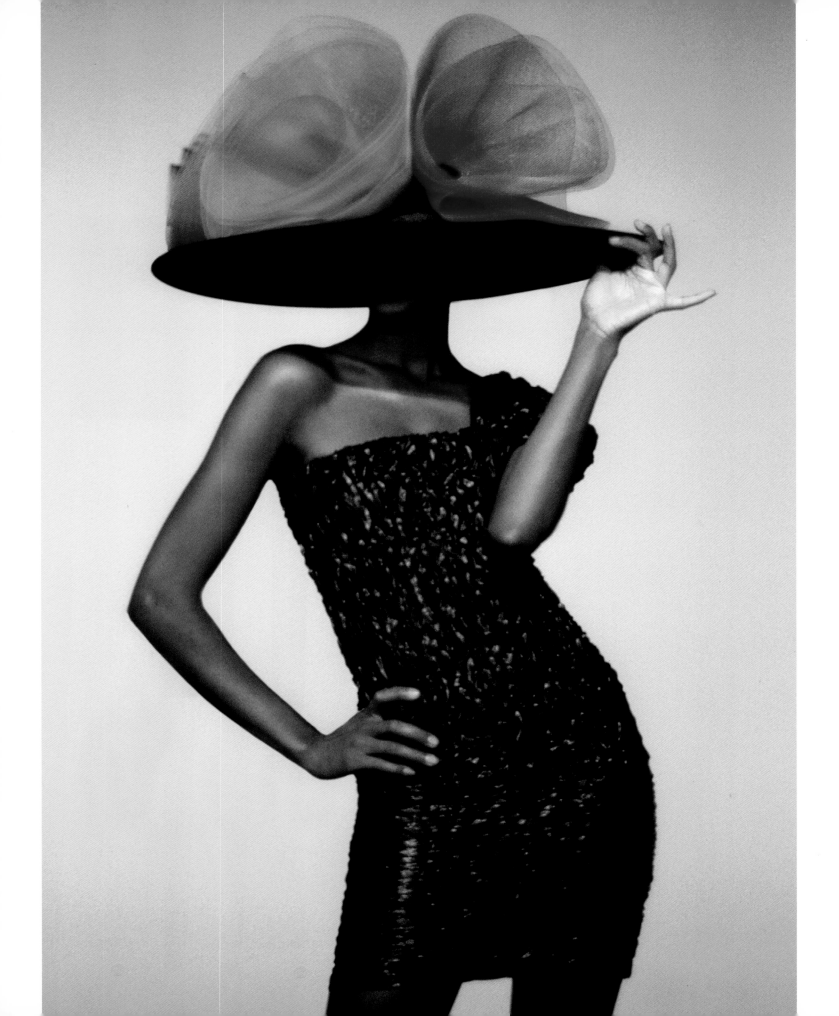

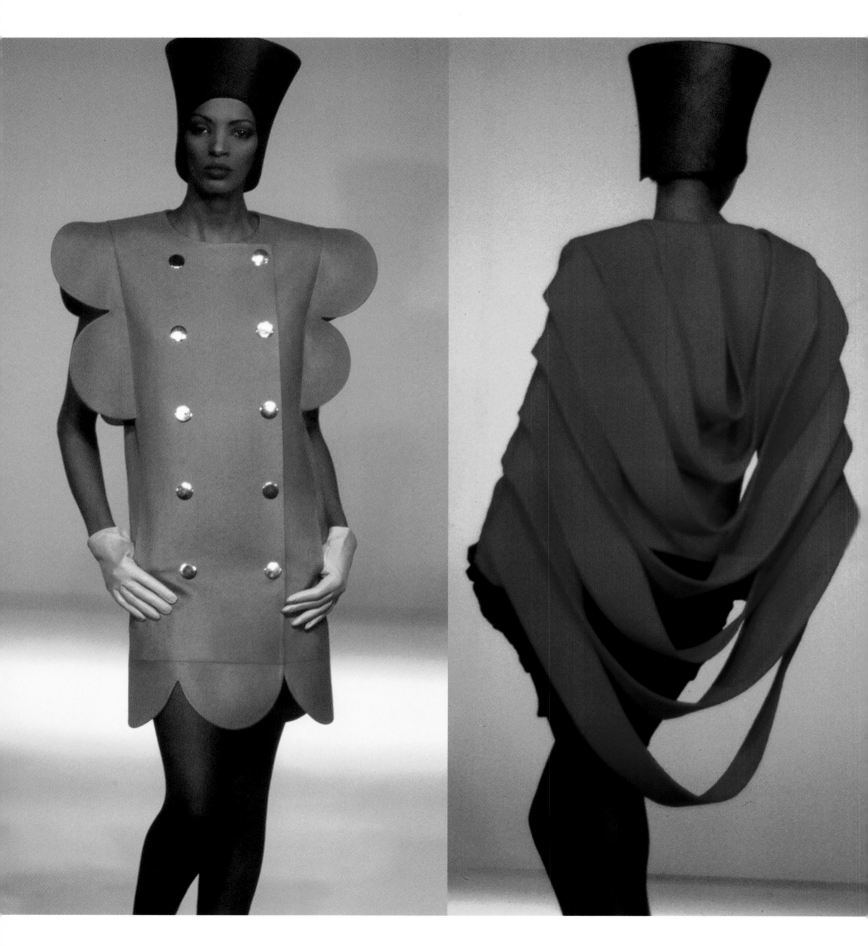

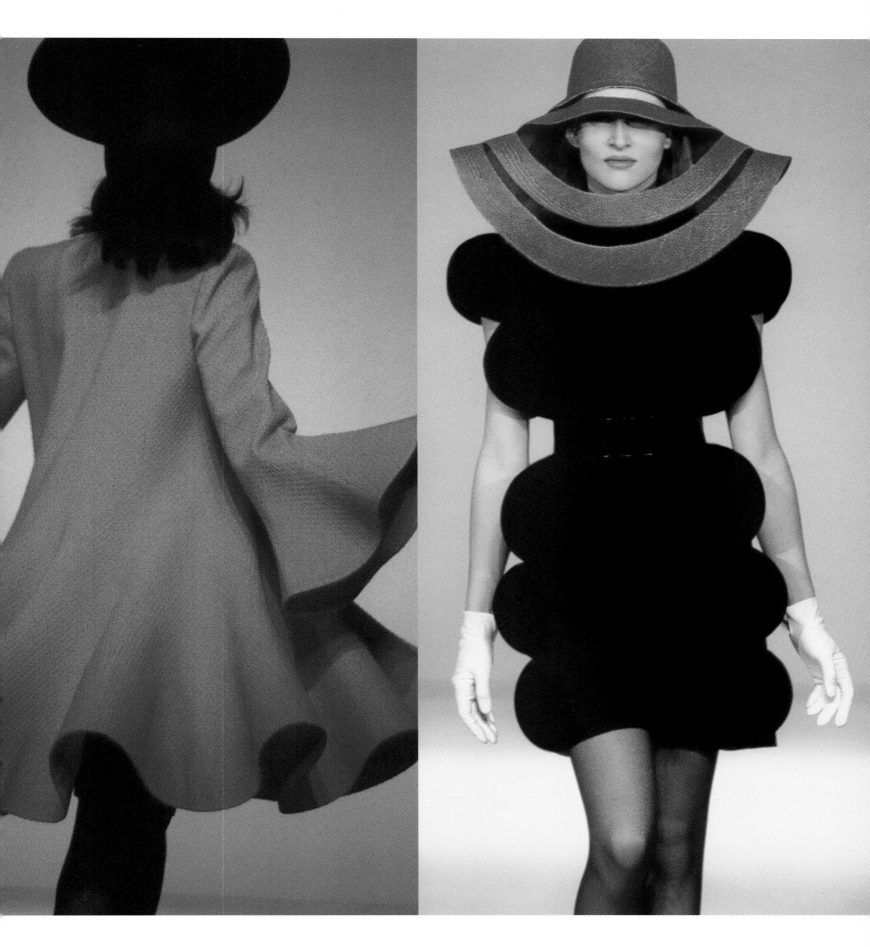

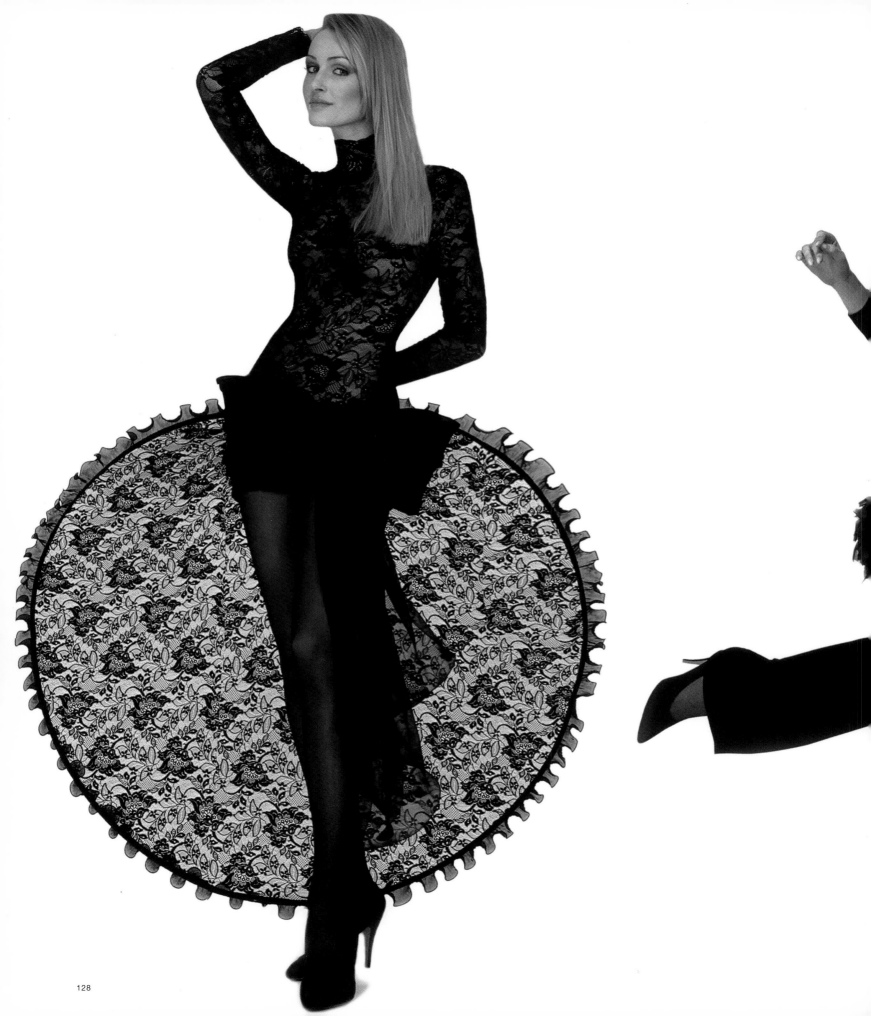

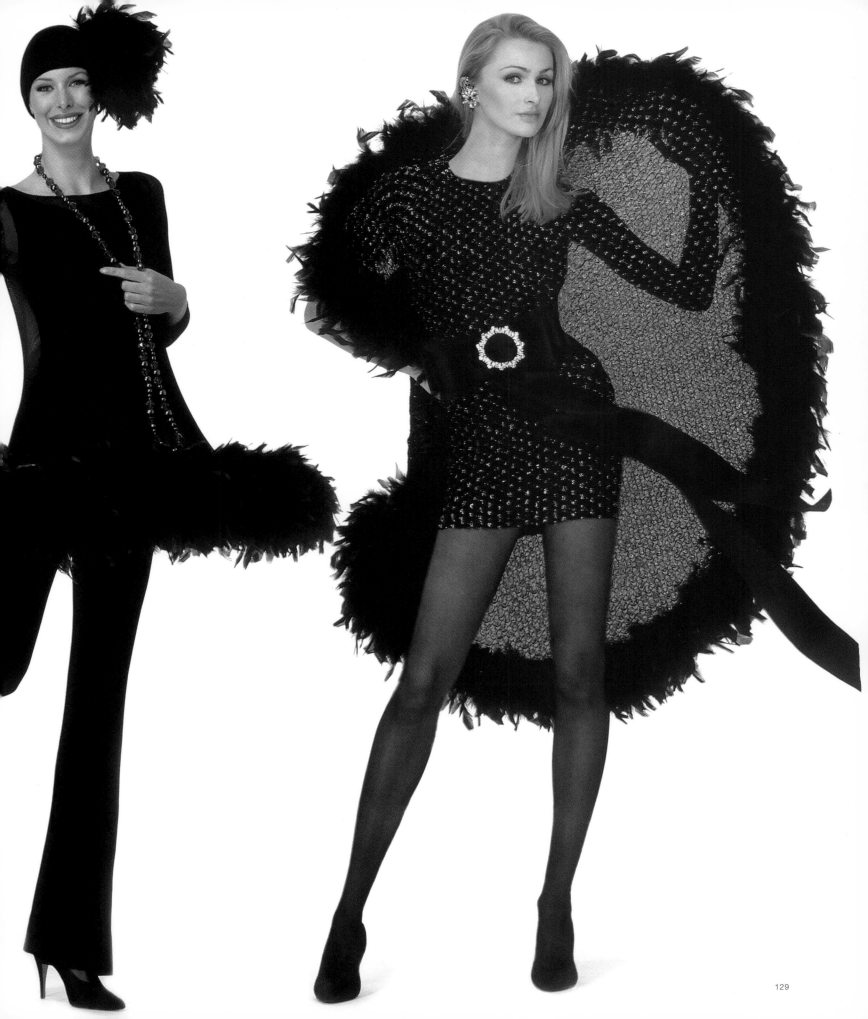

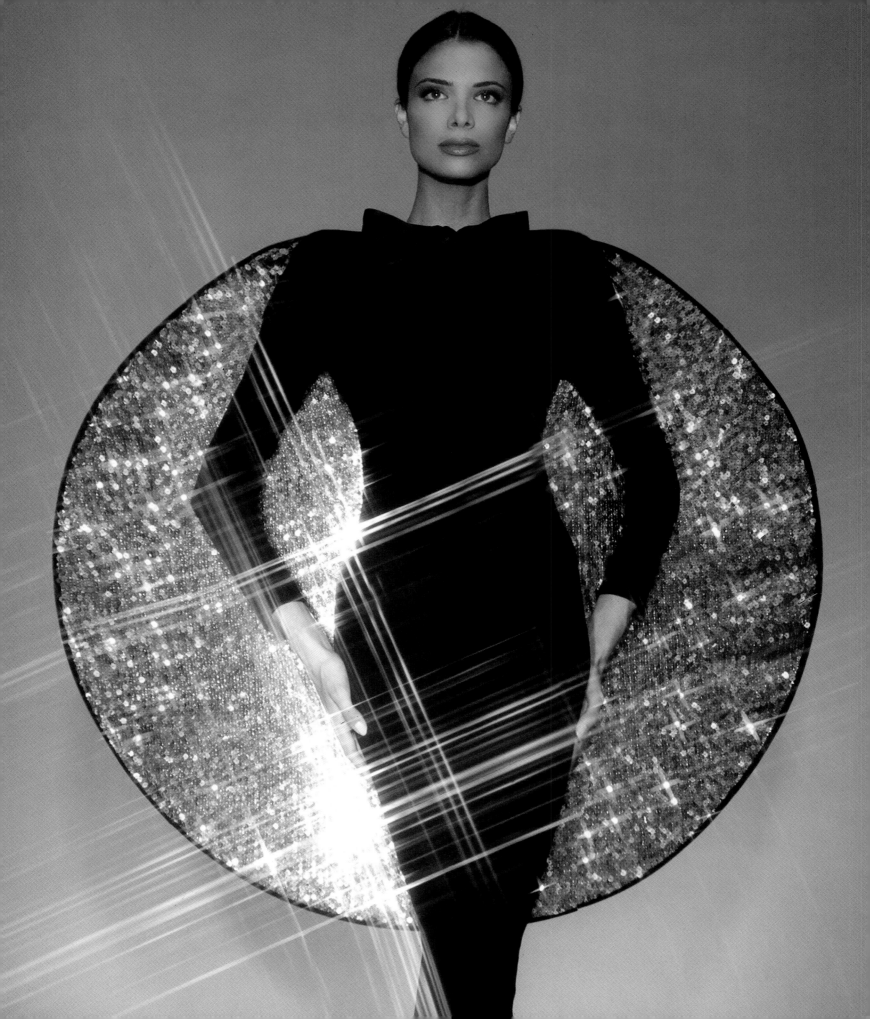

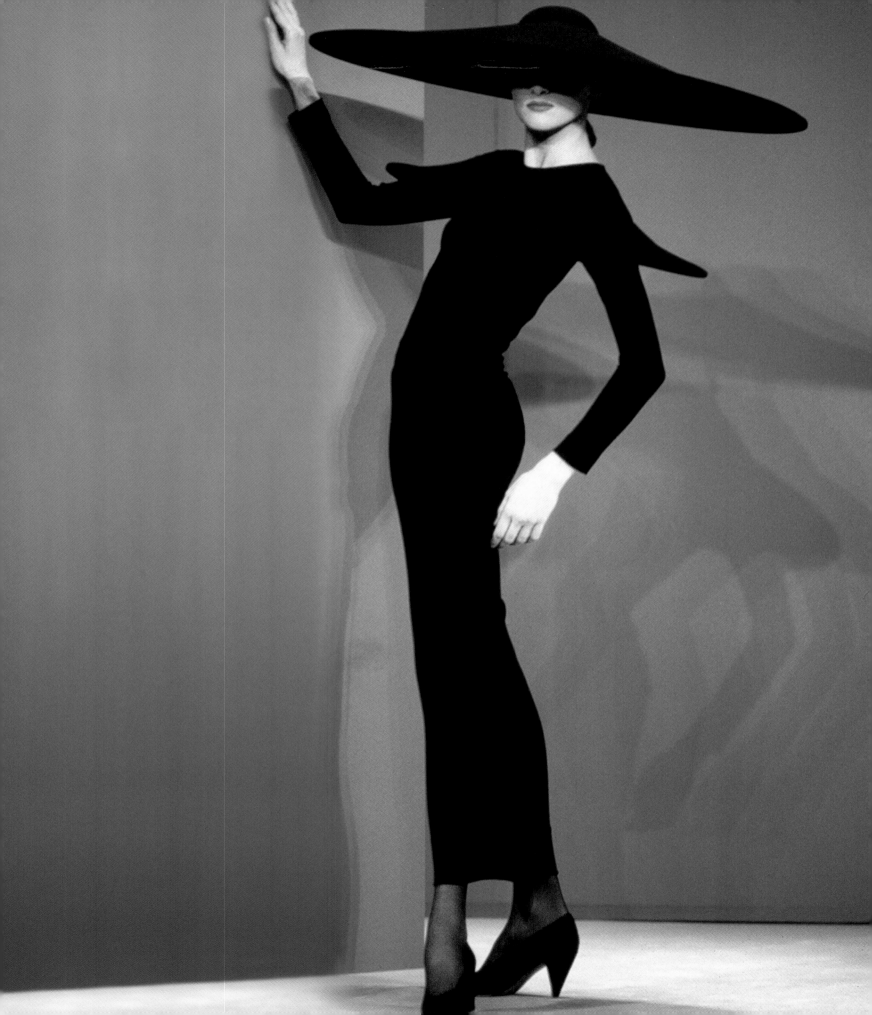

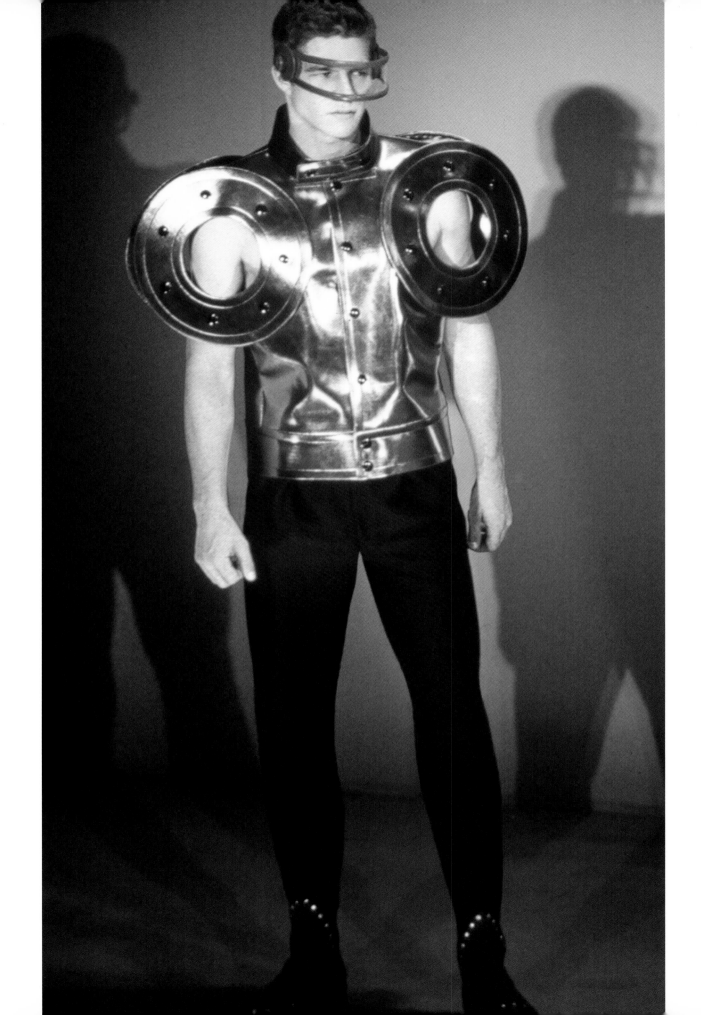

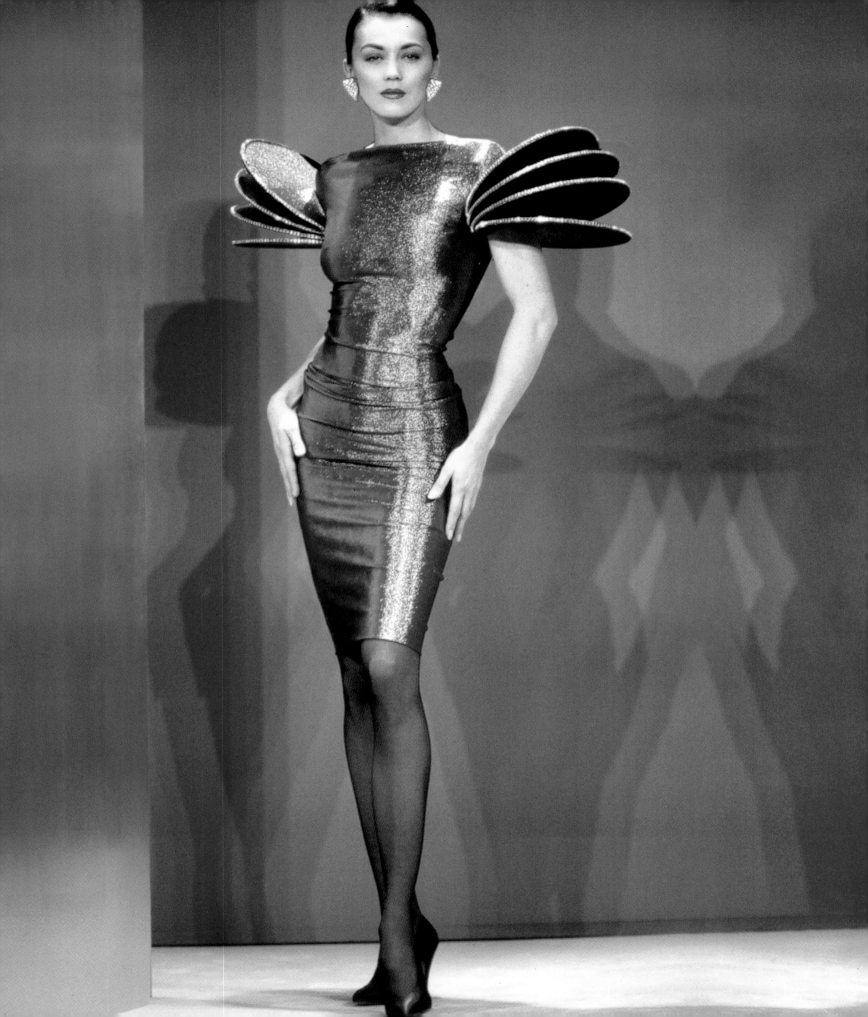

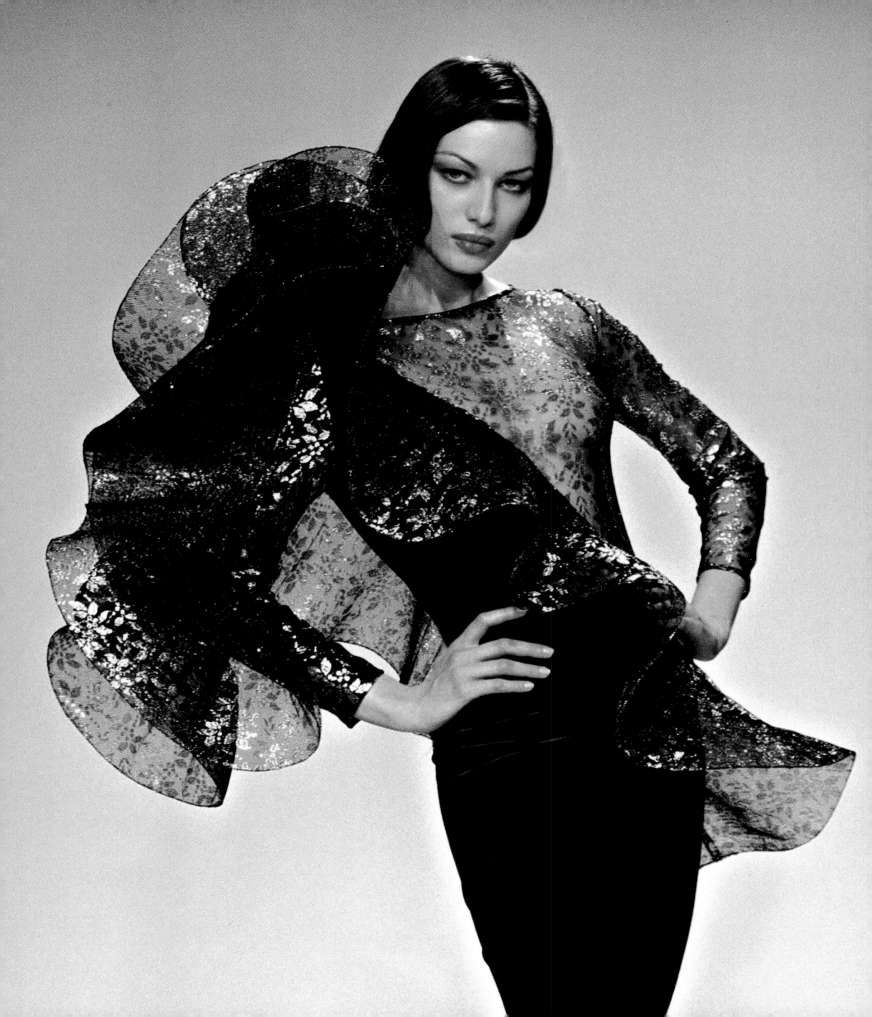

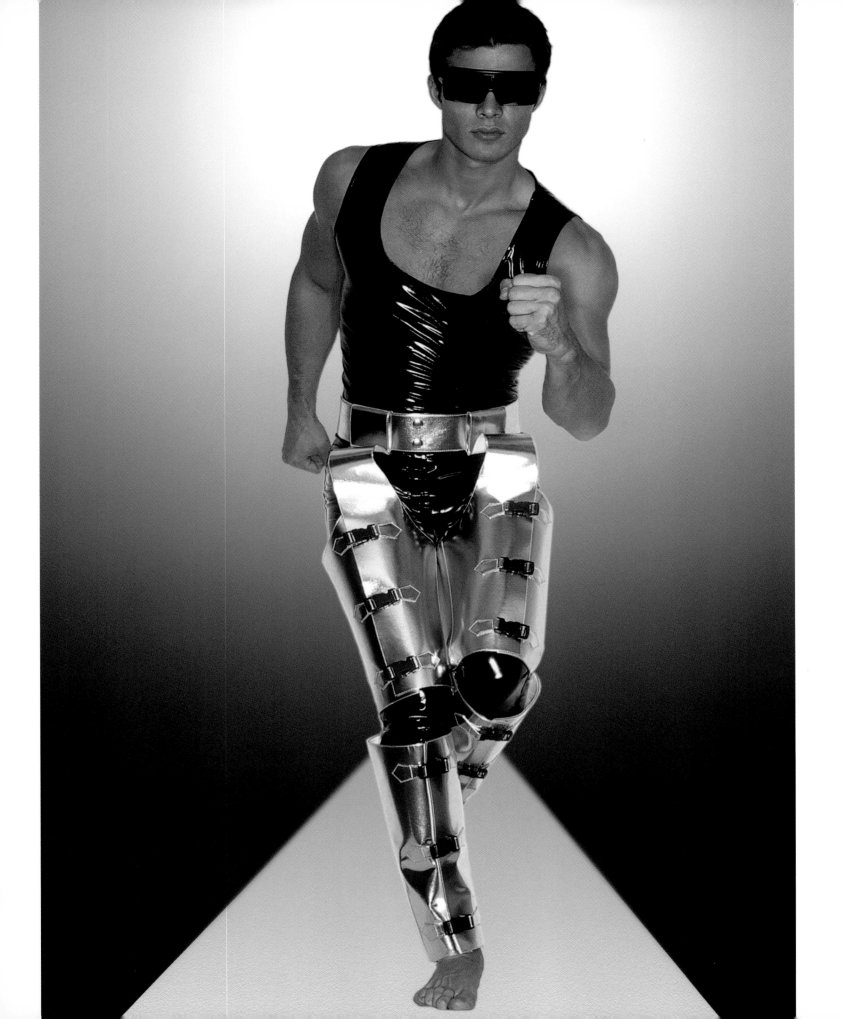

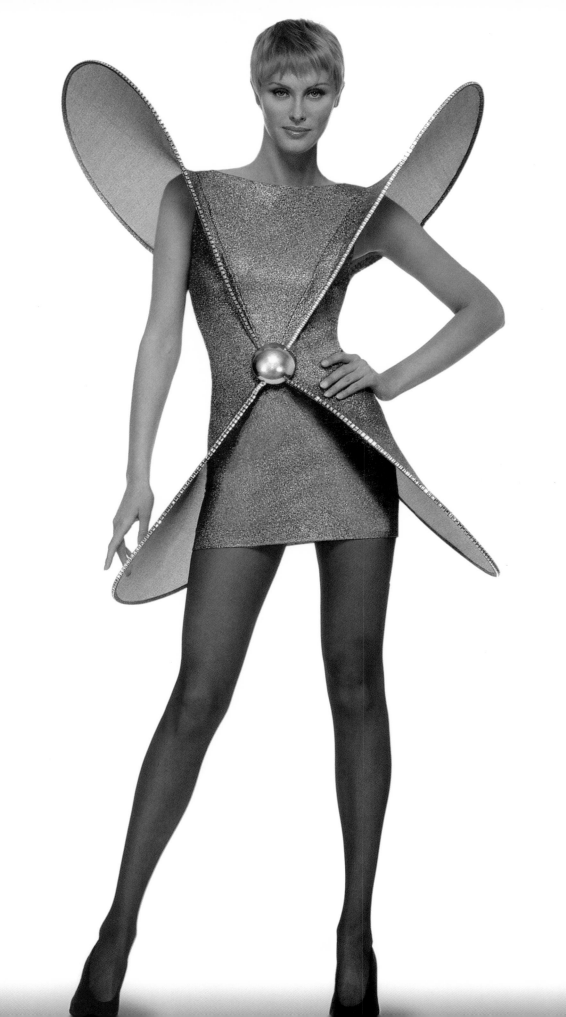

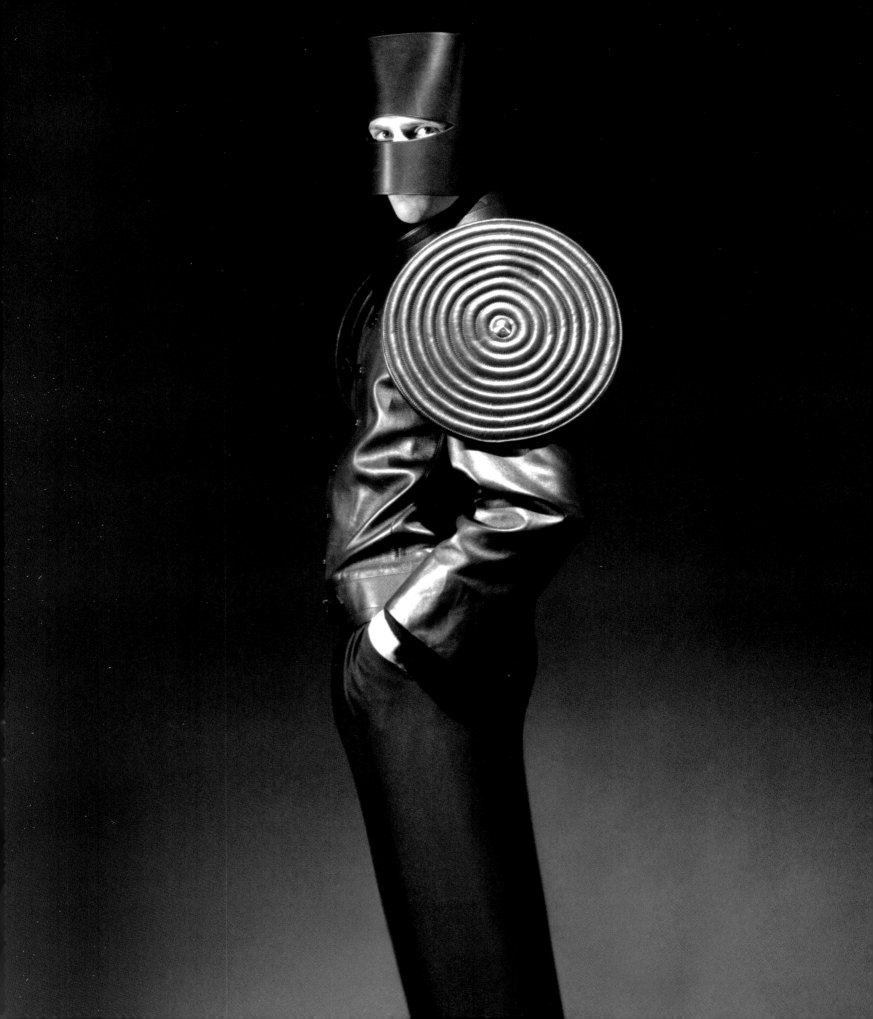

UTILITARIAN SCULPTURES

'My furniture is sculpture.
I love working as a sculptor.
It is my life, my passion,
my happiness, my joy,
my reason for working.'

Pierre Cardin called the series of haute couture furniture he presented in 1977 Utilitarian Sculptures. Forms do not relate to function. Function remains hidden. Style is derived from elementary geometrical shapes. Rotundas and pyramids represent perfect constructions in architecture due to their hermetic forms and aesthetic qualities. The simplicity of their forms grants them monumentality. Pierre Cardin returns these forms to a more human scale in his furniture. His wardrobes, chests of drawers, shelves and cupboards do not need a wall. They are mobile, functional objects of sculptural integrity. Concrete and atmospheric. Elegant and provocative. The arrangement of vertical and horizontal lines in the furniture corresponds with the principle of abstraction with which a human being understands space: in the reality of vertical posture and horizontal eye level, the surface is invested with dynamism. The configuration of small objects with larger ones is a reference to the force and impact of contrasts, providing a dynamic interplay of various volumes and forms. The colours of these interior objects can lay claim to the term 'free colours', which, like their forms, are independent of surrounding space. This turns them into very real objects with the immediacy of a vision.

Above: Pierre Cardin in Egypt, 1947

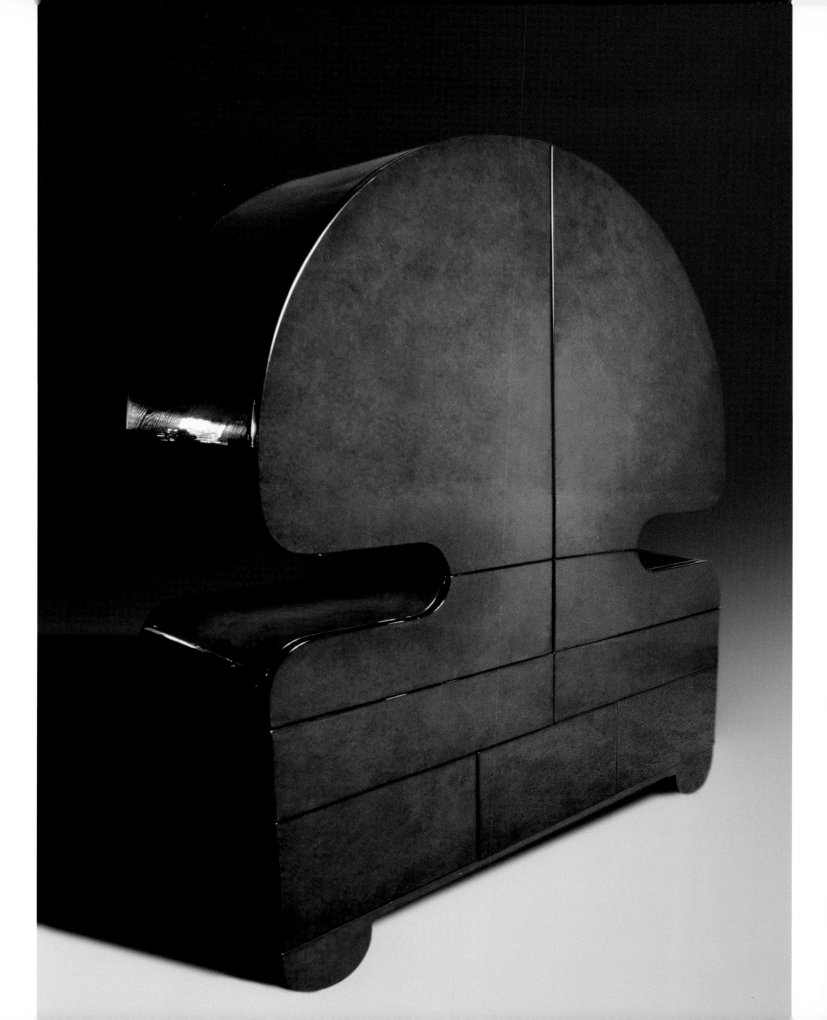

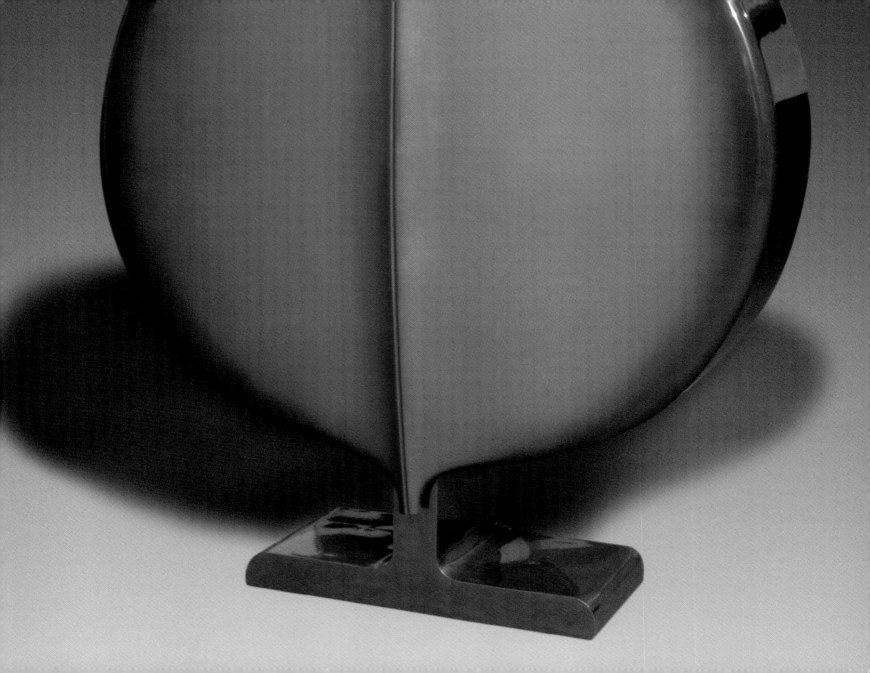

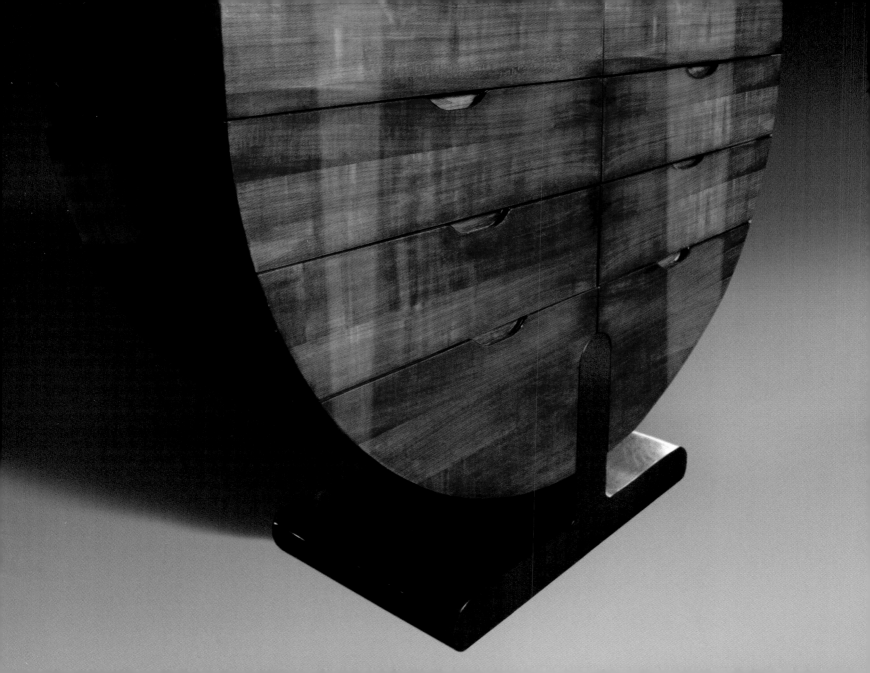

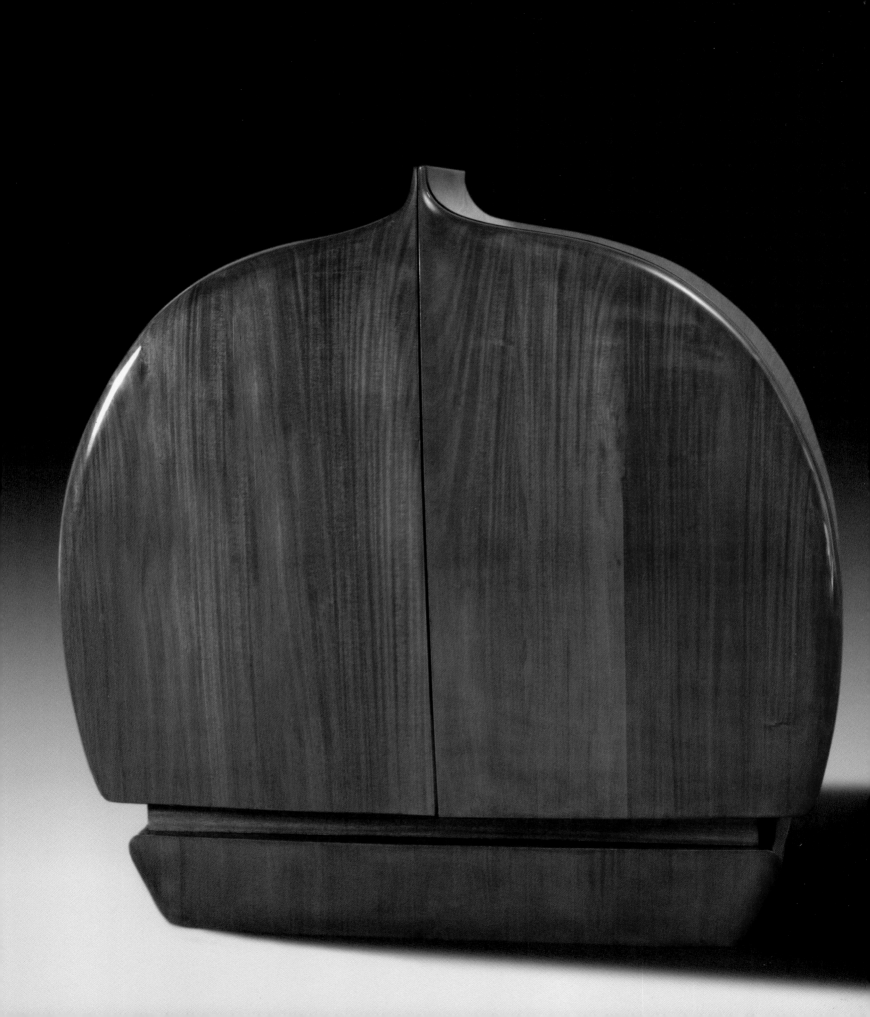

UTILITARIAN SCULPTURES

'One can put my furniture in the middle of a room. Its front is as beautiful as its back, its interior is like its exterior.'

Along the same lines as his fashions and accessories, Pierre Cardin created his first series of furniture in 1970 as sculptures with shining surfaces and brilliant colours. The collection, which appeared under the name Meubles Sculptures, originated from the idea of attuning *prêt-à-porter* and *prêt-à-meubler*. Philippe Starck belonged to the team between 1971 and 1972. The furniture was produced in limited numbers, with only eight pieces of each model manufactured, but this proved too expensive commercially. He then decided to put the furniture concept aside.

Utilitarian Sculptures, the haute couture furniture series launched in 1977, boasts spatial objects whose function is subordinate to an independent artistic form. The traditional vocabulary of furniture construction is not employed. However, the tradition of Far Eastern lacquer work is, like colour, employed as a means of heightening form. A threefold code is required to decipher the furniture and the formal language of geometry so characteristic of Pierre Cardin: the intellectual and sensual for the sculptural aspects and the functional for the practical object. Straight, bent and curved lines, circular, square, triangular and elliptical volumes, and brilliant and neutral colours define the style of these functional sculptures.

In Cardin's haute couture furniture, the fusion of form and function has found no counterpart in the symbiosis of creativity and commerce. They are one-offs. Wardrobes, tables, chests of drawers, shelves, occasional tables, cupboards, lamps, chairs, benches and beds – they possess neither temporal nor spatial affiliations. Monochrome spatial objects become vibrant light sculptures through the use of costly and exacting lacquer work. Shiny lacquer furniture in aggressive colours looks like mass-produced plastic furniture but is made of wood, organic and crafted with the finest of Asian artisan traditions. The application of this paradox between tradition and provocation is yet another means of introducing contrast and dynamism into the interior objects. In the same way, constructed lines break through the organic curves, fashionable colours are combined with a traditional palette, large and small, open and closed forms are mingled, the characteristic styles of Art Deco, Surrealism and Constructivism abstracted. According to Cardin, 'People buy furniture not because of the materials. They buy a dream revealing itself in the form. One must have dreams in life. They are the most important and dearest things.' Cardin's furniture dreams cannot be marketed.

In 2000 pieces from the furniture collections were presented at the Design Museum in London, and again in the Parisian department store Au Printemps in 2003, within the framework of a retrospective, and at the Viennese exhibition 'Pierre Cardin: Design & Fashion 1950–2005' in 2005. A personal selection of the Utilitarian Sculptures has found an apt setting in Pierre Cardin's numerous properties.

Above: Pierre Cardin, 1970
Opposite: Pulsion cupboard, 1970, L 118 x W 50 x H 135 cm

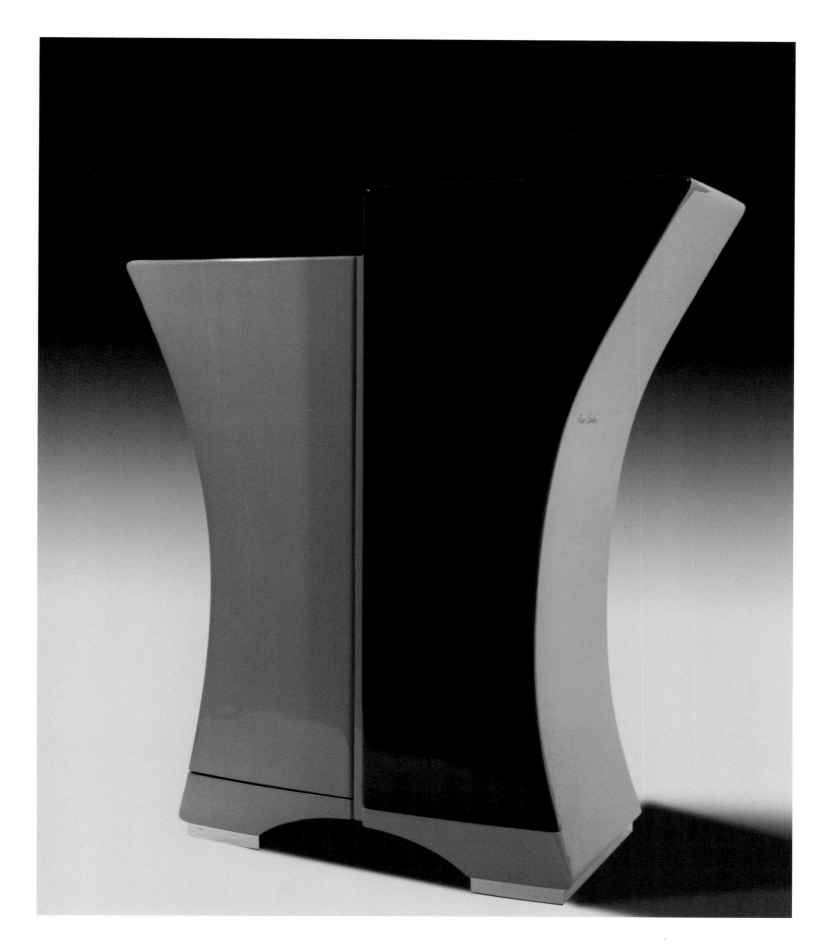

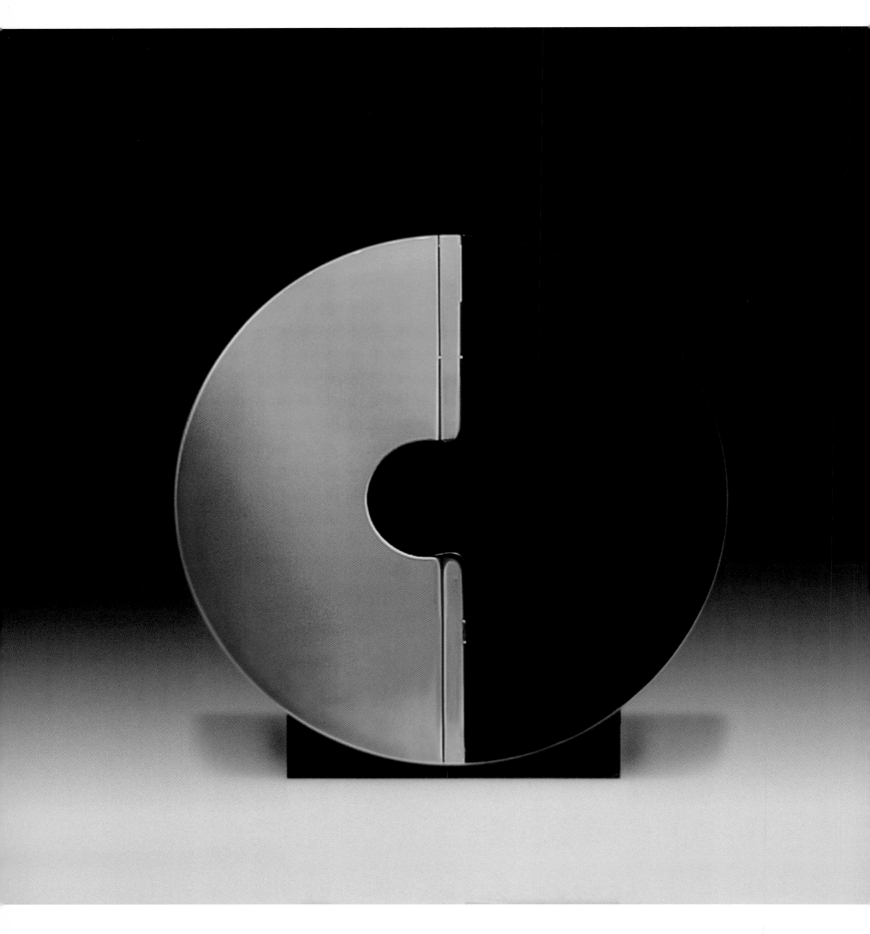

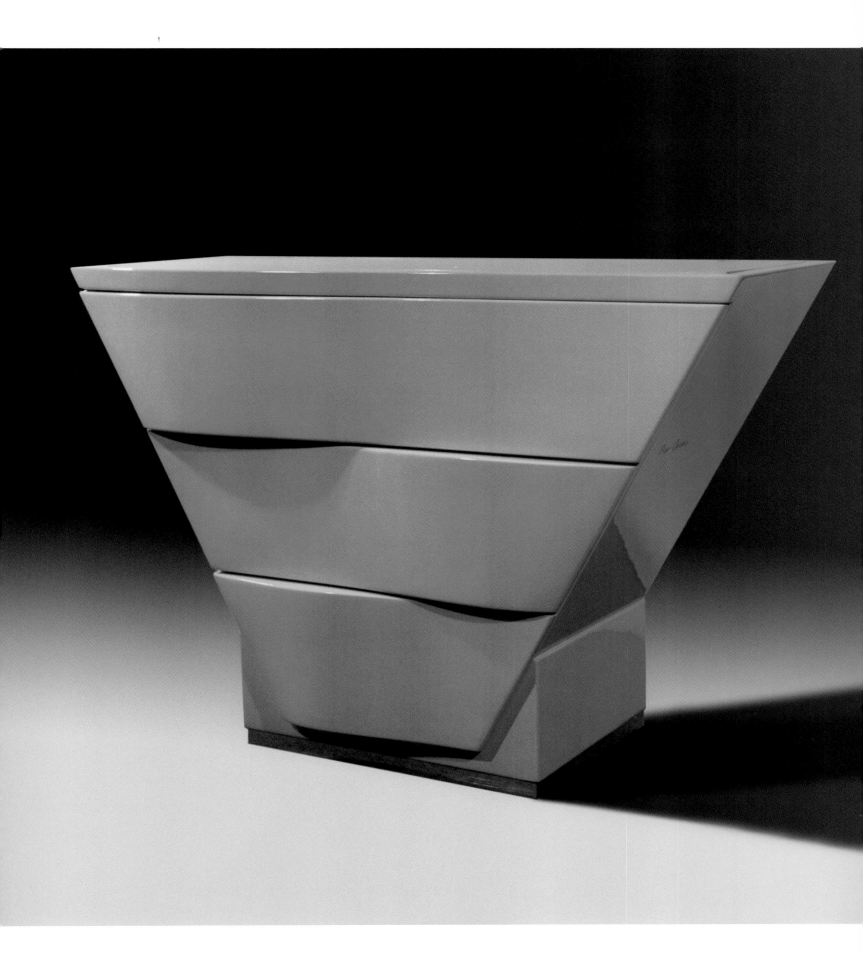

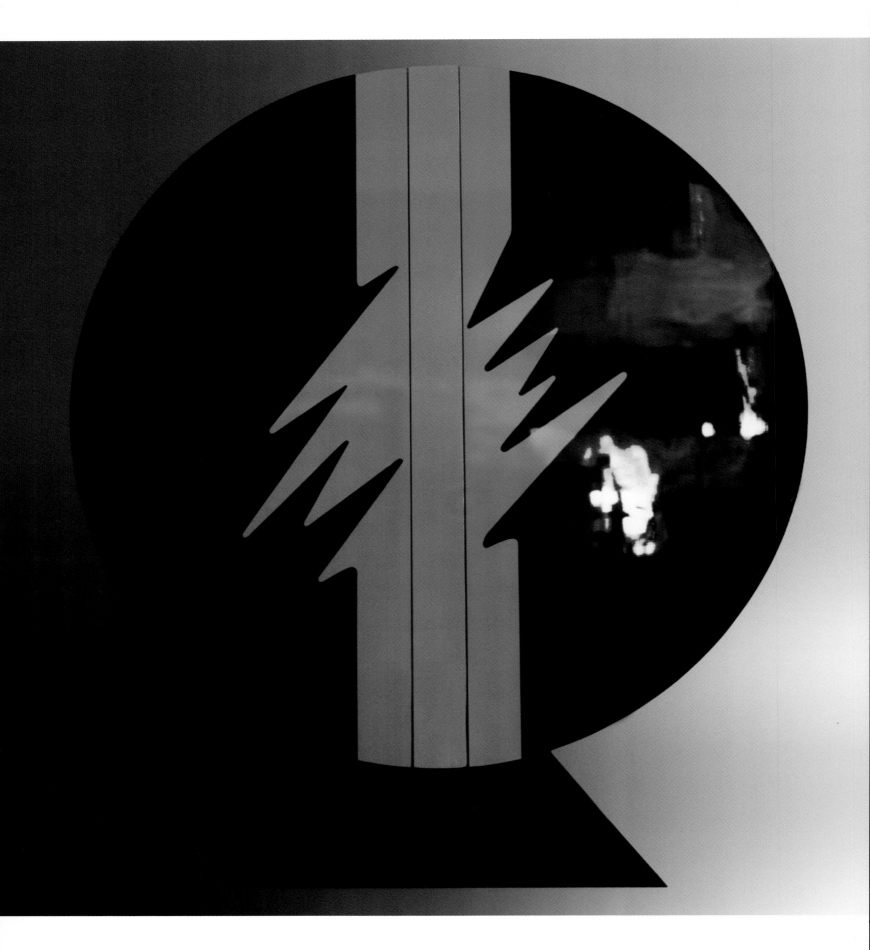

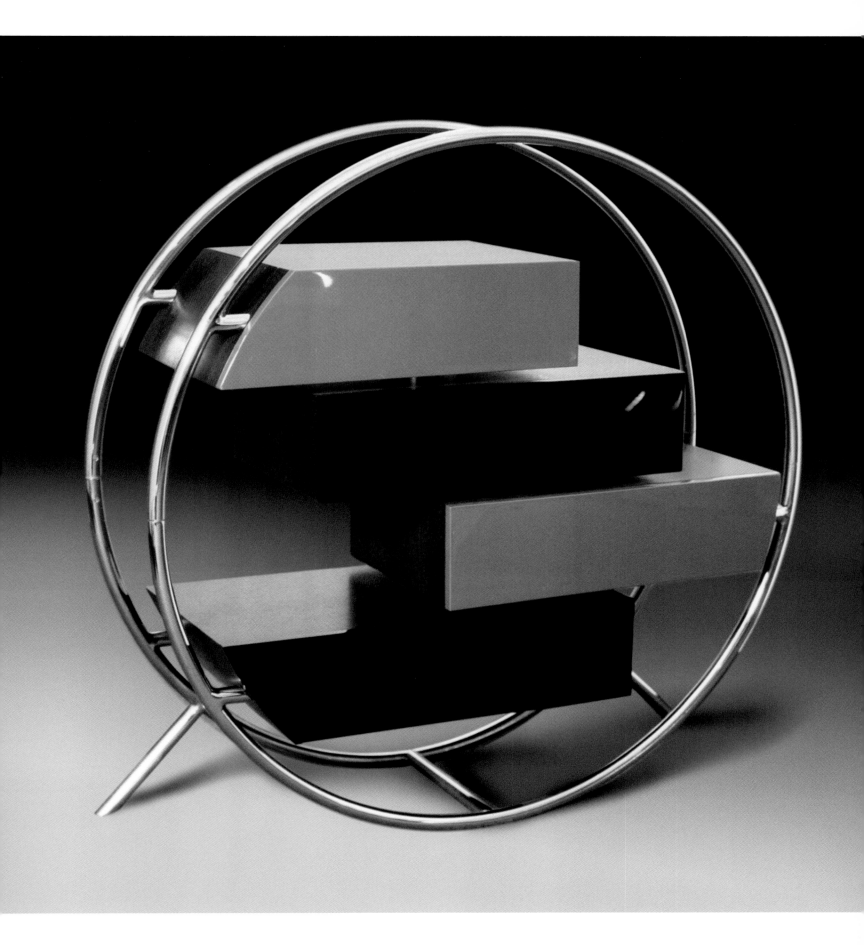

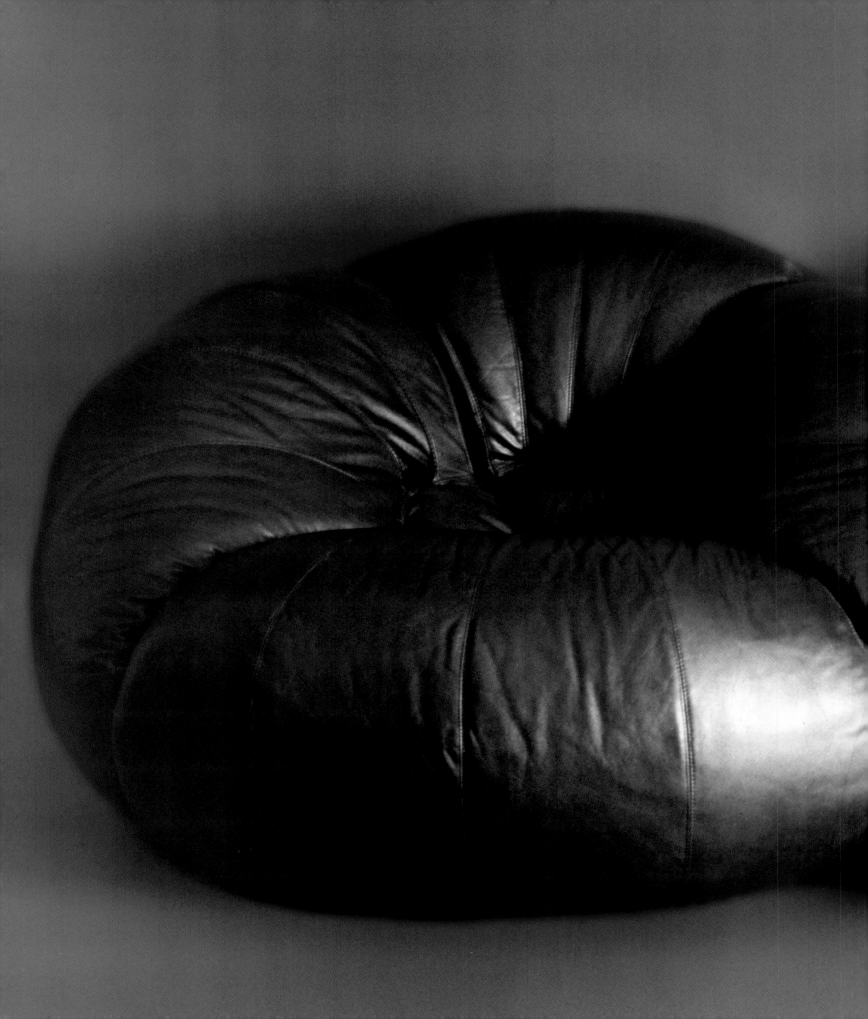

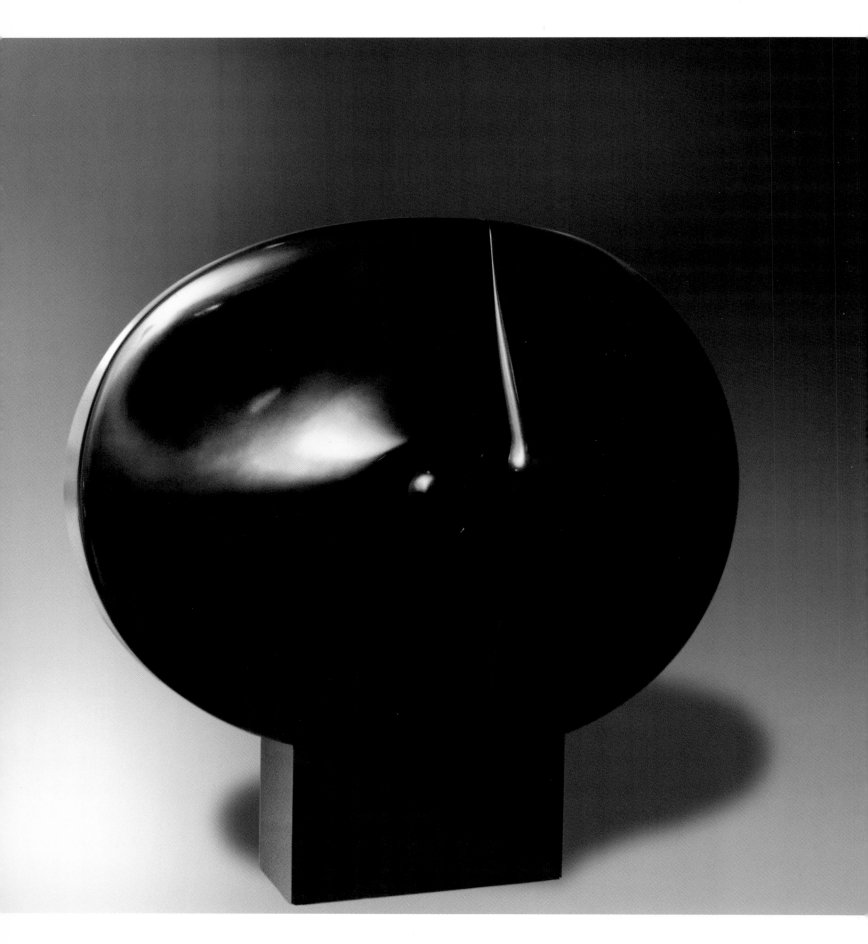

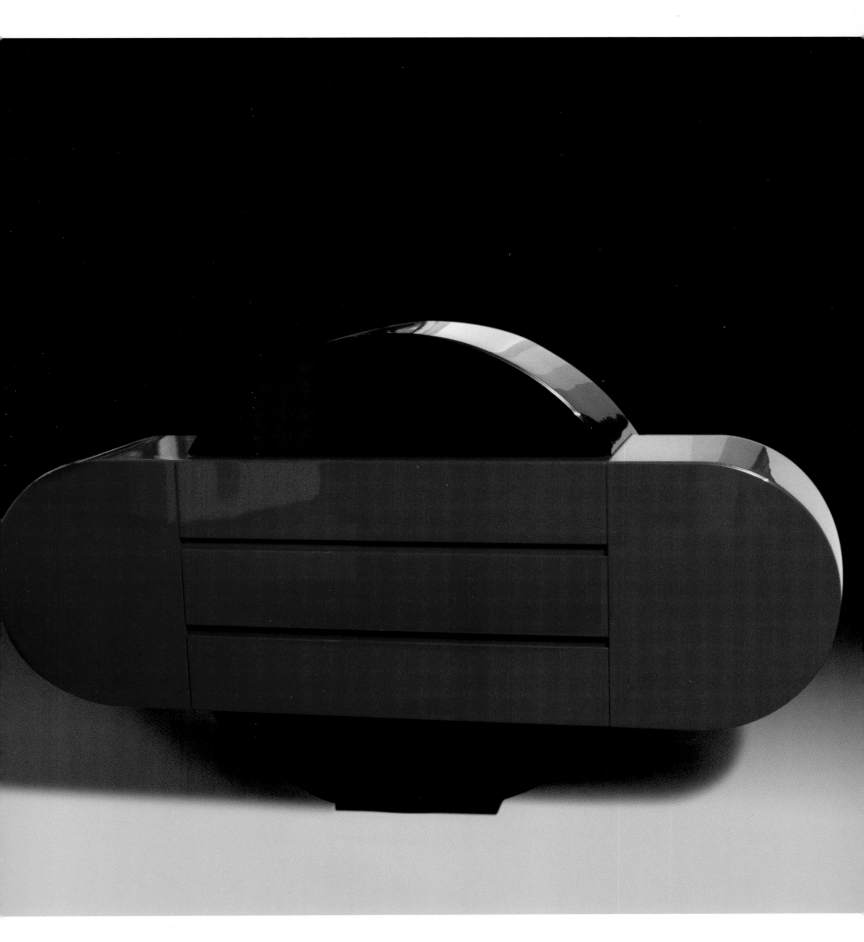

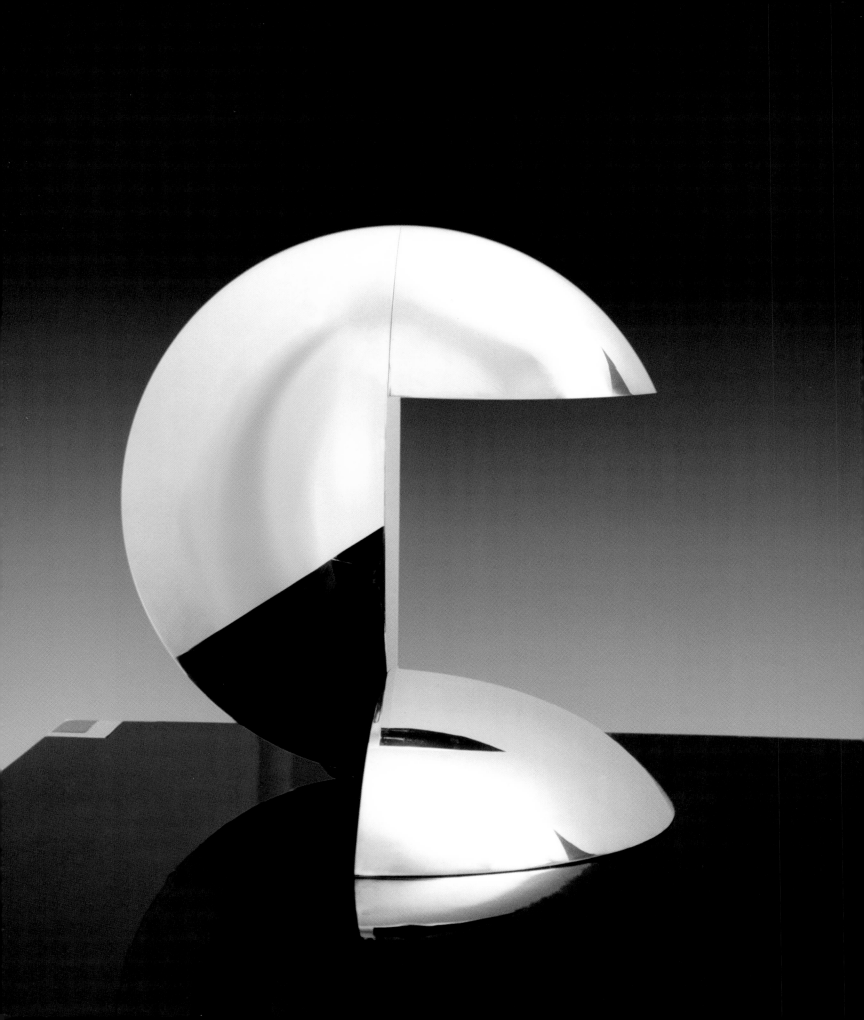

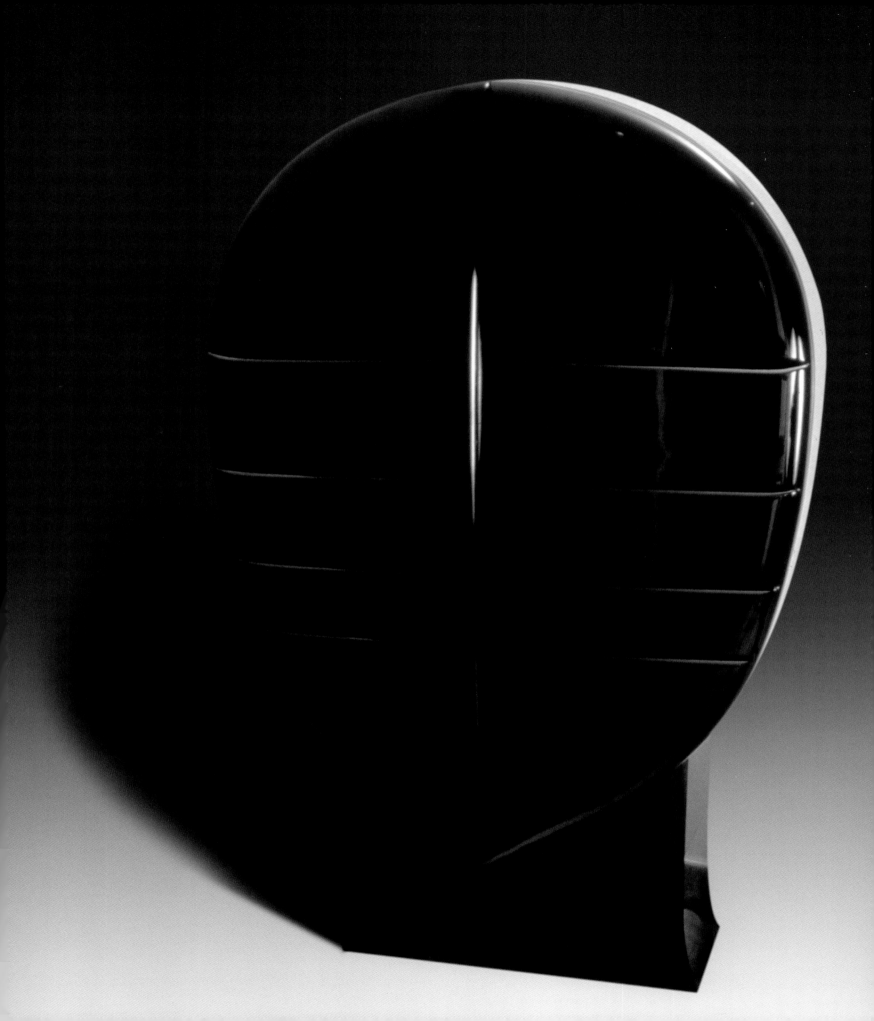

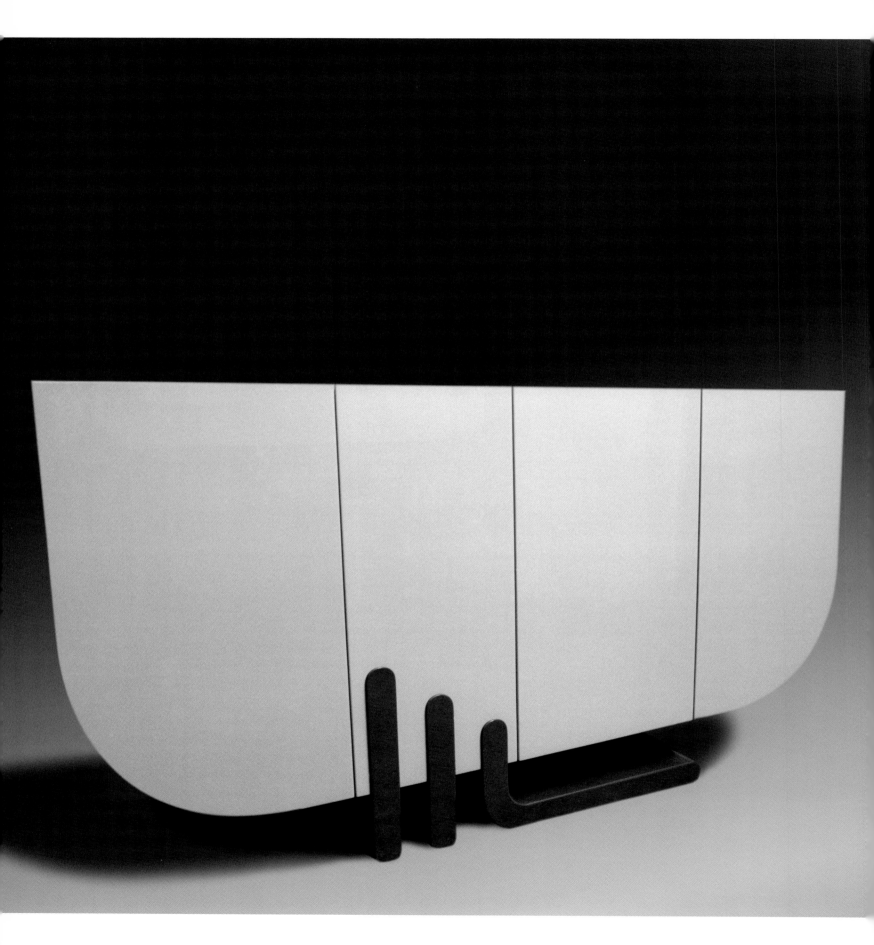

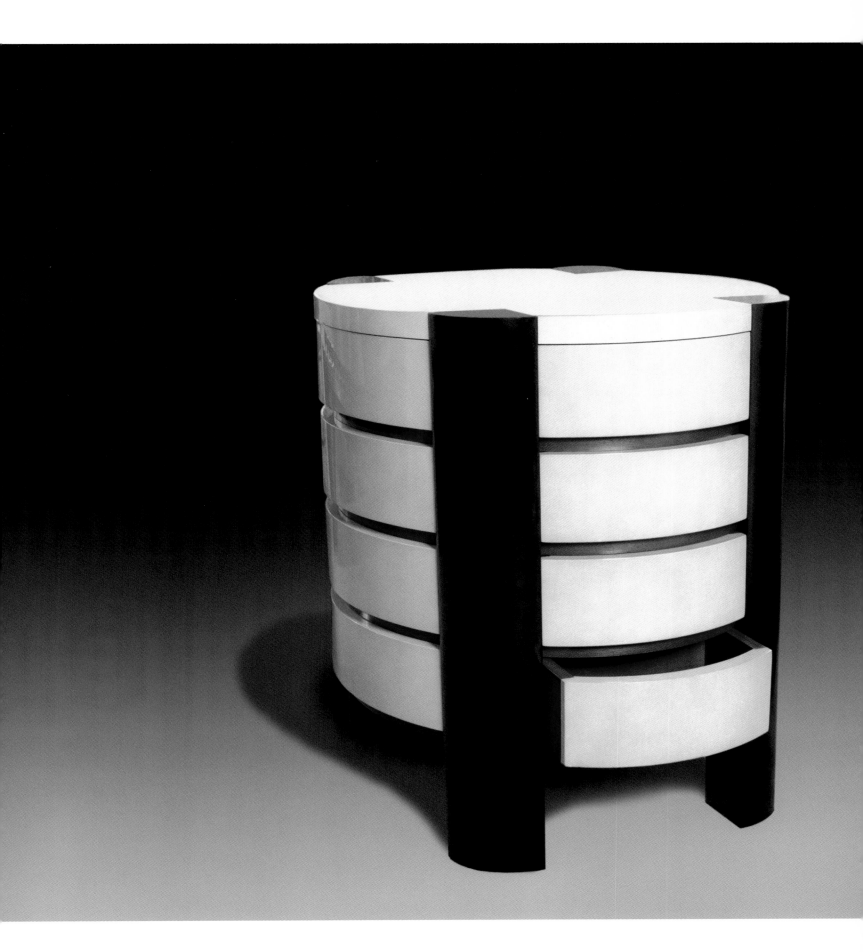

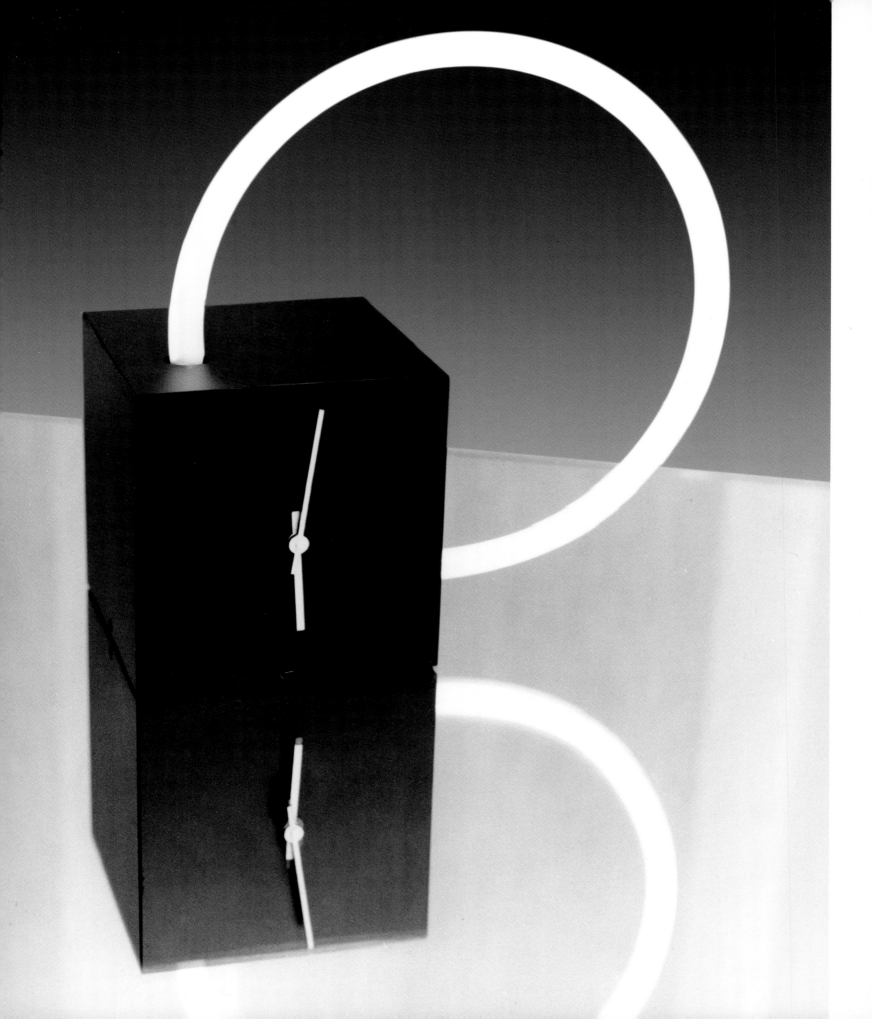

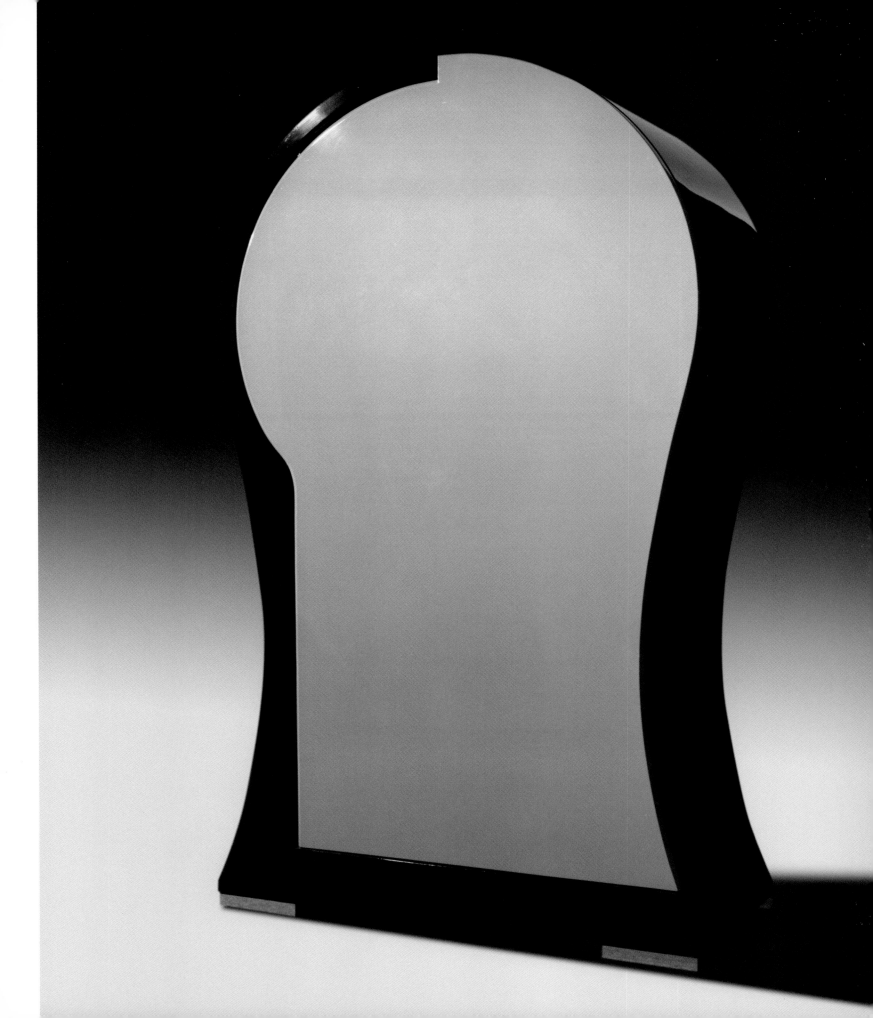

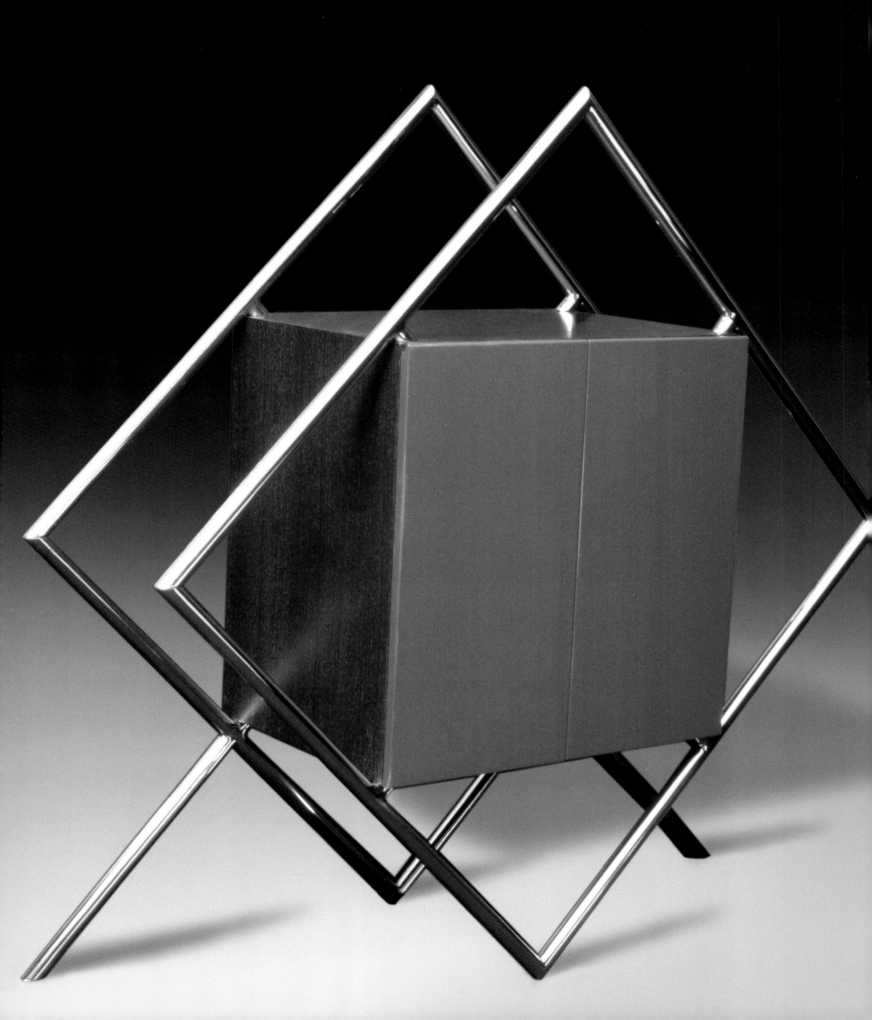

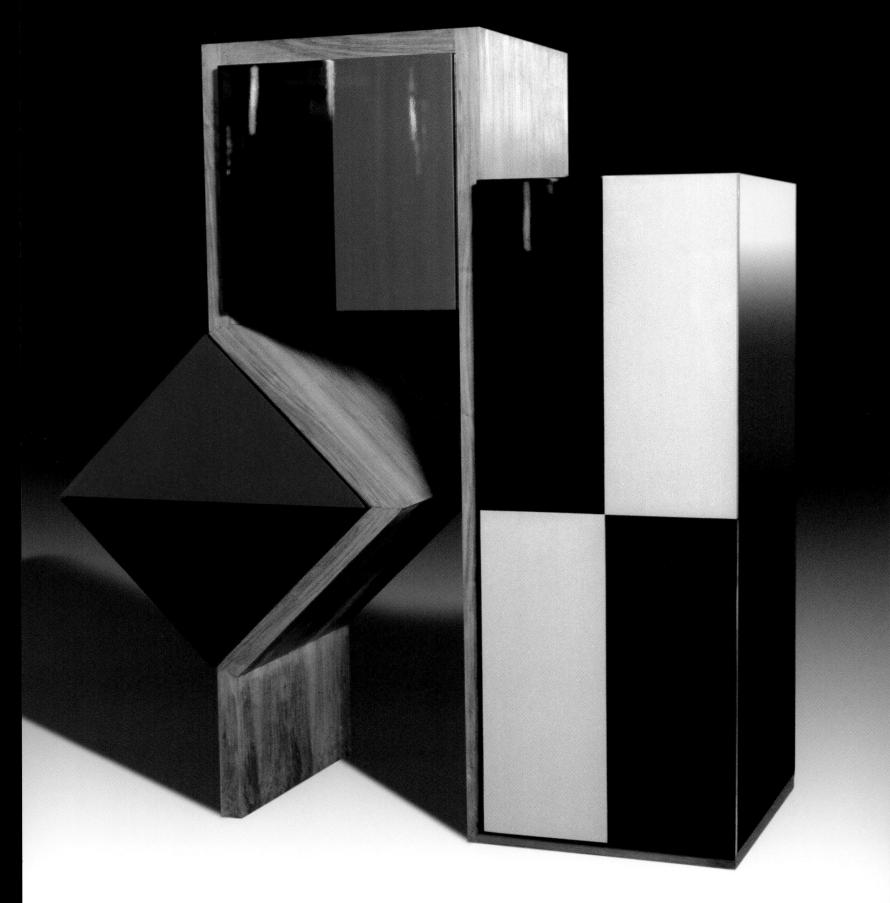

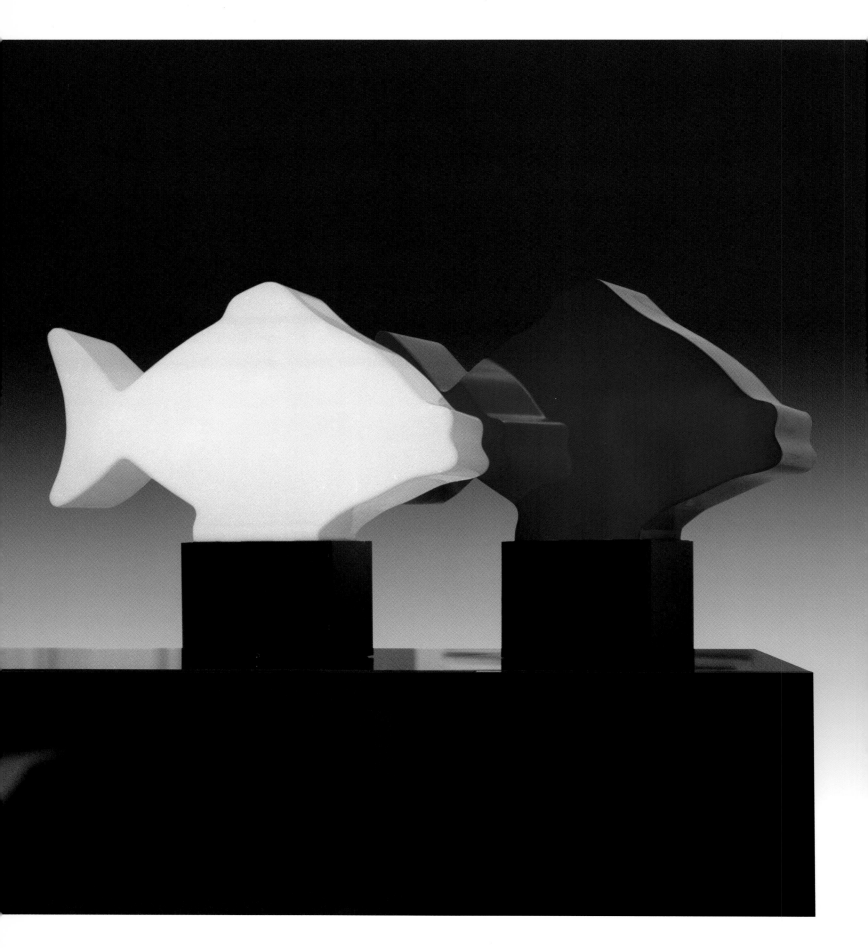

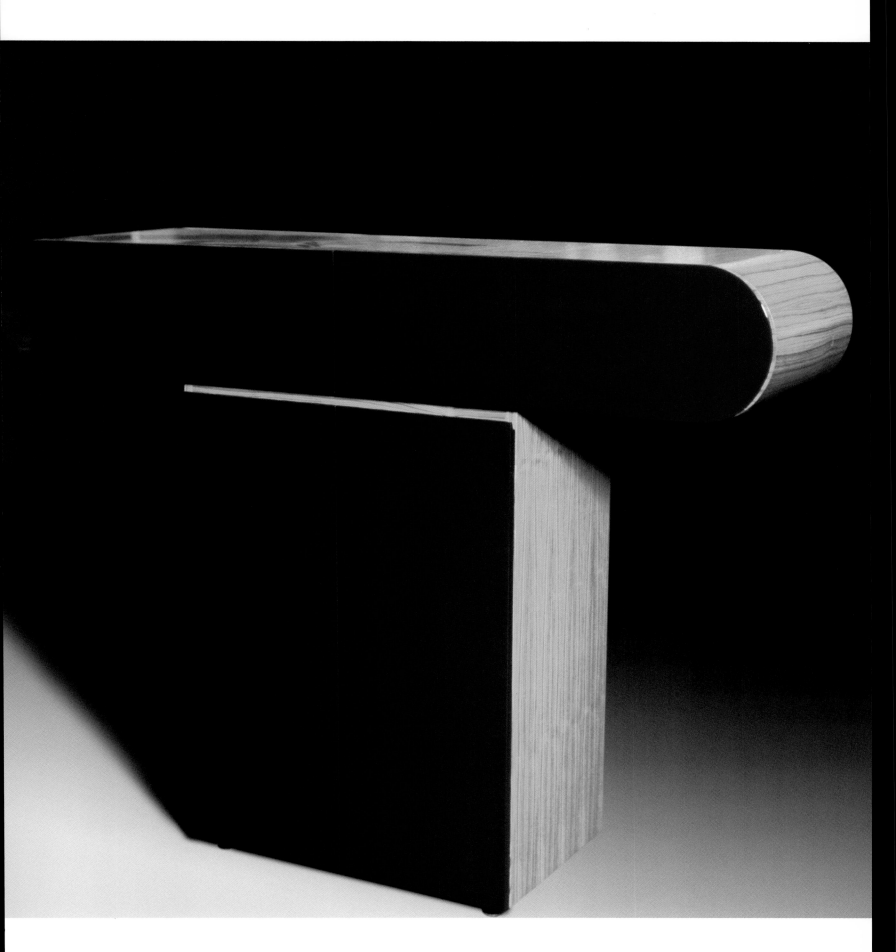

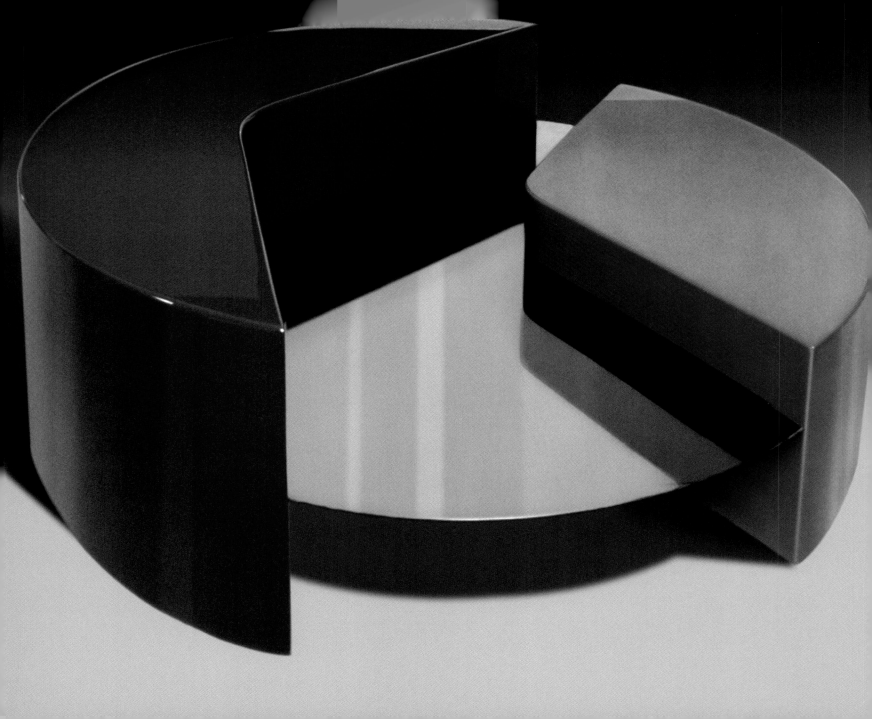

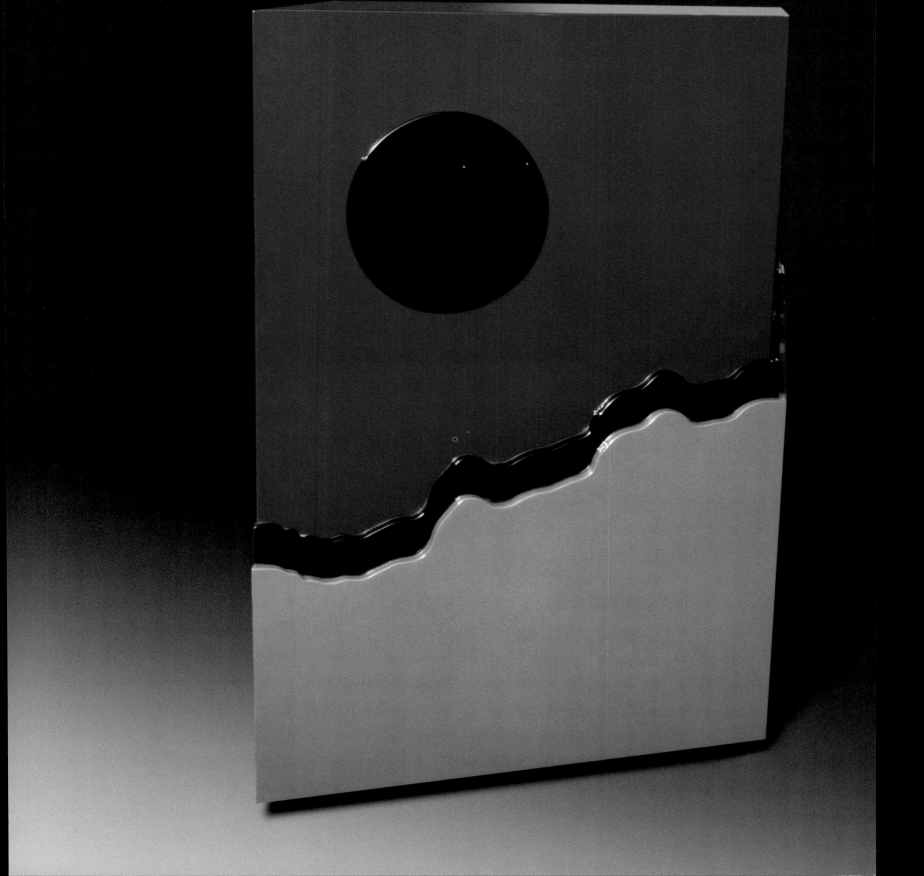

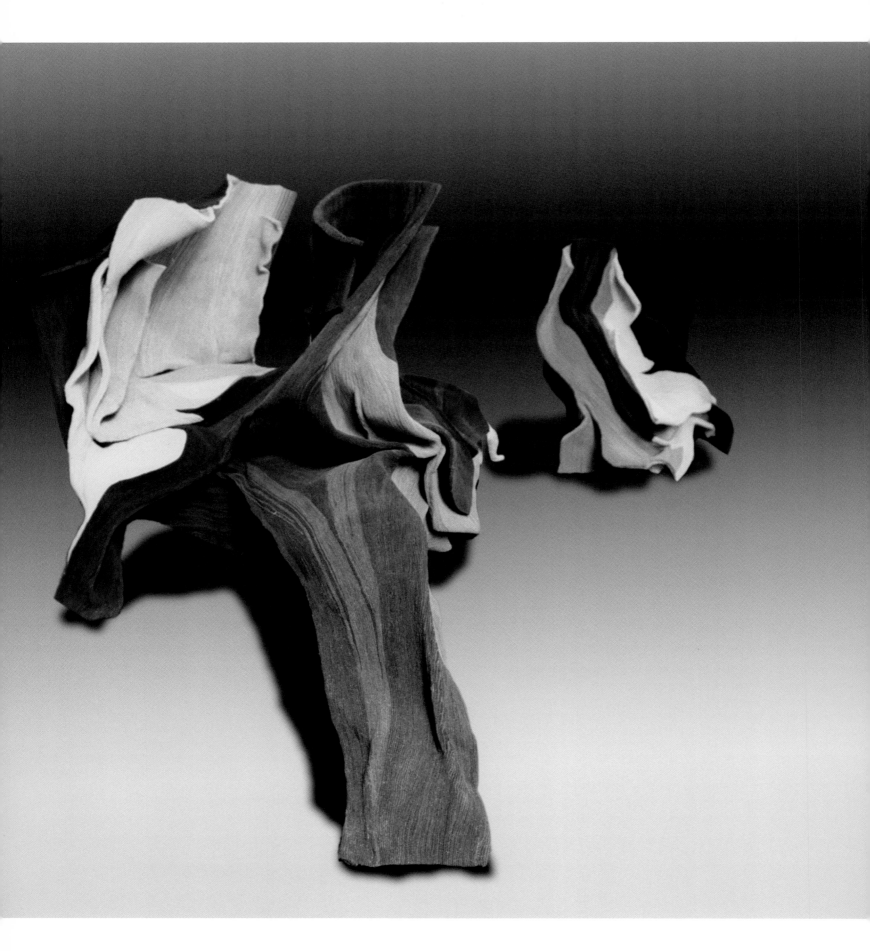

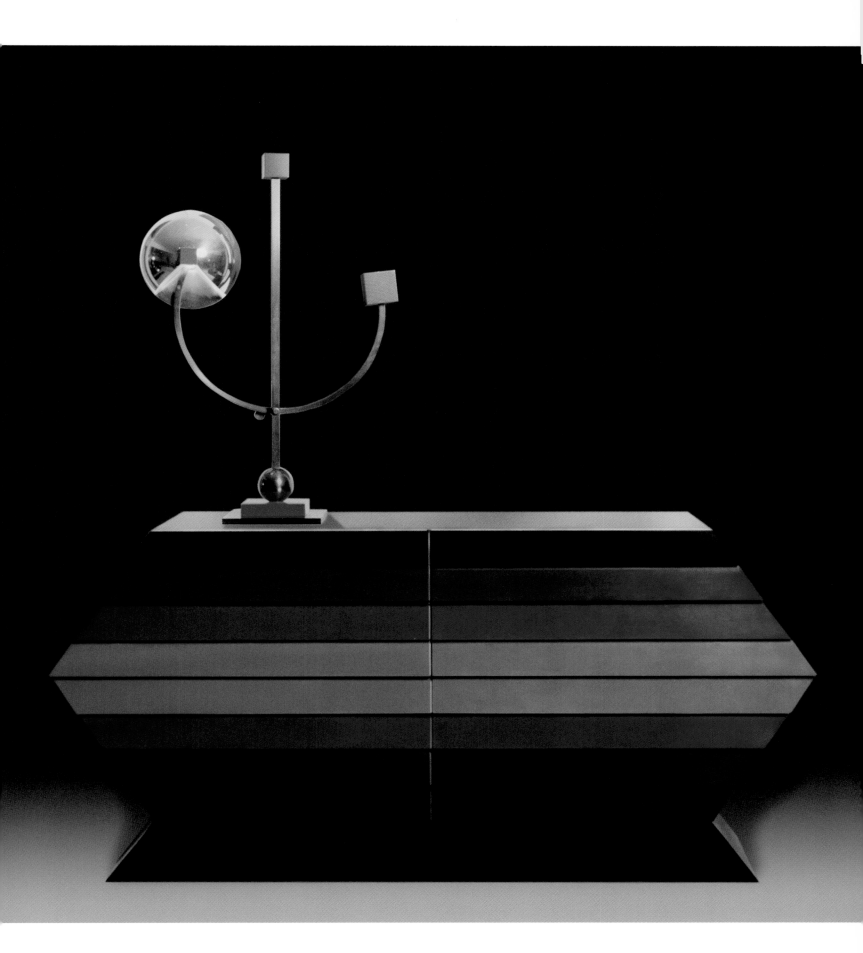

LE PALAIS BULLES

'This house is an erotic structure and it has a lot to do with fashion. When I design a dress, I don't design it around a woman's body. I design the dress and then put a woman inside it. The woman and dress interact, the dress adapts itself to the body and vice versa. That is how it has to be with houses too – an angular, modern house will always remain strange though. It doesn't interact.'

Within the range of options at an artist's disposal lies recourse to earlier forms and the transference of the force of these forms from one kind of art to another, and this is at the very foundations of creativity. The short passage in *Genesis* in which Noah's descendants describe the construction of a tower – the Tower of Babel – to reach to the heavens has come to be symbolic in the history of architecture of an endless challenge to create buildings of unearthly significance. Spheres, spirals and ellipses are especially suited to demonstrate the dynamics of revolutionary architectural ideas as built images of a larger world. Among the oldest examples are the Indian stupas dating from the 1st century BC, which are said to have been invented by Buddha himself.

Architecture as a signifier of power and greatness legitimized the compulsion to create a social and religious unity, such as the unity petrified as a world wonder in the pyramids of Giza or as a classical model for great buildings in the temple of Hatshepsut at Deir el-Bahari. Anthemios of Tralles, the architect of the Hagia Sophia, shaped the building as a sculptor and kinetics theorist. He aimed at investing solid material with the force of movement in the ecstatic gesture of the dome. Francesco Borromini employed concave and convex forms as visible mediums to create architectural dynamism, while Étienne-Louis Boullée's spherical architectural utopias were never realized.

The basic formula for architecture at the beginning of the 20th century was penned by Louis Henry Sullivan: 'Form follows function'. Antoni Gaudí remained unimpressed by this concept. He chose an amorphous basic form for his architectural fantasies, which he then embellished whimsically. His work has been labelled Catalan Art Nouveau. Reacting against the *béton brut* (raw concrete) style, Alvar Aalto, Eero Saarinen and Pier Luigi Nervi created organic pieces of architecture, giving them rolling and concave lines of great elegance. Jørn Utzon's concrete shells on the Sydney Opera House became a monument to the manifest fusion of architecture and sculpture. They enriched the architectural vocabulary of Postmodernism with abstract expression. Role swapping between architecture and sculpture characterizes Frank Owen Gehry's museum buildings.

Antti Lovag, the Hungarian-born architect, boatbuilder and pilot, founded a research centre with the factory owner Pierre Bernard, whose 'living in the uterus' concept was to become the programme and expression of their buildings. In 1975 Antti Lovag began to realize an architectonic assembly of bubbles of various sizes on a 8,500 m² plot on a slope above Théoule-sur-Mer. The experiment resulted in Le Palais Bulles, which was given its name by Sotheby's. Pierre Cardin purchased the building in an incomplete state, with building work spreading over a fourteen-year period between 1975 and 1989.

The complex comprises some twenty-five bubbles or pods, moulded in concrete and attached to a radial construction. Their porous outer skin is made of foamed polyurethane.

Opposite: Pierre Cardin at Le Palais Bulles, 1995

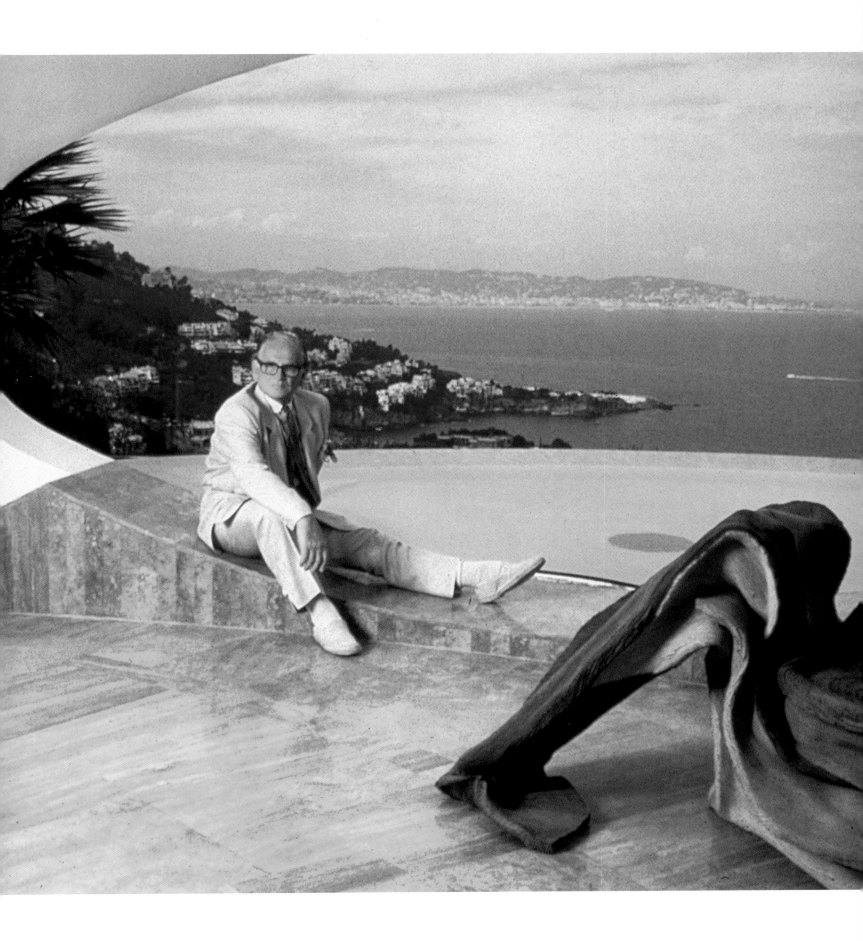

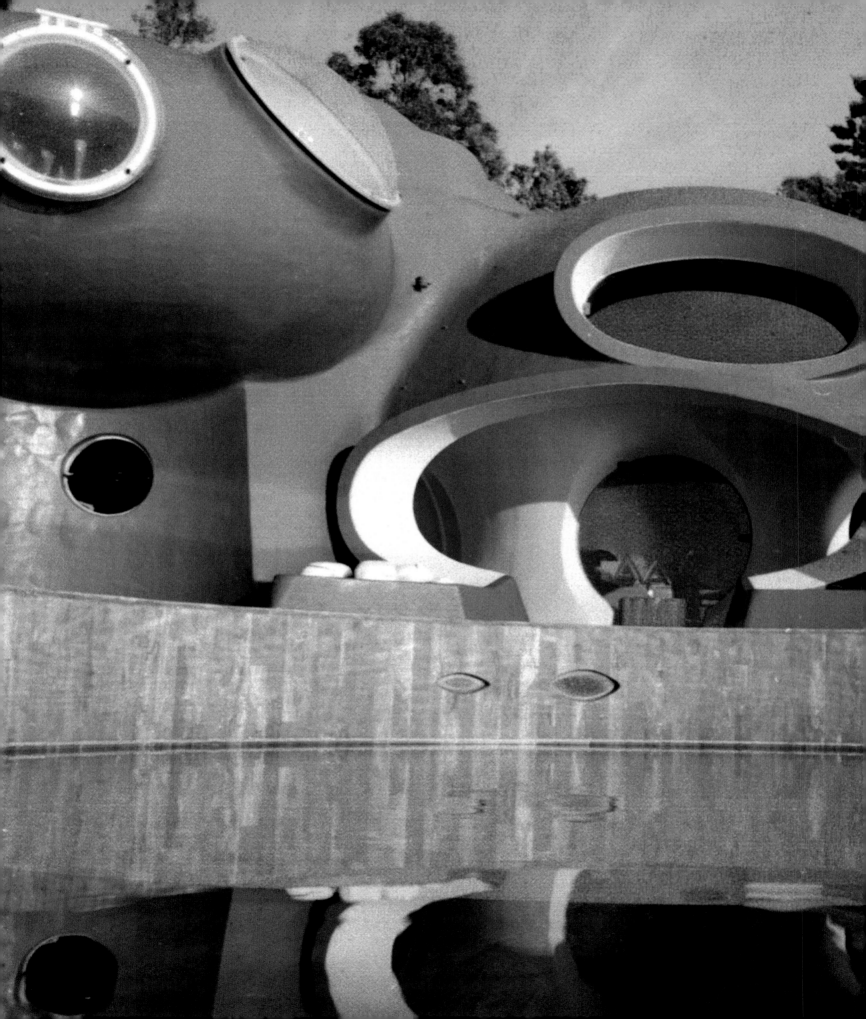

LE PALAIS BULLES

'I am fascinated by the architectonic concept. Le Palais Bulles is new and primitive at once. It is reminiscent of the body of an insect, a reptile, a bee and of the human body with its organs. I love this house, which has the naturalness of an egg. Everything is round without corners or edges. In its caves, which attract light like breasts, one feels like one is in a human body.'

Their organic effect is accentuated with earth tones. The arrangement of the bubble-shaped bulges follows neither the laws of symmetry nor those of statics. The amorphous conglomeration betrays no stringency in the construction and, visually speaking, it is in continual motion. The bubble shapes open to the outside world like the suction discs of a sea creature and were glazed with special glass from Murano. Circular and elliptical openings offer panoramic views without corners or angles. The reflection of the natural and modelled environment in the bull's eyes of these bubbles augments the enchantment of illusionistic effects erratically created by the fall of light and the three pools of water in the complex. Discernible verticals are in the vegetation alone: palms and slender growing Mediterranean plants, which constantly sway in the wind at this height. The various elevations of the bubbles, resulting from the steepness of the site, are bridged by narrow flights of stairs, themselves following the curves.

The concave shells found in the interior of the building are a counterpart to the convex melodies gracing its exterior form. They flow freely into one another, creating a system of cave-like spaces housing living, reception and bedroom areas, bathrooms as well as a kitchen and library, all defined by the manner in which the owner has furnished them. The living spaces are characterized by the round, curvilinear, organic and maritime furniture forms designed by Pierre Cardin and Claude Prévost. They harmonically echo the sensual flux in a building liberated from perpendicular architecture. Artefacts by young artists accentuate the zoomorphic bastion. The formal language of the windows and doors is akin to that of galactic curves derived from the circle and the dream world of Schoenberg's *Pierrot Lunaire*.

The plastically modelled forms of the building create an illusionistic atmosphere both inside and out. This is augmented by numerous reflections and the fall of light, which countermand boundaries between the interior and exterior world. They flow and mingle. Building and life derive meaning and sense here in an eternal passage of evolution. The impression, however, remains futuristic and innovative. The amorphous worlds of construction and residence at Le Palais Bulles do not speak the lingua franca of architecturally shaped reality. Its formal canon generates associations with extraterrestrial worlds. The building is an alien and is perceived as a concrete provocation. This inverts any sense of the building's organic plasticity into the very opposite. It mutates into a radical architectural utopia. Le Palais Bulles metamorphoses into a surreal uterus at night, with gleaming signals being sent to the world from its openings to submit to the formal canon of the architecture of elementary curves. The classical semi-circle of a private amphitheatre belonging to Le Palais Bulles recalls the nucleus in the wilful division of a cell.

Opposite: Partial view of Le Palais Bulles, 2002

Overleaf: Interior and exterior shots of Le Palais Bulles, 2002

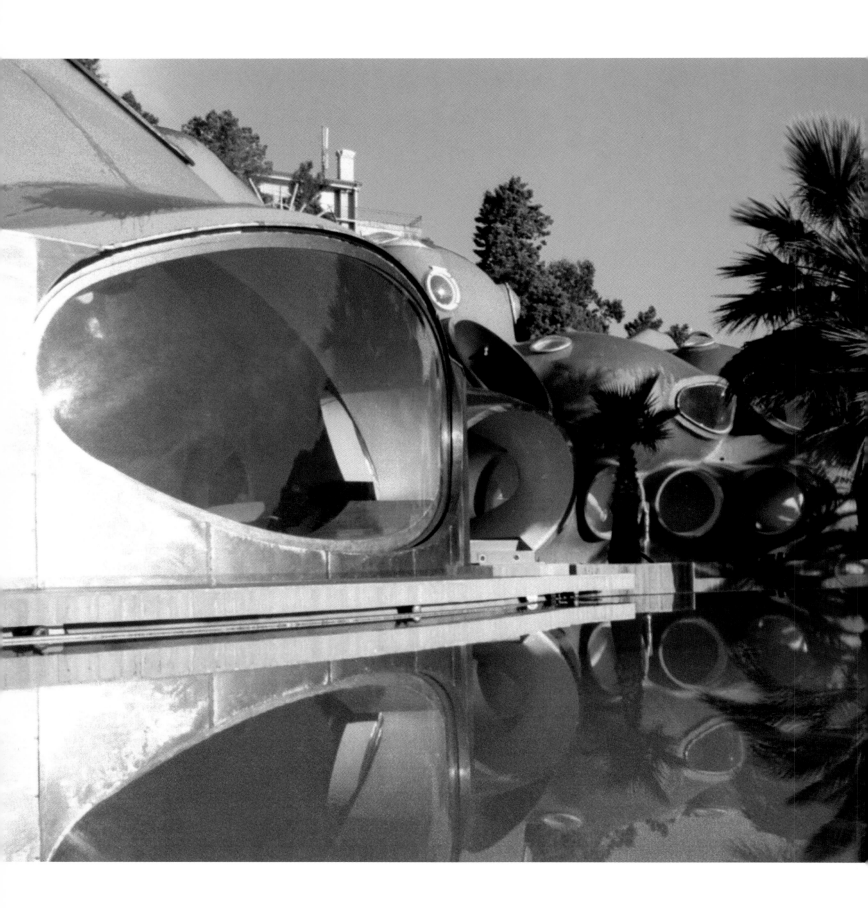

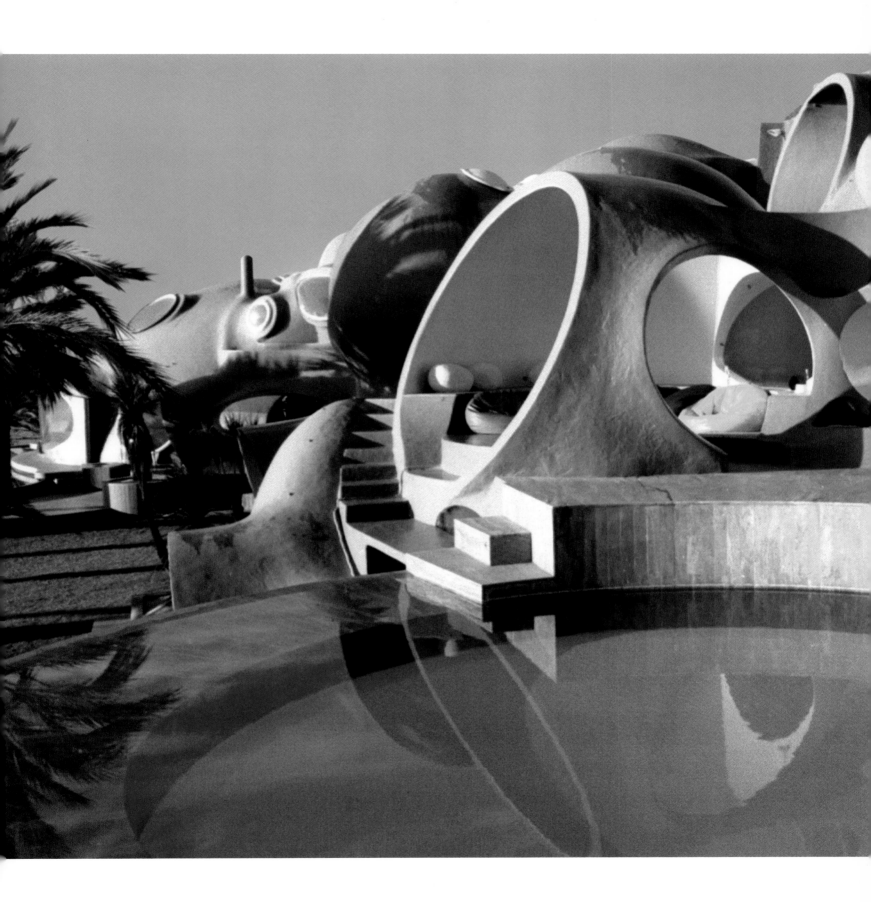

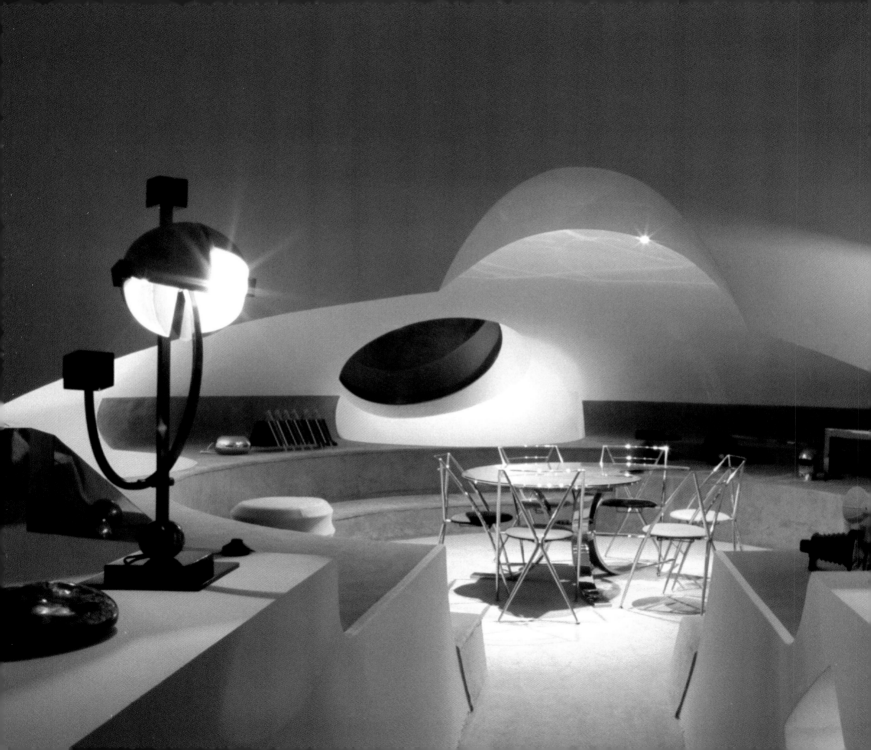

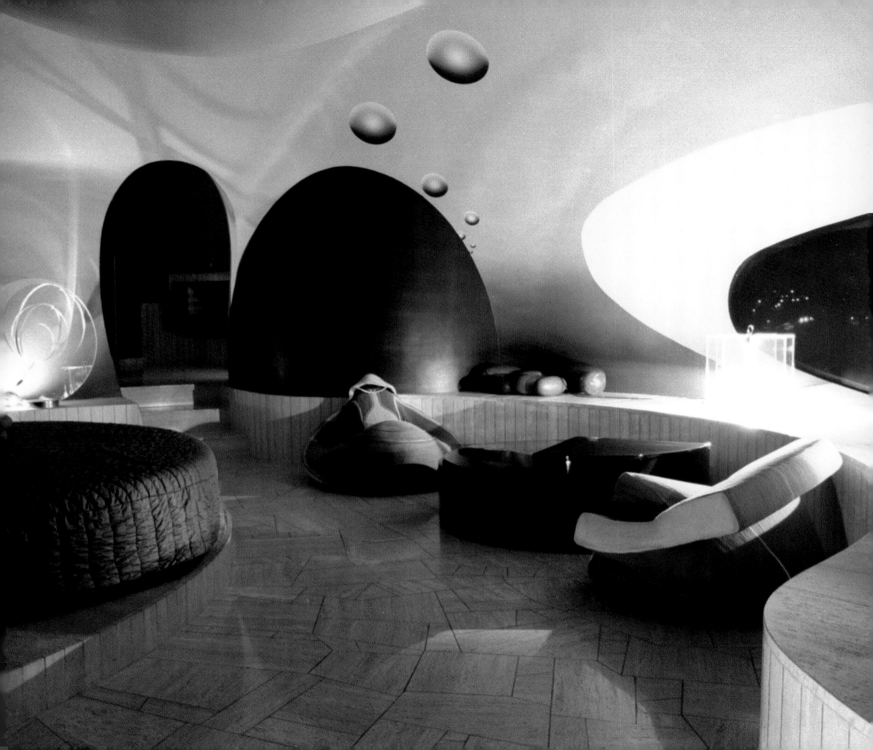

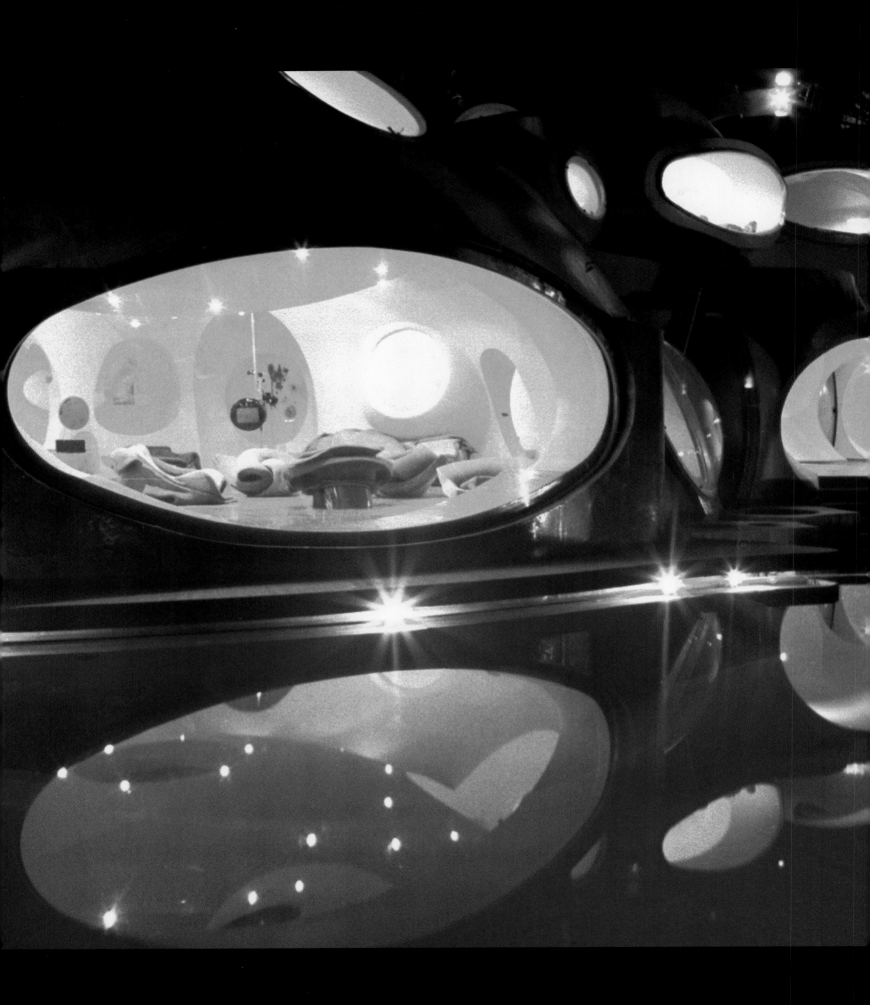

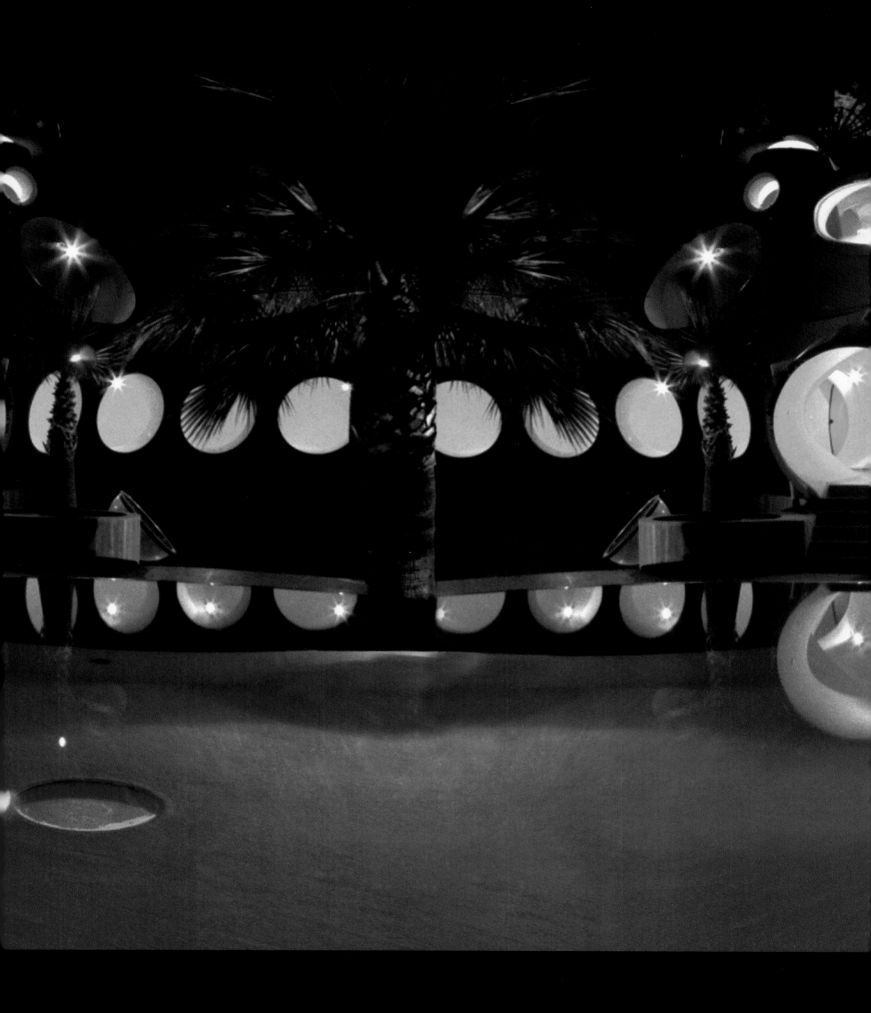

MAXIM'S DE PARIS

This outstanding Art Nouveau *gesamtkunstwerk* is located in the listed former palace of Cardinal Richelieu, Rue Royale 3. The noble establishment provides a stage for a cosmopolitan elite that excites the fantasy of people all over the world. While the fame of other Parisian restaurants of the Belle Époque lasted a mere moment in comparison to the glory enjoyed by Maxim's de Paris, the latter – which has been celebrated for over eleven decades – retained its luxury, allure and popularity. Neither the caprices of social fashions nor the shifts in economic fortunes experienced by society could debase the myth and magic that is Maxim's.

Maxim's was originally a café, named after its ambitious proprietor, the waiter Maxime Gaillard. Opened on 21 May 1893, it was to develop into the fixed star of the *jeunesse dorée*. Following Gaillard's death just two years later, Maxim's was bought by Eugène Cornuché, who was as devoted to the fine arts as he was to high society. He transformed Maxim's into a temple of exquisite pleasures and provided it with an aesthetic ambience in the Art Nouveau style. The wealth of forms and ornament and the sumptuousness and elegance of the interior struck a chord with the *joie de vivre* of the French elite, who fell readily under the spell of this sensual reinterpretation of the Louis XV tradition. It represented not a revolution but an evolution into a synthesis of the arts, a *gesamtkunstwerk* that made it possible to unify life and art on the highest plane.

This sensibility for a harmonious unity of furniture, decor, *objets d'art* and life style was not restricted to France. Originating with the Arts and Crafts Movement in England, it had seized the whole of Europe and America. However, its artistic manifestations were varied and governed by the ambiguity of a rational stringency and vegetation-based ornamentation. The artists and works of the École de Nancy – represented by Victor Prouvé, glass and furniture maker Emile Gallé and cabinetmaker Louis Majorelle, the Daum Frères as well as René Lalique – made a sensual interpretation of nature into something of a fait accompli in their modern art, characterized by feminine grace. This is why Paris became a good market for painter and stained-glass artist Louis Comfort Tiffany, son of American jeweler Charles Lewis Tiffany, but not for Charles Rennie Mackintosh. The floral decoration of William Morris, Mackintosh's compatriot, was better received. He showed his appreciation by opening a branch on the Seine. Edvard Munch was derided as a barbarous colourist and amateur painter because Art Nouveau saw the illusionistic poetry of Neo-Impressionism as its complement in painting.

Left, from top to bottom:
Jean Cocteau, 1966
Jean Michel Jarre and Charlotte Rampling, 1982
John Travolta, Margaux Hemingway and Pierre Cardin, 1983
Opposite: Grande Salle of Maxim's de Paris with the original glass ceiling from 1893

Overleaf: Original decor of the Grande Salle from 1895

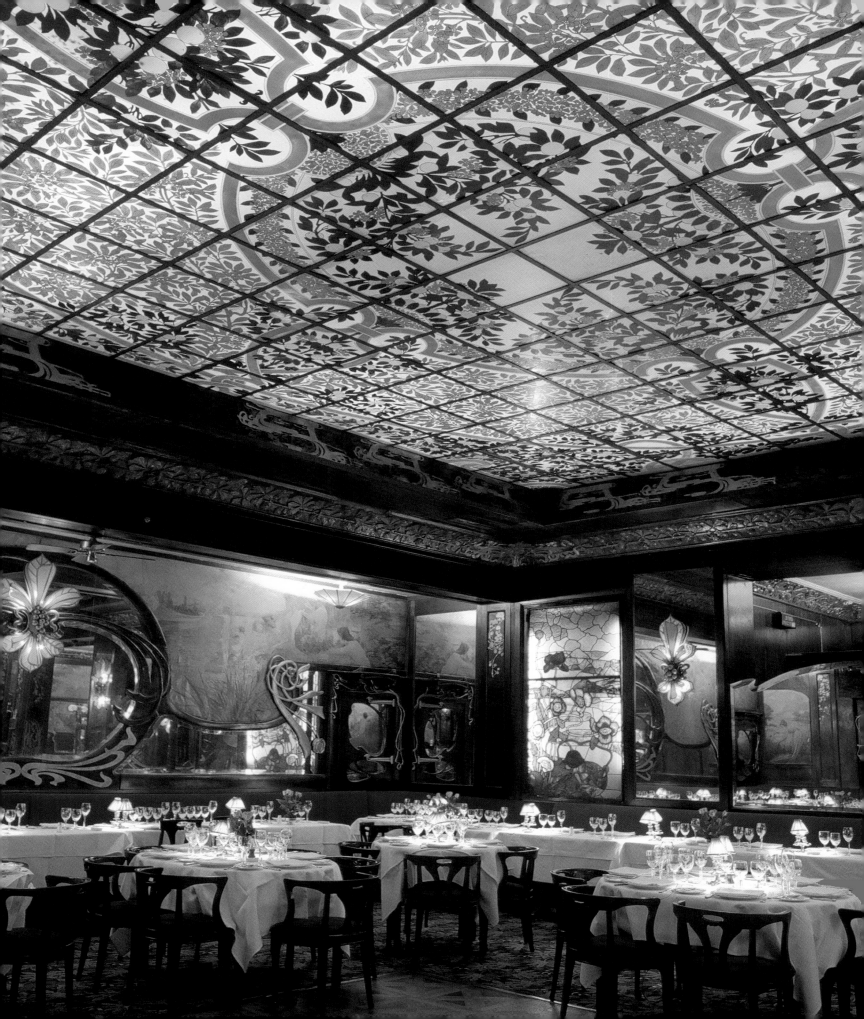

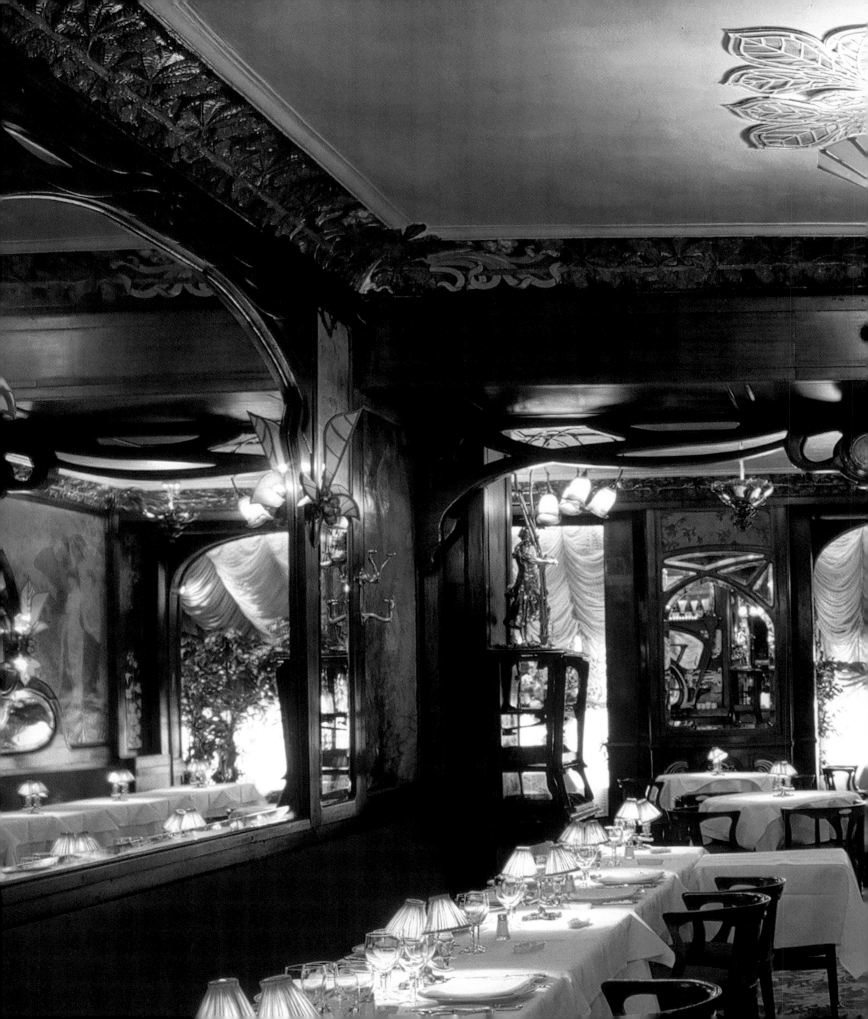

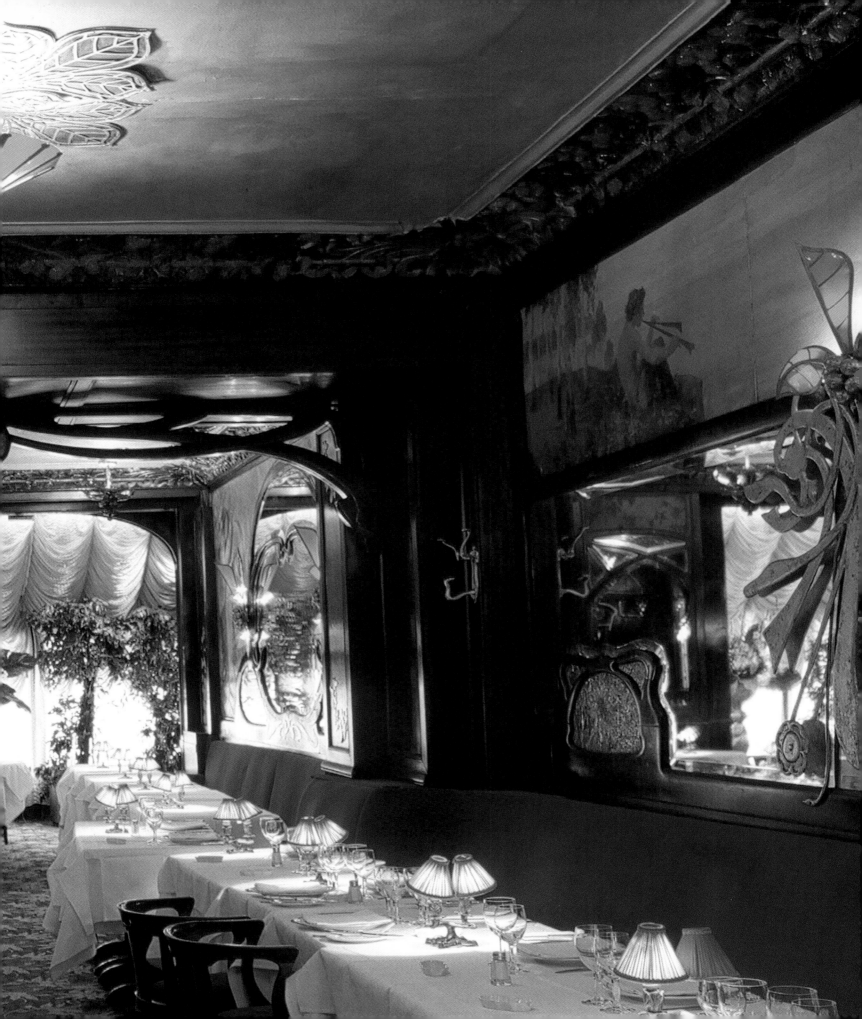

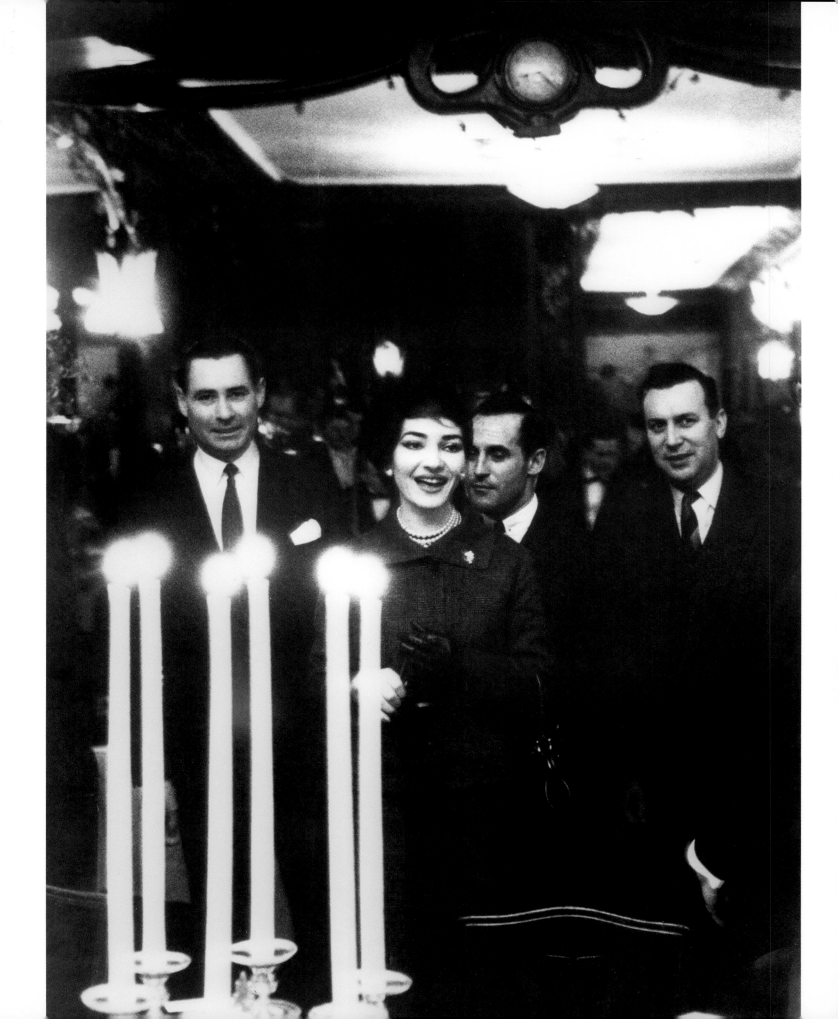

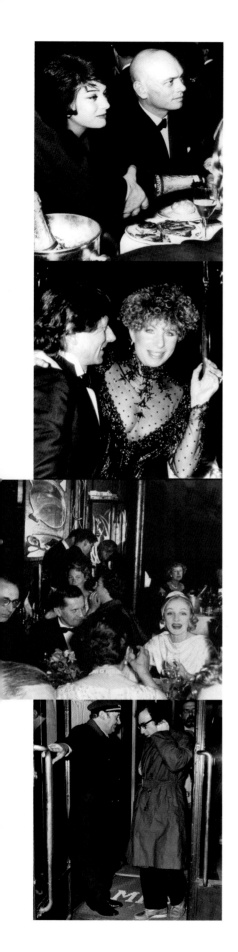

Art Nouveau celebrated its greatest triumph at the World Exhibition in 1900. This was only outdone by the triumph of Maxim's as Art Nouveau's choicest and most complete *gesamtkunstwerk*. Eugène Cornuché found an enthusiastic devotee of Art Nouveau in the figure of Louis Marnez, who knew just how to engage the right artists for the decoration of Maxim's – artists capable of investing the concurrence of art forms and the art of good living with unique opulence and sensuality. The muse was divine nature. The annual ebb and flow of nature – the cycle of birth, growth, ageing and death – were echoed in the crescendo and diminuendo of vegetative artworks in glass and crystal, metal and mahogany, damasks and velvets. With society's aspiration to make life itself into an art form, arabesques, tendrils, blooms and foliage became palpable symbols of desire, arousal and fulfilment. Although these states were personified in the ephemeral nymphs adorning the walls, art merged with reality in the figures of the aristocratic high priestesses of love who actually frequented the temple. They contributed as much to the fame of Maxim's as any of the artists who worked on the interior.

Alexandre Brosset adorned the entrance and façade with bronze tendrils and foliage as a metaphor of natural sensual delights. Léon Souvier enhanced mahogany-framed crystal mirrors, doors and columns with metal and glass motifs. He transformed the doors of the Grande Salle leading to the main kitchens into a fiery monument to French actress Sarah Bernhardt and the Comédie Française. On the walls, artists Martens and Sonnier not only paid frescoed homage to the beauty and seduction of the female body, which appears in the guise of nymphs enticing the guests to enjoy divine experiences with no threat of expulsion from this paradise, but they also unabashedly acknowledged the real promise of the art of love. The 180-pane glass ceiling in the Grande Salle is the Garden of Eden in enamel and is an inheritance from the times of Café Maxim's. The artistic programme utterly complied with society's earthly appetites by actually revoking the anonymity of the nymphs through the introduction of portraits of the most famous of Love's priestesses. Liane de Pougy, La Belle Otéro, Emilienne d'Alençon and Augustine de Lierre enjoyed their place alongside kings, dukes, princes and counts as *les grandes cocottes*, while *les petites cocottes* were relegated to the omnibus, the generously proportioned corridor leading to the Grande Salle, where the red bar was also located. The illustrator Georges Goursat – better known as Sem – occupied the same place at this bar for fourteen years and sketched with his pencil an epoch and its society in the quest for pure pleasure.

Glamorous times returned to Maxim's when Octave Vaudable purchased the restaurant after it had been taken over by a British company following the First World War and misappropriated, much to the chagrin of its elite clientele. Vaudable returned it to its former glory – an exquisite jewel adorning the finest of lifestyles, offset by the most refined of arts. The new age had augmented the collection of aristocratic clientele with pioneers of the air, automobile constructors, industrialists and bankers, celebrities of the art and literary worlds as well as stars of stage and film. After 1946 Louis Vaudable, Octave's son, received new guests from the Americas. The patina on the apotheosis of sensually disrobed femininity lent what was once exclusively a reference to coquettes the mantle of comforting if faded illusion, where even society party-giver Elsa Maxwell could feel snug. And it wasn't just hotelier Conrad Hilton and Orson Welles who shared her enthusiasm. Everyone who was anyone in the American world followed her eulogies: at this museum of Art Nouveau Elizabeth Taylor and Richard Burton, Charlie Chaplin, Bing Crosby, Frank Sinatra, Gary Cooper, Liza Minelli, Rita Hayworth, Yul Brynner, Barbra Streisand and many others encountered Yehudi Menuhin, Arthur Rubinstein and Maria Callas, Jean Cocteau, Pablo Picasso, Joan Miró, Max Ernst and Andy Warhol, who was permitted to take off his jacket. Salvador Dalí, Aristotle Onassis, the Duke and Duchess of Windsor, and Aga and Ali Khan

Opposite: Maria Callas, 1960
Left, from top to bottom:
Yul Brynner with a friend, 1970
Roman Polanski and Barbra Streisand, 1985
Jean-Paul Sartre and Marlene Dietrich, 1965
Woody Allen, 1990

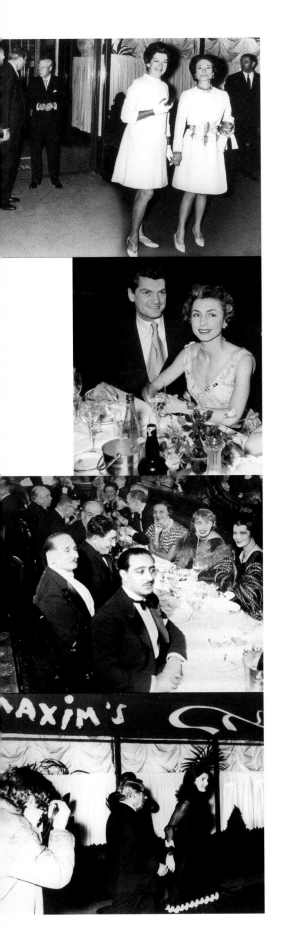

were regular patrons with tables at Maxim's. Prince Rainier of Monaco dined with his wife, formerly known as Grace Kelly, in the royal banqueting area. The spirit of modernity in which Art Nouveau artists had accomplished their work predetermined the means of reconciling the old era with the new age. Every epoch created its own social elite, but they all remained loyal to Maxim's.

In 1981 Pierre Cardin purchased the famous pantheon of Parisian hospitality. With him, the restaurant and palace not only gained a sensitive and knowledgeable enthusiast of Art Nouveau – Cardin himself is an avid collector – but the guests also won a patron who wished to share the most precious pieces of his collection with them. With generosity, dedication and vision, Pierre Cardin perfected the harmony of artistic haute couture and select haute cuisine. After painstaking renovation under the direction of Pierre Pothier, Maxim's presented itself more luxuriously than ever before.

The quality and richness of the craftsmanship that distinguished Art Nouveau were appraised according to taste and aesthetics in its time. Social categories determined artistic evaluation. The World Exhibitions of the industrial age were not just fairs celebrating progress but also showcases for modern art. Art Nouveau artists made use of the manufacturing power and distribution chains of industry without any qualms. Factory-produced quality furniture, ornate decorative art, finely crafted glass and ceramic objects, interior accessories and soft furnishings designed by artists all attest to this. Although Art Nouveau's stylistic formula for art, commerce and the art of refined living never achieved the timeless modernity of the Wiener Werkstätte and Bauhaus, it nevertheless played its part in paving the way to high-quality industrial design.

Within this context, Pierre Cardin's development of Maxim's into an eminently exportable *gesamtkunstwerk*, such as those artistically faithful replicas in Shanghai, Peking and Tokyo, is nourished by the same vision as the creation of a licensable range of the Maxim's brand, including men's and women's evening wear, perfumes and accessories, champagne, wine, flowers, confectionery, biscuits and a whole assortment of other tantalizing treats. Art and industry are no more enemies than luxury and commerce on the highest of levels. Pierre Cardin's cosmos of Maxim's embraces hotels belonging to the Résidence Maxim's chain, ships sailing under the Maxim's des Mers flag as well as the Maxim's on the Orient Express, gliding between London and Istanbul. Pierre Cardin converted the Résidence Maxim's in the immediate vicinity of the Elysée Palace into a museum of interior decoration in 1986. Some forty-three suites, ranging from 80 to 400 m², are inhabitable showrooms recreating historical ambiences from the Baroque to contemporary. Renowned artists have transformed the bathrooms into relaxing paradisiacal oases. The restaurant Atmosphère, the bar Maximum and an intimate summer garden are characterized by their select quality and beguiling sensuality. Maxim's des Mers is a floating artwork with sixteen suites on five decks. The world of Maxim's is just as round as the circle Pierre Cardin has chosen to be the symbol of the infinity of space, the fundamental metaphor for his versatile creativity.

Since October 2004 there has been a private museum on the fourth floor at Rue Royale 4, open to the public with no obligation to visit the restaurant: 'La Collection 1900' is a staged residential world of Art Nouveau covering 200 m² that has been brought together by Cardin over a period of fifty years. It is the only Art Nouveau museum in Paris. Among the collection of furniture, vases, lamps, decorative and functional objects, there are originals by Majorelle, Lalique, Gallé, the Daum Frères and Louis Comfort Tiffany.

Left, from top to bottom:
Duke and Duchess of Windsor and their entourage, 1968
Jean Marais and Elina Labourdette, 1965
Party for La Mistinguette, 1920
Aristotle Onassis and Jacqueline Kennedy, 1972
Opposite: Red bar in Maxim's de Paris

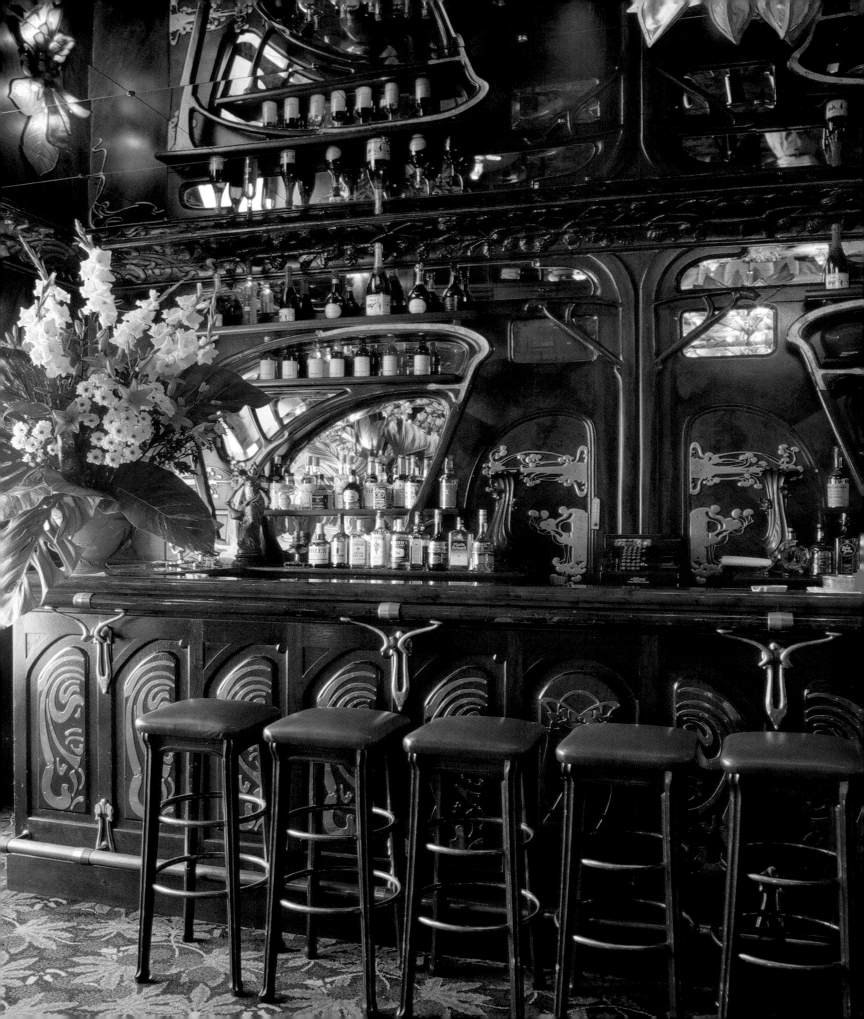

LACOSTE FESTIVAL

Pierre Cardin is the owner of a palazzo near the Teatro San Samuele in Venice which once belonged to Giovanni Giacomo Casanova (1725–98). It serves the native Venetian as a private retreat in the homeland of his childhood. The purchase of the Marquis de Sade's castle in Lacoste closes a circle encompassing a cosmos of culture, theatre, literature, music, dance, song and art. The origin or source of this circle is to be found in his earlier activities as a make-up artist and costume designer in Paris and its completion or resolution in his adopting the role of a Roman Maecenas. The music programme of the Lacoste Festival was opened in 2002 with Wolfgang Amadeus Mozart's *Don Giovanni* and a celebration in honour of the Marquis de Sade. Casanova is said to have reworked Lorenzo da Ponte's libretto for the opera *Don Giovanni* in Prague in 1787 at Mozart's request. These fixed stars of the literary and music worlds were obsessive lovers and free spirits, and Pierre Cardin invited them all to the opening of the Lacoste Festival in 2002.

The castle, a mere breath away from the cultural bastions of the South of France, is a ruin enthroned on a hill. It commands a view over rural Luberon with its small villages and, at its feet, a few stone houses flock together, their archaic grey corresponding to that of the ruin. The castle's situation tells of its medieval origins as a fortress in the struggle against the Saracens. The Marquis de Sade's family erected a country seat on its foundations in 1627. Donatien-Alphonse-François de Sade was born on 2 June 1740 into a provincial noble house, whose roots reach back to the royal dynasty. Like many other aristocratic families, the family suffered from a lack of money, and in 1763 a marriage was arranged between de Sade and the wealthy Renée-Pélagie de Montreuil. This union did not stop the Marquis leading an excessive extramarital love life. He was arrested only a few months after the wedding and incarcerated in the dungeons of Vincennes. He was to spend years there during the course of his life.

Libertine orgies at his ancestral country seat were followed by scandalous debaucheries in the underworld of human fantasy, which he committed to paper during the seven-year prison sentence imposed upon him by the King. The first edition of the novel *The 120 Days of Sodom* appeared in 1782, 'as a catalogue of the most terrible pain people could inflict on others'. The Marquis de Sade was not one of those imprisoned in the Bastille when it was stormed on 14 July 1789. He was held in the lunatic asylum of Charenton and was released during the general amnesty of 13 March 1790. The Revolution allowed him to publish a series of successful works. The Comédie Française put on his play *Le Misanthrope par Amour*. In 1791 came the novel *Justine*. He was as active as a politician.

Left, from top to bottom:
Marquis de Sade, engraving, c. 1760
Giovanni Giacomo Casanova, engraving, c. 1780
Wolfgang Amadeus Mozart, engraving, c. 1787
Opposite: Castle ruins of Lacoste

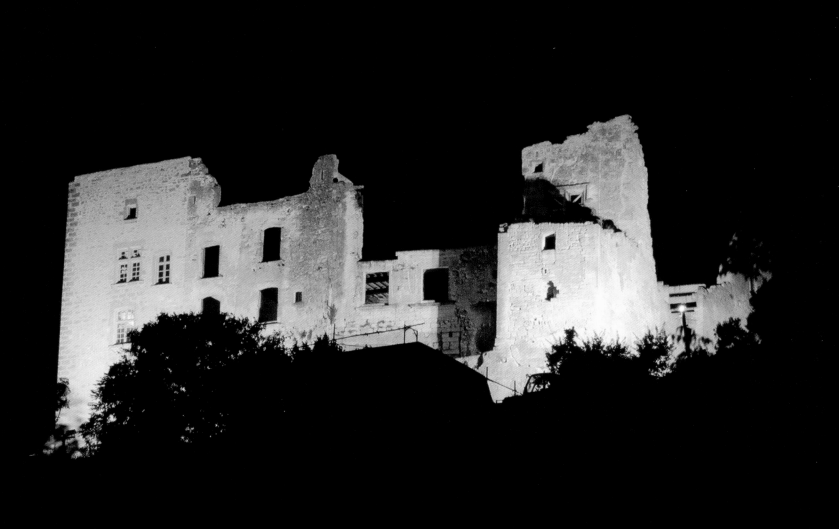

'Sade is a philosopher and a moralist in his own way.'

Jean Cocteau, L'affaire Sade, 1957

'Art is my other great passion besides my work.'

Pierre Cardin, 1970

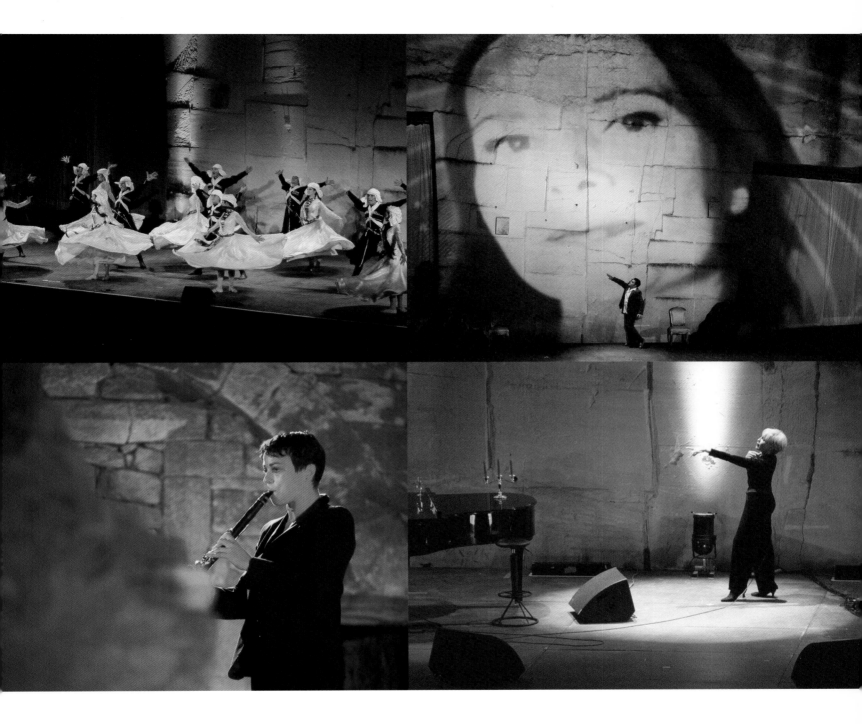

'He is famed as a chained philosopher and the first theorist of absolute revolution. In fact, he really was these things.'

Albert Camus, L'homme révolté (The Rebel), 1951

'I already own Casanova's palazzo in Venice and now I am the owner of the Marquis de Sade's castle. That closes the circle.'

Pierre Cardin, 2001

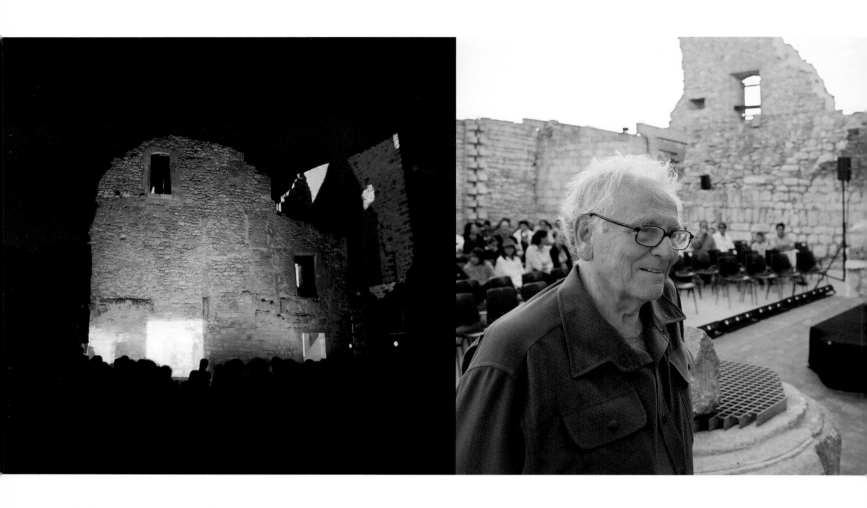

'The Marquis de Sade
is everywhere....
He is in every
library on a secret
shelf somewhere,
hidden so that he
can always be found.'

Jules Janin,
Revue de Paris, 1834

In 1793 he was made president of the Section des Piques of Paris. In this function he was involved in renaming the streets of Paris. He was accused of being a moderate by the Paris Commune, which led to his being arrested and imprisoned once again. The Marquis de Sade had to sell his property in Lacoste in 1796, which he had used intermittently between his detainments in prisons and asylums as a quiet refuge for writing. Finally, in 1801, the gates of Charenton were closed behind the Marquis forever. He was banished from public life in France as the author of the novel *The New Justine*.

Le divine Marquis de Sade was a lucid paradox, at once considered the source of everything one should not know about the darker sides of human lust and yet not recognized as the provocative rebel of freedom driving back the horizon for intellectuals and artists more than any before or after him. The Marquis de Sade had many masks and he also had to wear those he had not chosen for himself. The ban placed on his works by Napoleon's administration was only rescinded after the Second World War. The Marquis de Sade is a larger-than-life myth that still lives on.

In 2002 Pierre Cardin took up the Marquis de Sade's tradition by using the rural castle as a stage to celebrate a love of life and art in the Lacoste Festival, with plays, literary evenings, dance and song recitals. The Fondation Pierre Cardin not only finances renovation and maintenance work on the ruin but also the construction of a roofed stage and auditorium, with capacity for 300 spectators. It mainly serves to house literary events. The library, containing the collected works of the Marquis de Sade – at least those that were not burnt by his son – and housing efforts for its reception into the literature of today, was conceived as a research centre. An open stage akin to an amphitheatre has been introduced into the large courtyard and is reserved for opera and dance performances. Approximately 1,000 spectators can be accommodated there.

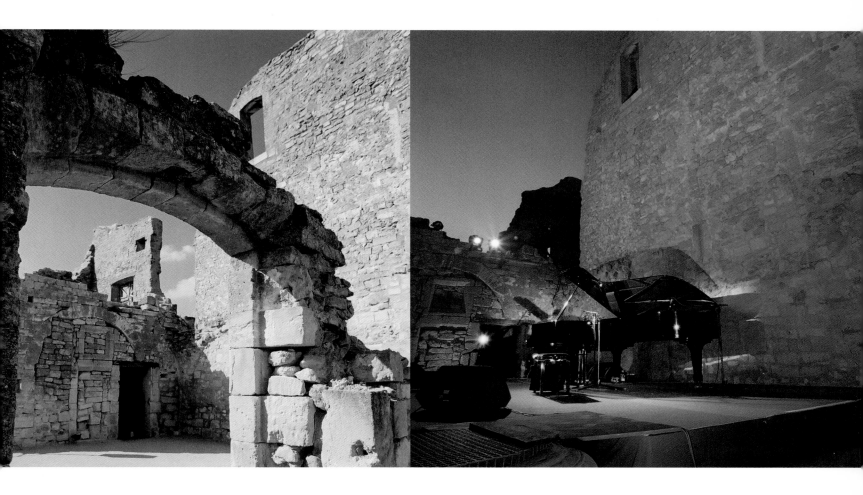

'The Marquis de Sade forces us to question fundamental problems that threaten our era in different guises: the true relationship between human beings.'

Simone de Beauvoir, Les temps modernes, 1952

The Lacoste Festival debut in 2002 followed the concept of Pierre Cardin and his director, Eve Ruggieri, to unite famous soloists and young talent in one festival that would come to be seen as the synthesis of all cultural activity in the South of France. The vision of the passionate theatre-maker has resulted in a year-round business uniting the fine and performing arts. At night the illuminated ruins become the lighthouse for his fascinating idea: 'A new Villa Medici will arise here.'

Photographs of the Lacoste Festival: Serge Alvarez, 2002–4

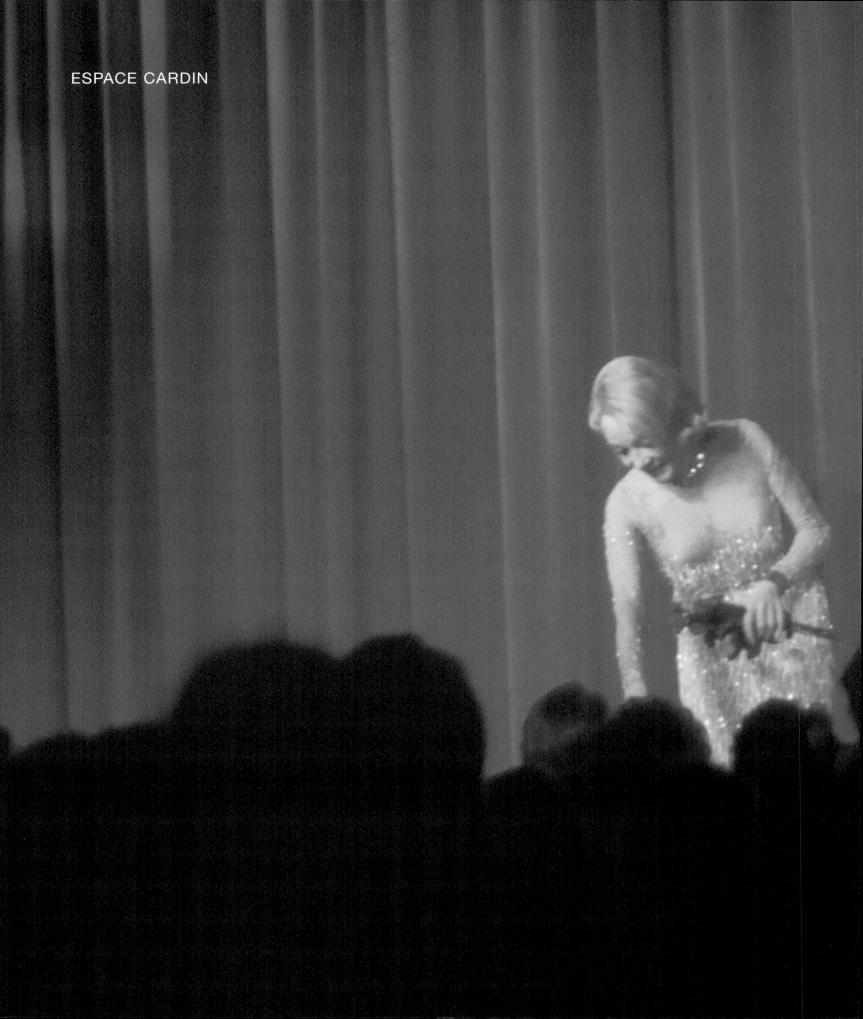

ESPACE CARDIN

ESPACE CARDIN

'The Espace is primarily
a place of research,
a place of eclecticism,
a place where the new can
be experienced on a
interdisciplinary level and
of the highest quality.'

In 1970 Pierre Cardin leased the Théâtre des Ambassadeurs from the city of Paris long term to develop the existing building into an art and cultural complex suitable not only for the staging of plays but also exhibitions and concerts. Visitors were also to be provided with a restaurant and film screenings in an integrated cinema. Pierre Cardin financed the comprehensive conversion of the building to accommodate this multifunctional purpose. The austere structure of the public façades was left intact with their pilasters and all four entrances, each decorated with two tapering columns crowned with Ionic capitals. These columns bear the linearly structured cornice running around the entire building, which itself dates from the 1930s. Its extended flat roof is highlighted by the stern melody of the higher flanks and the central tract. The building's height permitted the introduction of a further level.

The ground and first floors of the Espace Cardin are lit by uniformly high arched windows. They are framed in aluminium and communicate the spirit of modernity through this material, which was introduced into the building by the patron himself. Handrails and banisters of the same material follow the rigid formal canon of the building and secure the open staircase leading from the ground to the first floor. Intervisibility with the outside world remains uninterrupted. It appears in the form of a green backdrop of park-like gardens. Opposite the Espace Cardin on the Avenue Gabriel are the gardens of the British, Japanese and American embassies. The main façade looking on to the Champs Elysées provides views of the green verges fringing the famous boulevard.

The theatre is on the ground floor. The seats in the stalls and the circle as well as the staircases leading to the theatre sport a red gown. Every single one of the 800 seats has the same form, colour and covering. Every visitor is equally welcome and important in the theatre of the Espace Cardin. The cinema, conceived as a private screening area, is on the same level as the theatre circle. It has space for 100 people, all of whom can enjoy the comfort of soft, deep-moulded seats. Walls, screen stage and seats are in plum blue. This intense colour envelops the film world like the sweetness of the fruit that gave it its name. Exhibitions, functions, presentations as well as fashion shows by other designers, industry and art events have all turned the multifunctional spaces on the ground and first floor into a profitable centre for the investor and leaseholder. He also contributes financially to the running of the art centre and theatre.

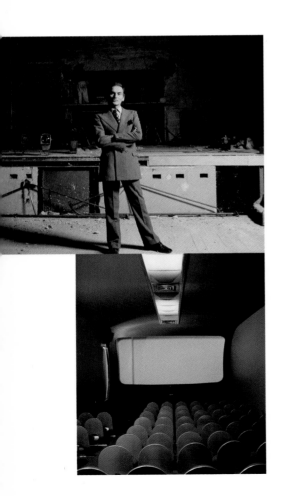

Preceding pages: Marlene Dietrich in the Espace Cardin, 1973

Left, from top to bottom:
Pierre Cardin, theatre-maker, art lover and patron, at the Espace Cardin, 1970
Cinema in the Espace Cardin, 1970–71
Opposite: Espace Cardin in Paris, Avenue Gabriel 1–3, 2005

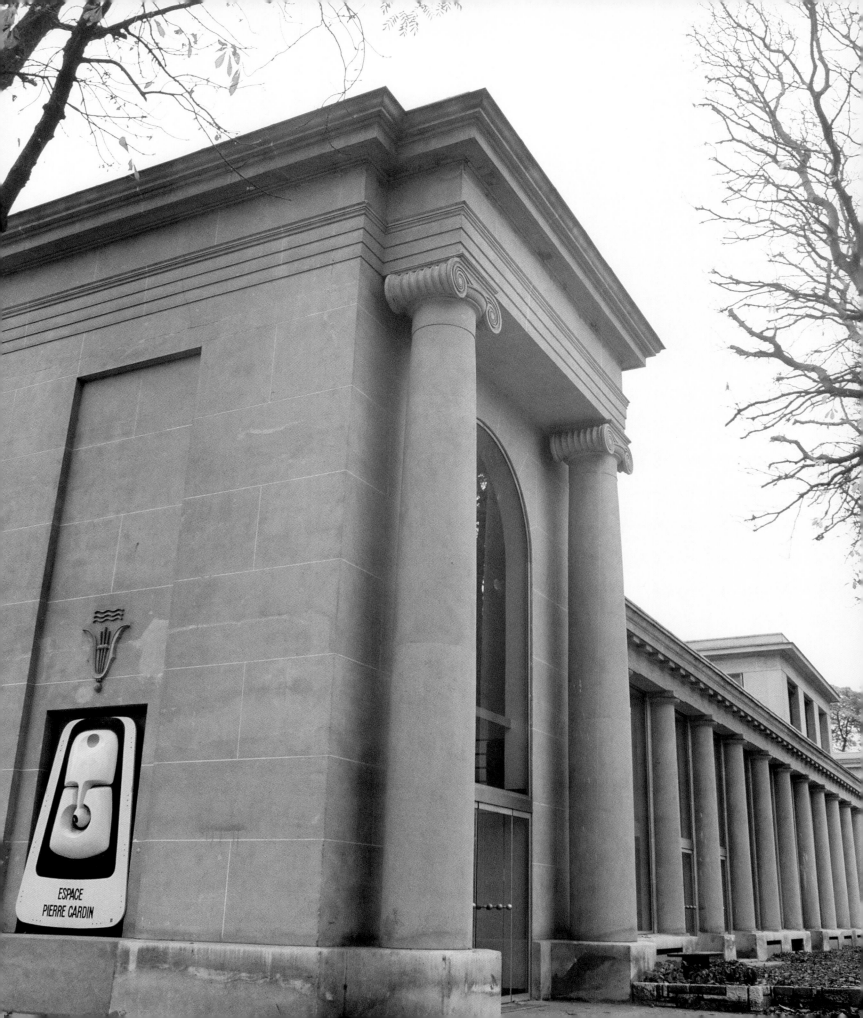

ESPACE
PIERRE CARDIN

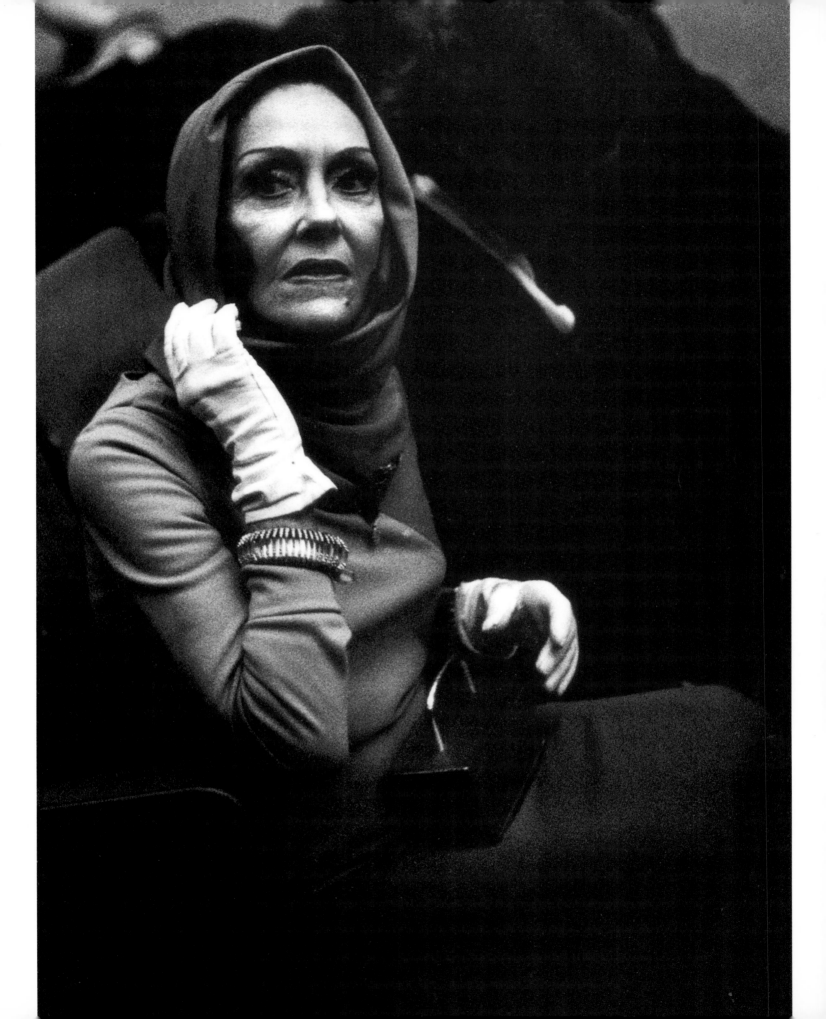

ESPACE CARDIN

Bob Wilson, Jeanne Moreau, Peter Handke, Marlene Dietrich, Gérard Depardieu, Kiri Te Kanawa, Ella Fitzgerald and Ivo Pogorelich, to name just a few, have all answered the call of Pierre Cardin, the theatre-maker, and unfurled their talent on the boards of a world stage. The synergies of theatre and film, art exhibitions and commercial presentations, events and week-long shows that can be experienced at the Espace Cardin result from the characteristically organic relationship between the micro and macro cosmos in all of the couturier's undertakings. In Pierre Cardin's construct of ideas and through his holistic approach, the apparent opposition of functions, media, forms and ideas becomes a means to promote creative and commercial dynamism. The lease agreement with Paris for the Espace Cardin is valid until 2010. Pierre Cardin will be eighty-eight by then and will certainly not entertain any thought of being separated from his Espace.

Opposite: Gloria Swanson, 1985
Left, from top to bottom:
Jeanne Moreau, 1970
Garden restaurant at the Espace Cardin, 1975
Alain Delon, 1974

BIOGRAPHY

Working for the Red Cross

On his way to Christian Dior

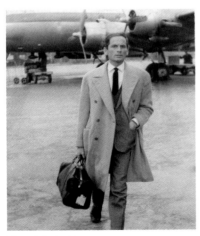

The globetrotter

1922
Born on 2 July near Venice, Italy, in Sant'Andrea di Barbarana, San Biagio di Callalta. Parents moved to France two years later. Spent his youth and apprenticeship years in central France.

1936
Wanted to become either a costume designer or an architect. Took up an apprenticeship with a draper and clothier.

1939
Left his parental home at the age of seventeen. Worked at a dressmaker's in Vichy and demonstrated his managerial talent in his work for the Red Cross.

1944
Arrived in Paris (November). Worked for Jeanne Paquin and Elsa Schiaparelli. Became acquainted with Jean Cocteau and Christian Bérard through Marcel Escoffier. Collaboration as costume designer for theatre and film. Designed for the cult film *The Beauty and the Beast*.

1946
Began his collaboration with Christian Dior (18 November). Collaborated on the 'New Look' collection, which became a fashion sensation in February 1947.

1950
Founded his own business for theatre costumes in the Rue Richepanse, Paris.

1953
Presented his first haute couture women's collection.

1954
The 'bubble dress', a worldwide success, became the trademark for Cardin's sculptural quality as a couturier. His first women's fashion boutique, Eve, was opened at Rue du Faubourg Saint-Honoré 118 in the 8th district, Paris.

1957
Opened Adam boutique for men. First trip to Japan. Became a guest professor at the Bunka Fukosa College for Design, Japan. Taught the three-dimensional cut.

1958
Received the Young Designers' Award in Boston (September).

1959
Presented his first ready-to-wear collection for women at the Parisian department store Au Printemps.

1960
Presented his first men's collection with the 'cylinder style'.

1961
Opened a ready-to-wear men's wear and accessories department.

1962
The Pierre Cardin Award for the best designer of the year was established at the Bunka Fukosa College for Design in Japan.

1963
Opened a ready-to-wear women's department.

1966
Awarded the Golden Spinning-Wheel by the city of Krefeld.
Presented his first children's collection in the presence of every triplet in Paris.
Opened a boutique and a studio for men's fashions in a six-storey building at Rue du Faubourg Saint-Honoré 5, Paris.

1968
Opened a boutique for children's fashion at Rue du Faubourg Saint-Honoré 8, Paris.
Signed a licensing deal for porcelain with the German company Hutschenreuther.

1969
Designed the uniform for flight attendants at Olympic Airways.

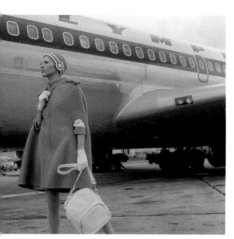

Uniform of Olympic Airways

Pierre Cardin and André Oliver

'*Maxim's belongs to Paris like the Eiffel Tower. It has the image of the successful and also knows their game with appearances. It is a place of yearning and a restaurant of love.*'

1970
Opened the Espace Cardin on the Avenue Gabriel 1–3, Paris, as a cultural cosmos, comprising a theatre, cinema, gallery, exhibition hall and restaurant.
1973
Awarded the Basilica Palladiana prize, which is presented annually to a successful Venetian by the city of Venice.
1974
Awarded the EUR, the Italian Oscar for outstanding contribution to showbusiness.
1975
Opened a design boutique at Rue du Faubourg Saint-Honoré 29, Paris.
1976
Opened another design boutique at Rue du Faubourg Saint-Honoré 72, Paris.
Made Grand Officer of the Order of Merit of the Italian Republic for outstanding service.
1977
Awarded the Golden Thimble (made by Cartier) by the French haute couture for the most creative collection of the season.
Opened the Evolution gallery at Rue du Faubourg Saint-Honoré 118, Paris (October).
Presented his first haute couture furniture collection, Utilitarian Sculptures, offering objects that were more like sculpture than furniture (October).
Opened the Maxim's boutique at Rue du Faubourg Saint-Honoré 76, Paris (November).
1978
Awarded the Prestige du Tourisme certificate for his contribution to the development of French tourism.
Opened Men of the Night Maxim's boutiques at Rue du Faubourg Saint-Honoré 82 and Rue Royale 5, Paris.
First trip to China (December).
1979
Awarded the Golden Thimble for the second time by the French haute couture for his spring/summer collection (January).
Staged fashion shows in Peking and Shanghai (March).
Opened Maxim's flower boutique at Rue de Duras in the 8th district, Paris (October).
1980
Opened Maxim's fruit boutique in the Rue de Duras, Paris (January).
Opened the women's fitting rooms at the Parisian Hôtel de Clermont-Tonnerre, Place François 1er 14 (January).
Opened a children's fashion boutique in the Palais des Congrès at Porte Maillot (April).
Opened a showroom for the ready-to-wear men's range at Rue Royale 7, Paris (September).
The Metropolitan Museum in New York held an exhibition celebrating Cardin's 30 years in design (October).
Opened an office in New York at 53 East 57th Street (October).
Opened an art gallery at Boulevard de Waterloo 47 in Brussels (December).
Opened two Pierre Cardin boutiques in Sofia (December).
Commissioned to design an aeroplane interior by the American Westwind Corporation.
1981
Reception, fashion show and dinner at the residence of the French ambassador in Bonn (March), marking the launch of the Maxim's brand in Germany.
Became the proprietor of the Parisian restaurant Maxim's de Paris at Rue Royale 3 (May).
Presented Choc, the new women's fragrance (July).
Dinner presentation of the Maxim's men's collection at Maxim's restaurant (September).
Trips to Brazil, Argentina and Mexico (October).
Retrospective of Cardin's 30 years in the business at the Grand Palais, Paris (October).
Launched bathroom design under the Espace label (October).
Presented car seat covers for the Renault 9 (October).

Characteristic dresses

Utilitarian sculpture

WMF Lizenzkollektion „Maxim's"

Travelled to China for the opening of the Pierre Cardin showrooms in the Sky Temple Gardens in Peking, near the Marco Polo Center (November).

The jewelry collection, Gold and Diamonds, presented at the Parisian Hôtel de Clermont-Tonnerre (December).

Opened a Maxim's boutique in Rome (December).

Gala dinner held at Maxim's for Kiri Te Kanawa (December).

1982

Opened a Maxim's restaurant in Brussels (March).

Retrospective of Cardin's 30 years in design at Sogetsu Kaikan museum in Tokyo (April).

A showroom opened for Pierre Cardin and Maxim's brands in Barcelona (May).

Awarded the Golden Thimble by the French haute couture for the third time (July) for the most creative collection of the season.

Launched the Maxim's champagne brand (September).

Made a knight of wines with the Ordre des Côteaux de Champagne (September).

Presented a knitwear collection in wool under the Pierre Cardin trademark (October).

Maxim's marked the exhibition 'La Belle Epoque' with a dinner at the Metropolitan Museum in New York (December).

Maxim's flower boutique moved to Rue Royale 7, Paris (December).

Contract signed (21 December) to establish a Maxim's restaurant in Peking.

1983

Opened the Minim's restaurant at Rue du Faubourg Saint-Honoré 76, Paris (January).

Made Knight of the Arts and Literature (February).

First trip to Moscow (March).

Made Knight of the Legion of Honour (April).

Opened the first Pierre Cardin boutique in Budapest (September).

Opened a Maxim's restaurant in Peking (September).

Opened a Maxim's restaurant in Rio de Janeiro (December).

1984

Opened a Pierre Cardin boutique in London (January).

Opened a Minim's restaurant with a bakery (July).

1985

Launch of the Pierre Cardin dolls (January).

German company Hutschenreuther presented licensed Maxim's porcelain to customers from all over the world (March).

Awarded the Ascof Brun as the most creative man of the year in Milan (March).

Launched the Maxim's women's fragrance (April).

Awarded the Officer Medal for exceptional services by the president of the French Republic (May).

Travelled to China and put on fashion shows (May).

Opened a Maxim's restaurant in New York (September).

Presented with the fashion Oscar at the Paris Opera (September).

Received the Golden Orchid for Maxim's.

Designed the uniform of flight attendants at the Hungarian airline Malév.

1986

Opened a Maxim's hotel in Palm Springs, California (February).

Signed licensing contract in Moscow for the production of women's, men's and children's fashions under the Pierre Cardin brand, and the opening of a 10,000 m² showroom was also agreed (April).

Maiden voyage of Maxim's des Mers to New York in May to mark the centenary celebrations of the Statue of Liberty.

Opened the Résidence Maxim's hotel at Avenue Gabriel 42, Paris (June).

1987

Inauguration of the bar on the second floor of Maxim's restaurant, Paris (May).

Opened a Résidence Maxim's hotel at Fifth Avenue and 55th Street in New York (December).

Presentation of the WMF Maxim's licensed collection.

1988

Haute couture department moved to the Hôtel de Clermont-Tonnerre (January).

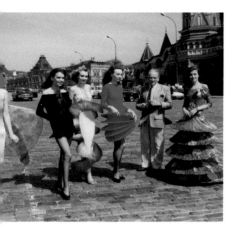

Fashion show in Red Square

Taking his place in the French Academy

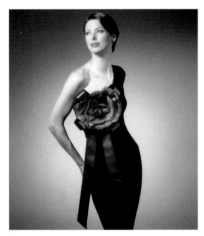

Women's fragrance Rose Cardin

Received the Exceptional Service Medal from the Republic of Italy (February).

Launched a new men's fragrance in Maxim's, Paris (June).

Travelled to the Vatican and the Far East (June), where he was received by six representatives: Pope John Paul II, King Bhumibol of Thailand, President Suharto of Indonesia, His Royal Highness Sultan Azlan Shah of Malaysia, Mrs Benazir Bhutto, Prime Minister of Pakistan, and Mrs Cory Aquino, President of the Philippines.

1989

Presented with a medal by Italian Prime Minister Giulio Andreotti (July).

Recognized for his contribution to interior design in New York.

1990

Received the Palme, the highest award presented by the Catalan Royal Academy of Fine Arts, in Sant Jordi (February).

Launch of the new women's fragrance, Rose Cardin (June).

Illustrated book about Maxim's launched called *Maxim's: Cent Ans de Vie Parisienne*, by Jacques Langlade (September).

Retrospective of Cardin's 40 years in women's wear and 30 years in men's in the Twentieth-Century Gallery at the Victoria & Albert Museum in London (October).

1991

Opened the second Résidence Maxim's hotel in Paris as well as an Italian restaurant, Le Cirque, at Rue du Cirque 20, Paris (January).

Made special ambassador to UNESCO (February).

Designed medals and jewelry for the UNESCO aid programme for Chernobyl (March).

Promoted to Officer of the Legion of Honour (April).

Retrospective of Cardin's 40 years in women's wear and 30 years in men's at the Museum of Fine Arts in Montreal (May).

Presented with Japan's highest distinction, the decoration of the Order of the Sacred Treasure, Golden and Silver star (May).

Fashion show for 200,000 people in Moscow's Red Square (June).

1992

Accepted membership of the French Academy of Fine Arts, Paris (February).

Launched the men's fragrance Énigme (May).

The official celebration of Pierre Cardin's reception into the French Academy of Fine Arts (December).

1993

Introduced a new cosmetics range (January).

Opened a second Maxim's restaurant in Peking.

First fashion show in Vietnam in Ho Chi Minh City and Hanoi (November).

1994

Retrospective in São Paulo coupled with a haute couture fashion show (March).

First meeting with Fidel Castro in Havana (June).

Received the honorary title of Silk Baron in Krefeld (September).

Granted honorary citizenship of the city of Xian on his 21st trip to China (September).

Pierre Cardin Fashion and Design Centers opened at the Institute for Textile Research and Textile Technology in Xian (September).

Retrospective of 40 years in the design business and a fashion show in the royal Sennyuji Temple in Kyoto (November).

1995

Opened a Maxim's boutique and a Maxim's restaurant in Moscow (June).

Met Nelson Mandela in South Africa (September).

Opened the first Pierre Cardin boutique in Riga.

First trip to Burma.

Launched another women's fragrance, Ophelie, in Paris (October).

Opened a three-month long exhibition, 'The Academy of Fine Arts Today', in the Espace Cardin (October).

Opened the first Pierre Cardin boutique in St Petersburg (November).

Travelled to Albania and received by President Sali Berisha (November).

Launched the women's fragrance, Ophelie, in Riyadh and Dubai (December).

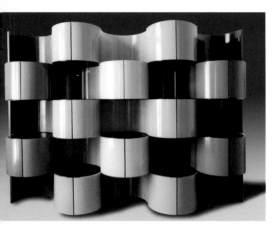

Utilitarian sculpture

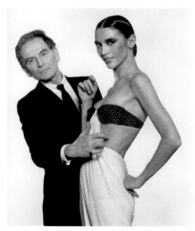

Haute couture fitting

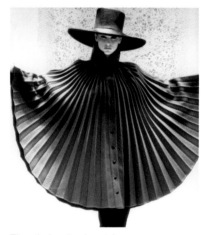

The circle: dominant form and metaphor

Exhibition of the six flags Pierre Cardin selected for the Year of Tolerance announced by UNESCO in the Navarra Gallery, Italy (December).

Presentation of the flags on Place de la Concorde in Paris before their take-off around the world.

1996

Evolution collection for 16 to 25 year olds presented in the new presentation room, Blue Sky, in Paris (March).

Presentation of the Flags of Tolerance in Eilat, Israel, and Petra, Jordan, before an international audience (April).

Showed his last couture collection at the Résidence Maxim's as a private show in the presence of Mrs Chirac, Mrs Pompidou and Mrs Jean Tiberi (April).

Presented this last couture collection at the American Embassy in Paris in the presence of Her Excellency Pamela Harriman (May).

Made chancellor by the Mediterranean Observatory for Information and Reflection (O. M. I. R.) (June).

Presented his highly fashionable collection for women and men as well as a new sportswear collection (10 July), marking the XXVI Olympic Games in Atlanta.

Launched the men's fragrance Sportif concurrently in honour of American youth.

Inauguration of painter Daniel You's exhibition 'Olympic Gods' in Atlanta.

Opened the first Maxim's smoking salon in Brussels (September).

Presented the second ready-to-wear Evolution collection in Blue Sky (October).

Launched Golden Sand, a self-warming pillow of sand.

First trip to Libya (November).

Launched the men's fragrance Centaures.

Awarded the France–Italy Prize of the Italian Chamber of Commerce in France

1997

Made an Officer of the Legion of Honour (January).

Opening of the exhibition '50 Years of Creativity' at the Espace Cardin (January).

8,000 bottles of wine from the cellars of Maxim's restaurant auctioned in Paris (June).

Opened a Minim's restaurant at Rue Royale 7, Paris (June).

Presented a new ready-to-wear men's collection for spring/summer 1998 (July).

Opened a Pierre Cardin shop in Cannes (September).

Presented the Evolution collection for spring/summer 1998 in Paris (October).

Presentation of the publication initiated by Pierre Cardin on The Swords of the Academy of Fine Arts at the Institut Français (October).

Opened the new restaurant, Atmosphere, at Résidence Maxim's, Paris (November).

Presentation of the Toyota 'Rav 4' with the Pierre Cardin label (November).

Made 'Chevalier de l´Ordre du Cédre' in Lebanon (December).

1998

14,000 bottles of high-quality wines from the cellars of the Parisian Maxim's auctioned in New York (March).

Presented the Evolution collection for autumn/winter 1998–99 (March).

Launched the new fragrance, Orphée, at Maxim's (March).

Opened a new Pierre Cardin boutique in Lyons.

Made honorary president of the International Dance Council (15 June).

New women's and men's collections presented with the theme 'Four Seasons 1999' in Paris (July).

Opened a new boutique for children's fashion on the Rue du Pont Neuf in the 1st district, Paris (24 September).

Presented the Evolution collection for spring/summer 1999 (October).

Opened the Evolution boutique at Rue du Faubourg Saint-Honoré 83, Paris (November).

Opened a Maxim's restaurant in Shanghai (15 November).

1999

Presented the Evolution collection for autumn/winter 1999 (March).

Opened a Maxim's restaurant in Geneva (24 June).

Presented the Evolution collection for spring/summer 2000 (October).

Decorated by the president of the Ukrainian Republic with the Order of Merit (December).

Retrospective at Au Printemps

Lacoste Festival

Fashion for the world of tomorrow

2000

Opened the 19th Maxim's restaurant in Monaco in the presence of Prince Albert.

Exhibition of the furniture series Utilitarian Sculptures at the Espace Cardin (February).

Launch of the new magazine *Parfums et Senteurs* (9 March).

Fashion show and exhibition of the International Creative Concept in Saint-Ouen (April).

Presentation of the Pierre Cardin retrospective in Shanghai and Peking (November).

2001

Welcoming ceremony for Jeanne Moreau as a member of the French Academy of Fine Arts (January).

Presented the ready-to-wear men's collection autumn/winter 2001–2 (28 January).

Purchased the Marquis de Sade's castle in the South of France (2 March).

Launch of the new fragrance, Tristan & Yseult, at the Espace Cardin (May).

The opening of the Lacoste Festival and a celebration in honour of the Marquis de Sade (13 July).

Awarded the Grand Prix Licom for the best licensing strategy (November).

Awarded the Golden Medal by the Société d´Encouragement au Progrès for his achievements, innovations and progress (December).

2002

Opening of a retrospective of Cardin's 50 years in the business in Los Angeles (14 February).

Show of the current fashion collection in Las Vegas (20 February).

Launch of a book on Maxim's in New York (21 February).

Presentation of the same book in Paris (15 March).

Opening of a retrospective of Cardin's 50 years in the business in Tokyo.

2003

Retrospective fashion show in Palazzo Corsini during Pitti Uomo in Florence (January).

The second season of the Lacoste Festival (July).

2004

Decorated with the Franciscus Skorina Order, Belarus's highest decoration, by President M. A. Lukashenko in Minsk (7 January).

Launch of the new fragrance, Revelation, in Paris (February).

Opening of the retrospective exhibition 'Pierre Cardin' in Franca Sozzani's gallery in Milan (25 February).

Inauguration of the exhibition and fashion show 'Tribute to Pierre Cardin' in the department store Au Printemps Haussmann in Paris (2 March).

Opening of the third season of the Lacoste Festival (July).

Inauguration of the Pierre Cardin private museum of Art Nouveau at Rue Royale 3, Paris, concurrent with the opening of the exhibition 'SEM' (12 October).

Bestowal of the Pierre Cardin Prize during the Sino-French Year and the Days of Good Fortune before the plenum of the parliament in Peking.

2005

Opening of the exhibition 'Pierre Cardin: Design & Fashion 1950–2005' at the Academy of Fine Arts in Vienna (3 May).

Simultaneous book presentation of *Pierre Cardin*.

Fourth season of the Lacoste Festival (July).

Ready-to-wear, 1995

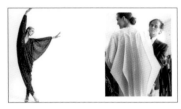

Left: Haute couture, 1978
Right: Fitting, 1981

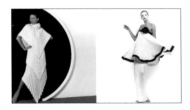

Left: Haute couture, 1974
Right: Haute couture, 1975

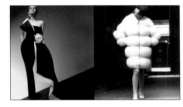

Left: Haute couture, 1994
Right: Haute couture, 1966

Jewelry, 1970

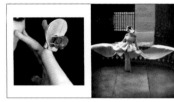

Left: Diamond ring, 1970
Right: Haute couture, 1988

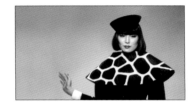

Haute couture, 1982

Left: Haute couture, 1968
Right: Haute couture, 1968

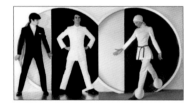

Left: Haute couture, 1971
Right: Haute couture, 1971

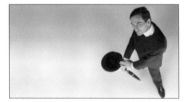

Pierre Cardin, 1969

Left: Pierre Cardin in the Beatles era
Right: Haute couture, 1992

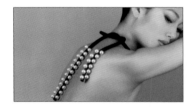

Jewelry, 1970

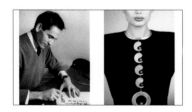

Left: Pierre Cardin in Japan, 1957
Right: Jewelry, 1970

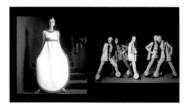

Left: Haute couture, 1971
Right: Haute couture, 1971

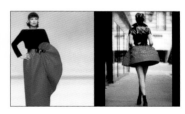

Left: Haute couture, 1982
Right: Ready-to-wear, 1996

Ready-to-wear men's wear, 1982

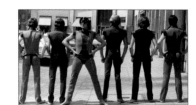

Ready-to-wear, 1972

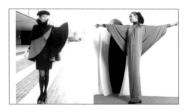

Left: Haute couture, 1981
Right: Haute couture, 1971

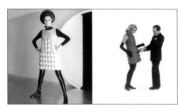

Left: Haute couture, 1968
Right: Lauren Bacall and
Pierre Cardin, 1968

Ready-to-wear, 1968

Left: Ready-to-wear, 1966
Right: Haute couture, 1969

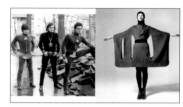

Left: Ready-to-wear, 1970
Right: Haute couture, 1971

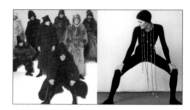

Left: Ready-to-wear, 1970
Right: Ready-to-wear, 1970

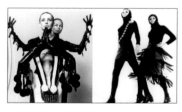

Left: Gloves, 1970
Right: Ready-to-wear, 1969

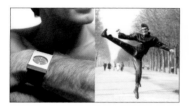

Left: Watch, 1970
Right: Ready-to-wear, 1986

Gloves, 1969

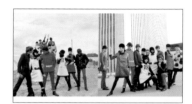

Left: Ready-to-wear, 1967
Right: Ready-to-wear
Cosmocorps collection, 1967

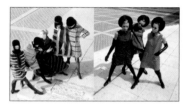

Left: Haute couture, 1966
Right: Haute couture, 1968

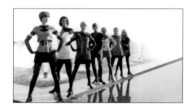

Ready-to-wear, 1968

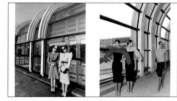

Left: Haute couture, 1979
Right: Haute couture Mod.Chic
collection, 1979

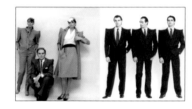

Left: Pierre Cardin with models, 1979
Right: Ready-to-wear, 1979

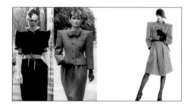

Left: Haute couture, 1979
Right: Haute couture, 1979

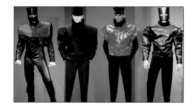

Ready-to-wear, 1991

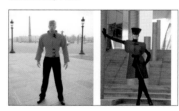

Left: Ready-to-wear, 1986
Right: Ready-to-wear, 1992

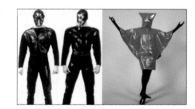

Left: Ready-to-wear, 1990
Right: Ready-to-wear, 1990

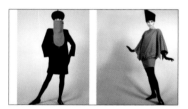

Left: Ready-to-wear, 1990
Right: Ready-to-wear, 1990

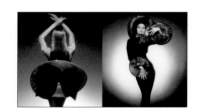

Left: Haute couture, 1992
Right: Haute couture, 1992

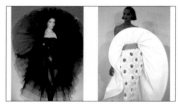

Left: Haute couture, 1991
Right: Haute couture, 1992

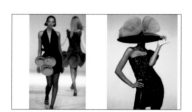

Left: Haute couture, 1992
Right: Haute couture, 1992

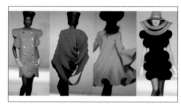

Haute couture, 1992

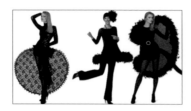
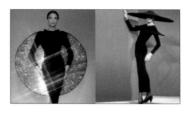
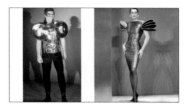

Left: Metal tie, 1980
Right: Jewelry, 1990

Haute couture Dentelles
collection, 1991

Left: Haute couture, 1991
Right: Haute couture, 1991

Left: Ready-to-wear, 1994
Right: Haute couture, 1991

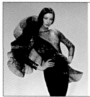
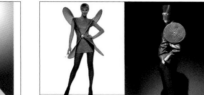
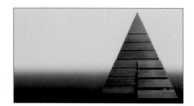
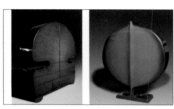

Left: Haute couture, 1998
Right: Ready-to-wear, 1995

Left: Haute couture, 1991
Right: Ready-to-wear, 1995

Pyramide Bois cupboard, 1977
L 55 x W 49 x H 180 cm

Left: Serrure cupboard, 1977
L 140 x W 45 x H 170 cm
Right: Chataîgne bar, 1970
L 150 x W 45 x H 180 cm

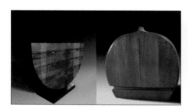
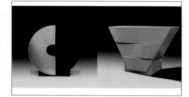
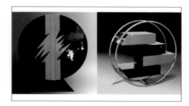
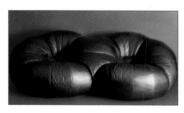

Left: Demi-Lune chest of drawers,
1977, L 160 x W 45 x H 110 cm
Right: Nicola cupboard, 1977
L 150 x W 45 x H 150 cm

Left: Éclipse bar, 1970
L 100 x W 46 x H 104 cm
Right: Océan chest of drawers, 2000
L 130 x W 49 x H 85 cm

Left: Éclair bar, 1977
L 140 x W 50 x H 160 cm
Right: Équilibre 4 shelves, 1977
L 136 x W 45 x H 136 cm

Leather sofa, 1977
L 300 x W 150 x H 50 cm

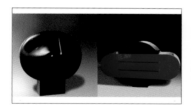

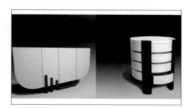

Left: Tête de lune bar, 1977
L 120 x W 43 x H 145 cm
Right: Équation chest of drawers,
1977, L 195 x W 53 x H 115 cm

Left: Demi-Lune lamp, 1997
L 50 x W 34 x H 50 cm
Right: Énigme cupboard, 1970
L 108 x W 38 x H 169 cm

Left: Bahut chest of drawers, 1987
L 170 x W 45 x H 90 cm
Right: Chest of drawers, 1987
L 120 x W 60 x H 140 cm

Left: Pendule Néon clock, 1980
L 44 x W 20 x H 44 cm
Right: Pulsion cupboard, 2000
L 106 x W 50 x H 175 cm

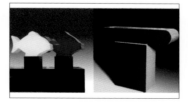
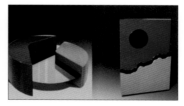

Left: Équilibre 3 cupboard, 1970
L 136 x W 45 x H 136 cm
Right: Secrétaire Espace, 1977
L 65 x W 37 x H 114

Left: Poisson lamp, 1990
L 40 x W 10 x H 35 cm
Right: Console, 1995
L 200 x W 48 x H 80 cm

Left: Table basse, 1977
L 120 x W 120 x H 40 cm
Right: Clair de Lune cupboard, 1970
L 82 x W 40 x H 126 cm

Left: Sofa, 2000
L 160 x W 190 x H 70 cm
Right: Nuit Bleue chest of drawers,
1970, L 180 x W 43 x H 86.5 cm

ACKNOWLEDGMENTS

Amassing information, articles, images and manuscript documents on such a versatile, creative and entrepreneurial personality as Pierre Cardin is not as easy as obtaining one of his ready-to-wear pieces. Zbigniew Krawczynski, who has been deeply involved in successfully structuring Pierre Cardin's licensing empire for decades, sought out, collected and made documentation available out of loyalty to his employer and enthusiasm for this book project. Without his efforts this illustrated book – the first ever to have been published on the cosmos of Pierre Cardin – would not exist. Yoshi Takata has accompanied the couturier and *créateur* with her camera for decades, capturing his work as a sculptor of fashion. Her invaluable photographs, painted with light and sensibility, endow this book with a special quality. Thank you also to Sergio Altieri, who is not just a gifted photographic and graphic artist, and the many young, unknown assistants who have been electrified and challenged by Pierre Cardin. Finally, I would like to thank publisher Christian Brandstätter who, as a great book lover, did not lose countenance, even when the original concept of the book was falling apart.

Elisabeth Längle

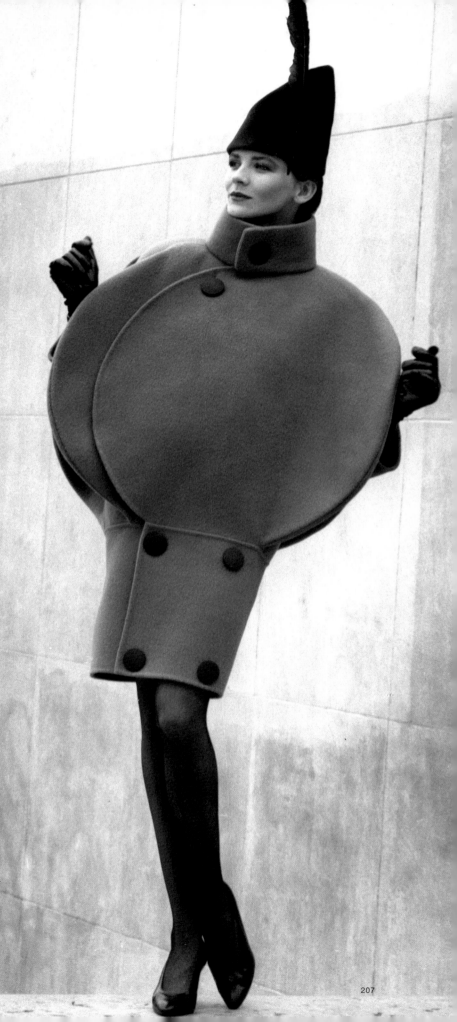

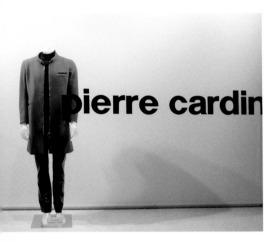

Photographs by Yoshi Takata and Sergio Altieri

First published in the United States of America in 2005 by
The Vendome Press
1334 York Avenue
New York, NY 10021

Original edition © 2005 Christian Brandstätter Verlag, Vienna
This edition © 2005 The Vendome Press, New York

ISBN: 0-86565-166-3

Library of Congress Cataloging-in-Publication Data

Längle, Elisabeth.
 Pierre Cardin / by Elisabeth Längle.
 p. cm.
 ISBN 0-86565-166-3 (alk. paper)
 1. Cardin, Pierre, 1922---Pictorial works. 2. Fashion designers--France--Paris--Pictorial
works. 3. Fashion design--France--Paris--History--20th century--Pictorial works. I. Title.
 TT506.L36 2005
 746.9'2'092--dc22

 2005007881

Printed in Austria

Preceding pages, right: Haute couture gown, 1988

Above: Retrospective at the Au Printemps department store, 2004

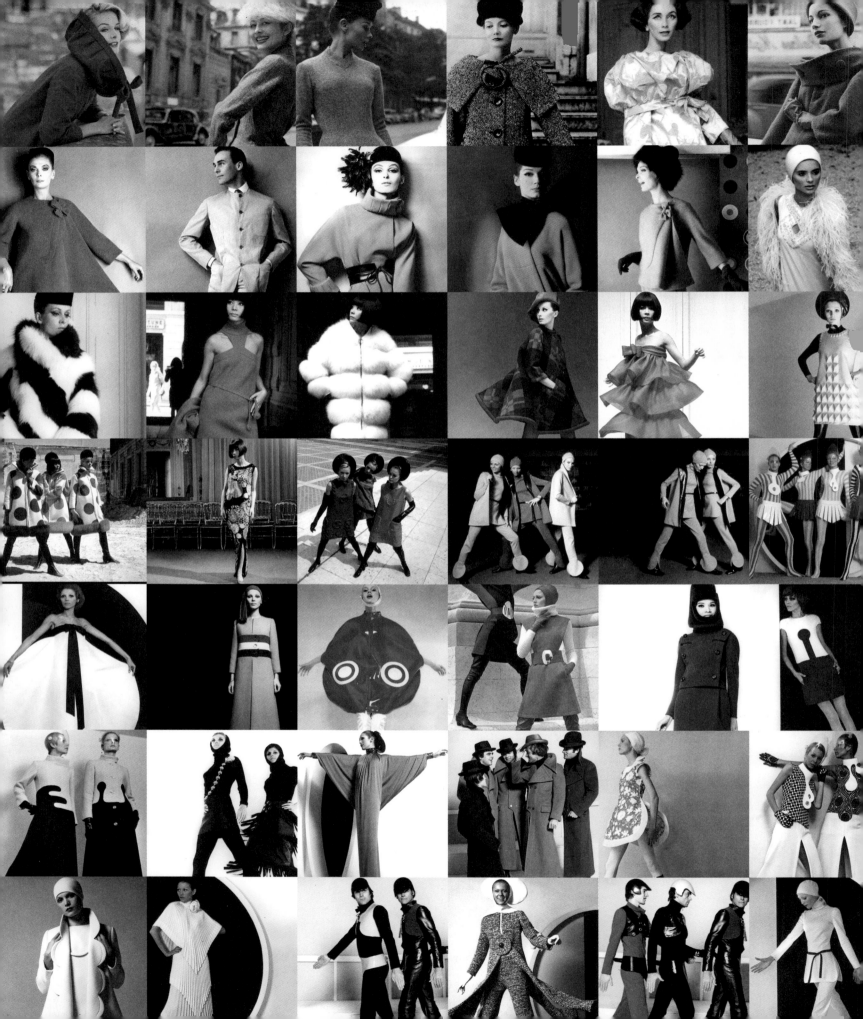